T0373398

Enactments

EDITED BY RICHARD SCHECHNER

To perform is to imagine, represent, live and enact present
circumstances, past events and future possibilities. Performance takes place across a
very broad range of venues from city streets to the countryside, in theatres and in of-
fices, on battlefields and in hospital operating rooms. The genres of performance are
many, from the arts to the myriad performances of everyday life, from courtrooms to
legislative chambers, from theatres to wars to circuses.

ENACTMENTS will encompass performance in as many of its aspects and realities as
there are authors able to write about them.

ENACTMENTS will include active scholarship, readable thought and engaged analysis
across the broad spectrum of
performance studies.

Death Tourism

DISASTER SITES AS RECREATIONAL LANDSCAPE

EDITED BY BRIGITTE SION

LONDON NEW YORK CALCUTTA

Seagull Books, 2014

Individual essays © Individual authors
This compilation © Seagull Books, 2014

ISBN 978 0 8574 2 107 4

British Library Cataloguing-in-Publication Data
A catalogue record for this book is available from the British
Library

Typeset by Seagull Books, Calcutta, India
Printed and bound by CPI Group (UK) Ltd, Croydon, CR0 4YY

In the memory of my friend Olivier Breisacher, an exceptional journalist and world traveller, who died accidentally in August 2012 while holidaying in Spain.

Contents

Acknowledgements

Most contributors to this volume presented papers at the conference 'Death/Dark/Thanatourism', which took place in April 2010 at New York University, sponsored by Transitions, a transatlantic research centre in the humanities and social sciences that is co-led by New York University and Centre National de la Recherche Scientifique, Paris, France. It is thanks to the vision of then co-directors Emilienne Baneth-Nouailhetas and Edward Berenson and especially deputy director Christophe Goddard, as well as Denis Peschanski, convener of a seminar on memory and memorialization, that I had the honour to organize the conference. The remarkable quality of the contributions convinced me to work on an edited volume. I am very grateful to Diana Taylor, one of my mentors, and to Richard Schechner, Enactment series editor for Seagull Books, for understanding that death tourism deserves serious scholarly attention. My personal interest in death tourism emerged and developed while I was writing my doctoral dissertation in performance studies, guided by Barbara Kirshenblatt-Gimblett; I am indebted to her for helping me conceptualize and analyse the phenomenon. Liana Pierce worked as my research assistant in the early stages of this adventure, and Justin Sharon agreed to be my first copyeditor; I thank them for their passion and strong work ethics.

It has been a pleasure to work with all the contributors to this volume; the process was both individual and collaborative and we are all thrilled of the outcome. This book would not have seen the light without the dedication, patience and enthusiasm of the Seagull Books team. It has been a delight to work with all of them and bring this project to fruition.

Introduction

BRIGITTE SION

Sites of violent death, such as concentration camps, prisons, battlegrounds, killing fields, places of terror attacks, plane crashes and natural disasters, have become part of the recreational landscape of tourism—or its subgenre, death tourism or dark tourism. This form of negative sightseeing is incorporated into an industry that is otherwise dedicated to pleasure, time out of time and escape as well as to edification, spiritual experience and personal transformation.

The phenomenon is not new: in ancient times, people made pilgrimages to the graves of martyrs, visited catacombs or attended public executions. In the twentieth century, however, death tourism has taken on new dimensions, with the worst atrocities committed by humans against other humans, including large-scale murder of civilians and strategic planning and implementation of such acts beyond national borders.

At the same time, the development of mass media and the democratization of travel and tourism have contributed to the transnational promotion, attraction and consumption of sites of violent death. As an example, international visitors with no personal connection to the 9/11 attacks want to see Ground Zero as much as developers of the National September 11 Memorial & Museum have to take into account foreign tourists in their plans for the new buildings.

The promotion of and attraction to sites of violent death has been called by various names: 'thanatourism' (based on the Greek root *thanatos* which is a personification of death), dark tourism, death tourism, grief tourism, trauma tourism, to name the most frequently used terms. In his seminal article, A. V. Seaton defines thanatourism as 'travel to a location wholly, or partially, motivated by the desire for actual or symbolic encounters with death, particularly, but not exclusively, violent death, which may, to a varying degree be activated by the person-specific features of those whose deaths are its focal objects' (1996: 240). This definition is behavioural rather than essentialist and describes thanatourism by the traveller's motives rather than by what actually takes place on the site.

Seaton also offers a typology of thanatourism, according to the following criteria:

a) Whether it is the single motivation or exists with other motivations
b) the extent to which the interest in death is person-centred or generalised. The purest form of thanatourism is travel motivated exclusively by fascination with death in itself, irrespective of the person or persons involved [. . .] At the other extreme is thanatourism in which the dead are both known to, and valued by, the visitor (e.g. a visit to a war memorial commemorating a dead relative). The more differentiated and comprehensive the traveller's knowledge of the dead, the weaker is the purely thanatouristic element (ibid.: 234–44).

This detailed typology is also limited, as it indexes sites according to motivation, a criterion that is not always identifiable, that may overlap categories or that just doesn't fit any.

In their book *Dark Tourism*, and in earlier articles, John Lennon and Malcolm Foley argue that

'dark tourism' is both a product of the circumstances of the late modern world and a significant influence upon these circumstances. Moreover, the politics, economics, sociologies and technologies of the contemporary world are as much important factors in the events upon which this dark tourism is focused as they are central to the selection and interpretation of sites and events which become tourism products (2000: 3).

This definition situates the phenomenon in modernity and intimates that technology, mass travel, consumerism and other modern features are core to death tourism, thereby precluding the inclusion of premodern sites. As some of the contributors show, sites of disaster—including battlefields, cemeteries, religious shrines or monuments—offer as much insight as contemporary memorials that clash with postmodern issues. Philip Stone agrees with Seaton, Lennon and Foley and defines dark tourism as 'the act of travel to sites associated with death, suffering and the seemingly macabre' (2006: 146), thus extending the definition to anything associated with death, including Halloween performances, ghost trains and other sites that may have been fabricated or remotely associated with actual violent death.

These scholars represent a particular academic perspective: British schools of tourism management and hospitality, often from a quantitative approach

focusing on the type and number of visitors, their motivations and practical issues relating to facilities, marketing and management. In recent years, anthropologists, sociologists and other social scientists have ventured into death tourism and produced groundbreaking works that raise issues about kitsch, commoditization, globalization, commemorations, ethics, material culture and museum displays (Kirshenblatt-Gimblett 1998; Sturken 2007; Williams 2007). However, the field remains vastly unexplored, particularly in relation to ritual, performance, spectatorship, media, trauma, memory and other embodied practices.

Laurie Beth Clark (2009), a contributor to this volume, has advocated the term 'trauma tourism'. She writes, 'The performative strategies of tourists include preparation, sometimes arduous journeys to and from the site, interactive engagement through photography, consumerism, the taking and leaving of mementos, and for some, subsequent acts of community service. Trauma memorials are called upon to serve multiple functions for these complex constituencies, which include education, mourning, healing, nationalism and activism' (ibid.: 1).

Clark's definition is the most adequate and encompassing of the phenomenon; it goes beyond typologies, motivation-based or marketing-oriented descriptions, and resists postmodern limitations. Though a number of scholars, including I, prefer 'death tourism' because it juxtaposes antithetic terms explicitly, they embrace Clark's definition. The slight disagreement revolves round 'trauma' as the core of the phenomenon, even when it is not immediately present or palpable. Death tourism points to the main object of this particular form of tourism: victims of violent death; it is explicit and encompasses a larger number of sites.

The goal this volume wants to achieve is to look at the complexity of the phenomenon; to open it up to multiple perspectives; to go beyond tourism as such and include objects, ruins, traces, buildings, photographs, souvenirs, performances; and to understand the numerous stakeholders—survivors, victims, architects, politicians, developers, vendors, students and tourists among others. The contributors to this volume are concerned with the tension between tourism and the memorialization of sites where violent (and often mass) death occurred—Latin American prisons; Nazi camps; mass graves in Cambodia, Bosnia and Rwanda; memorials to the victims of communism, fascism, the A-bomb, terrorism and others. The common denominators to these tragedies include the impossibility of performing funerary rites in the absence of identifiable human remains, the translation of violent death into museum displays

and the critical analysis of the role of the state in legitimizing crimes and in acknowledging and remembering these same crimes.

Death tourism stands at the nexus of many disciplines and raises complex questions about ethics, politics, religion, education and aesthetics. Rather than judge or critique such phenomena as tours of Auschwitz, Hiroshima, Cambodian killing fields, Chilean clandestine prisons or Italian memorials, this volume looks at the tensions created by the juxtaposition of human remains and food stands, political agendas and educational programmes, economic development and architectural ambition. The questions raised by sites of death promoted as tourist destinations are numerous: How does a state redefine its national identity after years of dictatorship? What is the role of death tourism in defining this new identity? What rituals are performed at sites of memory? How do visitors, pilgrims and school children share a space that is sacred for some and public for others? How are memory and trauma mediated by tourism? How are such sites of death marketed by travel agents, guidebooks and publicity materials? What boundaries are being pushed?

This collection of essays aims at enriching the scholarship on death tourism by addressing it from an interdisciplinary perspective. The 15 contributions in this volume demonstrate how death tourism can not only generate remarkable scholarship but also offer a new lens to analyse related issues such as national identity and politics, architecture, education, economic development, mourning and remembrance in a transnational perspective.

This book is divided into four sections. The first focuses on the intersection of tourism and memory—how tourism serves and abuses memory. Laurie Beth Clark takes the reader on a death tourism world tour during which she addresses ethical issues such as the conversion of sites of trauma into spaces of everyday life, behaviour etiquette and consumerism. Diana Taylor offers a personal account and analysis of her visit to Villa Grimaldi, the main torture centre during General Augusto Pinochet's military dictatorship in Chile. She ponders the role of the actual tour and the archival memory, the voice of the survivor and the audio guide, through her gaze and photographs, as well as the enduring power of each performance of memory. Mark Pendleton looks at a number of tragic sites in contemporary Japan that compete for memory and tourism attention: Hiroshima, theme parks that closed down after the economic crisis that culminated in the 2000s, and places associated with the Aum Shinrikyō sect and their deadly gas attack in the Tokyo subway in 1995.

The second section examines the tensions created by the display of human remains and graphic accounts of violence. Cambodia's killing fields, S-21 prison and local shrines give me an opportunity to reflect on ritual, non-Western religious beliefs and local politics of memory through the exhibition of human bones and skulls. Rainer Schulze examines the curatorial choices made for the new exhibit at the Bergen-Belsen Memorial in Germany and the challenges of modernizing the display of a former Nazi concentration camp in the land of the perpetrators. Mark Schaming presents the unique perspective of the museum curator involved in identifying, collecting and exhibiting objects from the 11 September 2001 attacks in New York City. He focuses on the agency of material culture and the new meaning that objects take on after such transformative violence.

The third section looks at memorial sites that help survivors, descendants or relatives of victims conduct a challenging return to the locus of trauma; this return is often associated with attempts to heal, appropriation and physical remnants such as ruins and mementos. S. I. Salamensky analyses food practices of contemporary Jews who venture into the history of their families through the Yiddish language, a cooking recipe or a kosher-style restaurant. Maura Coughlin presents a historical account of late-nineteenth-century Britons who honour these relatives and how a morbid culture developed and thrives to this day. Cara L. Levey looks at the Escuela Superior de Mecánica de la Armada, commonly known as ESMA, the Navy School of Mechanics used as Argentina's main clandestine torture centre during the military dictatorship (1976–83). Its transformation into a museum and memorial is contested by numerous stakeholders, including survivors, mothers of victims, human rights activists and some politicians on the Left and on the Right. Aniko Szucs deconstructs the House of Terror in Budapest, a controversial museum that addresses the fascist and communist dictatorships that ruled Hungary for half of the twentieth century; the exhibit is fragmentary, silent on numerous disturbing facts and potentially revisionist in its rendition of history.

The last section explores the emergence of identity politics in death tourism, and the role of the state in framing the narrative. Lindsey A. Freeman focuses on the phenomenon of atomic tourism in a former secret centre for nuclear research in Oak Ridge, Tennessee, that is now open to tourists. She examines the tension between nostalgia and kitsch, national pride and past glory, secrecy and publicity. Susanne C. Knittel looks at the role of the Italian state in three Second World War sites that are unequally promoted and curated to visitors, a

reflection of the ambiguous events that took place at these locations and how their memory has been interpreted and translated into exhibition panels. Mary Rachel Gould takes the Alcatraz Prison in San Francisco as a case study to analyse the current US prison system and how it is officially presented and idealized by the National Park Conservancy. Stephanie McKinney juxtaposes gorilla tourism and genocide tourism in contemporary Rwanda, both associated with violence and death, and looks at the ways in which both forms of death tourism are used to promote a new official Rwandan identity.

Together, these site-specific contributions also outline transnational patterns that apply to all sites of trauma turned into tourism destinations: memorial architecture, ethics of tourism, rules of conduct, official narratives and counter-narratives; the role of survivors and the expectations of tourists; the conflicting embodied performances; the marketing of sites of violent death. These sensitive topics clearly override quick judgement about death tourism, which is often denounced as kitsch, cheap thrills and macabre business. This book demonstrates that death tourism is complex and deserves serious and thorough scholarship.

Works Cited

CLARK, Laurie Beth. 2009. 'Coming to Terms with Trauma Tourism'. *Performance Paradigm* 5(2) (October): 1–31.

KIRSHENBLATT-GIMBLETT, Barbara. 1998. *Destination Culture: Tourism, Museums, and Heritage*. Berkeley: University of California Press.

LENNON, John, and Malcolm Foley. 2000. *Dark Tourism: The Attraction of Death and Disaster*. London: Continuum.

SEATON, A. V. 1996. 'Guided by the Dark: From Thanatopsis to Thanatourism'. *International Journal of Heritage Studies* 2(4): 234–44.

STONE, Philip. 2006. 'A Dark Tourism Spectrum: Towards a Typology of Death and Macabre Related Tourist Sites, Attractions and Exhibitions'. *Tourism: An Interdisciplinary International Journal* 54(2): 145–60.

STURKEN, Marita. 2007. *Tourists of History: Memory, Kitsch and Consumerism from Oklahoma City to Ground Zero*. Durham, NC: Duke University Press.

WILLIAMS, Paul. 2007. *Memorial Museums: The Global Rush to Commemorate Atrocities*. Oxford and New York: Berg.

PART I

Tourism and/as Memory

PART I

Tokens and its Memory

Ethical Spaces
Ethics and Propriety in Trauma Tourism

LAURIE BETH CLARK

In downtown Montevideo, Uruguay, the Punta Carretas Shopping Centre is built into the shell of a former prison. Although it is common knowledge that the prison operated as a clandestine torture centre, no commemorative plaque or any other information about the building's history is available to visitors nor has anything been done to suppress the historical function of the building as a prison. Rather, in true postmodern style, the unusual architectural features are showcased and combined in aesthetically interesting ways with the newer mall construction (figure 1). Iron gates have been left in place in what appear to be original prison hallways that now connect the mall to the parking lot, and it's hard to tell whether the razor wire on the parapets is intended to keep prisoners in or thieves out.

When I say 'common knowledge', I mean that almost anyone I asked casually about where to find the shopping mall that used to be a prison knew what I meant and was able to give me directions. For tourists, information about the building's history can also be found online in travel blogs and through tourist websites though it is not mentioned in the print version of the *Lonely Planet* guide to Uruguay. But for most at the mall—there to meet friends, shop or eat ice cream—the building's appalling history is irrelevant.

The only reference to the prison's history that I was able to find was in one of the mall's bookstores where many copies of a book called *La Fuga de Punta Carretas* (Escape from Punta Carretas) were prominently displayed (Fernández Huidobro 1991). This sensational documentary novel chronicles the 1971 prison break of over a hundred Tupamaru guerrillas.

In contrast, the Montevideo Museo de la Memoria ('museum of memory') is built in a mansion that has no site-specific history related to the violations of the dictatorship in Uruguay from 1973 to 1985. The building is the former home of General Maximo Santos. It was built in 1878 and restored between

9

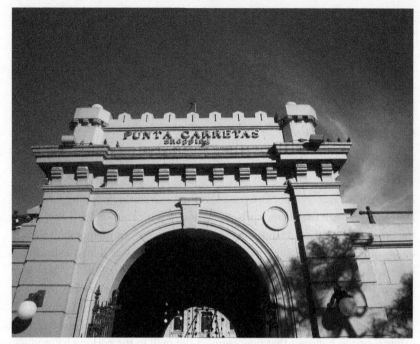

FIGURE 1. Punta Carretas Shopping Centre in Montevideo, Uruguay. Photograph courtesy of Clark Peterson.

2000 and 2005 as part of the kind of preservation effort that is generally aligned with state power rather than with a critique thereof.[1] It was simply a building, and not even a particularly convenient one, that was within the jurisdiction of the municipality when it was agreed upon that a museum should be designated. Within this opulent architecture, the basement has been repurposed by video artist Hector Solari for a video installation that evokes (rather than represents) a torture centre.

Why shouldn't a torture centre become a shopping mall? What is it about this use that rubs us the wrong way? Why do we find it troubling that the Peace Park at Nagasaki is used by skateboarders as a terrain park or that children like to hop from stele to stele or play hide and seek at the Memorial to the Murdered Jews of Europe in Berlin or that picnickers and romantic couples outnumber 'penitents' at Parque de la Memoria (memory park) in Buenos Aires? Why do we expect congruence between a site's history and its subsequent function? What are the limits of allowable use for the site of an atrocity? Are there certain spaces that are *so* violated that they should be preserved as

memorials for all of futurity? Which spaces and what violations would merit this designation and what lesser violations would we permit to have their sites re-functioned? Why do certain uses of spaces seem wrong? And when they seem wrong, does that mean that they violate our sense of propriety or our sense of ethics?

Ethics asks us to develop a sense of right and wrong by following specific principles. Ethics is a science of human conduct which articulates the rules that follow from our moral obligations. It is concerned with respect for ourselves as human beings as well as with the rights of others. By definition, ethics makes its demands on *all* humans.[2] Ethics makes claims about what is best for a society as a whole and tries to articulate these values in ways that can be adjudicated. This may be through the legal system, through authorities within a profession or through the allocation of resources and property.

In writing this essay, I found it useful to differentiate ethics from propriety, not because such a distinction is hard and fast but because it enables us to draw attention to more facets of this complex set of social practices. Propriety refers to 'conformity to established standards of good or proper behavior or manners' and 'appropriateness or suitability to the purpose or circumstances'.[3] I want to suggest that it is our sense of ethics that applies when we consider the more or less permanent uses of trauma sites (the civic designations, landscape design and architectural modifications that we do or do not allow to happen at a site) while it is our sense of propriety that comes into play when we consider what we might allow to take place within the already designated and designed trauma sites. It may be unethical for us to fail to mark the site of a former torture centre but once we have built a shopping centre, it is not inappropriate for teenagers to giggle there, although comparable behaviour would be constrained at a designated memorial. I am not asserting my opinion here about whether it is necessarily ethical or unethical to use spaces in particular ways. Rather, I mean to propose that our societal decisions to do so is a matter of ethics, that how we use land and architecture demonstrates something about the belief systems of our various societies, whereas the ways in which we regulate behaviours at these spaces is a matter of etiquette (propriety).

Propriety manifests itself as a concern at many established trauma sites. In some places, actual guidelines are posted. For example, at Choeung Ek (better known as the Killing Fields) in Cambodia, visitors are asked to 'dress suitably', 'keep quiet', remove hats and shoes and 'meditate before the boned monument'. Visitors are prohibited from opening the monument's doors, carrying weapons

or using drugs. In Berlin, rules are posted at the Memorial to the Murdered Jews of Europe that (in addition to providing safety precautions about the slope of the monument) prohibit dogs, music, running, skateboarding, rollerblading, barbecuing, drinking alcoholic beverages, smoking and climbing or jumping from stele to stele.

What we have here is a mix of rules so universal that it is surprising they need to be specified (no weapons or drug use), rules that seem to respond to specific past infractions (don't open the door, don't climb the stele), rules that try to teach local cultural practices (take off your shoes) and rules that are aimed at producing an *appropriately* sombre environment (don't laugh, run, play, etc.). There is hardly a consensus about the posting of such rules. For example, architect Peter Eisenman, who designed the Berlin memorial, actually objected to the posting of behaviour guidelines, arguing that quotidian use of the monument is a productive way to engage with history (Sion 2009).

Regulation of behaviour is often less explicit than in the aforementioned cases; it is accomplished through architecture, example or interaction. Buildings and spaces are designed in ways that communicate norms of behaviour. Carol Duncan and Allan Wallach (1980) have written about how buildings like museums and libraries put spectators in their place by scale and structure. Memorials use similar strategies to similar ends, suggesting, through monumental architecture and strategic design, that we move at a decorous pace or speak in hushed voices. Architectural devices are used to subtly or blatantly control the flow of traffic, to mark an artefact as significant or exclude a feature of the landscape from the 'text' of a site. Trauma sites may provide barriers to keep visitors from engaging directly with artefacts, like the plexiglass that protects Anne Frank's collection of photographs.

Trauma sites also tell us how to behave by invoking other spaces for which behavioural norms are established. The most widespread mimicry is of cemeteries, but trauma sites also frequently look like places of worship or museums, all of which imply solemnity and reverence. Trauma memorials also frequently look like parks, which is one of the reasons why the prohibition of park-appropriate behaviour (music, barbecues, pets) needs to be specified through signage.

The presence or absence of a gift shop or a cafeteria, its placement and its contents all help to clue the visitor into the kinds of behaviours considered appropriate. At Auschwitz, it is possible to buy coffee and crackers from a vending machine within the visitor's centre at the entrance but it is necessary

to leave the grounds in order to have a substantial meal. At the Jewish Museum in Berlin, on the other hand, there is an elegant and large cafeteria that serves a kosher Jewish and Israeli-inflected menu. At Kazimierz (the former Jewish ghetto in Krakow), food *is* the memorial. Themed restaurants have been created that serve the cuisine of the disappeared (*gefilte* fish, *kugel, tzimmes*) as well as honorific foods and beverages (kosher vodka, *klezmer* cake). At the Kigali Genocide Memorial Centre in Rwanda, the cafeteria is well off the beaten path and caters to employees rather than tourists. Even the placement of the restrooms (beyond the borders of the trauma site) communicates something about the place of quotidian demands within memory culture.

Like food concessions, gift shops reflect both the tenor and the content considered suitable for the locale (as well as for economic and social factors). When I visited, all of the items for sale (postcards and books) at Dachau were black and white and a sign clarified the demand for sales on behalf of past visitors and the use of revenues for site maintenance.[4] At the Cape Coast and Elmina sites associated with slave trade in Ghana, the gift shops have no items that document the site, reflecting the lack of capitalization in the country in

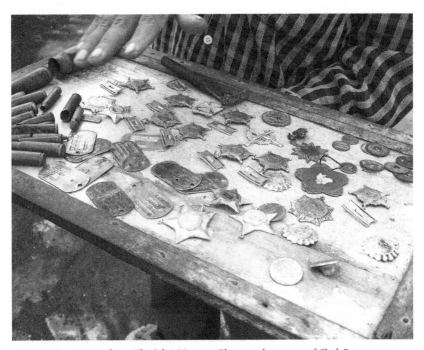

FIGURE 2. Souvenir vendor at Khe Sahn, Vietnam. Photograph courtesy of Clark Peterson.

general and in this venue in particular; rather, they sell local handicrafts that provide an opportunity for visitors to participate in alleviating the region's endemic poverty. At Vietnam War sites, souvenir sales are scattershot and impromptu, consisting mainly of real and fake war memorabilia (dog tags, zippo lighters) with some communist kitsch (figure 2). The gift shop at the Oklahoma City Memorial, like the museum, emphasizes rescue efforts over the trauma and has a larger range of gifts for children than most others, including story books, toy ambulances and stuffed search-and-rescue dogs. The gift shops at Tuol Sleng and Choeung Ek have extensive video selections that place *The Killing Fields* (the 1984 dramatization of the Khmer Rouge regime in Cambodia) alongside *The Simpsons* (the longest-running animated sitcom dramatizing middle-class American life). In Japan, the gift shops allow for explicit activism (from paper crane supplies to T-shirts) but are also far more permissive of kitsch (Hello Kitty Hiroshima and Hello Kitty Nagasaki) than their European and North American counterparts.

Memorial sites also regulate behaviour through example. In their rapid removal of all traces of spectators' contributions (artefacts, mementoes, graffiti),

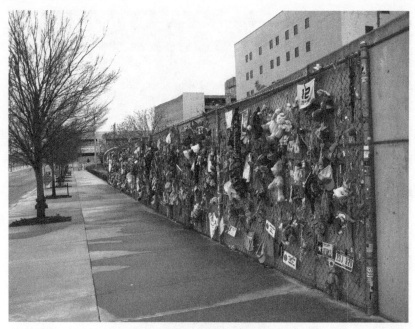

FIGURE 3. Fence with mementos at the Oklahoma City Memorial, USA. Photograph courtesy of Clark Peterson.

sites discourage participation by suggesting to a visitor that no one else before them has chosen to leave anything behind. Other sites mark certain kinds of participation as appropriate. At Dachau, a room-size glass-fronted display showcases memorabilia from governments and heads of state, showing that official mementoes are permissible but individual tokens are not. By contrast, sites in Japan have strategically placed flower receptacles and racks or vitrines for housing paper cranes; these serve not only to encourage but also to constrain the placement of artefacts. At Oklahoma City, a portion of the fence that served as the impromptu shrine immediately following the bombing of the Alfred P. Murrah Federal Building has been preserved as part of the permanent memorial, and visitors frequently arrive with mementoes they intend to contribute (figure 3).

Finally, visitors are told how to comport themselves at places of memory through interactions. Guides, guards and other tourists all tell us what we should and should not do. We are asked directly to be quiet, to stay with our group, not to run and indirectly not to ask too many questions or questions that are too confrontational. At My Lai village in Vietnam, at the conclusion of my tour of the massacre site, my guides sat me down at a table with a comment book and a box of tissues (with the implication that I would/should cry). At Cape Coast, I was offered the opportunity to purchase a prayer for the ancestors. At a number of sites in Rwanda, I was handed a donation box or instructed by my driver to tip the guard.

It is common for tour groups to be segregated in order to defuse tensions emerging from different notions of propriety. In Vietnam, war veterans from the United States run their own tours, distinct from those of the general population of North American, European and Australian tourists. In Ghana, African Americans and Afro-Caribbeans visit the site independent of white tourists. In both countries, local tourists (mostly school groups) do not mix with either of the international groups of visitors. Auschwitz arranges special events for survivors and the World Trade Center Memorial has a portion of the museum that is accessible only to the families of victims.

Despite all of this explicit and implicit guidance, visitors to trauma sites manage to misbehave all the time. The viewing platforms at the World Trade Center site were covered with commemorative graffiti as soon as they were opened to the public. People leave mementoes at trauma sites even when the management actively discourages it; the Vietnam Veterans Memorial has collected so much memorabilia that they have had to plan for a museum to house it. In my tour group at Auschwitz, a child carried her scooter with her. Children

do play hide and seek in the Memorial to the Murdered Jews of Europe and adults eat their picnic lunches on top of the stelae. Adolescents use the Peace Park at Nagasaki to skateboard and couples like to canoodle at the Parque de la Memoria in Buenos Aires.

A recent controversy erupted round the Australian artist Jane Korman's trip to Poland where she videotaped (and then posted on YouTube) her father Adolek Kohn (an 89-year-old survivor of Auschwitz), herself and her three grown children dancing to Gloria Gaynor's song 'I Will Survive' at locations that included concentration camps, ghettos, synagogues and memorials.[5] Many found this behaviour—the dancing and the posting of the video—objectionable. But many others defended the project. Here's a blogger's response that covers a multiplicity of feelings in a short span:

> People seem to be up in arms over the video (titled 'Dancing Auschwitz: I Will Survive'), some angered because they believe it's disrespectful. Personally, it made my stomach twist and my heart swell. I literally teared up. Though we lost a great many, we did, as a people, survive. And I'm all about stomping on our horrific past through subversive acts, even if it includes employing a hokey *b'nai mitzvah* party disco standard.[6]

Certainly, disco dancing at a genocide site falls well outside many established social norms. The Korman–Kohn case raises a plethora of issues. Among these are the questions of what is appropriate behaviour for an artist, for a tourist, for a holocaust survivor, for his family and for those viewing the work on the Internet and in galleries. While acts represented in the video represented a breach of propriety, the artist's project was an 'ethical' one in that it intentionally draws attention to the bourgeois normalization that limits the ways in which we might respond to horror.

If actions that are transient and open to debate fall under the rubric of propriety, then what would it mean to say that it is *unethical* (as opposed to inappropriate) to use a trauma site for what are perceived to be frivolous activities? What ethical principles does it make recourse to? Is it something we owe to the dead, to the living or to the land? To say that the designation of memorial sites is a matter of ethics would mean that spaces that may legally be private spaces belong to the public in some way. And therefore it means that in a discussion of trauma memorials, we must always consider who has the power to determine whether a site will be designated as a memorial. In the debates over

the reclamation of the World Trade Center site, for example, some of the most irreconcilable differences were between those who had commercial interests in the site and those who understood it as having come to belong to the community of the dead.[7] In *Tourists of History: Memory, Kitsch, and Consumerism from Oklahoma City to Ground Zero*, Marita Sturken (2007) details the conflicts at Ground Zero between the claims of family members of the victims (who consider the entire terrain to be a mass grave) and the developers (who think that the prime real estate they own is being held hostage by social agendas).

As far as our debts to the dead and to the living are concerned, as Avishai Margalit argues in *The Ethics of Memory* (2002), our 'thin' relations (to humanity as a whole) provide a less compelling case of our obligation to remember than our 'thick' relations (to our immediate communities). This suggests that although most trauma sites deploy rhetoric about their importance to society, they are in fact sustained by their network of social connections to victims, survivors and members of politically or ethnically allied communities.

Over and above our general obligation to remember, there is something we believe specifically about the power of *place* to invoke and sustain memory that makes us more likely to (p)reserve the actual sites of atrocities for special uses. Many people believe that the dead or their spirits inhere in or revisit places: land, architecture, trees.[8] Practices based on this include providing food, spirits, money, flowers or burning incense for the dead. But people who do not subscribe to specific place-based beliefs about the dead often behave as though they do. People go to graveyards to talk to dead relatives, make pilgrimages to battlefields and maintain roadside shrines at the location of traffic accidents, and an endless supply of films feature buildings that are haunted by the ghosts of people who were murdered there.

Karen Till suggests that 'places can be seen as thresholds through which the living can connect to the voices, imprints and inheritances of those who have gone before' (2010: 2). She uses the term 'spectral traces' to refer to the not necessarily visible markings on the sites of traumatic histories. The significance of such sites may be sustained through oral histories and archives and 'through acts of discovery, juxtaposition, re-presentation and relocation'. The not-yet-visible, she says, is defined through a web of social relations:

> Spectral traces, especially at places marked constitutively by acts of violence and injustice, often re-emerge when a society is undergoing change; individuals may come into contact with past lives through

objects, natures, and remnants that haunt the contemporary landscape. [...] Such remainders constitute the social realities of place; their resonance forms an affective network granting thick meaning to an inhabitant's experience of belonging. Caring for place, then, invites an *ethical* relationship with spectral traces and recognizes how these past presences occupy the realities of our lived worlds—even while we also understand them as existing 'elsewhere', beyond the realms of the living (ibid.: 1–2; emphasis added).

Till's evocations of ethics in this context draws attention to the ways in which site sacralization is practised. Nancy Gates-Madsen, citing Mircea Eliade, explains that 'the sacred manifests itself in certain places, which are substantially set apart from profane space' (2012: 157). Sacred spaces are 'qualitatively different' from their surrounding milieu, 'set apart from the ordinary' (ibid.: 157–8). According to Gates-Madsen, this implies that 'humans do not choose these spaces; rather, they arise seemingly independent of human influence' (ibid.: 158). In the conventional understanding, it is an 'act of (the) god(s)' that sets spaces outside of the quotidian. But in the case of historical trauma, I argue, it is the *inhumanity* of the atrocity that partitions the trauma site from its human surroundings. In other words, memory sites are made sacred by their desecration. But, as Gates-Madsen points out (citing Chidester and Linenthal), humans are key players in making spaces sacred. Sacralization must be practised (and is also limited by practise). Individuals and bureaucracies are active participants in sustaining the sacred status of a trauma site.

Because ethical obligations require (some degree of) social consensus, the project of site-specific memory is significantly hampered (if not thoroughly impaired) in countries that lack social consensus. Citizens of many countries in South America have profound political disagreements with one another about their shared history. There is no consensus about whether their dictatorship period constituted a trauma. The disappearances may be considered acts of state terror or justifiable actions on the part of legitimate governments. Disagreements exist about how many people disappeared and whether the disappeared could be considered enemies of the state. In such an environment, the designation of memorial sites is considerably more fraught, so that throughout Argentina and Chile, former detention centres continue to be used as police stations, automotive repair shops and (as mentioned above) shopping malls. In *The Shock Doctrine*, Naomi Klein (2007) describes how a film crew chances upon evidence of a torture centre inside the upscale mall Galerias Pacifico in

Buenos Aires. The ruins of the detention centre at Club Atletico in Buenos Aires, buried by highway construction in late 1977, were uncovered in early 2002. In the former case, commerce goes on without any indication of history, whereas in the latter, a site-specific memorial has been constructed.

Lack of agreement about just what needs to be remembered may also explain why the violence of the partition of India and Pakistan is recalled through ephemeral rather than site-specific memorials. But the absence of site-specific memorials may also reflect cultural differences about the practice of memory. For instance, memory cultures clashed following the bombings in Kuta, Bali. Families of international victims (a majority of whom were Australian) felt strongly that the sites should be developed as memorials whereas the Balinese were anxious to return to business as usual. This was not merely a matter of crass commercialism or even financial desperation but, rather, a religious conviction that once a ritual cleansing ceremony had restored 'a sense of balance and harmony to the island's community, marking *the end* of its dark period' (Tumarkin 2005: 62; emphasis added), further marking of the site was not only unnecessary to the Balinese but actually counter-indicative.

Sometimes social consensus is achieved by fiat, as is the case in Rwanda where the post-genocide dictatorship has legislated mourning in the form of government-mandated rituals practised at ubiquitous memorial sites. In making this observation, I do not mean to underplay the trauma suffered by and need for healing on the part of the Rwandan people. Rather, it is to draw attention to the way in which President Paul Kagame's government has used the horrors of the genocide to bolster its power and suppress opposition (Meierbach 2011). In his definitive project, *Les Lieux de Memoire* (The Places of Memory, 1984–92), Pierre Nora draws attention to the integral role of nationalism to the project of memory in France (see Nora 1996–98). Japan and Israel have also effectively played their victim roles for nationalist purposes (Takahashi 2004; Novick 1994). Some iterations of the plans for the World Trade Center Memorial do the same (Sturken 2007: 165–218). Thus, the deployment of traumatic memory does not always hold a moral high ground; sometimes its ethics are questionable or even reprehensible. Nonetheless, *un*ethical behaviour is still a matter of ethics.

If we were to agree that we have an ethical obligation to use trauma sites commemoratively, then one of the biggest challenges we face is a question of limits. What is our responsibility to violated spaces? Is there an extremity of violence that is not recuperable? What is the level of violence at which it is permissible to reclaim space? After all, we live within a world of violence. Many

(possibly even most) places are former battlefields or graveyards. While controversies spring up over the protection of the Indian burial mounds in Wisconsin or the African American cemetery in Manhattan, by and large, we understand that the loci of certain deaths are potentially reusable. In the United States cemetery plots are sustained in perpetuity, or at least for so long as the maintenance fees continue to be paid, whereas in Europe graves in public cemeteries are reused after as few as 30 years. Deathbeds are also birthplaces and we think of this as an acceptable, even desirable, cycle of life. Even if we limit memorial designation to places where massacres and genocides have taken place and agree that such places should be forever preserved as memorials, what do we do in countries like Rwanda and Cambodia where evidence of genocide continues to be uncovered on a daily basis, in the form of the bones of victims, and it seems as though every inch of land is tinged with blood? It would be neither possible nor ethical to remove the entire country from its agricultural function and to make every killing field into a memorial. Rather, the function of memory is consolidated into synecdochic sites. Bones are collected in ossuaries (discussed below) and these sites concentrate memorial functions.

Trauma memorials by definition emerge from troubled situations. This means that the process of moving from trauma to memorial is far from straightforward. A number of different factors impede memorial construction. Obviously, a trauma neither proceeds nor concludes with memorial construction (and how perverse it would be if it did). As a result, the raw materials at a trauma site are inevitably lacking. What follows is a discussion of the ways in which decisions about space allocation and space usage, which seem to have ethical implications or ramifications, may result from pragmatic constraints. Site developers may begin with a decimated lot or an evocative ruin. They may choose to reconstruct the infrastructure of atrocity or to add commemorative architecture. They may be forced to work with sites that are still in use or they may be barred from such sites altogether and forced to place memorials in alternative venues. The trauma commemorated may be fully documented or discovery of the extent of the atrocity may still be underway. In all these cases, the kinds of options that developers exercise within these constraints reflect their own ethics, the ethics of the society as a whole and the ethical responses they hope to elicit from visitors to the site.

It is not uncommon in the wake of a trauma to try to erase all evidence thereof. The US military forces destroyed all evidence of wrongdoing at My

Lai. Erasure is not necessarily the work of denial—at least not denial in the political sense, though it may be denial in the psychoanalytical sense. The impulse immediately following a tragedy is to clean it up. Sometimes, this is a highly ethical impulse (as in the wake of almost any environmental trauma). More often, it is somewhere between pragmatic (we need to get back to work in this space) and therapeutic (we don't want to look at this crisis any more) needs. Cleaning up can be part of empowerment on the part of a suffering population. It may proceed directly out of rescue efforts, as it did at the World Trade Center sites.

What was unusual about Ground Zero, however, was the rapidity with which memorial design proceeded. Almost from the moment of the crisis, proposals for memorials were put forward and some (like the Tribute in Light annual art installation at the 9/11 memorial site) were enacted very early on. Moreover, the World Trade Center wreckage was sieved not only for human remains and evidence but also stored with an eye to memorial design. There may not be a single other example in the world of where a memorial process was so quickly conceived and enacted. It is far more common for the work of building memorials to belong to the next generation, not championed by those who survived the trauma but, rather, by their children.[9]

Holocaust memorialization efforts, for example, began in earnest in the 1960s. Jewish families looking for roots in Eastern Europe typically found no evidence of the *shtetls* from which their ancestors emigrated or were forcibly removed in the late nineteenth and early twentieth centuries. What was not obliterated in pogroms was usurped by local residents. So many authors have written about Jews searching for unavailable ancestral homes that it has become a familiar trope. The best-known representation and one of the most beautiful is the moment in Leiv Schreiber's film of Jonathan Safran Foer's book *Everything Is Illuminated* (2002), where the main character finds a completely preserved phantom archive. What makes this image so poignant is its impossibility: the protagonist finds what we imagine used to be there, lovingly preserved. The Théâtre de Complicité production *Mnemonic* (1999) also features this journey of unrequited longing through Eastern Europe, as does Lilly Brett's novel *Too Many Men* (2001). Such a journey of desire has also been carefully documented in a non-fiction work by Marianne Hirsch and Leo Spitzer (2010). In a lecture in Madison that preceded the publication of *Ghosts of Home: The Afterlife of Czernowitz in Jewish Memory*, Hirsch beautifully summarized the encounter

with an unavailable remainder in her lecture title: 'This is it, this is it. Only it's completely different.'[10]

Empty spaces can prove hauntingly evocative as trauma memorials. Many visitors to Poland's concentration camps point out that the massive voids of Birkenau—the largest Nazi concentration camp—signify loss more effectively than the pavilions full of information at Auschwitz. Similarly, the empty grounds at Treblinka (near today's Warsaw) and the sparse signage at My Lai suggest the absence they commemorate more successfully than sites cluttered with memorial sculptures.

In places where memories have not been completely erased, there are ruins. In some ways, ruins are the most ideal architecture for a trauma memorial to inherit. On the surface, they are the least ethically fraught. They evoke the 'right' emotions, the kind of longing, sorrow, wistfulness that we believe to be the appropriate emotions for memorial sites. Ruins move us in two directions: they provide evidence both of survival and of destruction. They are simultaneously devastating and uplifting. According to a review of Robert Ginsberg's *The Aesthetics of Ruins* (2004), Ginsberg gives extensive treatment to this 'uncanny' quality of ruins which 'shifts between familiarity and unfamiliarity, repulsion and attraction, [. . .] being and becoming' (quoted in Trigg 2006: 119).

Sites in Poland, Japan, Ghana, South Africa and Rwanda all make productive use of ruins. Near Krakow, the many acres of Jewish cemetery are today in nearly the same state as they were left in at the end of the war. The overgrown and shattered headstones are a haunting and effective reminder of the scale of the community that was lost. In Hiroshima, the preserved shell of a destroyed building has come to be known as the Atomic Bomb Dome. Now designated a UNESCO world heritage site, the architectural skeleton nestled into the functional skyline is a poignant reminder of the destructive capacity of nuclear weapons. The power of the Ghanaian slave forts in part derives from their state of decay which evokes the violence of the buildings' former deployment. And, with each passing year, the decaying genocide site at Ntarama in Rwanda only seems to be more effective in communicating the awfulness of the massacre that took place in that church.

However, ruins as memorials are less ethically reliable than they first seem. As Rose Macaulay elaborates in her book on the *Pleasure of Ruins*, Western cultures have taken '*delight* in decayed or wrecked buildings' (1953: xv; emphasis added) since Roman and Victorian times. She details how 'down the ages, men

have meditated before ruins, rhapsodized before them, mourned *pleasurably* over their ruination' (ibid.; emphasis added) and finds:

> [I]t is interesting to speculate over the various strands in this complex enjoyment, on how much of it is admiration for the ruin as it was in its prime [. . .], how much is association, historical or literary, what part is played by morbid pleasure in decay, by righteous pleasure in retribution [. . .], by mystical pleasure in the destruction of all things mortal [. . .], by egoistic satisfaction in surviving [. . .], by masochistic joy in a common destruction [. . .] and by a dozen other intertwined threads of pleasurable and melancholy emotion (ibid.: xv–xvi).

In other words, looking at ruins, at least for Westerners, has a long history associated with pleasure. It is important to realize that our comfort with ruins as a memorial strategy does not fully derive from their seemingly ethical capacity to communicate concrete evidence of an atrocity and its cessation. Rather, our ease with ruins reflects a historically complex engagement with a multiplicity of satisfactions alongside our grief and condemnation.

If a trauma site does inherit a ruined structure (or intact architectural remains), a set of dilemmas about preservation emerges almost immediately. At the Centro Candestino de Detencion, Tortura, y Extermino el Olimpo (The Clandestine Centre for Detention, Torture and Extermination) in Buenos Aires, a guide articulated this concern for us: Should we expend additional resources on sadistic architecture? For the present moment, their decision is to preserve but not restore. There is something paradoxical about using resources (either funds or labour) to bolster evidence of atrocity, to restore or maintain a torture cell, a gas chamber or a crematorium. This ethical dilemma is a profound one for many site developers. I find similar concerns at work in many parts of the world, particularly at concentration camps, prisons and torture centres, where the sites straddle evidentiary and bereavement functions.

But if it is perverse to preserve evidence of evil, how much more so is it to (re)build such structures from scratch? Reconstructions not only elicit similar ambivalence about expenditures but they also risk undermining the veracity of evidence. The bunkroom at Dachau in Germany, which was rebuilt for visitors to comprehend with ease the living conditions in the camps, is too clean to evoke the horror of actual conditions and plays into the hands of Holocaust deniers through its artificiality.

Even more troubling are some of the immersive environments that have
been created at memorials to help tourists understand what it felt like to be
there during the trauma. At Oklahoma City, spectators begin their tour of the
museum in a closed room that abruptly begins to shake, simulating the expe-
rience of workers in the Murrah building at the moment of the blast. At Nagasaki
in Japan, an immersive installation uses flashing lights to recreate the moment
of the blast and represents victims using mannequins with melting flesh. At
Seodaemun Prison in Seoul, South Korea, visitors walk down a hallway listening
to soundtracks of prisoners screaming from behind closed doors, crawl inside
an inhumanely small isolation cell and sit in a chair in front of a mannequin
jury whose verdict causes the visitor's chair to drop beneath them (figure 4).[11]

What is disconcerting about these participatory exhibits, all of which
emerge from the best intentions of designers and curators to help tourists move
beyond the cerebral and cognitive to understand an affective dimension of the
trauma they document? Immersive installations at trauma memorials border
on (or cross the line into) kitsch. As overly sentimental and reductive treatments
of weighty content, they threaten to cheapen the experience of trauma. They

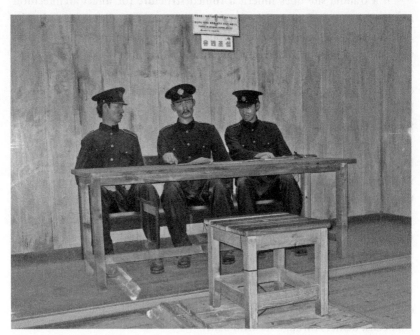

FIGURE 4. Interactive exhibit at Seodaemun Prison in Seoul, South Korea. Photograph courtesy of
Clark Peterson.

also blur the distinction between shock (dismay) and sensation (thrill) and, since they rely on technologies and strategies similar to those used by haunted houses and other environments that mine fear for pleasure, they seem incongruous in the otherwise sombre and reverent milieux of memory culture. By playing the atrocity for thrills, they threaten to move the spectator towards prurience and away from contemplation. Moreover, they offer us representations and experiences unlinked from criticality.[12]

Almost diametrically opposed to these trauma installations is the remarkable work that Memoria Abierta (Open Memory) in Buenos Aires is doing to reconstruct clandestine torture centres *virtually*. They are compiling the fragmented memories of former detainees (none of who were ever allowed more than a glimpse of their environment) to assemble three-dimensional virtual simulations of the spaces where they were held that have been destroyed or that remain inaccessible to the public. These memory recovery efforts are not undertaken with tourists in mind. Their purpose, first and foremost, is evidentiary; they are to be part of the judicial record of the crimes committed there. What is more, they are part of a recovery effort, helping survivors to reach closure by placing concretely outside themselves and into communal memory the experiences they survived in isolation.[13]

Some of the best-known memorials in trauma culture and some of the most troubling are the ossuaries in Rwanda and Cambodia. Though there is a long history of Catholic reliquaries, most Westerners find the amassing and display of human remains in Rwanda and Cambodia unnerving.[14] Advocates of the ossuaries, which consist largely of skulls and femurs neatly ordered in rows that allow for enumeration, defend them on the grounds that they provide undeniable evidence of the scale of the genocide. But the sites in Rwanda are also active functioning parts of the communities in which they are situated. Each local site serves as a repository of all the bones uncovered throughout the year until they are ceremonially integrated each April. At first, whole lime-preserved bodies were left in place where they fell at a church in Nyarubuye. This aspect of the Nyarubuye Genocide Memorial has now been dismantled but bodies are a dominant feature of the Murambi Genocide Memorial Centre where classroom after classroom is filled with pallets of desiccated corpses (figure 5).

Visceral responses evoked by these memorials may be attributed to the estrangement of contemporary spectators from death, the resemblance of the figures to our own, the unfamiliar smell or the contorted postures of many of

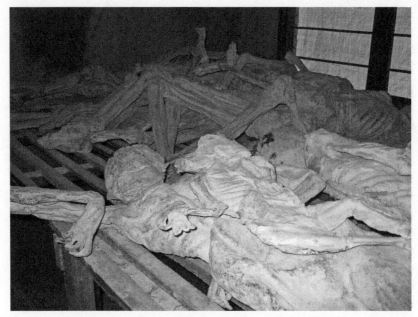

FIGURE 5. Limed corpses at the Murambi Genocide Memorial Centre in Rwanda. Photograph courtesy of Clark Peterson.

the figures that could be construed to reflect painful deaths. Sara Guyer has written persuasively about the way such memorials fail:

> The memorials expose impersonality: they do not restore individuals; they do not turn corpses into names. This impersonality certainly can be understood as the impersonality of genocide. But it also is the impersonality of death in general, revealing again the threat to memorialization that genocide effects. In leading us to see the dead as the perpetrators of the genocide saw the living, the memorials also lead us to see just the dead: the bones and cadavers of which every one of us is composed and will become, and which signal the event of death without rendering it intelligible. The memorials do not give us insight into death or genocide, apart from the negative insight of its enduring unrecollection—even at the sight where it occurred, even through the very remains of the dead (2009: 174).

As the discussions of ruins, reconstructions and ossuaries illustrate, there seems to be an almost universal expectation that people should 'feel something' at memorials (that it would be appropriate for them to do so). To walk away

unmoved would signal a failure of the site. Yet what one should feel (grief, anger, shock) and, perhaps even more so, how one should be made to feel it remains unresolved.

Whether or not there are ruins to preserve, most memorials contain some new construction to supplement, enhance or stand in for residual architecture. These newer constructions are used to fulfil the commemorative burden of the sites and to house artefacts and documentation of the atrocity. The former aspires to be affective, the latter informative. This tension between pedagogy and emotionality is one of the core tensions of memorial design. Affective memorial architecture is remarkably formulaic. Most sites rely on a limited vocabulary of architectural tropes: walls of names, plinths and stelae, empty chairs, descending/ascending spirals, symbolic gardens and water features. Since the construction and unexpected success of Chinese American architectural artist Maya Lin's Vietnam Veterans Memorial in Washington DC, walls of names have become de rigueur for trauma memorials. Building on the convention of engraved stone burial markers, such walls intend to recognize individuals and at the same time to mark the grander scale of loss. Interesting variations on this can be found at the Parque de la Memoria in Buenos Aires where only one-third of the total estimated *desaparecidos* ('disappeared') have been identified by name. There, blank markers far exceed those that are engraved. In Rwanda, where whole families and communities were lost, it is rare to be able to provide any names at all. But the monument at Nyarubuye, which tries to make a mass death individual with un-engraved markers, demonstrates the transcultural reach of this memorial trope even into settings where the victims cannot be identified.

To represent the monumentality of loss, giant tomb-like plinths are a popular choice. Both Peter Eisenman's Memorial to the Murdered Jews of Europe and Daniel Libeskind's outdoors memorial sculpture 'Garden of Exile' within the Jewish Museum in Berlin feature this type of architecture. The empty chair is perhaps an over-obvious symbol for absence. Empty-chair memorials can be found at Oklahoma City (where larger and smaller chairs help differentiate between the adults and children who perished), in the former Polish ghetto of Podorge (where Oskar Schindler's well-known factory was located) and near the airport in Santiago, Chile (in honour of three martyred school teachers). Spirals are another common memorial form, claiming to represent descents into the abyss of the atrocity as well as ascents towards hope. Though often set in the landscape, as done in the courtyard of the School of Architecture at La

Plata or the memorial at Columbine High School, spirals are also placed indoors, quite effectively, for instance as seen at Hiroshima. Frequently offered as a healing environment, memorial gardens are also often used symbolically. At the Villa Grimaldi peace memorial in Chile, each rose variety is given the name of a female victim or survivor, whereas the gardens at the Kigali Genocide Memorial Centre have such elaborate symbolic schemes that an audio guide is provided to decipher them. Water features, such as fountains, pools and streams, are commonly provided for meditation and reflection.

A number of factors have contributed to this uniformity in memory culture. Curators of memorial sites from all over the world belong to the same professional organizations and meet one another regularly at international conferences to share 'best practices'. The same limited pool of jurors and architects select and design most high-profile memorials. Lower-profile memorials are often designed in imitation of (or in homage to) the better-known memorials, in part because survivors and victim's families often insist on the use of conventions they have seen implemented successfully elsewhere. The international audience for trauma memorials finds most legible those elements that are familiar. Furthermore, memorial tropes are largely derived from pre-existing funeral practices which have also been unified globally through colonization, religious homogenization and mass media.

Existing architecture may be enlisted to house the volumes of information and artefacts that are found at most memorials. This is the case at Auschwitz where the former barracks are dedicated to a series of thematically organized displays. But in the absence of sufficient surviving real estate, many memorial sites construct museums to house the repositories of artefacts of which they are custodians and to present the voluminous information necessary to complete their educational mission. Such museums differ little from their off-site counterparts; that is, they are constructed functionally. The elaborate museum displays found in existing architecture at Dachau differ little from their counterparts in new constructions at Oklahoma City, Nagasaki and Kigali. In these cases, the residual architecture is not being used for its evocative function as a ruin nor is the new architecture serving a commemorative purpose. Rather, they are warehouses.[15]

Although the predominant strategy of memorialization is to segregate the spaces of trauma from ongoing activities (as described in the earlier discussion of 'site sacralization'), a number of trauma sites round the world are located within actively used spaces. For example, the United Service Organizations–led

tours of the demilitarized zone (DMZ) in Korea are built round historical events leading up to the Korean War (1950–53), but the DMZ itself is still a tense border where tourists are given strict guidelines on how to comport themselves, in this case, not for reasons of propriety but for security, so that the act of a tourist does not incite new violence. Coin-operated binoculars provide an enhanced view across the border but tourists may not raise their hands or wave. Although on my visit I had the sense that the danger was being overplayed by tour guides, there *have* been border skirmishes fairly recently in some of the same spaces where tourists go.

Many of the Rwandan churches where massacres took place are still in use. Our guide reported that there was substantial conflict between survivor communities and the Catholic Church about whether to resume worship at locations where the church failed to protect the refugees who had congregated for asylum. Although the church at Nyamata has been rendered non-functional by the metonymic evocation of the deceased through mounds of their clothing stacked on pews, the church at Kibeho holds regular services in an environment that is marked to remind users of the events that transpired there. During the genocide, holes were punched in the walls of the church by *génocidaires* in order to murder the people sheltered there. When religious authorities insisted that the church be restored, Rwandan congregants decided to paint the replaced bricks in purple, the colour of mourning.

Related strategies for inserting memorials into actively used spaces can be found in Argentina and Germany. The organization Barrios por la Memoria y Justicia has been working with neighbourhoods throughout Buenos Aires to install mosaic plaques commemorating residents who disappeared. In Berlin, artists have created a number of effective interventions in the urban landscape, such as Christian Boltanski's Missing House, Renata Stih and Freider Schnock's Memorial to the Deported Jewish Citizens of the Bayerische Viertel and Micha Ullman's Bibliotek Memorial to the Nazi book-burnings. These urban interventions are effective in drawing attention to the fact that many traumas are not localized at memorial sites but are rather dispersed throughout a culture/country. France and Italy also have widespread practices of dispersed memorialization, with documentation of official history and resistance offered in plaques and site-specific web links.[16]

In this essay, I have mostly been concerned with questions about how the desecrated grounds of traumatic violence are recuperated as memorials. But I

would like to take a moment to consider the inverse question: (why) does a memorial *need* to be located at the site of a trauma?

Numerous reasons exist not to build site-specific memorials. Assigning traumatic histories to specific locations may obscure the widespread nature of traumas, which do not take place only at bomb sites, crematoria and clandestine torture centres but are enacted throughout society—socially, economically, politically, juridically and even interpersonally. By concentrating memorial functions, we may inadvertently pardon those who should be held accountable. In some cases, as exemplified by the Armenian genocide, the locus of the trauma may be politically unavailable. Turkey still refuses to admit historical events of the genocide let alone allow memorials to be constructed. Instead, memorials to the Armenian genocide can be found in 30 other countries.[17] But even for the Holocaust, although multiple trauma sites have been recuperated as memorials, diasporic populations in the United States, South Africa, Argentina and in many other countries have felt the need to commemorate the Holocaust where they live.[18] As mentioned earlier, the placement of a memorial may be merely opportunistic, the availability of a particular plot of land or a particular building at serendipitous timing. Along these lines, Gates-Madsen (2012) has written a thorough analysis of the confluence of forces that led to the placement of the Parque de la Memoria on the Costanera Norte in Buenos Aires and the work that was done afterwards to make the place significant.

In spite of these strong arguments in favour of off-site memorials, I would still argue that site-specific memorials, while imperfect, offer a unique opportunity. I opened this essay with a set of questions about what our *obligations* to desecrated spaces. I would like to conclude with some thoughts about *opportunities* such spaces afford. Visitors come to these sites as pilgrims, in a heightened state of awareness, prepared to engage with difficult questions, and are therefore more receptive to ethical mediations.

Montevideo, despite its relatively limited set of trauma memorials, offers us another interesting example in the Espacio de Arte Contemporaneo Ex-carcel Miguelete. Located in a former women's prison, this museum embraces the political opportunity afforded by its architectural history. In the same way as the museum's name draws attention to its prior function, so too the architecture and the curatorial policy of the museum are structured to draw attention to the politics of the site. Within the museum, large portions of the prison that remain un-reclaimed are available to viewers through a panoramic, two-storey tall glass window. Artists (or museum curators) have added text and installation

elements that clarify the history of the building and invite further reflection. In addition, the artwork on display often interacts productively with the history, even when it is not site-specific. For example, the travelling exhibit on display there in the fall of 2010 showcased survival strategies of the disenfranchised from many parts of the world. By placing such displays within reclaimed prison cells, the already poignant content of the exhibition was given added resonance.[19]

The South African memorial at Constitution Hill, like the Punta Carretas Shopping Centre, is built in and on the remains of a prison. In this case, it is the Old Fort Prison complex where political prisoners were held and tortured during apartheid. But unlike the clueless postmodernism of Punta Carretas, the merger of ruins with new construction in Johannesburg is founded in a political project. By embedding its constitutional court in a former prison, South Africa reminds its legislators on a daily basis of the political struggle from which the new government emerged. Rather than a suppression or erasure of the site's tortured history, this site performs a disclosure. Rather than suggesting that recovery from trauma means returning to commerce as usual, this building insists that the work of post-traumatic societies is juridical vigilance.

It is clear that trauma sites are highly charged. Whether we prefer a spiritual understanding of these spaces or one that is socially determined, we can agree that stakeholders (survivors and victims' families, perpetrators and their descendants, curators and site managers, governmental authorities and human rights organizations, neighbours and tourists) are deeply invested in the deployment of space. Insofar as trauma sites draw spectators in heightened states of awareness, such spaces provide the opportunity for activism, for thinking beyond their site-specific histories towards our responsibilities for intervening in ongoing trauma towards alternative outcomes. What such sites can do is to invoke an ethical response, a response that draws questions about ethics to the foreground—not the ethics of what to do with the designated space but the ethics of what was done there historically and the ethics of what we continue to do in the world today.

Notes

1 The term used on site for the restoration *'recuperación patrimonial'*, which can be translated as 'asset recovery', actually makes blatant the bolstering of state that underlies heritage projects.

2 Paraphrased from an email from Dr Rita Clark, a psychoanalyst who teaches medical ethics, and from the website 'Dictionarygeek' http://www.dictionarygeek.com/?url=http://www.-wordnik.com/words/&word=ethical (last accessed on 9 January 2014).

3 See dictionary.com at http://dictionary.reference.com/browse/propriety (last accessed on 30 April 2014).

4 The sign reads: 'The International Committee of former Dachau prisoners has initiated the sale of brochures and photographs upon the request of visitors to the site. The net proceeds accrue exclusively to the Committee, which is dedicated to the improvement and completion of the museum and the memorial site.'

5 'I Will Survive: Dancing Auschwitz'. Available at: http://videosift.com/video/I-Will-Survive-Dancing-Auschwitz (last accessed on 30 April 2014).

6 'Disco dancing on concentration camp grounds'. Available at: http://www.-jweekly.com/blog/full/58598/disco-dancing-on-concentration-camp-grounds/ (last accessed on 30 April 2014).

7 In their Introduction to *Of Property and Propriety: The Role of Gender and Class in Imperialism and Nationalism*, Judith Whitehead, Himani Bannerji and Shahrzad Mojab (2001) point out that property rights and notions of propriety are (not only) etymologically related. Their project is to demonstrate how culturally specific notions of propriety and underlying property rights are bound up in one another and to consider how identities are 'legally and ideologically articulated [. . .] as a sense of entitlement to citizenship in the nation' (ibid.: 4). Thus, the question of ethics (in terms of property rights) and propriety (in terms of behavioural norms) that I am trying to distinguish are inextricably intertwined.

8 Practices associated with spirits of the dead can be found in Catholicism, Buddhism and Animism in Africa, Latin America and Asia and among African Americans and Native Americans in North America.

9 In *Memorial Museums: The Global Rush to Commemorate Atrocities* (2007), Paul Williams argues that the pace of memorialization is accelerating. Following his logic, it may be the case that the rush towards commemoration at the World Trade Center site is because it is contemporary. Memorials were also built fairly quickly at Columbine, Colorado, after the Columbine High School massacre in 1999 and at Oklahoma City after the bombing in 1995. It may also be true that highly capitalized spaces move more quickly towards memorials. Thus, by this logic, we see a very short turn around, a matter of a few weeks, between the attacks on the Taj Mahal Palace Hotel in Mumbai,

India, and the erection of a memorial there. Also refer to Madrid's Atocha Station memorial monument to the victims of the suicide attacks in 2004.

10 Lecture at the University of Wisconsin on 29 October 2007. Available at: http://humanities.wisc.edu/workshops/past-mellon-workshops/trauma-tourism/ (last accessed on 30 April 2014).

11 The Cu Chi tunnels in Vietnam and the Anne Frank House in the Netherlands are not reconstructions but share an immersive sensibility. They invite spectators to fantasize about surviving under adversarial conditions. Like museums that document the deprivation of the depression in the United States or the war years in London or Tokyo, they also encourage a kind of nostalgia that is not exactly a remembrance of loss.

12 These three-dimensional tableaux also share a problem with two-dimensional representations of trauma, such as paintings, in that as representations they run afoul of our cultural consensus regarding the fundamental unrepresentability of trauma.

13 This project is being developed by Gonzalo Conte. Available at: http://www.memoriaabierta.org.ar/ (last accessed on 30 April 2014).

14 Majdanek in Poland also has a massive repository of human remains but the ashes it contains do not elicit the same identificatory response that is produced by human bones. The human fragments that will be part of the memorial at Ground Zero are also unrecognizable and will be kept in a viewing area that can only be accessed by family members.

15 In lower-resource circumstances of developing countries, it is common to replace the museum function with personalized guide services. In Ghana and Vietnam, the sites' legibility depends on the information the guide delivers, whereas the information in the guided tour at Auschwitz is a *précis* of and redundant to that which could be garnered from the information panels.

16 http://resistenzatoscana.it/.

17 Argentina, Armenia, Australia, Austria, Belgium, Brazil, Bulgaria, Canada, Chile, Cyprus, Egypt, Ethiopia, France, Georgia, Germany, Greece, India, Iran, Israel, Italy, Lebanon, Netherlands, Poland, Switzerland, Syria, Ukraine, United Kingdom, United States, Uruguay, Venezuela. Available at: http://www.armenian-genocide.org/memorials.html (last accessed on 30 April 2014).

18 Wikipedia lists more than a hundred Holocaust memorials, less than a quarter of which are actually located at sites directly associated with the traumas they commemorate. Available at: http://en.wikipedia.org/wiki/List_of_Holocaust_memorials_and_museums (last accessed on 30 April 2014).

19 'Exposición Post-it City-Ciudades Ocasionales en Montevideo'. Available at: http://www.artespain.com/06-10-2010/noticias/exposicion-post-it-city-ciu-dades-ocasionales-en-montevideo (last accessed on 30 April 2014)

Works Cited

BRETT, Lily. 2001. *Too Many Men*. New York: William Morrow.

DUNCAN, Carol, and Allan Wallach. 1980. 'The Universal Museum Survey'. *Art History* 3(4): 448–69.

FERNÁNDEZ HUIDOBRO, Eleuterio. 1991. *La Fuga de Punta Carretas* [Escape from Punta Carretas]. 3rd edn. Buenos Aires: Tupac Amaru Editorial.

FOER, Jonathan Safran. 2002. *Everything Is Illuminated: A Novel*. Boston: Houghton Mifflin.

GATES-MADSEN, Nancy. 2012. 'Marketing and Sacred Space: The Parque de la Memoria in Buenos Aires'. In Ksenija Bilbija and Leigh A. Payne (eds), *Accounting for Violence: Marketing Memory in Latin America*. Durham, NC: Duke University Press, pp. 151–78.

GINSBERG, Robert. 2004. *The Aesthetics of Ruins*. Amsterdam: Rodopi B. V.

GUYER, Sara. 2009. 'Rwanda's Bones'. *Boundary 2* 36(2): 155–75.

HIRSCH, Marianne, and Leo Spitzer. 2010. *Ghosts of Home: The Afterlife of Czernowitz in Jewish Memory*. Berkeley, LA: University of California Press.

KLEIN, Naomi. 2007. *The Shock Doctrine: The Rise of Disaster Capitalism*, 1st EDN. New York: Metropolitan Books / Henry Holt.

MACAULAY, Rose. 1953. *Pleasure of Ruins*. London: Weidenfield and Nicolson.

MARGALIT, Avishai. 2002. *The Ethics of Memory*. Cambridge, MA: Harvard University Press.

MEIERBACH, Jens. 2011. 'Topographies of Remembering and Forgetting: The Transformation of Lieux de Memoire in Rwanda' in Scott Straus and Lars Waldorf (eds), *Remaking Rwanda: State Building and Human Rights after Mass Violence*, 1st EDN. Madison: University of Wisconsin Press, pp. 283–97.

NORA, Pierre. 1996–98. *Realms of Memory: The Construction of the French Past*. VOLS 1–3 (Lawrence D. Kritzman ed., Arthur Goldhammer trans.). New York: Columbia University Press.

NOVICK, Peter. 1994. 'Holocaust Memory in America' in James Edward Young (ed.), *The Art of Memory: Holocaust Memorials in History*. New York: Prestel, pp. 159–65.

SION, Brigitte. 2009. 'Affective Memory, Ineffective Functionality: Experiencing Berlin's Holocaust Memorial' in William Niven and Chloe Paver (eds), *Memorialization in Germany since 1945*. London: Palgrave / Macmillan, pp. 243–52.

STURKEN, Marita. 2007. *Tourists of History: Memory, Kitsch, and Consumerism from Oklahoma City to Ground Zero*. Durham, NC: Duke University Press.

TAKAHASHI, Yuichiro. 2004. 'Exhibiting the Past: The Japanese National War Museum and the Construction of Collective Memory' in Peter Eckersall, Uchino Tadashi and Moriyama Naoto (eds), *Alternatives: Debating Theatre Culture in the Age of Con-Fusion*. Brussels: Peter Lang, pp. 127–42.

TILL, Karen E. 2010. 'Mapping Spectral Traces' in Karen E. Till (ed.), *Mapping Spectral Traces*, VOL. 2. Exhibition catalogue. Virginia: Virginia Tech College of Architecture and Urban Studies.

TRIGG, Dylan. 2006. 'The Aesthetics of Ruins (Review)'. *The Journal of Aesthetic Education* 40(4): 118–21.

TUMARKIN, Maria. 2005. *Traumascapes: The Power and Fate of Places Transformed by Tragedy*. Carlton: Melbourne University Press.

WHITEHEAD, Judith, Himani Bannerji and Shahrzad Mojab. 2001. Introduction to Himani Bannerji, Shahrzad Mojab and Judith Whitehead (eds), *Of Property and Propriety: The Role of Gender and Class in Imperialism and Nationalism*. Toronto: University of Toronto Press, pp. 3–33.

WILLIAMS, Paul. 2007. *Memorial Museums: The Global Rush to Commemorate Atrocities*. Oxford: Berg.

Trauma as Durational Performance:
A Walk through Villa Grimaldi, Santiago de Chile

DIANA TAYLOR

I

It is the year 2006: Pedro Matta, a tall, strong man walks up to us when we arrive at the unassuming side entrance to Villa Grimaldi, a former torture and detention camp on the outskirts of Santiago de Chile. He is a survivor who twice a month or so gives a guided tour to people who want to learn about what happened there. He says hello to Soledad Fallabella and Alejandro Gruman, my colleagues in Chile who thought that, given my work with human rights groups in Argentina, I would be interested in meeting Matta.[1] He greets me and hands me the English version of a book he has written: *A Walk Through a 20th Century Torture Center: Villa Grimaldi, Santiago de Chile; A Visitor's Guide* (2000). I tell him that I am from Mexico and speak Spanish. 'Ah,' he says, his eyes narrow as he scans me, 'Taylor, I just assumed . . .' The four of us walk into the compound. I ask whether I can take photographs and record the visit; he says, 'Of course.' I have my tape recorder and video camera. I've come prepared.

The space is expansive. It looks like a ruin or a construction site; there's some old rubble and signs of new building—a transitional space, part past, part future. In several ways, it is hard to get a sense of where we are standing. A hand-made sign at the entrance—Parque Por la Paz Villa Grimaldi—informs visitors that 4,500 people were tortured here and 226 people disappeared or were killed between 1973 and 1979. I take a photograph of the sign that reminds us that this place is simultaneously a torture camp, a memory site and a peace park. Like many memory sites, it reminds us that this tragic history belongs to all of us and asks us to behave respectfully so that it might remain and continue to instruct. Lesson 1, clearly, is that this place is 'our' responsibility.

'This way, please.' Matta, a formal man, walks us over to the small model of the torture camp to help us visualize the architectural arrangement of a place

now gone: Cuartel Terranova (barrack 'new land'). The mock-up is laid out, like a coffin, under a plastic, slightly opaque sunshade that distorts vision (figure 6). As in many historically important sites the model offers a bird's-eye view of the entire area. The difference here is that what we see in the model is no longer there. Even though we are present, we will not experience it 'in person'. So, one might ask, what is the purpose of the visit? What can we understand by being physically in a torture centre once the indicators have disappeared? Does the space offer evidence unavailable elsewhere or cues that trigger reactions in visitors? Little besides the sign at the entrance reveals the context. But, of course, we are here in person with Matta who takes us through the *recorrido* (walkthrough). Matta speaks in Spanish; it makes a difference. He seems to relax a little, though his voice is very strained and he clears his throat often.

The compound, originally a beautiful nineteenth-century villa used for upper-class parties and weekend affairs, was taken over by the Dirección de Inteligencia Nacional (DINA, the National Intelligence Directorate), General Augusto Pinochet Ugarte's special forces, to interrogate people detained by the military during the massive round-ups. As thousands of people were captured,

FIGURE 6. Pedro Alejandro Matta keeps his eyes on the ground. Photograph courtesy of Diana Taylor.

many civilian spaces were transformed into makeshift detention centres. Villa Grimaldi was one of the most infamous. In the late 1980s, one of the generals sold it to a construction company to tear down and replace with a housing project. Survivors and human rights activists could not stop the demolition but after much heated contestation, they did secure the space as a memory site and peace park in 1995.[2] Aside from markers to past atrocities, the space also provides a pavilion for concerts and activities associated with promoting peace and democracy. Matta, among others, has spent a great deal of time, money and energy to ensure the space remains a permanent reminder of what the Pinochet government did to its people. Three epochs, with three histories, overlap on this space that even now has multiple functions: evidentiary, commemorative, reconciliatory and pedagogical.

The miniature detention camp positions us as spectators. We stand above the model, looking down on its organizational structure. The main entrance to our top left, we are told, allowed passage for vehicles that delivered the hooded captives up to the main building. Matta's language and our imagination populates the inert space. He points to the tiny copy of the large main building that served as the centre of operations for DINA: here, the military planned who they would target and how and they evaluated the results of the torture sessions. The officer in charge of Villa Grimaldi and his assistants had offices here and officers had a mess hall. The space housed the archives and a shortwave radio station kept the military personnel in contact with their counterparts throughout South America. In the small buildings that run along the perimeter to the left, the prisoners were divided up, separated and blindfolded—men here, women there. Miniature drawings made by survivors line the periphery: hooded prisoners pushed by guards with rifles for their 30 seconds at the latrines; a hall of small locked cells guarded by an armed man; a close-up drawing of the inside of one of the cells in which half a dozen shackled and hooded men are squeezed in tightly; an empty torture chamber with a bare metal bunk bed equipped with leather straps, a chair with straps for arms and feet, and a table with instruments (figure 7). The objects reference behaviours. We know exactly what happened there/here. Matta points to other structures on the model. It is clear that the displacement offered by the model gives him a sense of control— he no longer needs to fully relive the image to describe it; he can externalize and point to it over there. The violence, in part, can be transferred to the archive, materialized in the small evidentiary mock-up. He is explicit about the criminal politics and very clear in his condemnation of the Central Intelligence

FIGURE 7. Drawings made by former prisoners. Photograph courtesy of Diana Taylor.

Agency's role in the Chilean crisis. His blue eyes pierce me and then he remembers I am not *that* audience—an audience, but not that audience.

Looking down at the model in relationship to the larger space, I see we are standing on the site of the main building, usurping the military's place. Looking offers me the strange fantasy of seeing or grasping the 'whole', the fiction that I can understand as systemic criminal violence even as we position ourselves simultaneously in and above the fray. We are permitted to identify without identifying. We are not implicated except to the degree that we can understand the information transmitted to us by the mock-up and Matta, our guide. This happened there, back then, to them, by them Recounting performs and reinforces the spatial and temporal strategy of displacement. The encounter, at this point, is about representation and explication of the facts. The model, made by survivors, stages the evidence. The mock-up or 'fake' gives others at least a glimpse of the 'truth' of Terranova. I take photographs, wondering how the tenuous 'evidentiary' power of the photo might extend the fragile evidentiary claim of the model camp. My photographs might illustrate what this place is, not what it was. So why? I know what happened at Villa Grimaldi but wonder

whether being there helps me know it differently. Can I, with my camera, do anything to further make visible the criminal violence? The 'other' violence—the economic policies that justified and enabled the breaking of bodies—remains safely outside the frame.

We look up and round at the place itself. There's not much to see of the former camp. The remains of a few original structures and replicas of isolation cells and a tower dot the compound, emptied though not empty—empty *of* something palpable in its absence. No history. No one responsible. Activists planted rows of birch trees (*abedules*), I learnt later, to symbolize the fragile and solitary condition of the ex-prisoners, along with their resistance.[3] With the camp demolished, Matta informs and points out, but he does not seem to connect personally or emotionally to what he describes. The objects have been reconstructed and placed to support the narration—this happened here. I imagine some visitors must actually try to squeeze themselves in the tiny, upright isolation cell. They might even allow someone to close the door. Does simulation allow people to feel or experience the camp more fully than walking through it? Possibly. Rites involving sensory deprivation prepare members of communities to undertake difficult or sacred transitions by inducing different mental states. The basic idea—that people learn, experience, and come to terms with past/future behaviours by physically *doing* them, trying them on, acting them through and acting them out—is the underlying theory of ritual, older than Aristotle's theory of mimesis and as new as theories of 'mirror neurons' that explore how empathy and understandings of human relationality and intersubjectivity are vital for human survival (see Gallese 2001). But these reconstructed cells have a funfair quality to them for me and I stay away. Following Matta from place to place, it becomes clear that these props do not help me relate. Rather the opposite: the less I actually see intensifies what I imagine happened here. My mind's eye—my very own staging area—fills the gaps between Matta's formal matter-of-fact rendition and the terrifying things he relates.

Matta walks us towards the original entrance—the massive iron-gate now permanently sealed as if to shut out the possibility of further violence. From this vantage point, it is clear that another layer has been added to the space. A wash of decorative tiles, chips of the original ceramic found at the site, form a huge arrow-like shape on the ground pointing away from the gate towards the new 'peace fountain' ('symbol of life and hope' according to Matta's booklet) and a large performance pavilion. The architecture participates in the rehabilitation of the site. The cross-shaped layout moves us from a criminal past to a

redemptive future. Matta ignores that for the moment; he is not in the peace park. This is not the time for reconciliation. His traumatic story, like his past, weighs down all possibility of a future. He continues his *recorrido* through the torture camp (see Lazzara 2006).

Matta speaks impersonally, in the third person, about the role of torture in Chile—500,000 people tortured and 5,000 killed out of a population of 8 million. I do the math—1 in 16. More tortures and fewer murders occurred in Chile than in neighbouring Argentina where the Armed Forces permanently disappeared 30,000 of their own people. Pinochet chose to break rather than eliminate his 'enemies'—the population of ghosts, or individuals destroyed by torture, thrown back into society would be a warning for others. Matta speaks about the development of torture as a tool of the state from its early experimental phase to the highly precise and tested practice it became. Matta's tone is controlled and reserved. He is giving archival information, not personal testimony, as he outlines the daily workings of the camp, the transformation of language as words were outlawed. *Crimenes, desaparecidos* and *dictadura* (crimes, disappeared and dictatorship) were replaced by *excesos, presuntos* and *gobierno militar* (excesses, presumed, military government).

As we walk, he describes what happened where and I notice that he keeps his eyes on the ground, a habit born of peering down from under the blindfold he was forced to wear. The shift is gradual—he begins to re-enact ever so subtly as he re-tells. I feel compelled to register the moment: I take a photograph as if to capture the move inwards, into the dark space in which we stand but cannot see. He moves deeper into the death camp, here pointing at an empty spot: 'Usually unconscious, the victim was taken off the *parrilla* (metal bed frame), and if male, dragged here' (Matta 2000: 13). Maybe the lens will grasp what I cannot. Looking down, I see the coloured shards of ceramic tiles and stones that now mark the places where buildings once stood and the paths where victims were pushed to the torture chambers. As we follow, we too know our way by keeping our eyes on the ground: *Sala de tortura* (torture chamber), *Celdas para mujeres detenidas* (cell for detained women).

I follow Matta's movements but also his voice that draws me in. Gradually, his pronouns change—'they tortured *them* becomes they tortured *us*.' He brings us in closer. His performance animates the space and keeps it alive. His body connects me to what Pinochet wanted to disappear, not just the place but also the trauma. Matta's presence performs the claim, embodies it, *le da cuerpo*. He has survived to tell. Being *in place* with him communicates a very different

sense of the crimes from looking down on the model. Walking through Villa Grimaldi with Matta brings the past up close, past as actually not past. Now. Here. And in many parts of the world, as we speak. I cannot think past that, rooted as I am to a place suddenly restored as practice. I too am part of this scenario now; I don't need to lock myself up in the cell to be *doing*. I have accompanied him here. My eyes look straight down, mimetically rather than reflectively, through his downturned eyes. I do not see really; I imagine. I *presenciar*; I presence (as active verb). Neuroscientists call this embodied cognition, but we in theatre have always understood it as mimesis and empathy—we learn and absorb by mirroring other people. I participate not in the events but in his transmission of the affect emanating from the events. My presencing offers me no sense of control, no fiction of understanding. He walks through the Patio de Abedules; he sits on the semicircle that remains from the camp; he tells. When he gets to the memorial wall marked with the names of the dead (built 20 years after the violent events), he breaks down and cries. He cries for those who died but also for those who survived. 'Torture,' he says, 'destroys the human being. And I am no exception. I was destroyed through torture.' This is the climax of the tour. The past and the present come together in this admission. Torture works into the future, yet it forecloses the very possibility of a future. The torture site is transitional but torture itself is transformative—it turns societies into terrifying places and people into zombies (Godoy-Anativia 1997).

As Matta leaves the memorial wall, his tone shifts again. He has moved out of the death space. Now, he is more personal and informal in his interaction with us. We talk about how other survivors have dealt with trauma, about similarities and differences with other torture centres and concentration camps. He says he needs to come back. The walkthrough reconnects him with his friends who disappeared. Whenever he visits with a group who is interested in the subject, he feels he is doing what he wishes one of his friends had done for him had he been the one to have disappeared. Afterwards he goes home physically and emotionally drained, he says, and drinks a litre of fruit juice and goes to sleep, waking up only the following morning. His body still hurts from the torture and he has developed debilitating after-effects. We continue to walk, past the replica of the water tower where the high-value prisoners were isolated, past the *sala de la memoria* (memory room)—one of the few remaining original buildings that served as the photo and silkscreen room. At the pool, also original, he narrates one of the most chilling accounts told to him by a collaborator. At the memory tree, he touches the names of the dead that hang like

leaves from the branches. Different commemorative art, like the large sign with names of the dead, remind us that *El olvido esta lleno de memoria* (forgetting is full of memory). And, of course, the ever hopeful *Nunca Más* (never again). He barely notices the fountain—the Christian overlay of redemption was the government's idea, clearly.

After we leave the site, we invite Matta to lunch at a nearby restaurant that he recommends. He tells us about his arrest in 1975 for being a student activist, his time as a political prisoner in Villa Grimaldi, his exile to the United States in 1976 and his work as a private detective in San Francisco until he returned to Chile in 1991. He used his investigative skills to gather as much information as possible about what happened in Villa Grimaldi, to identify the prisoners and name the torturers stationed there. One day, when he was having lunch in this same restaurant after one of the visits to Villa Grimaldi, an ex-torturer walked in and sat at a nearby table with his family. They were having such a good time. They looked at each other and Matta got up and walked out.

Later, Soledad tells me that Matta does the visit the same way every time— stands in the same spot, recounts the same events, cries at the memorial wall. Some commentators find this odd, as if the routine makes the emotion suspect. Are the tears for real? Every time? Is there something fake about the perform-ance? Is Matta a professional trauma survivor? But the re-enactment, I believe, is central both to trauma and to performance. Trauma, like performance, is known by the nature of its repeats, 'never for the first time'. We speak of trauma only when the event cannot be processed and produces the characteristic after-shocks. Trauma, like performance, is always experienced in the present. Here. Now. And yet it endures. This double temporality defines them both.

Trauma lays down new memory tracks. Neuroscientists suggest that these paths are physiological as well as material, fixed in the brain as a specifically patterned circuit of neurons. Being in a situation can automatically provoke certain behaviours unless other memory tracks are laid down to replace them (see Gallese, Eagle and Migone 2007). A cue or trigger can suddenly send the mind back to another space and time that is experienced as viscerally and immediately present. The goal of various kinds of treatments, such as immersion therapy and virtual reality, is to gradually and carefully expose people to the place or thing that traumatized them until they can separate out the cue from the uncontrolled emotional onslaught. For people trapped in the stairwells of the falling World Trade Center, for example, stairs may take on a terrifying dimension that makes it difficult, if not impossible, for them to use stairs or

even use lifts.[4] Before too long, the hope is that they come to feel that the stairs are not in and of themselves dangerous or life-threatening. Moreover, they may be able to access the memories of the day when they choose to without being overwhelmed and disoriented by intrusive thoughts and feelings. The old cues no longer transport the person back to the traumatic injury.

For a survivor of torture, going back to the torture camp is a deliberate re-entry into a painful memory path. Memory, we know, is linked to place— one clear reason why that place needs not only to exist but also to be marked for the violence to be acknowledged. For any guide, routine serves a mnemonic function—people can remember certain events by associating them with place (see Abercrombie 1998). Through the *recorrido*, the act of walking, the body remembers. Matta, I believe, has been able to separate some of the traumatic experiences from his daily life, choosing to encounter them and even allowing himself to feel them in safe settings such as these guided visits. These 'tours' then give him a way to keep his past alive yet under control. A change in Matta's routine might well change the emotion. But routine also protects against unexpected affect—survivors can often recall some aspects of their torment and not others—there are some places (literally and physiologically) where no one dares to go.

For Matta, both victim and witness, trauma is a durational performance. His experience does not last two hours—it has lasted years, since he was made to disappear by the armed forces. His reiterated acts of leading people down the paths characterize trauma and trauma-driven actions to channel and alleviate trauma. As for the Mothers of Plaza de Mayo in Buenos Aires, the ritualized tour offers him both personal consolation and revenge. Memory is a tool and a political project—an honouring of those who are gone and a reminder to those who will listen that the victimizers have got away with murder. His tour, like the Mothers' march, bears witness to what gets spectacularized (a society in which judicial systems cannot bring perpetrators to justice) and what is made invisible (rapacious economic systems that make certain populations disappear). Yet the walkthrough, like the march, also makes visible the memory paths that maintain another topography of place and practice, not of terror but of resistance—the will not only to live but also to keep memory alive.

The Parque de la Paz, I have suggested, is a highly 'practised' place. The violently contested history of spatial practices continues to return and disturb the Chilean social body. Villa Grimaldi demonstrates the centrality of place in individual and collective memory. What happens to that multilayered and

palimpsest space is tantamount to what happens to Chileans' understanding of the dictatorship: Will people repress, give evidence, remember or forget? The warring mandates about the space rehearse the more salient public options: tear it down to bury the violence; build a commemorative park so that people will know what happened; honour the past by hosting cultural events in the pavilion and move on; forget about this desolate place, forget about this sorry past. Nowhere is there talk of justice or retribution.

Matta, of course, has been instrumental in building the evidence. He has investigated and helped collect the information of what happened at Villa Grimaldi. He has worked to preserve the space as a memorial site. He has helped construct the model. He has written and published the booklet *A Walk Through a 20th Century Torture Center: Villa Grimaldi, Santiago de Chile; A Visitor's Guide*. He has actively participated in creating the external material markers that designate this a 'dark site'. He has even prepared for a visit without him present. The book maps out every move; the brutal images in the margins make visible every practice: 'Here the torture began' The book, given the nature of print media, tells the same story the same way every time. It outlines the path and numbers the stops—here people were tortured with electricity The numbers in the book—like a tour guide—align with the map. Actually, it's a double map—one layer shows the torture camp, the other (a semitransparent layer of onion paper) outlines the Peace Park, with the pavilion, the fountain and the numbered places of interest: 'storage of confiscated goods' and 'sites for hanging'. A red dotted line outlines the *recorrido* exactly as Matta conducts it. This trace, then, is the trauma made visible in the archive, envisioned by Matta to outlast him and transmit meaning to those who come later to visit the space.

Being in the site with Matta, however, is a powerful experience—one of a kind for me even if it is a repeat performance for him. What does Matta's performance want of me as audience or as witness? What does it mean to witness and the quality of *being in* place? He needs others (in this case me) to acknowledge what happened there and thus complete the task of witness. *To witness*, a transitive verb, defines both the act and the person carrying it out; the verb precedes the noun—it is through the act of witnessing that we become a witness. Identity relies on the action. We are both the subject and the product of our acts. Matta is the witness for those who are no longer alive to tell; he is witness to himself as he tells of his own ordeal; he is a witness in the juridical sense, having brought charges against the Pinochet dictatorship. He is also the object of my witnessing—he needs me to acknowledge what he and others went

through in Villa Grimaldi. The transitivity of 'witness' ties us together; that is one reason he is keen to gauge the nature of his audience. Trauma-driven activism (like trauma itself) cannot simply be told or known; it needs to be enacted, repeated and externalized through embodied practice.

Torture, of course, produces the opposite of witnessing—it silences, breaks personal and social bonds and guts all sense of community and responsibility. Torture isolates and paralyses both victims and bystanders who are tempted to look away. 'Percepticide' is what I have called this elsewhere (Taylor 1997). This is why regimes continue to practise torture even though they know that they receive no 'actionable' information. It is inaction they seek. My job, as I understand it, is to take action (maybe with a small a, as opposed to inaction), to acknowledge the violence generated by our governments, to follow Matta in his re-enactment, to make connections to the other events I know to be true, to write about the place, to donate money or to bring other people.

Still, I understand what Matta is doing here better than I understand what I am doing here. I wonder about aura and worry about voyeurism and (dark) tourism. Is Matta my close-up—bringing up unspeakable violence as close as possible? If so, to what end? This too is multilayered in the ways that the personal, interpersonal, social and political come together. Walking through Villa Grimaldi with Matta, the oversized issues of human rights violations and crimes against humanity—too large and general at one level—take on an immediate and embodied form. According to Fredric Jameson, it enables us 'to insert ourselves, as individual subjects, into an ever more massive and impersonal or transpersonal reality outside ourselves' (1992: 54). In our everyday lives, we have no way of dealing with violent acts that shatter the limits of our understanding. We all live in proximity to criminal violence and, though some of us have felt it more personally than others, this violence is never *just* personal. This is the strength and weakness of this kind of memorialization: it is so personalized and concentrated that it tends to focus just on the designated victims and space. But if we focus only on the personal trauma, we risk evacuating the politics. Standing there, together, bringing the buildings and routines back to life, we bear witness not just to the personal loss but to a system of power relations, hierarchies and values that not only allow but require the destruction of others.

The questions posed by these dark sites extend far beyond the fences built round them. The small model near the entrance is to Villa Grimaldi what Villa Grimaldi is to Chile and what Chile is to the rest of the Americas: a miniature rendition of a much larger project. There were 800 torture centres in Chile

under Pinochet. If so many civic and public places like villas and gyms and department stores and schools were used for criminal violence, how do we know that the whole city did not function as a clandestine torture centre? The scale of the violations is stunning. The ubiquity of the practice spills over and contaminates social life. The guided tour through Villa Grimaldi gives us an intensely condensed experience within the compound walls. But here, within the camp, it is clear that the violence only appears isolated and bracketed from everything that surrounds it. We might control a site and build a wall round it, but the city, the country, the southern cone, the hemisphere has been networked for violence—and beyond too, of course, and not just because the United States openly engages in outsourcing torture. The ubiquitous and ongoing practice of torture changes the meaning of the visit. We don't have to be tourists (understood as visitors with nothing at stake) to be part of this tour but, rather, citizens of the world.

As I follow Matta deeper down the paths, his experience resonates with me in part because I actually do always know what happened here/there and accept that this, like many other sites, is my responsibility. I do participate in a political project that depends on making certain populations disappear. I am constantly warned to keep vigil, to 'say something' if I 'see something'. Though I shirk responsibility when I first meet Matta—the Mexican government had nothing to do with the Chilean coup—there is another layer. After years of my own self-blinding, I realize that the Mexican government, under then president Luis Echeverría, made disappear thousands of young people, about the same age as I was then. Now that I live and work in the United States, I know my tax dollars pay for Gitmo. For me, the emotional charge of the visit comes from the friction between place and practice—inseparable, though often displaced and at times disavowed. Something has been restored through the tour that brings several of my worlds into direct contact. As the multi-tiered space itself invites, I recognize the layers and layers of political and corporeal practices that have created these places, the histories I bring to them, the transparent and flimsy dividers that differentiate them and the emotions that get triggered as we walk through them in our own ways.

Matta, the booklet tells us, 'feels a strong desire to transform history into memory'. He makes the past come alive through the performance of his *recorrido*. Yet trauma keeps the past alive in Matta as well—the future is not an option for him as long as Terranova continues to call him to that place. The 'future' in fact might be a very different project. In the best of all possible

worlds, the future would mean turning this memory into history, the testimonial walkthrough into archival evidence, Matta's personal admonition into legally binding indictments against perpetrators, and visitors into witnesses, human rights activists and voters. Someone else, maybe someone who has never been tortured, would lead the tour, with or without Matta's guide. But that future is predicated on a past in which justice has been done and/or trauma transcended or resolved. That future is nowhere in sight even though the arrow points us towards the fountain symbolizing 'life and hope'. The tour does not offer us the end of traumatic memory or the end of performance. Looking downwards, we follow Matta as he negotiates this transitional space between remembrance and future project.[5]

II

It is the year 2010: I hear that the renovations on Villa Grimaldi have been completed under the Michelle Bachelet government (herself a victim of detention and torture in Villa Grimaldi) and outfitted with an educational and resource centre. An audio tour is available in several languages. Clearly, it is time to go back—this time without a survivor to try to understand how presence and voice affect my understanding of the space. Again, I choose the 'tour' in Spanish. The quiet, rhythmic voice of the unidentified female 'guide'—I find out later—belongs to a well-known actress of Chilean *telenovelas* (soap operas). But without knowing this, I sense that the young, fresh voice has been untouched by the violence she is describing. The instructions are clear from the outset—I am to move to the different points in the audio tour, marked on the xeroxed map and, at the site, by the same ceramic markers. But this is a radically different experience. The homemade sign at the gate, reminding me to behave, is gone—replaced by a steel plinth, an indication of its incorporation into an institutional system. I feel alone and confused as I start the walkthrough. I fumble with the buttons on the digital recorder and feel silly with the headphones even though there is almost no one else there. I feel alone, awkward and wonder (again) what I am doing there. I get impatient as the voice tells me in a matter-of-fact way about the political acts that led to the creation of this torture centre—I feel I know this 'information' already. I am tempted to pull the headphones off, but resist. When the audio segment comes to an end, I stop, fumble on the map for the next 'stop' and move towards it.

I shuffle between the recorder and the map. My hands are full so I can't hold my notebook or easily take photographs. I feel more like a tourist than a

researcher. My job, I remind myself, is to stay on track and try to engage with the account. Yet, I have become a passive, perhaps even reluctant, listener.

The voice without the body radically changes my experience of being *in place*. There is no 'I' or 'me' envisioned in this audio tour—no human being who challenges me or holds me in part accountable for what happened. The communicative pact is between two unknowns, whose reasons for participating in this project remain unexplored. Instead of bringing the past up close, and making evident the networks that link us not just affectively but politically, the audio shuts (and locks) the gateway to that past. From a safe *now*, I enter into the land of FYI, long ago and far away.

The *recorrido* follows the same route taken by Matta—the model camp the locked iron gate, the cells and memorial wall. But some new buildings and exposed remnants of the original villa discovered in recent excavations can be seen. Now the site is more orderly, the paths more clearly marked and illuminated, some of the beauty of the villa restored with the wading pools and multiple fountains. The forbidding walls to the exterior have been knocked down or fell during the 2010 earthquake. The site has been integrated, visually and politically, into the surrounding neighbourhood. The neighbouring houses are clearly visible. Their view of the 'park' must be quite pleasant.

I keep walking. The crisp, soft voice of the audio, which draws on a great number of testimonies, gives far more detail than Matta did. More dates, figures, facts. The separation of data into short bits makes sense in a way, allowing the listener time to move from place to place. But the segments are disturbing, not just in their disembodied content but in their fragmentation. They start and end abruptly—often after a particularly interesting or disturbing image. 'Segment 5: Patio de Abedules—the men were allowed to sit on the bench in the open air for a few minutes a day under strict supervision. Because they could not see, they depended on their sense of smell and developed a secret code of sounds to communicate.' Wait, say more! But the audio goes dead. 'Segment 6: Cells and torture rooms—the women's cells had a window painted over through which they could see the men being taken to the torture rooms. They could identify the men and their torturers. Next door to them was a room called the *parrilla* (grill) where prisoners were stripped, bound to metal beds and tortured with electricity.' End of section. No, let me down easy! Next segment. The fragments are disturbing but also misleading, as if we can separate the different moments, routines and spaces. The same matter-of-fact tone speaks unimaginable brutality and describes the voice of the woman captive with a voice like

Edith Piaf's, who sang to drown out the screams of the torture. Even when the voice cites specific testimony, there is no change in tone. The steady rhythm (with the slight tilt at the end of each phrase) flattens out the retelling. Clearly, the narrator does not want to be sensationalist. She wants to explain what happened where. I understand and respect that decision; yet, as I take in the facts, it is hard to relate to the events and to the space. The voice does not speak to me. She is removed, both by age and distance. The audio has been recorded in a studio, a controlled environment far from the violent events, and I find the disconnect between the environments, the tone, the clarity of the recording and the tale distracting. Matta's presence allowed us to grasp the parts in relation to the larger frame of violations, in part embodied in his aching body. The booklet too tries to pull together into an overarching narrative and image of the maps. But the sound clips start and fall into silence, giving no clue as to their larger telling. The pauses between segments too seem very different from Matta's recounting. His silences were full of memory. His face, body, mood transmitted his thinking processes and affective swings. I cannot identify the silences of the audio—they simply go dead. If forgetting and silence are full of memory, full of life, the audio has a hard time capturing that life.

What does this tour ask of me? The voice thanks me for my visit. It explains that Villa Grimaldi is a material and symbolic trace of state terrorism under Pinochet. The explanation clearly connects criminal practice to neo-liberal economic politics. It says that the visit is a look to the past. Still, 'we hope' (says the unidentified voice) that it prompts reflection on the present and an impetus to halt human rights abuses throughout the world. If 'I' am interested in knowing more, then please visit the web page, etc. She also gives me a phone number.

When I ask the people who have created the audio about their reasons for choosing a young actress with no ties to the violent past to narrate the walk-through, they say they want the younger generations to identify with it.[6] This visit, then, is no longer about Matta and trauma and justice deferred. It is about getting the next generation to listen and try to understand the past. The audio tour contains and encapsulates the past for those who come after.

So it looks as if Villa Grimaldi has been domesticated—not for the survivors but as a political project. As the adage goes, if you want to forget about an event, build a monument or museum to commemorate it. The visceral pain I felt with Matta has given way to repose. The renovated park clearly transmits the sense of a different political moment. I walk through the park not in the present tense

but in the past. With the opening of the new Museo de la memoria y los Derechos Humanos (Museum of Memory and Human Rights) in 2010, it appears that the contestation has given way to a time of acceptance and memorialization. With the renovations, Villa Grimaldi has also entered into the visual and commemorative practice of more recent memory parks. The new building reminds me of Parque de la Memoria in Buenos Aires. So does the display of the oversized photos of the dead towards the exit that now replace the list of names that used to occupy the same spot. The images try to personalize a moment that has now, for all legal and practical purposes, been pronounced dead.

It is not an exaggeration to state that future knowledge of this site will only be available through archival materials—the audio tour, the replicas, the memorial wall, the art pieces staged in the experiential practice that characterizes current memorialization practices. We enter the space that has been set up in such a way that the archival objects might spark an affective reaction in the visitors. But it is hard for me to imagine that these objects will move someone who has not been involved in the practice, who has never been to the site or who has no connection to what happened there. The punctum or cue has to resonate in the viewer/listener. Trauma lives in the body, not in the archive.

I take the headphones back to the office and speak to the young woman who works there. I ask what brings her here. Her father has been a prisoner at Villa Grimaldi, she says, but never speaks of his experience, though he has come back to the camp/park/memory site a couple of times. She worries that her office will be closed down—the right-wing government that succeeded Bachelet in 2010 is not interested in looking back. The newly inaugurated Museo de la memoria y los Derechos Humanos, she tells me, has also lost 40 per cent of its operating budget. The repose offered by the domestication of Villa Grimaldi and the lulling voice is not as untroubled as it seems. These are still contested spaces and contested pasts. Villa Grimaldi continues to disturb. It cannot be so easily absorbed. Not dead yet, I think, and feel relief. As I say goodbye to her, I re-experience the force of tour as performance and as trauma, and I know it is never for the first, or last, time.

Notes

1 The research that came out of that project was published (in part) in my book *Disappearing Acts: Spectacles of Gender and Nationalism in Argentina's 'Dirty War'* (see Taylor 1997).

2 Teresa Meade writes that Villa Grimaldi was the 'only "memorial" of torture in Latin America' when it was built in 1995 (2001: 125). Now Parque de la Memoria (Memory Park) and Escuela Superior de Mecánica de la Armada, commonly known as ESMA, in Buenos Aires also function as memorials.

3 Audiotape during guided tour, Villa Grimaldi, 2010.

4 Interview with JoAnn Difede, principal investigator of a Department of Defense clinical trial contract entitled 'Enhancing Exposure Therapy for PTSD: Virtual Reality and Imaginal Exposure with a Cognitive Enhancer' at the Weill Cornell Medical College, Cornell University, New York (10 February 2011).

5 This first section is adapted from lectures in 2009 and has been previously published as Diana Taylor (2011).

6 My thanks to Evelyn Hevia, one of the creators of the audio tour, for her help and generosity.

Works Cited

ABERCROMBIE, Thomas A. 1998. *Pathways of Memory and Power: Ethnography and History among an Andean People*. Madison: University of Wisconsin Press.

GALLESE, Vittorio. 2001. 'The "Shared Manifold" Hypothesis: From Mirror Neurons to Empathy'. *Journal of Consciousness Studies* 8(5–7): 33–50.

———, Morris N. Eagle and Paolo Migone. 2007. 'Intentional Attunement: The Mirror Neuron System and its Role in Interpersonal Relations.' *Journal of the American Psychoanalytic Association* 55(1): 131–76.

GODOY-ANATIVIA, Marcial. 1997. 'The Body as Sanctuary Space: Towards a Somatic Topography of Torture'. Unpublished manuscript.

JAMESON, Fredric. 1992. *Signatures of the Visible*. London: Routledge.

LAZZARA, Michael J. 2006. *Chile in Transition: The Poetics and Politics of Memory*. Gainesville: University Press of Florida.

MATTA, Pedro Alejandro. 2000. *A Walk Through a 20th Century Torture Center: Villa Grimaldi, Santiago de Chile; A Visitor's Guide*. Santiago de Chile: Pedro Alejandro Matta.

MEADE, Teresa. 2001. 'Holding the Junta Accountable: Chile's "Sitios de Memoria" and the History of Torture, Disappearance, and Death'. *Radical History Review* 79: 123–39.

TAYLOR, Diana. 1997. *Disappearing Acts: Spectacles of Gender and Nationalism in Argentina's 'Dirty War'*. Durham, NC: Duke University Press.

———. 2011. 'Trauma as Durational Performance: A Return to Dark Sites' in Marianne Hirsch and Nancy K. Miller (eds), *Rites of Return: Diaspora Poetics and the Politics of Memory*. New York: Columbia University Press, pp. 268–79.

The Manhattan Project Time Machine:
Atomic Tourism in Oak Ridge, Tennessee

LINDSEY A. FREEMAN

The scenery of the future. Eventually the only scenery left. The more toxic the waste, the greater the effort and expense a tourist will be willing to tolerate in order to visit the site. Only I don't think you ought to be isolating these sites. Isolate the most toxic waste, okay. This makes it grander, more ominous and magical [. . .] And the hot stuff, the chemical waste, the nuclear waste, this becomes a remote landscape of nostalgia. Bus tours and postcards, I guarantee it (DeLillo 1997: 286).

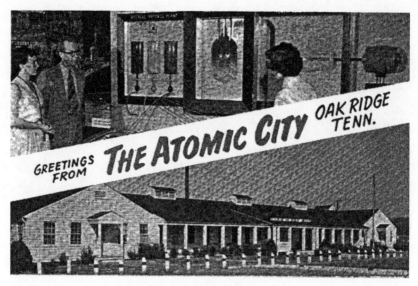

FIGURE 8. Greetings from the Atomic City, Oak Ridge, Tennessee. Copyright Richards and Southern Inc. Photography and design by Robert E. Calonge.

After completing a bus tour of the former Manhattan Project factories in Oak Ridge, Tennessee, I jotted off a few quick postcards to my friends in New York: 'Wish you were here.'[1] In his 1997 novel *Underworld*, Don DeLillo turned a gimlet eye to the close of the twentieth century and satirically, but presciently, foresaw tourism to nuclear sites. This fictional imaginary has since become a reality and promises to grow in the future. Former sites of the Manhattan Project, as well as its progeny—nuclear storage facilities and ageing apparatuses from cold war nuclear complexes—are becoming places of interest for tourists. Just as industrial tourism became popular in areas of de-industrialization so nuclear tourism is becoming a more common practice in spaces of de-nuclearization (Freeman 2010, forthcoming; MacCannell 1999; Urry 2002; Gusterson 2004; Veitch 2010; Wray 2006). A clear example of this trend is the atomic tourism generated by the Secret City Festival of Oak Ridge, which includes tours to the uranium processing facilities of the Manhattan Project.[2] These enormous factories supplied the material that fuelled the atomic bomb, Little Boy, which was dropped on Hiroshima in 1945 (figure 8).

Looking out onto present-day Oak Ridge from the window of a slow-moving tour bus on the hottest of summer days, it is difficult to imagine that this sleepy town was once teeming with world-renowned physicists and vast scores of labourers working round the clock to produce enough fissionable uranium-235 for an atomic bomb. Along with Hanford, Washington and Los Alamos, New Mexico, the town of Oak Ridge was one of the three secret cities created solely for the Manhattan Project. Although the town was a federal military reservation and the ultimate goal was to produce fuel for the bomb, great care was taken with respect to town planning for its residents, who were overwhelmingly civilian. Oak Ridge was designed by the New York architectural firm Skidmore, Owings & Merrill to have all the amenities of an ideal American town. The town's layout, replete with parks and sidewalks, was a precursor to the suburban planning that would sweep the United States after 1945. During the Second World War, the population of Oak Ridge swelled to over 75,000 residents and contained one of the highest concentrations of PhDs per square mile of any place in the world, including several Nobel Prize winners. Today, Oak Ridge is a small city of nearly 30,000 that resembles many other North American cities with its modern subdivisions, Starbucks and Wal-Mart. Yet, at its core, this small city of East Tennessee is still a major science centre with strong ties to the federal government, which remains the town's largest employer. The city houses the Oak Ridge National Laboratory (ORNL) as well as the

Y-12 National Security Complex, and is often home to the world's fastest computer.[3]

While science is still the dominant field in Oak Ridge, the city has turned to atomic tourism to make visible the town's former invisibility as a secret city—to remind locals of their atomic past and to attract visitors to the region. In the last couple of decades, Oak Ridge has increased its efforts to retain its past in museum displays, memorials, histories and festivals. Yet, despite local boosterism, in the twenty-first century, the United States is experiencing a loss of much of its nuclear history. The origins of Oak Ridge and its fraternal twin on the western side of the country, Hanford, Washington (the town created to produce the plutonium needed for the bomb that was dropped on Nagasaki) are nearly forgotten outside of their geographic regions. Only Los Alamos seems to be remembered, and even if vaguely so. The remains of the Manhattan Project—the atomic factories of the 1940s built at warp speed to produce fissile materials—have for the most part been left in ruin, their contaminated corpses exposed in plain sight. In recent decades, efforts have been made to perform the dual procedures of decommission and decontamination on these toxic bodies. Clean-up efforts, which are undisputedly necessary, are geared in three major directions: eradication (complete removal and burial of radioactive materials), resurrection (attempts to renew spaces for scientific or commercial endeavours) and, lastly, atomic tourism (the focus of this article).

Sites of atomic tourism attempt to breathe new life into these decaying bodies, to halt the erasure of the nation's nuclear past, but they do so mostly by conjuring the prelapsarian days before the full extent of the dangers of nuclear weapons were known. These are nostalgic spaces that look back to a time when an undisputed enemy gave meaning to the Manhattan Project and where, later, during the cold war, the fate of democracy seemed to rest on the production of these weapons; times before the immense waste of capital, people and land were more fully known.[4] Although tourism to former uranium factories may seem an odd choice for Americans with limited vacation days, atomic tourism is becoming a burgeoning industry. In the last 20 years, many new sites of nuclear tourism have emerged and other long-standing spaces of nuclear heritage have been re-imagined and renovated: the B-Reactor Museum in Richland, Washington, the Atomic Testing Museum in Las Vegas, Nevada, and the National Museum of Nuclear Science and History in Albuquerque, New Mexico, are examples of this trend. Most sociological work on the subject has focused

on museum displays and the museal controversies that followed (Dubin 1999; Nobile 1995; Thelan 1995; Zolberg 1998).[5]

Although museums are a key site of 'mnemonic socialization' places where we learn what to remember and how to remember, and certainly deserve close scrutiny from the social sciences, other sites of collective memory and spaces of memory practices should not be overlooked (Zerubavel 2003). Here, I have attempted to partially alleviate this gap by focusing on atomic tourism as a form of spatial practice and potentially social praxis. As a *critical tourist*[6] using ethnographic methods, I have examined the performance and consumption of atomic memories through the annual Secret City Festival in Oak Ridge. By taking into account several key points of the festival, including the main grounds, a bus tour and a train excursion, I have sought possible nodes of connection or friction between the atomic past and the nuclear present that could lead to a re-imaging of the relationship between America and her bombs, now and in the future.

Atomic Tourism as Nostalgic Tourism: Longing for the Bomb

> Don't underestimate our capacity for complex longings. Nostalgia for the banned materials of civilization, for the brute force of old industries and old conflicts (DeLillo 1997: 286).

Even as a micro-genre of the tourism industry, atomic tourism draws tourists from a wider population than one might expect, including not only those interested in nuclear physics and science (more generally) but also history buffs, anti-nuke activists, dark tourists, patriotic tourists, post-tourists[7] and nostalgic tourists. Visiting the immense factories and testing grounds of the atomic age is a type of risk—dark or thanatourism—where part of the appeal is being close to the actual or perceived danger of the space (Lennon and Foley 2000; Seaton 1996; Tarlow 2005). While atomic tourism fits into the dark tourism genre, it is also more specifically a form of what I call 'nostalgic tourism', especially when it involves visiting sites located in communities that owe their existence to the beginning of the atomic age, places such as Oak Ridge or Los Alamos.

Nostalgia for what is a more difficult question. Nostalgia, like memory, is a diffusion of feeling, difficult to pinpoint, messy and vague. Although compared to memory, which is viewed as noble even when confused, nostalgia is often taken as sickeningly sentimental, emotionally indulgent and even tacky; it is

the velvet Elvis painting to memory's Caravaggio. The architectural historian M. Christine Boyer refers to nostalgia as 'a sweet sadness generated by a feeling that something is lacking in the present, a longing to experience traces of an authentic, supposedly more fulfilling past, a desire to repossess and re-experience something untouched by the ravages of time' (2001: 201). Although it is often mistaken as such, nostalgia is not only a feeling that inflicts individuals, rather it is also, and perhaps primarily so, a social disease (Boym 2001). Nostalgia not only interferes with individual psyches but can also have a destabilizing effect and threaten the well being of societies. Sociologist Dean MacCannell warns of the dangers of a society caught longing for the past, which leaves it 'vulnerable to overthrow from within through nostalgia, sentimentality and other tendencies to regress to a previous state . . . which retrospectively always appears to have been more orderly or normal' (1999: 82). Longing for mid-century Americana and the dawn of the atomic age is a particular strain of nostalgic illness; one of the side effects is the desire to visit sites where this past can be experienced. When feelings of uncertainty and malaise in the present grow, desires to return to a time deemed more stable and meaningful escalate.

A prominent position in the sociology of tourism argues that touristic practices are the modern form of pilgrimage and a quest for authenticity in a world that is seen as increasingly commodified and artificial (MacCannell 1999). As more of the world becomes knowable through ever faster and vaster communication and transportation technologies, this search for authenticity increasingly turns inwards—towards one's own society rather than outside it. In other words, the search for authenticity becomes primarily a temporal expedition rather than a spatial one. As tourism has become more historically bent, it has become more nostalgic.

Nostalgic tourist spots conjure a desire to be there *in situ*, to act out and to consume the past. This desire to re-experience is what makes nostalgia, performance and tourism such good bedfellows: a logical *ménage à trois*. Often, connected to a sense of home or home-ness, nostalgic spots are places where we imagine that we fit, a community of which we are a part that circumstances have separated us from, but to which we long to return (or to turn for the first time, if we have never been there before). Nostalgia is painful because it carries with it a sense that there is something *out there* or *back there* that is authentic, something that we belong to or something that belongs to us, a *something* that is just out of reach. If this is nostalgia, do people actually long for the atomic bomb, for the imagined hearth of the calutron[8] at the uranium production

plant? Absolutely. As DeLillo says, 'Don't underestimate our nostalgia for complex longings' (1997: 286).

Nostalgic tourism is a type of death tourism; it is a visit to the death of a dream slipped away, an imagined future or present just out of reach. Through nostalgic tourism we can visit collapsed dreams in a representation of their former glory. In general, nostalgic tourists want to visit another time; they want to see progress, not quite at a halt, but at a moment of 'past progressing', which is not quite a frozen moment but more of a running in place—a treadmill moment that elicits a feeling of being there. No one is completely fooled by the treadmill effect, but it does get our bodies and minds to a place of imagining and/or remembering. In other words, it can take us to a place where nostalgia can be felt and where ideas about the past can be fixed into our own memories, even if we did not experience these pasts directly (Landsberg 2004). In the case of atomic tourism to the former Manhattan Project sites of the 1940s, this means attaching memories of being suspended in those heady times of working on the bomb against two formidable enemies: time and the Axis powers.

As sectors of the United States turn from industrial organizational modes to post-industrial social structures and practices, tourism emerges as a leading industry that reshapes the landscape. The very factories that used to produce material goods become tourist sites where narratives about the industrial past are transmitted and consumed; the same is true for atomic factories as it is for other industrial products. These spaces become fascinating because they no longer exist; while their form is still material, their content is ghostly and the work that was performed there has become phantasmagorical. As their usefulness as producing apparatuses fade, they become nostalgia factories, sites of reverse futurism. Exposure to atomic sites could lead to critical reflection and to the demystifying and questioning of the past. When visits to these spaces are only celebratory, these sites become dangerous tools of nostalgic propaganda and spaces for the engineering of forgetting.

Today, Oak Ridge finds itself in a purgatorial present, where both its golden era as a key site for the Manhattan Project and its once imagined future as a driving force towards atomic utopia can only be experienced through mnemonic practices in the present. According to St Augustine, we can only live in the present, but this present has three registers: 'a present of things past, memory; a present of things present, sight; a present of things future, expectation' (1860: 319). Life is always lived simultaneously in these tri-temporal registers but there are times and places where their overlap and entanglement become more intense

(Foucault 1986). Historical festivals are particularly good at conjuring a feeling of spatial–temporal multivalence because they focus on action and participation in the present while simultaneously functioning as conduits to the past.

Secret City Festival: The Main Grounds

The festival promotes the history of the city and unites its World War II heritage with the technological advancements that are ongoing within the City of Oak Ridge (The Secret City Festival official website).[9]

Through the two-day Secret City Festival celebration, Oak Ridge commemorates its atomic heritage and at the same time attempts to reaffirm its status as a 'science town'. Tours are mostly filled with nostalgic praise for the efforts of Oak Ridgers during the Manhattan Project, but there is always a mention of the current techno-scientific security work being done in the laboratories and plants. The imbalance of information—where the past far outweighs the present—could be attributed to several factors, including: (1) a deliberate focus on heritage tourism; (2) the difficulty in explaining complex nuclear physics to a general audience; (3) the fact that much of the work being done in Oak Ridge is still secret and connected to 'national security', especially at the Y-12 National Security Complex; and (4) the fact that the powerful drama of a victorious wartime story about the first atomic bomb is arguably more compelling and entertaining than current stories that can be told about, for instance, breakthroughs in medical isotope technology.

Composed of a network of loosely connected sites, the Secret City Festival is spread out through the town. The main festival grounds are located adjacent to the library, just off of Oak Ridge Boys Way, named after the country-western group. In direct view across the turnpike is the recently renovated high school with an enormous atomic symbol affixed to its brick facade. The festival then spills out onto Bissell Park, located just beyond the library; here, there are craft stands, food vendors and a DJ who spins records for a handful of dancing teenagers while younger children jump around like excited electrons in oversized blow-up playground equipment. All of these activities take place as the sounds of faux warfare rage in the background; the Second World War re-enactment nearly drowning out the stereo spewing the latest radio hits.

The festival, held every June, is an odd affair, where mid-century bobby-sock nostalgia does 'the twist'[10] with nuclear physics and military machismo. Strangely, one of the most popular performances of the two-day event is the

Second World War battle re-enactment. There are two performances staged by the 'Five Oh First Group' re-enactors: 'World War II Combat Re-enactment' and 'WWII Living History'. It is nearly a hundred degrees outside as soldiers in period dress invade 'Normandy'. Artillery is on display from tanks to guns to grenades. Smoke blankets the battlefield as ersatz soldiers scamper across the grounds, taking and giving orders, grunting, clutching their chests and dying with dramatic flair. The medics are there too, scooping up the injured and attending to wounded brethren. This resurrected battle carried out on home soil is peculiar for a place that was actually a haven from fighting during Second World War, where neither bayonets nor grenades but microscopes and Geiger counters were daily wielded. Perhaps this spectacular display is chosen because it is hard to imagine what a re-enactment of scientists working in their laboratories with miniscule particles would look like, although this is precisely the legacy Oak Ridgers are fighting for—the recognition that the laboratory did as much to win the war as the battlefield. The live performance illustrates how the Secret City Festival shrinks time and space: the war in Europe is brought home and festivalgoers are transported to the 1940s. The re-enactment also demonstrates how history can become a spectacle, a dramatic performance of the past rather than a strict retelling.

The Secret City Festival is also a commercial affair, including many options for souvenirs from the practical to the kitsch. The available objects include all kinds of T-shirts, key chains and frisbees, emblazoned with each year's theme, such as 'From the 40s to the Future!'. Some items were printed with glow-in-the-dark ink, which must be a wink to radioactive properties. Yet, the souvenir table with the most attention was also the most nostalgic space where the black-and-white prints from the official Manhattan Project photographer, Ed Westcott, were on offer. During Oak Ridge's tenure as a secret city, civilians were not permitted to photograph the town, so Westcott's photographs are the dominant and often solitary record of that time. Westcott was an employee of the federal government, and his post is reflected in the images, which have an unmistakable propagandistic quality—Oppenheimer poses as an atomic dandy, smoking; industrious women tend victory gardens; girl scouts march in front of the X-10 graphite reactor; and even the garbage collectors smile as they haul heavy barrels (see Westcott 2005). The commercial and nostalgic nature of the festival with its emphasis on participation and consumption reflects a change in the way societies remember in the second half of the twentieth century. As the French historian Jacques le Goff points out:

This pursuit, rescue, and celebration of collective memory [. . .] less in texts than in spoken word, images, gestures, rituals, and festivals, constitutes a major change in historical vision. It amounts to a conversion that is shared by the public at large, which is obsessed by the fear of losing its memory in a kind of collective amnesia—a fear that is awkwardly expressed in the taste for the fashions of earlier times, and shamelessly exploited by nostalgia-merchants; memory has thus become a best-seller in a consumer society (1996: 95).

In historic and nostalgic tourism today, the visitor more often than not becomes part of the performance of the space, actively consuming and purchasing memories, along with gift shop souvenirs.

Department of Energy Facilities Public Bus Tour

The science was a miracle. The city of Oak Ridge itself was a miracle (Department of Energy tour guide, during a bus tour on 17 June 2010).

As part of the annual Secret City Festival, the city of Oak Ridge (along with the Department of Energy) conducts bus tours to sites of atomic heritage and current scientific research centres in order to connect the two, as the festival's slogan suggests: 'From the 40s to the Future!'. Bus tours have long been a staple of the modern tourism industry, particularly where security is at risk. Poverty tours, disaster tours and gangland tours, just to name a few examples, all favour the bus with a cinematic window on the dangerous and untouchable sites outside the glass. The tourists are protected inside the vehicle's hulking shell and delivered to sites where they may exit and re-enter. Here, the bus becomes a liminal zone between everyday life and touristic experiences—a placeless place, a timeless time.

Accompanying the revolutions of axes and wheels underneath the hull of the bus a steady chatter emanates from the tour guide, who is almost always attached to the community, but no longer actively so. For example, in the Gangland Tours of Los Angeles the tour guide is a former gang member; the Hurricane Katrina Tours operated by Circle Line is led by a resident of New Orleans; in Oak Ridge the guide is usually a former Manhattan Project worker or Cold Warrior. Because of their connection to the site, the tour guides are most often seen as experts imbued with local and inside knowledge.

On 17 June 2010, I board a bus to take a tour of the Department of Energy Facilities operated by University of Tennessee-Battelle. I show my passport to

prove that I am a US citizen and not a foreign national, which would make me ineligible for the tour. I then climb the short steps into the body of the bus. The vehicle is modern but the atmosphere is retro; the cabin is filled with music from the 1940s. I am the youngest person by at least three decades, so I settle in the penultimate row, letting those with canes and walkers take the seats in front. As the last of the passengers settle in, the tour guide takes the microphone and informs us that we will visit three of the eight 'signature facilities of the Manhattan Project': the tour will make stops at Y-12's New Hope Center, the ORNL and the historic X-10 Graphite Reactor. We will not be visiting the Y-12 National Security Center because it is still too secret, but we will make a stop at their new history centre. There is some grumbling at this news. I cannot help but wonder whether this forbidden site also connects with the history of the place, making the tour more exciting—there are still secret things that cannot be seen!

As our tyres edge out of the parking lot one of the first things we are told is that in 1942 it was 'proved that science can be moved from the laboratory to the battlefield' and this is 'the one thing to take away from the tour'. Next, the guide suggests that a pseudonym for the Manhattan Project could be 'miracle'. I write MIRACLE in large letters in my field notebook and circle the word with violence. I wonder at first if this is a peculiarity of the tour guide, this thing about miracles, but as I take part in the two-day festival, I hear magic, science, luck and miracles all being held responsible for the 'success' of the Manhattan Project. The rhetoric of science and religion tangle and turn over on themselves as Oak Ridgers attempt to tell the story of their past, a story told as if the outcome was inevitable and/or divinely ordained.

Our first stop is the new Y-12 History Center, which was created according to our tour guide to 'improve the lab's ability to communicate with the community'. Here, we watch a propagandistic video and are able to walk around for a few minutes and look at some artefacts—including my favourite, an 'atoms for peace o'mary' metal given to Catholic airmen during the cold war. Soon, we are given plastic bags to 'fill up on goodies', which includes promotional DVDs (seven in total!), Y-12 logo pencils and not much else. The DVDs cover the history of Oak Ridge and of Y-12—*Our Hidden Past: Y-12's First Mission, This Is Y-12: America's Uranium Center of Excellence* among others.

Our next stop is the ORNL, formerly the X-10 Graphite Reactor, where now the major focus is no longer enriching uranium but something called the Spallation Neutron Source. We are told that this is the largest industrial project in the world and that it contributes to research in the field of medical isotopes.

This is the part of the tour that focuses on promoting current research and painting a picture of Oak Ridge as the future of nuclear science (now an even tinier science that concentrates not only on atoms but their particles, specifically neutrons) in addition to its past. ORNL, we learn, is also home to the Head-quarters for Homeland Security Technology Section, the building that houses its brain centre lies just off of Reactor Road. Not much can be said about what goes on there because like many things in Oak Ridge this is still top secret.

Back on Reactor Road, we travel to the historic X-10 Graphite Reactor, which has been preserved. We stare at the reactor's gigantic loading face, full of cylindrical holes with mannequins dressed in protective suits in halted action. We are encouraged to place ourselves back in time when the reactor was in operation, 1943–63. The place is all metal knobs, levers and lights. Upstairs in the observation deck, large cut-outs of workers illustrate what the protective clothing would have looked like. Like the mannequins they are paused, but somehow look more life-like, even though they are only two-dimensional, because they are actual photographs of real workers blown up to life-size. Another group arrives, a tour made up entirely of armed forces members, and we are shooed out, as they are hustled in. I can hear a snippet of their tour guide's spiel, and after two minutes I can tell that it has an even more patriotic tone than our own (figure 9).

Back on the bus the colourful tour guide reminds the passengers that there were 'many miracles in the Manhattan Project'. The guide launches into an explanation: he says one day he realized that science and miracles were not contradictory and that in fact 'Jesus de-molecularized himself, just like "beam me up Scotty"'.[11] He continues talking about science fiction from the twentieth century, trying to add some mystique to Oak Ridge, he says, 'You get into the Twilight Zone[12] with Oak Ridge—seven gates, seven bridges.' Next we are told that in addition to the Manhattan Project, the site has another claim to fame, the former uranium factory is in the Guinness Book of World Records for the most raccoons in a dumpster at one time—21. While I know this is meant to be humorous, an attempt at levity, it makes me think of the radioactive bunnies found in Hanford, Washington (Scheck 2010) and the damage done to the environment at these sites. After some more comedic attempts and efforts to connect with the group through pop culture, the tour guide turns nostalgic and posits that 'the success of the project in World War II was not something this nation could do today—the country has become too individualistic.' This

FIGURE 9. Loading face of the X-10 graphite reactor. Copyright Ed Westcott.

narrative of a selfish nation in decline is the most oft-repeated during the festival (noted 13 times in my field notes).

Secret City Scenic Excursion Train

The train that takes you back to one of the greatest wartime achievements in history (Southern Appalachia Railway Museum).[13]

On 19 June 2010, progress is derailed in the Atomic City. The Secret City Scenic Excursion train, carrying a slew of atomic tourists, hops the tracks and ends up with the caboose nearly topsy-turvy (Smith 2010). No one is physically injured in the accident, although we can imagine that local pride is bruised. As the unruly locomotive lies on its side, the 75 to 80 passengers are herded onto a bus that will take them back to town. This interruption of progress draws attention to other stalled technological fantasies of the twentieth century. Perhaps more than any other part of the festival, the train tour contains multiple levels of industrial history.

The Secret City Scenic Excursion Train began to run in 1998 with support from the Department of Energy, Community Reuse Organization of East

Tennessee, Heritage Railroad and a 'small group of rail enthusiasts' who started the Southern Appalachia Railway Museum.[14] The train tours are run by self-proclaimed 'train geeks' who have some knowledge of the atomic history of Oak Ridge, although the narrative focus of the tour is centred on glorious technological pasts largely writ—triumphs of the railroad engineers and of the atom splitters. Despite the celebratory rhetoric, from both inside and outside the window of the Secret City Excursion Train, ghosts of expired technological utopias loom large.

Inside, the train functions as a rolling museum of railroads and industrialization. Promotional materials for the tour wax nostalgic with promises to 'turn the clock back to yesteryear' with a 'return to the heyday of passenger railroading'.[15] For my tour, I ride in car no. 2164, built by the Pullman Company in 1926 for the Southern Railway system.[16] This particular train worked both the *Carolina Special* route as well as the *Tennessean*, which ran back and forth between Knoxville and Washington DC. Today, the train rolls again, but now only at 14-mile stretches at a time—7 miles out to Blair, Tennessee and 7 miles back to the K-25 Heritage Center, the former Department of Energy facility for producing uranium.

In the 1880s, George Pullman, an industrialist from Illinois and the manufacturer of my tourist train car attempted to create a model factory town outside Chicago. In 1894, increasing tensions between the workers and the managers led to a wildcat strike, which brought down his utopian vision. The fighting was sparked by the heavy-handed paternalism and excessive restrictions that Pullman had placed on his workers, as well as a steep reduction in wages.[17] If you know the story of Pullman, the workers' revolt comes to mind. If not, the train car exists alone, as a beautiful object, from which a more complicated past has been whittled, leaving only 'the heyday of passenger railroading'. On my tour, my tour guide made no mention of the connection between industrial strife and Pullman train cars.

Outside the train's rectangular windows, another post-utopian landscape is visible; its most obvious feature is the massive ruin of the K-25 plant with its mammoth walls and girders partially exposed. The task of the K-25 plant, which came into being at the close of the Manhattan Project and continued through the cold war, was to produce fissionable uranium for the nation's nuclear arsenal. Shuttered in 1985, the factory has been reduced to a relic of the atomic age, a superfund site,[18] and a ruin to gaze upon outside the window of a tourist train car. Yet, at one time, the U-shaped K-25 plant was a modern

architectural marvel, the largest roofed structure in the world, one mile long and four stories high. The plant was so spread out that, to get from one end to the other efficiently, scientists used bicycles. Not only its size but also its scientific methods were considered record-breaking. Gaseous diffusion, the process at work at K-25, was discovered to be the most efficient method for enriching uranium and is, to this day, still considered top secret (figure 10).

Now, a highly toxic ruin, the K-25 illustrates the failure of the atomic age to create efficient clean energy and global peace. Its hulking shell is also a reminder of the failure to plan for the wastes that these factories would produce. Executives from the Bechtel Jacobs Company, the Department of Energy's major clean-up contractor in Oak Ridge, described the dire situation, where the plant 'has been idle for 23 years with little or no maintenance, and has caved-in roofs, unsafe floors and cracked columns' (Huotari 2008). The extremely contaminated materials will remain for millennia with no chance for recycling or renovation. At one time, plans were circulated to save portions of the plant for a new museum or other commercial endeavours, but the Department of Energy has since declared that the buildings of K-25 'are not fit for reuse and pose potential long-term environmental and safety problems' (ibid.).

Although the age of the railroads and the age of the atom seem disconnected, proximity to rail lines is actually a key issue in choosing sites for the secret cities

FIGURE 10. K-25. Copyright Ed Westcott.

of the Manhattan Project. Ironically, even in the age of airplanes, the railways are deemed more important for transporting materials for the production of atomic bombs. The rails, criss-crossing the country, are thought to be less conspicuous and less dangerous than planes. Materials from Oak Ridge, Hanford and other atomic sites travel to Los Alamos mostly by rail, often with atomic couriers dressed as salesmen with uranium encased in small golden canisters strapped to their wrists or tucked inside briefcases (Lang 1948: 18–19).

While my train tour is the standard one, there are also thematic ones: an excursion focuses on fall foliage, a 'Santa Train', a Valentine's day jaunt and, most fantastical, a 'Mystery Dinner Train', at the intersection of atomic and railway history. As advertised:

> Secret City mysteries [are] exposed!!! The Southern Appalachia Railway Museum and the Oak Ridge High School Masquers drama club present an evening of mystery and intrigue set against the background of one of World War II's most secret facilities. Breathtaking drama ensues. Can *you* [underlined in original] identify the culprit and save the free world? [. . .] Menu selections include beef tenderloin with mushrooms and garlic butter, chicken breast with wine sauce, and a vegetable medley. Each dinner includes a tossed salad, specially prepared vegetables, fresh bread, dessert, and tea or coffee.[19]

This performance fits into the living history genre of historical tourism, where the intention is to transport the visitor to the time in question through interaction with the past in the present. In this case, the tourist is transported back to the cold war and patriotically called in the service of the nation—to spot the atomic spy, all the while nibbling on a hot meal.

Today, trains still transport much of the 'hot' waste from nuclear production facilities and decommissioned reactors to storage locations. In fact, trains carrying toxic materials from the rusting K-25 building run parallel to the refurbished throwback trains from the early twentieth century carrying atomic tourists. Le Goff describes memory as 'an intersection' (1996: 51). Forgetting, then, travels on parallel tracks that never meet. If radioactive waste is kept out of sight and narratives about its dangers are silenced, if we are kept on the other tracks hearing only the triumphant stories, it is possible that the more complicated history of the atomic age will be forgotten. At present the toxicity of the K-25 cannot be ignored, its crumbling facade is still in plain view. But what will happen years down the line when the processes of decommission and decontamination are declared finished? Will the difficult history of the atomic legacy

be swept away and buried? Will the dangers of nuclear energy and nuclear weapons be silenced, left unmentioned during future atomic train tours, like the history of the worker's strife in Pullman? Will promotional brochures nostalgically paint a triumphant portrait of the U-shaped K-25 building and forget about the workers and the waste? Or will we build tourist sites that feature our nuclear waste, as DeLillo (1997) mused, or as Ukraine has done in Chernobyl? Will these patterns repeat themselves in the wake of the Fukushima Daiichi Nuclear Power Plant disaster? With radioactive waste this becomes even more important because it is all too easy to forget what cannot be seen.

The Future of Atomic Tourism

> The 'Atomic Age'—once synonymous with modernity—already possesses a vaguely antiquated feel to it (Veitch 2010: 321).

The atomic history of the United States *is* the history of the American twentieth century where the building of the bomb and the victory of Second World War elicit emotional responses—nostalgic longing for some, feelings of horror for others, or perhaps some combination of the two. The mid-twentieth century is widely portrayed through museums, media and popular culture outlets as a time when America was on top, or at least felt like she was. This kind of technological nostalgia lines the casket of atomic history and with it is buried the stillborn dreams of a nuclear paradise. The story of the bomb is supposed to end with 'atoms for peace', the nuclear equivalent of happily ever after, yet we never quite get there. Alongside current fears of Iranian and North Korean nuclear pursuits lies the stalled dreams of nuclear ease: fantasies of atomic cars are now on blocks in the yard of our collective imaginations and visions of entire cities populated with nuclear heated homes have grown cold, frozen into collective memories of what was once thought possible.

Yet, in towns such as Oak Ridge, these dreams are being re-experienced and performed through atomic tourism. The Secret City Festival is a self-conscious effort to jog local, regional and national collective memories of the victory of Second World War and the end of the cold war by calling attention to the role of the town in those undertakings. While the festival is a cacophonous space with a variety of commercial activities and social groupings, each with their own agenda, one voice does break through all the chatter. This voice calls for commemoration of the town's role in the Manhattan Project as well as its ongoing role as an important science city and a key to national security. The

annual festival partnered with the Smithsonian-affiliated American Museum of Science and Energy, several monuments, a heritage walk, an international friendship bell and an inn in the process of restoration (where many famous dignitaries and scientists stayed, including Oppenheimer) work together to keep the atomic legacy of the town alive.

French historian Pierre Nora asserts, ' "lieux de mémoire" originate with the sense that there is no spontaneous memory, that we must deliberately create archives, maintain anniversaries, organize celebrations, pronounce eulogies, and notarize bills because such activities no longer occur naturally' (1989: 7). In Oak Ridge, the issue is less about the absence of spontaneous memory in the present than about the very near future, when those who actually built the town, as well as the materials for the atomic bomb, will no longer be around. Those who formed the tightly bound community of the 1940s are now mostly octogenarians concerned with the historical legacy that they will leave behind.

If the Secret City Festival is any indication of the story that the original Oak Ridgers intend to impart to future generations—and I believe it is—then the legacy penned will most likely be a morality tale of good versus evil, where the United States is always cast as the good guy, starring Oak Ridgers as atomic cowboys riding tall in the saddle and wearing white hats and lab coats. The nostalgic trend in atomic tourism is a dangerous one. If memory is in fact, as Le Goff suggests, an 'intersection' (1996: 51), my hope is that future sites of atomic tourism will manifest transitional spaces, not only celebratory ones, where critical thought about the nuclear past can emerge and where new thinking and new decisions about the nuclear future can arise.

Notes

1 Field research for this article was conducted during the 2009 and 2010 Secret City Festivals and January 2011.

2 As further evidence of this move towards nuclear tourism, Ukraine's Emergency Situations Ministry began accepting tourists to Chernobyl's 'zone of alienation', the area surrounding the failed reactor, starting in 2011 and the US National Parks Service is currently preparing to add the Manhattan Project to its roster of National Historical Parks (see, for example, Marson 2010).

3 As of 2012, Oak Ridge's supercomputer is considered the world's fastest (see Munger 2012).

4 The full picture will never be known, of course. Bringing new information to light is an ongoing process—some documents are still classified and many more have been destroyed.

5 Although museums are certainly not the only way to understand collective memory of the atomic bomb, museal displays are a good indicator of the mnemonic temperature, especially in national museums, as the Smithsonian Enola Gay controversy has shown.

6 'Critical tourism' is a social practice defined by Lucy Lippard (1999: 4). Here, my position as a researcher is also informed by Dean MacCannell's figure of the 'tourist-ethnographer' (1999: 177).

7 The post-tourist takes an ironic stance towards tourist sites; she notices their social constructedness and understands that this artifice is an integral part of the enjoyment of such spaces. The post-tourist travels with a wink (see Feifer 1985; Urry 1992).

8 The calutron, designed by Ernest Lawrence, is a mass spectrometer that was used for separating isotopes of uranium during the Manhattan Project.

9 Available at: http://secretcityfestival.com/ (last accessed on 17 June 2010).

10 In fact, in 2010 Chubby Checker received top billing on the musical stage to celebrate 50 years of 'The Twist'.

11 This catchphrase comes from the popular American science-fiction television series *Star Trek*. The phrase was a command uttered by Captain Kirk to his chief engineer Montgomery 'Scotty' Scott when he needed to be transported back to the mother ship, the *Starship Enterprise*.

12 A popular genre-crossing American television show, which combined science fiction, suspense, horror and psychological drama. The original series ran from 1959 to 1964.

13 This quote is from the Southern Appalachia Railway Museum's promotional materials, which can be found at atomic memory sites and tourist information centres located in Oak Ridge.

14 'The Secret City Scenic Story', Promotional material from the Southern Appalachia Railway Museum, 17 June 2010.

15 'Secret City Excursion Train'. Available at: http://www.techscribes.com/sarm/srm_scs.htm (last accessed on 29 December 2010).

16 The vintage passenger cars have been pulled by Alco diesel locomotives since the 1950s.

17 For an excellent history of Pullman, see Stanley Buder (1967).

18 Superfund sites are highly contaminated locations that have been given special priority for a clean-up by the federal government of the United States under

the Comprehensive Environmental Response, Compensation, and Liability Act of 1980.

19 'Murder Mystery Dinner Train'. Available at: http://www.techscribes.com/sarm/murder_mystery_2009.htm (last accessed 17 June 2010).

Works Cited

BOYER, M. Christine. 2001. 'Cities for Sale: Merchandising History at South Street Seaport' in Michael Sorkin (ed.), *Variations on a Theme Park: The New American City and the End of Public Space*. New York: Hill & Wang, pp. 181–204.

BOYM, Svetlana. 2001. *The Future of Nostalgia*. New York: Basic Books.

BUDER, Stanley. 1967. *Pullman: An Experiment in Industrial Order and Community Planning, 1880–1930*. New York: Oxford University Press.

DELILLO, Don. 1997. *Underworld*. New York: Simon & Schuster.

DUBIN, Steven C. 1999. 'Battle Royal: The Final Mission of the Enola Gay' in *Displays of Power: Memory and Amnesia in the American Museum*. New York: New York University Press, pp. 186–226.

FEIFER, Maxine. 1985. *Going Places: The Ways of the Tourist from Imperial Rome to the Present Day*. London: Macmillan.

FOUCAULT, Michel. 1986. 'Of Other Spaces'. *Diacritics* 16(1): 22–7.

FREEMAN, Lindsey A. 2010. 'Happy Memories under the Mushroom Cloud: Utopia and Memory in Oak Ridge, Tennessee' in Yifat Gutman, Adam D. Brown and Amy Sodaro (eds), *Memory and the Future: Transnational Politics, Ethics, and Society*. London: Palgrave Macmillan, pp. 158–78.

———. Forthcoming. 'A Plutonium Tourism Ode: The Rocky Flats Cold War Museum" in Mary Mostafanezhad and Kevin Hannam (eds), *Moral Encounters of Tourism*. Honolulu, HI: Ashgate.

GUSTERSON, Hugh. 2004. 'Nuclear Tourism'. *Journal for Cultural Research* 8(1): 23–31.

HUOTARI, John. 2008. 'K-25 Demolition Begins'. *The Oak Ridger*, 16 December. Available at: http://www.oakridger.com/localnews/x1009172630/K-25-demolition-begins (last accessed on 15 May 2011).

LANDSBERG, Alison. 2004. *Prosthetic Memory: The Transformation of American Remembrance in the Age of Mass Culture*. New York: Columbia University Press.

LANG, Daniel. 1948. *Early Tales of the Atomic Age*. New York: Doubleday.

LE GOFF, Jacques. 1996. *History and Memory*. New York: Columbia University Press.

LENNON, John, and Malcolm Foley. 2000. *Dark Tourism: The Attraction of Death and Disaster*. London and New York: Continuum.

LIPPARD, Lucy. 1999. *On the Beaten Track: Tourism, Art, and Place*. New York: New Press.

MACCANNELL, Dean. 1999. *The Tourist: A New Theory of the Leisure Class*. Berkeley: University of California Press.

MARSON, James. 2010. 'Kiev Sees Chernobyl as Tourist Hot Spot'. *The Wall Street Journal*, 13 December. Available at: http://online.wsj.com/article/ SB100014240-527487037278045760172034209528.html (last accessed on 15 May 2011).

MUNGER, Frank. 2012. 'ORNL Reveals Worlds Fastest Computer'. *Knoxville News Sentinel*, 12 November. Available at: http://www.knoxnews.com /news/2012/nov-/12/ornl-unveils-worlds-fastest-computer-151-titan/ (last accessed on 6 October 2013).

NOBILE, Philip (ed.). 1995. *Judgement at the Smithsonian: The Bombing of Hiroshima and Nagasaki*. New York: Marlowe & Company.

NORA, Pierre. 1989. 'Between Memory and History: Les Lieux de Memoiré'. *Representations* 26: 7–24.

ST AUGUSTINE. 1860. *Confessions*. Boston, MA: Gould & Lincoln.

SEATON, A. V. 1996. 'Guided by the Dark: From Thanatopsis to Thanatourism'. *International Journal of Heritage Studies* 2(4): 234–44.

SCHECK, Justin. 2010. 'Bunnies Are in Deep Doo-Doo When They "Go Nuclear" at Hanford'. *The Wall Street Journal*, 23 December. Available at: http://online.wsj.com/-article/SB10001424052748704694004576019280235026892.html (last accessed on 29 December 2010).

SMITH, Donna. 2010. 'Secret City Train Derails'. *The Oak Ridger*, 19 June. Available at: http://www.oakridger.com/breaking/x1501907775/Secret-City-Fest-train-derails (last accessed on 29 December 2010).

TARLOW, Peter T. 2005. 'Dark Tourism: The Appealing "Dark" Side of Tourism and More' in Marina Noveilli (ed.), *Niche Tourism: Contemporary Issues, Trends and Cases*. Amsterdam & Boston: Elsevier, pp. 47–58.

THELAN, David. 1995. 'History after the *Enola Gay* Controversy: An Introduction'. *Journal of American History* 82: 1029–35.

URRY, John. 2002. *The Tourist Gaze*, 2nd EDN. London: Sage.

VEITCH, Jonathan. 2010. 'Dr. Strangelove's Cabinet of Wonder: Sifting through the Atomic Ruins at the Nevada Test Site' in Julia Hell and Andreas Schönle (eds), *Ruins of Modernity*. Durham, NC: Duke University Press, pp. 321–38.

WESTCOTT, Ed. 2005. *Through the Lens of Ed Westcott: A Photographic History of World War II's Secret City* (Sam Yates ed.). Knoxville: University of Tennessee.

LINDSEY A. FREEMAN

WRAY, Matt. 2006. 'A Blast from the Past: Preserving and Interpreting the Atomic Age'. *American Quarterly* 58(2): 467–83.

ZERUBAVEL, Eviatar. 2003. *Time Maps: Collective Memory and the Social Shape of the Past*. Chicago: University of Chicago Press.

ZOLBERG, Vera L. 1998. 'Contested Remembrance: The Hiroshima Exhibit Controversy'. *Theory and Society* 27: 565–90.

Theme Parks and Station Plaques: Memory, Tourism and Forgetting in Post-Aum Japan[1]

MARK PENDLETON

A middle-aged woman stands before a small plaque in a corner of a nondescript Tokyo subway station. She is hemmed in on all sides by black-suited journalists carrying closely held notebooks or shoulder-mounted television cameras. Subway staff in pressed uniforms and white gloves line a passageway to the stationmaster's office, where long tables shrouded in white have been prepared to hold flowers and to focus prayers. Occasional passers-by wander in, pausing for a few moments and moving on, their thoughts unknown and unreported. For the most part, however, commuters ignore the scene, seemingly too busy to watch, to listen, to remember.

The woman is Takahashi Shizue, the spokesperson for the Chikatetsu Sarin Jiken Higaisha no Kai (Subway Sarin Victims' Association), and today she is marking the fourteenth anniversary of her husband's death.[2] Takahashi Kazumasa, a worker at this downtown station, was killed on 20 March 1995 by toxic sarin gas released by members of the religious sect Aum Shinrikyō (hereafter Aum).[3] Each year, victims of the gassing gather to remember the 13 people who died and the over 6,000 affected at the hands of Aum. Accompanied by supporters and a large media contingent, they visit the sites of the gassings to leave flowers and prayers for the dead and remind others of their experiences.

This otherwise nondescript downtown station has become one of the central sites in processes of commemoration for victims and survivors and, to a lesser extent, the general public. Commemorative activities also take place at other such sites including the locations of sect headquarters, meeting places and companies; burial sites of sect members and others who were killed in earlier incidents; and the regional city of Matsumoto where Aum members had previously released sarin in 1994, killing eight and injuring several hundreds. For victims and others affected by these incidents, these disparate locations

75

are culturally inseparable from their traumatic pasts and play an important function for pilgrimage, commemoration and recovery. Members of the public also interact with these sites through practices of tourism. At some of these sites, alternative attractions exist for tourists that may be disrupted by the acknowledgement of their dark histories. Others may be attractive precisely for their macabre nature.

Sites with traumatic histories, such as these, are popular tourist destinations in contemporary Japan, as in many other parts of the world. The two cities devastated by atomic bombs (Hiroshima and Nagasaki) have been particularly attractive to tourists over the last 65 years (Siegenthaler 2002; Broderick 2010). Increasingly, sites of dark or trauma tourism such as these seem global in their appeal, with locations of mass murder, genocide, war and torture on the itineraries of travellers the world over (Clark 2009; Lennon and Foley 2000). These sites carry for tourists a sense of unease at 'immersion in a place of mass death, where horrors happened within living memory' (Love 2006: 214). In fact, this unease is likely part of their appeal.

In this essay, I explore the connection between tourism, history, memory and place, with a focus on two sites that relate to the period of violence round the 1995 subway gassing. I am interested in exploring how competing demands to commemorate loss and to attract visitors structure tourists' interactions with sites and frame approaches to tourism in places with dark pasts. I focus first on Kamikuishiki, a small town west of Tokyo in which various Aum facilities were located and which also had a long history of cultural connections to darkness and death as a popular suicide destination. After the Aum-related incidents of the mid-1990s, the town tried to combat these associations through the development of tourist infrastructure, most famously a *Gulliver's Travels* theme park. I then turn to the Kasumigaseki area of central Tokyo, the target of the 1995 subway attack, downtown heart of much of Japan's state infrastructure and the focus of the commemorative activities mentioned above. Kasumigaseki station has been proposed as the location for a permanent memorial to victims of Aum, a site its proposers hope will attract future tourists. I analyse these particular sites within the national context of cultural memory and the global growth in trauma tourism discussed above. In Japan, like many other places with traumatic histories, the struggle to reconcile commemorative imperatives with desires to forget remains ongoing and unresolved.

Death Town

Kamikuishiki was a small town in Yamanashi prefecture, west of Tokyo. Surrounded by the volcanic lakes at the base of Mount Fuji and adjacent to a picturesque forest, the village of 1,500 people was ideally located to take advantage of its natural setting and appeal to a tourist market of day-trippers and weekenders from Tokyo. Despite its idyllic location, however, two factors worked against the town's attempts to attract tourists. The first was the location within the town of the headquarters of the Aum sect, which became publicly known in the mid-1990s and is discussed below. The other was the forest mentioned above—Aokigahara, also known as Jukai (sea of trees).

The eerily quiet forest, with its high density of trees, volcanic floor and resulting absence of immediately obvious wildlife, has earned the reputation of the second busiest suicide spot in the world (after San Francisco's Golden Gate Bridge).[4] Suicide has been a major cause of death across Japan for some time, with over 20,000 deaths reported each year since at least 1978. According to the 2010 Suicide Policy White Paper published by the Japanese Cabinet Office, the numbers rose markedly in the mid- to late 1990s, crossing the 30,000 per year barrier in 1998 and remaining above that level since (Naikakufu 2010: 2). While in most cases people choose to die in or near where they live, the one statistically significant exception in Japan is Yamanashi prefecture, where suicides occur at one-and-a-half times the expected rate for its resident population (ibid.). Earlier records of attempted suicides in Aokigahara also reflect this fact, with 111 of the 116 people considered in a 1988 study residing in prefectures other than Yamanashi before their suicide attempts (Takahashi Yoshitomo 1988: 172). Yamanashi prefecture, and more specifically Aokigahara, has been a destination spot for suicide for some time.

In recent decades, the forest has also become associated with suicide through popular culture. This association is most apparent in Tsurumi Wataru's controversial multimillion-copy-selling 1993 guidebook to suicide, *Kanzen Jisatsu Manyuaru* (The Complete Manual of Suicide), which famously discusses the benefits and disadvantages of a range of suicide methods. The book also functions as a perverse tourist guidebook of sorts, with maps and directions to popular suicide spots across Japan available both to the suicidal and those with a morbid interest in death alike. The book profiles Aokigahara as 'the perfect place to die' (Tsurumi 1993: 70–5).[5]

The annual number of suicides reported in Aokigahara grew through the 1990s to a peak of around 80 a year by the end of the decade (Naikakufu 2010: 2). In 2000, over 100 bodies retrieved from the forest were being stored in a building in the town of Kamikuishiki awaiting cremation or collection (Hadfield 2000). Mayor Kobayashi Takatoshi, of the adjacent town of Narusawa, was quoted in 2001 as saying, 'We've got everything here that points to us being a death spot. Perhaps we should just promote ourselves as "Suicide City" and encourage people to come here' (Connell 2001). Despite Kobayashi's flippancy, news reports indicated that a tourist phenomenon related to suicide was very much in place, both for individuals wanting an 'appropriate' place for their final moments and for those seeking the macabre.[6] The forest is also heavily featured in international tourist guides and traveller web forums about Japan, with mention of it often being tied to cultural stereotypes of Japanese as pro-suicide.[7]

In March 1995, the events on the Tokyo subway drew further attention to Kamikuishiki. Over several weeks, police raided the sites and made multiple arrests, much of which was broadcast live on national television. As Helen Hardacre commented, 'coverage of the police investigation was the overwhelming preoccupation of newspapers and TV news programs of all kinds from its inception on March 22 through mid-June 1995' (2007: 174). On the day of Aum leader Asahara Shōkō's arrest, the six commercial television channels together reportedly aired over 100 hours of Aum-related coverage (ibid.). This televisual bombardment included reporting on what occurred at the site and on the rumoured activities of Aum, leading to the realization that Kamikuishiki was not simply the headquarters of an unusual religious organization but also the site for the manufacture of toxic sarin gas, among other risky scientific experiments and criminal activities.[8]

For residents of Kamikuishiki, the news was not entirely surprising. Suspicions arose in the July before the subway attack, when residents reported to local police unusual 'chemical' smells emanating from the compound (Abe 2008: 10–12; Kisala 1995: 8; Takimoto 2005). Subsequent investigation led to the detection of sarin in the town's soil. News of this was reported on the front page of the *Yomiuri Shinbun*, Japan's highest-circulation daily in January 1995, precipitating widespread concern about the actions of Aum and prompting an escalation of media and police interest in the sect (Abe 2008: 10–12). The year 1994 also saw Aum members release toxic sarin gas in the city of Matsumoto in the adjacent prefecture of Nagano, with fatal consequences.[9] With the events of 1994 and 1995, the village of Kamikuishiki was no longer simply a gateway to

Aokigahara but had also to bear an additional negative mark, tied closely in popular imagination to the events of the Tokyo subway and the actions of Aum.

The villagers of Kamikuishiki and its neighbouring towns were certainly concerned about the impact of Aum on their lives and on tourism to the region. Abe Saburō, who was responsible for handling the post-1995 bankruptcy of the Aum sect, reported that Kamikuishiki villagers advocated against the continued presence of any believer, sect building or facility in their town (ibid.: 82). He also reported receiving a letter in 1996 from then mayor of the neighbouring town of Tomizawa, which also hosted Aum facilities. In arguing for state intervention to support the region, Mochizuki Hidejirō wrote, 'Citizens already living with fear and unease had not planned for negative impacts such as a sharp drop in tourism' (in ibid.: 86–7). For towns that relied heavily on the tourism industry, the negative association with Aum added unexpected financial strain on their economy.

During the 1990s hangover of the Japanese economic boom, the Japanese state funded numerous construction projects aimed at driving regional and rural economic growth. Towns in many regions of Japan, including the one surrounding Kamikuishiki, also encouraged the growth of tourism projects. One of the more grandiose of these projects was the construction and opening in Kamikuishiki in 1997 of a theme park based on Jonathan Swift's *Gulliver's Travels* (1726), called Fuji Garibaa Ōkoku (Fuji Gulliver's Kingdom). The key features of the park were a large sculpture of Gulliver tied down in the mythical village of Lilliput, a small zoo featuring wallabies and reindeer, and a bobsled facility.[10]

It is unclear exactly why developers imagined a *Gulliver's Travels* theme park would be successful in Japan, or particularly in Kamikuishiki, although its development is by no means an isolated example. The late twentieth century saw a range of widely varied theme parks open in regional areas of the country to varying degrees of success. These include Parque España (now called Shima Spain Village) in Mie prefecture, near Osaka, and Huis Ten Bosch in Nagasaki on the southern island of Kyushu.[11] These exist alongside the more 'globalized' franchises of the two Disney theme parks in Tokyo and Universal Studios Osaka, although the long economic decline since the early 1990s has seen several close their doors.[12]

Numerous studies have been conducted into the role of theme parks in the construction of late twentieth-century Japanese recreation practices. Much of this research emerged after the opening of Tokyo Disneyland in 1983 and its

popularization through the 1980s and 1990s. Yoshimi Shunya (2000), for example, points to the changes in post-war Japanese consumption patterns as one marker for the acceptance and popularity of Tokyo Disneyland, arguing against a simplistic idea that it marked an 'Americanization' of popular culture in Japan.[13] For Yoshimi, Tokyo Disneyland is not simply an amusement park but emblematic of a structural change in consumption patterns of global capitalist life (ibid.: 222). Yoshimoto Mitsuhiro (1994) takes this further by comparing Tokyo Disneyland with the proliferation of 'foreign villages' like Huis Ten Bosch mentioned above. Yoshimoto, like Yoshimi, warns against a simplistic lumping together of these developments with 'Westernization', and argues that these projects say more about consumption practices of the Japanese than the cultural influence of some 'West'. For Yoshimoto, 'the "foreign villages" are constructed to attract the tourists from neighbouring [regional] prefectures [. . .] to boost the local economy and, no matter how strange it may sound, to re-establish the specificity of regional culture' (ibid.: 193–4), all the while reliant on the capital and corporate culture of the Tokyo metropolis.[14]

The changing nature of post-war Japanese entertainment and consumption practices, combined with regional decline and injections of capital from Tokyo, led to the development of sites such as Gulliver's Kingdom. Cultural antecedents similar to those that predated Tokyo Disneyland may have prompted the developers to imagine the success of the *Gulliver's Travels* theme park.[15] These popular cultural representations of Gulliver and his worlds may have prompted the desire to develop and participate in the expansion of cultures of consumption and excess manifest in theme parks, a desire closely tied to capitalist cosmopolitanism, or what Yoshimoto refers to as the 'imperial expansion of Tokyo's hegemonic culture' (ibid.: 194). In a town marked by the economic decline prevalent in rural Japan, fearful of losing tourists, yet close enough geographically to take advantage of its proximity to the Tokyo region, the Gulliver's Kingdom project was evidently appealing.

Gulliver's Kingdom operated from 1997 to 2001, closing after the 1999 collapse of its financing bank (along with multiple other mid-level Japanese banks) and declining visitor numbers (*Japan Times* 2001).[16] For several years, however, the site remained in its closed and abandoned state, attracting a different form of tourists, *haikyo* enthusiasts. *Haikyo* literally means 'ruins' and has come to mean 'a practice of ruins tourism', whereby photographers, artists and others travel to and document the large number of modern industrial and other ruins resulting from the collapse of the post-war Japanese economic

bubble and the corresponding process of urbanization.[17] The bestselling *Japan Deathtopia* series of photography books by Kobayashi Shin'ichirō also capture this interest, starting with *Deathtopia: Haikyo Yūgi* (Deathtopia: Ruin Play) in 1998 (Kobayashi 1998, 2001, 2004). Interest in the aesthetics and cultural heritage of ruins continues to grow, with a campaign underway to register the ruins of the modern industrial sites of Kyūshu and Yamaguchi in the southwest of the country on the UNESCO World Heritage Register.[18] Gulliver's Kingdom became a popular *haikyo* destination between 2001 and its ultimate demolition in 2006, and photographs of its ruins remain a prominent feature on several *haikyo* enthusiasts' websites.

The failure of the Gulliver's Kingdom project represents the failure of Kamikuishiki's civic attempts to reinvigorate itself and create distance from the dark legacies of suicide and Aum through tourism. Declining economic opportunity and resulting drops in population and tax income in the region resulted in the town of Kamikuishiki itself disappearing in 2006, being split in two between the city of Kōfu to the north and the town of Fujikawaguchiko to the south. Kamikuishiki ceased to exist on 1 March 2006, the same year the theme park was demolished.[19]

In what remains of Kamikuishiki, there are few reminders of Aum activity. Many sites have been rebuilt to serve different functions, some tourism-related (*Yamanashi Nichinichi Shimbun* 2010: 1). On the site of the sect's largest facility the town has built a 7,000-square-metre park and marked the site with a memorial plaque, the sole marker of the dark history of a town that no longer exists.

The Plaque in the Corner

A plaque is also the sole permanent reminder of the events of 20 March 1995 in the Tokyo subway. The plaque was affixed on the first anniversary of the attacks on a wall near the Kasumigaseki stationmaster's office. It is the only public memorial in Tokyo and has thus become a focus of annual commemorative ceremonies. The plaque's stated purpose is to remember those who died, specifically the two subway workers killed at that station. On the anniversary of the attacks, temporary memorial sites are also set up at several of the affected stations, as outlined above.

Commemoration of the event has long been important for victims, for personal mourning, to honour the dead and for social reasons associated with public neglect. Survivors expressed their concerns about public forgetfulness

soon after the incident (Takahashi Shizue 1998: 3). However, for much of the last 15 years, victims have focused their energies on battles for public compensation (which they only achieved in 2008) and judicial processes (which are largely concluded but remain ongoing in some cases) (Takahashi Shizue 2008). As these matters have drawn to a close, the focus of some involved in victim support has shifted to the question of how to prevent the event from being forgotten and, through this, how to prevent it happening again. For victims and their supporters, memorialization in the form of a site that would attract visitors was seen as one way of keeping the incident in public memory. The most concrete proposal to date appeared at the annual memorial ceremony in 2009 when anti-cult lawyer and activist Takimoto Tarō presented a short paper entitled 'A Plan to Avoid the Fading [of Memory]', in which he proposed something more than the simple plaque—a permanent memorial to victims at Kasumigaseki station, the target of the attacks (see Takimoto 2009). In making his proposal, Takimoto drew on a few key themes that resonate with international discussions of memorial construction and tourism.

Takimoto argued that victims had suffered 'unspeakable suffering' and that they were forced to battle on two fronts: against the Aum sect and the 'system' of government and media. According to him, two factors should be retained and conserved in a permanent form: 'In order to prevent a recurrence we should preserve in history a shape that future generations will understand' (ibid.). His proposal was tied directly to the idea that future generations will and should seek out this site for pilgrimage, tourism and education about recent Japanese history.

Thus, the design of the memorial must work across generational divides and retain the dual focus of outlining both the facts of the incident and the subsequent battles between the victims, the organization and individuals responsible and the system that failed to help the affected. In considering what shape that might be, Takimoto surveyed a range of what he saw as similar tourist destinations, including the domestic memorial sites to atomic bomb victims in Hiroshima and Nagasaki. He argued that while the scale is different between Hiroshima/Nagasaki and the subway incident, the 'indiscriminate mass murder' is not. He pointed to memorials to the Sakamoto family—a lawyer who was investigating the Aum sect, and was killed along with his wife and baby son by Aum members. These memorials were built on the sites where their bodies had been dumped in three regional locations across central Japan.[20] Takimoto described the Sakamoto memorials as serving as a 'base' for retaining the memories of the dead, a concrete focal point for challenging

the ephemerality of personal memory. His third domestic example concerned the ongoing debates about how the former village of Kamikuishiki should remember its role as host of Aum's central compound. His final set of models, and the only ones not drawn from Japan, included the various 9/11 memorials in New York, Washington and elsewhere. In this range of sites, we can see a drawing together of what Maria Tumarkin has termed 'traumascapes' or places 'marked by legacies of violence, suffering and loss, [in which] the past is never quite over' (2005: 12).

While Takimoto's proposal was written simply as a starting point for discussion and by no means indicates what form any future memorial may take, his references to Hiroshima/Nagasaki and to 9/11 are of particular interest as sites of mass tourism. In highlighting a common thread of what he calls 'indiscriminate mass murder' he also drew a connection between the two 'Ground Zeroes' absent in much of the official discussion round the 9/11 site. As others have pointed out, the adoption of the Ground Zero label in New York elides the role of the United States in creating many previous ground zeroes, most notably Hiroshima/Nagasaki. With this linguistic trick, the US is transformed from historic perpetrator to ahistoric victim, and its role in perpetrating indiscriminate killing is erased (Simpson 2006: 43; Smith 2006). Conversely, the atomic bombs of 1945 transformed Japan into the victim of a war in which it was primarily an expansionist imperial aggressor, and clouded much of post-war Japanese history in a politics based on this complicated victimization (Orr 2001; Oda 1966). This shrouding of Japan's imperial past extended to the designs for the Peace Memorial Park in Hiroshima, as Lisa Yoneyama has pointed out: '[The design] can be traced back to a nearly identical ground plan that had been adopted three years before Japan's surrender as part of a grand imperial vision, the Commemorative Building Project for the Construction of Greater East Asia' (1999: 1). Both designs were the creations of world-renowned architect Tange Kenzō.

In thinking through how the practices of memorialization and commemoration impact culture and politics in the context of Hiroshima, Yoneyama asks 'how acts of remembering can fill the void of knowledge without re-establishing yet another regime of totality, stability, confidence, and universal truthfulness. How can memories, once recuperated, remain self-critically unsettling?' (Ibid.: 5.) As I have discussed elsewhere, the incorporation of subway victim experience into a globalized 'terror' victim politics after 9/11 elides the substantive differences in both the nature of the violence perpetrated and the subsequent diversity of victim experience (Pendleton 2008, 2009).

However, as with Hiroshima, there are elisions in Takimoto's proposal with regard to what forms of memorial design might attract visitors to the site. Takimoto suggests that the site of a subway gassing memorial should be somewhere with trees close to an aboveground exit of Kasumigaseki station. While the arboreal message of renewal remains a popular cliché of memorial sites, the mnemonic movement in Takimoto's proposal is in the opposite direction to many.[21] The 9/11 memorial in New York, for example, goes down into absence and reflection, a reversal of the aerial and visually dramatic nature of the 2001 attacks; Takimoto, however, suggests that any potential subway memorial ought to come up, to emerge from the underground to the visible surface, a response to what people like Murakami Haruki have described as an invisible, underground social evil that seeped to the surface in the 1995 gassing.[22]

Takimoto (2009) suggested a large, concrete relief depicting a scene such as Picasso's famous painting of the fascist bombing of Guernica during the Spanish Civil War, arguing that any memorial should be confronting, which would cause later generations to 'feel' the seriousness and atrocity of the event. The suggestion of a large, solid relief is notable as a contrast to the emptiness featured in many other memorial designs. This emptiness can be seen in the double voids left at the base of the former Twin Towers in New York, the hulking wreck of Hiroshima's Atomic Bomb Dome or the empty place pointed to by the sculpture in the Nagasaki Peace Park that hints at both the origins of the bomb and the vastness of the sky above.[23] These absences stand testament to the destructive violence of war or terrorism as well as provide an empty void to be filled through reflection and contemplation.[24] In searching for an appropriate response to the ephemeral, subterranean and unmarked violence of the subway attack, however, Takimoto clutches at the surface, the hard, the visible—the stable and universal that Yoneyama (1999: 5) warns against. His earlier reference to the 'base' of memories at the Sakamoto memorials also reflects this. It seems that Takimoto wants to concretize that which is fleeting, to make the invisible, indistinguishable traces of the sarin gas (and its memory) solid and graspable, with all the potential for ossification this involves.

Why the particular example of Guernica was chosen is not clearly explained in Takimoto's document. However, implicit in his proposal is an understanding of victimization that is universal, as seen in his comment about the 'indiscriminate mass murder' that links the sites. It is this idea of a universality of 'victim experience' that connects the subway gassing and Takimoto's reading of Guernica. This call on the universal is also seen in other dark sites with tourist

appeal, such as two of those mentioned as Takimoto's inspiration—the ground zeroes of Hiroshima and New York.

The victims and survivors of the Tokyo subway gassing are regarded as innocents caught up in a war not of their choosing. Takimoto sees Picasso's depiction of the horrors of the (fascist) war on the 'innocent' as being capable of representing a similar war-like process of victimization experienced by those in Tokyo. The violence enacted on victims at the sites he references causes them to be imbued with a sacredness that transcends the political, creating in the process a notion of a universal victim experience. Takimoto wants this universality to be the driving force behind the creation of a Tokyo memorial. His hope, it appears, is that this memorial may serve, as the Guernica painting has, as a representation of resistance against violence directed towards the innocent.[25]

His idea of shared victim experience is by no means unique. Several interactions have taken place between victims' groups in Tokyo and New York (Pendleton 2009). More surprisingly, some have also taken place between Hiroshima and New York. Sasaki Masahiro, for example, is the brother of Hiroshima victim and famous origami-crane-folder Sasaki Sadako. In 2008, he presented one of Sadako's original origami cranes to the Tribute WTC Visitor Center, an initiative of the September 11th Families Association, and the major tourist facility at the former World Trade Center site.[26] For Sasaki Masahiro, the decision to donate the crane was based on the shared victimization of innocent people and the fact that the Ground Zero site in New York, like Hiroshima, acts as a 'place where people from around the world gather to pray for peace' (Japan Info 2007). Traumascapes in their perceived sacredness become both tourist destination and site of pilgrimage.

David Janes (2010), in discussing the connection between Hiroshima and New York, points to Pierre Nora's famous statement that 'memory attaches itself to sites, whereas history attaches itself to events' (1989: 22). For Janes, this rings true for these sites, permanently attached to traumatic memories. Although these memories are by no means static or unchanging, Janes sees the connection between the sites as based on people's relationship to their 'sacredness'. Memories have become attached to these sites 'in spite of changing foreign policies and public issues debates', which allows them to function as sites of pilgrimage and commemoration not tainted by political differences (Janes 2010: 158). Janes sees Sadako's crane as forging a link between the two cities of New York and Hiroshima through the 'narrative of innocent suffering attached to them' (ibid.).

However, this universalization of human suffering and its connection to sacredness is problematic as it *relies* on the decoupling of Sadako's crane, like the sites themselves, from political contestations about their meaning. This decoupling is, as Janes argues, what allows objects and sites of tourism to stand in as universal markers of human suffering. The reason the crane is usable and largely uncontroversial in New York City is related to its decoupling from the history of Hiroshima. The World Trade Center site in its manifestation as a sacred site is also ahistoric. However, while Janes can point to Sadako's crane as serving a function of promoting 'unity, social cohesion and a more peaceful future' (ibid.: 159), its capacity to do so is reliant on the removal of history and politics from the processes of commemoration in favour of an uncritically abstracted universality of human experience.

Takimoto's Tokyo memorial is unlikely to be realized in this form. However, that victims' groups are beginning to talk about the means by which their experiences may be commemorated and how to attract trauma tourists to these locations is interesting. That these conversations are taking place within transnational frameworks of universality and sacredness demonstrates the global spread of memorial practices and forms. They also demonstrate the elision of political and historical contestations over the meaning of such forms and the sites they become attached to. For future tourists, these sites become universal representations of a common human experience, instead of potential sites for exploring the historical and political motivations that continue to create victims of extreme violence.

Never Forget?

The important element in both the cases outlined here is the complicated interaction of politics and history with a popular narrative of active forgetfulness in post-war Japan. Just as victims were claiming that the public had already forgotten their losses in the Tokyo subway, developers in the town of Kamikuishiki were fantastically dreaming of capitalizing off a new future through the forgetting of the town's dark past. As Takimoto turned years later to how to commemorate the subway incident and why, his focus was on drawing connections between disparate groups of victims, of both political violence and war.

Remembering and forgetting infuse these two cases. In Takimoto's proposal we see a localized response to the seemingly global imperative to 'never forget'. Contained within this ubiquitous phrase is an inevitable silence that sits uncomfortably alongside its affective force and tourist appeal. For Laurie Beth Clark,

the tension between the desire to remember and the demand to 'put the past behind us' (2009: 14) is marked in many such tourist sites. This tension is clearly manifest in sites of active forgetting, such as Kamikuishiki. However in sites of reflective tourism, like the Ground Zeroes in Hiroshima, Nagasaki and New York, the tension also exists. Alongside the commemoration of universal human suffering is a forgetting of the contested histories and politics that these sites are bound up in. The desire to remember the incident of 20 March 1995 through a permanent plaque or a concrete relief depends on the permanent location of these incidents in collective memory or, in other words, in the resolved past. That the subway gassing precipitated increases in surveillance, the suspension of religious freedom in Japan and an ongoing ambiguity of the role of the Japanese state in creating and continuing states of victimization is forgotten in the commemorative 'regime of totality, stability, confidence and universal truthfulness' (Yoneyama 1999: 5). The seemingly global demand to 'never forget' individual victims of violence through a call to universal experiences ultimately requires wilful acts of forgetting.

Notes

1 A preliminary version of this paper was presented at the Dark/Death/Thanatourism Conference at the Transitions International Research Center in the Humanities and Social Sciences at New York University (NYU) in April 2010. I would like to express my thanks to the organizer Brigitte Sion and those present for their constructive feedback. Thanks also to Ed Berenson from NYU and Denis Peschanski from Centre National de la Recherche Scientifique (France) for facilitating my stay in New York.

2 Japanese names are presented in the order they would appear in Japanese, family name first, followed by given name. All translations from Japanese are mine, unless otherwise noted. I attended the events marking the fourteenth anniversary of the subway gassings on 20 March 2009. Media reports from other years also indicate the central role of these sites in annual commemorative practices (see, for example, *Japan Today* 2010; BBC 2005).

3 Aum Shinrikyō members simultaneously released toxic sarin gas in five train carriages across the Tokyo subway system during the morning peak hour. The attack was targeted at the downtown government hub of Kasumigaseki. For a good account of the background to the case and the sect responsible, see Ian Reader (2000); for personal accounts, see Murakami Haruki (2000). Incidents associated with members of Aum also incorporate additional gassings, murders, violent attacks and other criminal activities. Robert Kisala and Mark R. Mullins (2001) have grouped these together as the 'Aum affair'.

4 While I am not aware of any reputable global, comparative studies to confirm this ranking, these two sites certainly reflect the highest raw numbers of suicides that I have come across. Reports in the mid-1980s indicated that Aokigahara at that time had more suicides than the Golden Gate Bridge (see Takahashi Yoshitomo 1988). Representations of these sites are also fairly common in popular culture, with rankings often listing the Golden Gate Bridge, Aokigahara and the UK's Beachy Head as the top three suicide locations in the world (see, for example Hunt 2006).

5 The publication of Tsurumi's book was highly controversial and provoked a media storm both in Japan and outside. Tsurumi capitalized on this attention by publishing a second volume, featuring a selection of media reports, correspondence he had received and other reflections on the first book (Tsurumi 1994).

6 An Asahi newspaper article reported that police set up a mobile police box at the entrance to Aokigahara to assist with suicide prevention and tourist enquiries (*Asahi Maitaun Yamanashi* 2010).

7 For example, see this thread on Japan-Guide.com: http://www.japan-guide.com/forum/quereadisplay.html?0+22661 (last accessed on 10 April 2011).

8 Numerous book-length treatments of the events surrounding the 1995 Tokyo subway gassing and its aftermath have been published in English, with many more in Japanese. A selection of informative English titles includes works by Ian Reader (2000) and Haruki Murakami (2000). Other sources that give overviews of different levels of quality include works by David E. Kaplan and Andrew Marshall (1996) and Daniel A. Metraux (2000).

9 Matsumoto victim Kōno Yoshiyuki was falsely and publicly suspected of being responsible for this attack, which left his wife in a 14-year-long coma from which she never awoke, dying in 2008. He has published multiple volumes about the incident and its impact on his life (Kōno 1998, 2001, 2008).

10 Maps and images of the theme park site have been archived here: http://www.ne.jp/asahi/mkoba/z/gullivertop.htm (last accessed on 20 April 2010). While several popular websites, blogs and other sources suggest that the theme park was built directly on the site of Aum headquarters, the processes of bankruptcy, land sales and associated processes outlined in bankruptcy administrator Abe Saburō's volume *Hasansha Oumu Shinrikyō* (2008) indicate that this is not possible. A 2010 article in the *Yamanashi Nichinichi Shinbun* confirmed that the Gulliver's Kingdom site was about three kilometres from the main location of Aum facilities—the No. 6 Satyam site.

11 Huis Ten Bosch is inspired by the historic Dutch connection to Nagasaki, with the Dutch being the only European power allowed to trade with Japan during the long *sakoku* (closed country) period from the early seventeenth century to the mid-nineteenth century. This trade was restricted to the port

of Dejima in Nagasaki. No immediately obvious cultural connection can be found between Mie prefecture and Spain. Shima Spain Village is owned by the mass transport/retail/tourism conglomerate Kintetsu (see http://english.-huistenbosch.co.jp/ and http://www.parque-net.com/foreign/english/index.-html, last accessed on 10 August 2010).

12 See http://www.tokyodisneyresort.co.jp/index_e.html and http://www.usj.-co.jp/e/ (last accessed on 10 August 2010).

13 Theme parks relating to Japanese cartoon and animation cultures also began to appear at around the same time. Tokyo's Sanrio Puroland, for example, opened in 1990 themed round the Sanrio stable of characters, Hello Kitty being the most well known internationally (http://www.puroland.jp/company/outline.html, last accessed 10 November 2010).

14 Both Yoshimi Shunya (2000) and Yoshimoto Mitsuhiro (1994) connect the popularity of Disneyland with pre-existing popular cultural forms, most notably the 'Disneyland' programme, which aired on Japanese television from 1958 to 1967.

15 In Part 3 of Jonathan Swift's book, Gulliver travelled to Japan. The appearance of tropes from the stories in numerous post-war Japanese cultural texts may, however, be more significant. These include Numa Shōzō's 1956 serialized novel *Kachikujin yapū* (Yapu, the Human Cattle), the 1965 Tōei animation *Garibaa no uchū ryokō* (Gulliver's Travels Beyond the Moon, the production of which future Studio Ghibli animation great Miyazaki Hayao first worked) and Miyazaki's 1986 multi-award winning film *Tenkū no shiro Rapyuta* (Castle in the Sky), which featured a floating island named after Swift's Laputa.

16 For more on the late 1990s banking crisis in Japan, see Akihiro Kanaya and David Woo (2000).

17 While there is insufficient space here to go into a great amount of detail about the *haikyo* phenomenon, the existence of a plethora of *haikyo* websites in both English and Japanese is a relatively unexplored area of research: see, for example, http://www2.ttcn.ne.jp/hexplorer/, http://kiokuya-haikyo.versus.jp/, http://home. f01.itscom.net/spiral/, http://www.uer.ca/ and http://www.-michaeljohngrist.com /ruins-gallery/ (all last accessed on 7 April 2010). The interest in industrial ruins is also by no means an exclusively Japanese phenomenon (see, for example, Edensor 2005; Hell and Schönle 2010).

18 See http://whc.unesco.org/en/tentativelists/5399/ (last accessed on 20 April 2011).

19 Kamikuishiki was not alone in its fate, with the decline of regional Japan resulting in many mergers of towns and cities. These mergers form part of what was known as the Great Heisei Merger (*Heisei Dai-gappei*), which

resulted in the reduction of the numbers of towns, villages and cities in Japan from over 3,200 at the end of the twentieth century to just 1,800 as of March 2006. For more on the effects of this move, see Anthony Rausch (2010).

20 Memorials were built at or near the sites where bodies had been dumped in three prefectures of central Japan—Niigata, Tōyama and Nagano. A map of these locations can be found at: http://www.mars.dti.ne.jp/~takizawa/memorial01.html (last accessed on 20 August 2010). The father of Sakamoto Satoko, the lawyer's wife, has also published a memoir of his experiences after her death (Ōyama and Aonuma 2000).

21 National 9/11 Memorial and Museum website. Available at: http://www.national911memorial.org/site/PageServer?pagename=New_Memorial_Page (last accessed on 20 August 2010).

22 Murakami describes the events on the subway as a manifestation of underlying violence in Japanese society. He writes 'subconscious shadows are an "underground" that we carry around with us, and the bitter aftertaste that continues to plague us long after the Tokyo gas attack comes sweeping out from below' (2000: 199). I explore this spatial dynamic in greater detail in an article in the journal *Japanese Studies* (Pendleton 2011).

23 Much has been written about the commemorative function of space in memorial design, particularly in relation to these three sites. See, for example, Lisa Yoneyama (1999, Chapter 2) and Peter Siegenthaler (2004).

24 The World Trade Center Memorial Competition Jury statement described the winning 'Reflecting Absence' entry in part in the following way: 'In our descent to the level below the street, down into the outlines left by the lost towers, we find that absence is made palpable in the sight and sound of thin sheets of water falling into reflecting pools, each with a further void at its center' (available at: http://www.wtcsitememorial.org/about_jury_txt.html, last accessed on 20 August 2010).

25 The particular sites chosen as reference points are also instructive. Takimoto Tarō (2009) does not mention Holocaust sites, such as Auschwitz-Birkenau, or sites of Japanese atrocities during the Asia-Pacific war, notably the Chinese city of Nanjing. He also does not mention sites associated with other previous uses of nerve gases like sarin, such as the Kurdish lands subjected to the gas by Saddam Hussein's regime in Iraq. Despite calls on the universal, then, his notion of universality is limited to national frames or to 'sacred' sites closely associated through contemporary political alliances or mass media coverage.

26 The story of Sasaki Sadako, who died at the age of 12 from leukaemia as a result of her exposure to the Hiroshima atomic bomb 10 years earlier, has been immortalized in statues in Hiroshima and Seattle, and in a number of popular books published round the world. Karl Bruckner's *Sadako Will Leben*

(Sadako Wants to Live) first appeared in German in Austria in 1961, followed shortly after by Frances Lobb's translation into English as *The Day of the Bomb*. Eleanor Coerr's 1977 book *Sadako and the Thousand Paper Cranes* popularized the story further in the English-speaking world. The Tribute Center is intended to function as an interim visitor centre until such time as the official Memorial and Museum is open to the public (see http://www.trib-utewtc.org, last accessed on 12 April 2011).

Works Cited

ABE Saburō. 2008. *Hasansha Oumu Shinrikyō: Kanzainin 12nen no tatakai* (The Bankrupt Aum Shinrikyō: The Receiver's 12-Year Battle). Tokyo: Asahi Shinbun Shuppan.

ASAHI MAITAUN YAMANASHI. 2010. 'Aokigahara jukai ni jisastu bōshi kōban, Fujiyoshi-dashi, Kankō annai mo' [Fujiyoshida City Installs Suicide Prevention Police Box, Providing Tourist Advice As Well]. *Asahi.com*, 13 August. Available at: http://my-town.asahi.com/areanews/yamanashi/TKY201008120420.html (last accessed on 20 August 2010).

BBC. 2005. 'Sarin Attack Remembered in Tokyo'. *BBC*, 20 March, Available at: http://news.bbc.co.uk/2/hi/asia-pacific/4365417.stm (last accessed on 20 August 2010).

BRODERICK, Mick. 2010. 'Topographies of Trauma: Dark Tourism, World Heritage and Hiroshima'. *Intersections: Gender and Sexuality in Asia and the Pacific* 24 (June 2010). Available at: http://intersections.anu.edu.au/issue24/broderick.htm (last accessed on 12 November 2010).

BRUCKNER, Karl. 1962. *The Day of the Bomb* (Frances Lobb trans.). London: Burke.

CLARK, Laurie Beth. 2009. 'Coming to Terms with Trauma Tourism'. *Performance Paradigm* 5(2): 1–31. Available at: http://www.performanceparadigm.net/journal/-issue-52/articles/coming-to-terms-with-trauma-tourism/ (last accessed on 20 August 2010).

COERR, Eleanor. 1977. *Sadako and the Thousand Paper Cranes*. New York: G. P. Putnam's Sons.

CONNELL, Ryann. 2001. 'Suicides Stir Up Stink in Fuji's Fearsome Forest'. *Mainichi Daily News*, 11 July.

EDENSOR, Tim. 2005. *Industrial Ruins: Space, Aesthetics and Materiality*. Oxford: Berg.

HADFIELD, Peter. 2000. 'Japan Struggles with Soaring Death Toll in Suicide Forest'. *Telegraph*, 1 November. Available at: http://www.telegraph.co.uk/ news/world-news/asia/japan/1373287/Japan-struggles-with-soaring-death-toll-in-Suicide-For-est.html (last accessed on 7 April 2010).

HARDACRE, Helen. 2007. 'Aum Shinrikyō and the Japanese Media: The Pied Piper Meets the Lamb of God'. *History of Religions* 47(2–3): 171–204.

HELL, Julia, and Andreas Schönle (eds). 2010. *Ruins of Modernity*. Durham, NC, and London: Duke University Press.

HUNT, Tom. 2006. *Cliffs of Despair: A Journey to Suicide's Edge*. New York: Random House.

JANES, David. 2010. 'Hiroshima and 9/11: Linking Memorials for Peace'. *Behavioral Sciences of Terrorism and Political Aggression* 2(2): 150–61.

JAPAN INFO. 2007. Newsletter of the Consulate-General of Japan in New York, VOL. 3. Available at: http://www.ny.us.emb-japan.go.jp/en/c/2007/japaninfo0709.html (last accessed on 10 June 2011).

JAPAN TIMES. 2001. 'Kamikuishiki's Gulliver Park Falls'. *Japan Times*, 13 November. Available at: http://search.japantimes.co.jp/cgi-bin/nn20011113a8.html (last accessed on 7 April 2010).

JAPAN TODAY. 2010. 'Tokyo Marks 15th Anniversary of Subway Sarin Attack'. *Japan Today*, 20 March. Available at: http://www.japantoday.com/ category/crime/-view/tokyo-marks-15th-anniversary-of-subway-sarin-attack (last accessed on 20 August 2010).

KANAYA, Akihiro, and David Woo. 2000. 'The Japanese Banking Crisis of the 1990s: Sources and Lessons'. *Working Paper of the International Monetary Fund*, Working Paper No. WP/00/7, January 2000. Available at: http://www.imf.org/-external/pubs/ft/wp/2000/wp0007.pdf. Accessed 10 September 2013.

KAPLAN, David E., and Andrew Marshall. 1996. *The Cult at the End of the World: The Incredible Story of Aum*. London: Arrow.

KŌNO Yoshiyuki. 1998. *Tsuma yo! Wagaai to kibō to tatakai no hibi* (My Wife! Our Days of Love, Hope and Struggle). Tokyo: Ushio Shuppansha.

———. 2001. *'Giwaku' wa hareyō tomo: Matsumoto Sarin Jiken no hannin to sareta watashi* (Even if Cleared of 'Suspicion': On Being Made a Matsumoto Sarin Incident Suspect). Tokyo: Bungei Shunju.

———. 2008. *Inochi aru kagiri: Matsumoto jiken o koete* (As Long as There Is Life: Overcoming the Matsumoto Incident). Tokyo: Daisan Bunmeisha.

KISALA, Robert. 1995. 'Aum Alone in Japan: Religious Responses to the "Aum Affair" '. *Nanzan Bulletin* 19: 6–34.

———, and Mark R. Mullins (eds). 2001. *Religion and Social Crisis in Japan: Understanding Japanese Society through the Aum Affair*. Basingstoke and New York: Palgrave.

KOBAYASHI Shin'ichirō. 1998. *Deathtopia: Haikyo Yūgi* (Deathtopia: Ruin Play). Tokyo: Media Factory.

———. 2001. *Haikyo Hyōryū* (Ruins Drift). Tokyo: Magazine House.

———. 2004. *No Man's Land: Gunkanjima*. Tokyo: Kodansha.

LENNON, John, and Malcolm Foley. 2000. *Dark Tourism: The Attraction of Death and Disaster*. London: Continuum.

LOVE, Rosaleen. 2006. 'A Perverse Appeal'. *Griffith Review* 14: 213–19.

METRAUX, Daniel A. 2000. *Aum Shinrikyō's Impact on Japanese Society*. Lewiston, NY: Edwin Mellen Press.

MURAKAMI, Haruki. 2000. *Underground: The Tokyo Gas Attack and the Japanese Psyche* (Alfred Birnbaum and Philip Gabriel trans). London: Harvill.

NAIKAKUFU. 2010. *Jisatsu taisaku hakusho* (White Paper on the Measures against Suicide). Tokyo: Naikakufu (Cabinet Office of the Japanese Government).

NORA, Pierre. 1989. 'Between Memory and History: Les Lieux de Memoire'. *Representations* 26: 7–24.

NUMA Shōzō. 1991[1956]. *Kachikujin yapū: Kanketsu hen* (Yapu, the Human Cattle: The Final Volume). Tokyo: Mirion.

ODA Makoto. 1966. 'The Meaning of "Meaningless Death" '. *Journal of Social and Political Ideas in Japan* 4(2): 75–85.

ORR, James J. 2001. *The Victim as Hero: Ideologies of Peace and National Identity in Postwar Japan*. Honolulu: University of Hawaii Press.

ŌYAMA Tomoyuki, and Aonuma Yōichirō. 2000. *Satoko Kikoemasuka: Oumu Sakamoto ikka satsugaijiken, chichioya no shuki* (Can You Hear Me, Satoko? A Father's Testimony of the Aum Sakamoto Family Murders). Tokyo: Shinkōsha.

PENDLETON, Mark. 2008. 'Globalising Victims of Terror: Shared Memories and Memorialising in the Subway Sarin Incident Victims Association and the September 11th Families Association'. Proceedings of the 17th Biennial Conference of the Asian Studies Association of Australia, Melbourne, Australia.

———. 2009. 'Mourning as Global Politics: Embodied Grief and Activism in Post-Aum Japan'. *Asian Studies Review* 33(3): 333–47.

———. 2011. 'Subway to Street: Spaces of Traumatic Memory, Counter-memory and Recovery in Post-Aum Tokyo'. *Japanese Studies* 31(3): 359–71.

RAUSCH, Anthony. 2010. 'Post Heisei Merger Japan: A New Realignment in the *Dōshū* System'. *Electronic Journal of Contemporary Japanese Studies*, Discussion Paper 2, 20 April. Available at: http://www.japanesestudies.org.uk/discussionpapers/2010/-Rausch.html (last accessed on 27 August 2010).

READER, Ian. 2000. *Religious Violence in Contemporary Japan: The Case of Aum Shinrikyō*. Honolulu: University of Hawaii Press.

SIEGENTHALER, Peter. 2002. 'Hiroshima and Nagasaki in Japanese Guidebooks'. *Annals of Tourism Research* 29(4): 1111–37.

SIMPSON, David. 2006. *9/11: The Culture of Commemoration*. Chicago and London: University of Chicago Press.

SMITH, Terry E. 2006. *The Architecture of Aftermath*. Chicago and London: University of Chicago Press.

SWIFT, Jonathan. 2001. *Gulliver's Travels* (Robert DeMaria Jr. ed.). London and New York: Penguin Books.

TAKAHASHI Shizue. 1998. 'Hajimeni: Kono shuki o dasu ni atatte' (Introduction: On Why We Published This Collection) in Chikatetsu Sarin Jiken Higaisha no kai (ed.), *Soredemo Ikite iku: Chikatetsu sarin jiken higaisha shukishū* (Living On Even Then: Subway Sarin Incident Victims' Stories). Tokyo: Sunmark, pp. 1–4.

———. 2008. *Koko ni iru koto: chikatetsu sarin jiken no izoku toshite* (Being Here: As a Bereaved Family Member of the Subway Sarin Incident). Tokyo: Iwanami Shoten.

TAKAHASHI Yoshitomo. 1988. 'Aokigahara-jukai: Suicide and Amnesia in Mt. Fuji's Black Forest'. *Suicide and Life-Threatening Behavior* 18(2): 164–75.

TAKIMOTO Tarō. 2005. 'The Ten Years of the Aum Trial'. Translated by Yuko Kurashige and Jeremy Clark. Available at: http://www.cnet-sc.ne.jp/canarium/t-comment33-.htm (last accessed on 24 August 2010).

———. 2009. 'Fūka sasenai tame no ippōsaku: memoriaru an' ('One Way to Prevent the Fading of Memory: A Memorial Plan'). Unpublished paper distributed at the 14th Annual Memorial Service to victims of the subway sarin incident, Tokyo, 20 March.

TSURUMI Wataru. 1993. *Kanzen Jisatsu Manyuaru* (The Complete Manual of Suicide). Tokyo: Ōta Shuppan.

——— (ed.). 1994. *Bokutachi no 'Kanzen Jisatsu Manyuaru'* (Our 'Complete Manual of Suicide'). Tokyo: Ōta Shuppan.

TUMARKIN, Maria. 2005. *Traumascapes: The Power and Fate of Places Transformed by Tragedy*. Melbourne: Melbourne University Press.

YAMANASHI NICHINICHI SHINBUN. 2010. 'Oumu Chikatetsu Sarin jiken kara 15 nen, Kyū Kamikuishiki, kyōdan? Isan? ni jumin fukuzatsu' (Fifteen Years after the Aum Subway Sarin Incident: Ambivalence for Residents of the Former Kamikuishiki. Religion? Heritage?). *Yamanashi Nichinichi Shinbun*, 20 March, p. 1.

YONEYAMA, Lisa. 1999. *Hiroshima Traces: Time, Space and the Dialectics of Memory*. Berkeley and Los Angeles: University of California Press.

YOSHIMI Shunya. 2000. 'Consuming "America": from Symbol to System' in Chua Beng-Huat (ed.), *Consumption in Asia: Lifestyles and Identities*. London and New York: Routledge, pp. 202–24.

YOSHIMOTO Mitsuhiro. 1994. 'Images of Empire: Tokyo Disneyland and Japanese Cultural Imperialism' in Eric Smoodin (ed.), *Disney Discourse: Producing the Magic Kingdom*. New York and London: Routledge, pp. 181–202.

PART II

Exhibiting Death

Conflicting Sites of Memory in Post-Genocide Cambodia[1]

BRIGITTE SION

A new road connects the town of Siem Reap to Anlong Veng in northern Cambodia; it now takes less then two hours from the temples of Angkor to reach the last bastion of the Khmer Rouge, in what used to be a dense jungle. It is enough time for my driver, 31-year-old Vann, to tell me the story of his family.

'Every Cambodian family has lost relatives under the Khmer Rouge,' he says. Vann's mother lost her husband and children in the early years of Pol Pot's murderous regime. She remarried and gave birth to a new set of children, including Vann. 'A total of 10 family members died,' he sums up. Later, when Vann was in school, he was required, along with all residents of his village outside Siem Reap, to excavate the killing fields and exhume the bodily remains for cremation. 'The smell was horrible,' he recalls. 'I see too many bones. It scares me.' For years, Vann avoided the mass graves. 'My children don't know what happened.'

A Khmer song is playing in the car. 'Old music from the 1960s,' he says by means of introduction. 'The singer was killed.' We pass Anlong Veng and continue through the lush countryside and rice fields towards the Thai border. It takes a number of stops and questions, and a few dollars, to find the cremation site of Pol Pot, who was burned hastily in 1998 on a pile of rubbish. It is hidden behind a house, amid high weeds, junk and garbage. A low wooden fence and a rusty corrugated-metal roof mark the spot. Next to it, a faded blue sign in Khmer and English reads 'Pol Pot was cremated here. Please help preserve this historical site. Ministry of Tourism.' (figure 11).

There are plastic plates for offerings and small jars filled with burnt incense. As I start taking pictures of the site, Vann takes off his sandals, pulls out a lighter and ignites an incense stick as a tribute to the spirit of the dead. I cannot help but react strongly. 'Vann, what are you doing? Pol Pot was responsible for the death of 10 family members, and you are paying your respect to him?'

FIGURE 11. Pol Pot's cremation site. Anlong Veng Province, Cambodia, 2009. Photograph courtesy of Brigitte Sion.

Holding the smoking incense between his joined palms, he replies, 'I know, but it is a long time ago. It is time to forget.'

This vignette from the summer of 2009 illustrates the divided memory of the genocide perpetrated in Cambodia by the Khmer Rouge between 1975 and 1979, under the leadership of Pol Pot. Thirty years after a Marxist dictatorship—the self-proclaimed 'Democratic Kampuchea'—caused the death of about 1.5 million people (or a quarter of the population), collective memory inches its way through monuments, commemorations, an international court judging Khmer Rouge cadres, new textbooks and artistic productions. However, memorialization stands at the centre of conflicted interests—the government's politics of reconciliation, Buddhist beliefs in karma, economic development, mass tourism opportunities, international law and national historical narratives.

This essay examines the performance of memory in Cambodia through the lens of various memorials and commemorative practices: the major sites of

murder in Phnom Penh (the Tuol Sleng prison and the Choeung Ek killing fields), local repositories of victims' remains in villages, places associated with the perpetrators (such as Pol Pot's cremation site) as well as various holidays connected to the genocide. I look at the boom in memorials, the multiple functions they have to perform, the various populations and interests they serve, the different commemorations and ceremonies, and the resulting tensions. I argue that memorialization efforts take on different shapes and espouse conflicted narratives that serve opposing agendas, in which the memory of the Khmer Rouge's victims is not always the priority.

Many remarkable scholarly works have been written about the Khmer Rouge takeover, the establishment of Democratic Kampuchea, the atrocities committed against civilians in the name of Marxist ideology and the terrifying human death toll (Chandler 1999a; Kiernan 1996; Etcheson 2005; Hinton 2005).

In the last decade, a growing number of survivors published testimonies and memoirs about their personal suffering, mending their lives after the genocide or finding peace in exile (Nath 1998; Ung 2006; Chandler 1999b). Together with documentary films by Cambodian directors (who are often survivors themselves), these accounts brought the genocide to a larger international audience (Panh 2003; Saidnattar 2009; Poeuv 2006).

Cambodia has recently been in the news with the first trial of a Democratic Kampuchea leader under the auspices of the Extraordinary Chambers in the Courts of Cambodia. After the National Assembly passed a law in 2003 establishing an international court for the prosecution of crimes committed under the rule of Democratic Kampuchea, the first warrants against high-ranked leaders were issued in April 2004. The first defendant was Guek Eav Kaing, alias Duch, who was the commander of the Tuol Sleng prison (known as S-21 in the Khmer Rouge code). As such, he was responsible for sending over 14,000 people to their deaths after extended torture and inhumane treatment. Duch's trial, which spanned from 2009 to 2010, was the first opportunity to publicly document the genocidal operations and to memorialize the victims, since numerous civil parties were represented and scores of witnesses testified in memory of the dead. Another four top-ranked officials—Khieu Samphan (alias Hem), Ieng Thirith (alias Phea), Ieng Sary (alias Van) and Nuon Chea, all elderly—have been indicted for crimes against humanity and detained since 2007. They are awaiting trial, provided they do not die first, as did Pol Pot and Ta Mok ('the butcher').

Although these trials have generated new research on the genocide and the remembrance of victims, little has been written about the memorialization efforts, especially in relation to memorial sites and commemorative practices. The articles written by Paul Williams (2004) and Judy Ledgerwood (1997) espouse an anthropological and museum studies perspective but focus exclusively on the centre of the Khmer Rouge killing machine, Tuol Sleng and Choeung Ek. Rachel Hughes (2006) is one of the rare scholars to have explored local genocide memorials as well, albeit briefly.[2] Here, I examine a variety of memorial sites and commemorative practices, embracing the hyper-local and the transnational, as well as political, economic and religious motivations.

Over a hundred memorial sites are related to the genocide in Cambodia, from mass graves to urns and ossuaries to public artworks, but most of them are scattered in the provinces and not easily identifiable by foreign visitors. This partially explains why local memorials have not generated much scholarship. However, the main reason that national and international attention turned to Tuol Sleng and Choeung Ek lies in the original agenda of these memorials. Both sites were the first 'genocide museums' that meant to display the crimes of the Khmer Rouge while primarily fulfilling a political agenda. In other words, Tuol Sleng did not become a tourism destination over time; curatorial and marketing strategies to attract visitors have been essential since its inception.

When 100,000 Vietnamese troops invaded Cambodia in January 1979, those who stormed the barricaded compound of Tuol Sleng found dead bodies in shackles, fresh bloodstains on the walls, human bones, torture instruments, photographic archives and memos left by the Khmer Rouge who had just fled. On the one hand, while the Khmer Rouge were physically eliminating thousands of people and making the identification of human remains impossible, on the other, they were meticulously documenting their crimes—mug shots of those imprisoned, tortured and killed; volumes of 'confessions' obtained under pressure; lists of names given under duress—a paradoxical policy of erasure and evidence not unlike that of the Nazis.

The army preserved everything and immediately asked a Vietnamese museum expert, Mai Lam, to turn Tuol Sleng into a museum that would document the crimes of Democratic Kampuchea. Mai Lam was a colonel in the Vietnamese army who had fought in Cambodia during the first Indo-China war and had previously organized the Museum of American War Crimes in

Ho Chi Minh City. He came with experience and with an agenda. The genocide museum opened a year later, in 1980, first to foreign dignitaries and later to the general public.

A former school, Tuol Sleng consists of four three-storey concrete buildings round a grassy courtyard planted with palm trees. A wall with an entrance gate surrounds the compound. To the left of the courtyard, next to the hanging pole, are 14 tombstones of the dead bodies found by the Vietnamese army. To the right, a gift shop sells bootlegged books and DVDs about the genocide, as well as Cambodian arts and crafts; next to it, one can buy cold drinks at a stand. The first building includes the torture rooms, each with a rusty metal bed, some torture instruments (such as shackles) and a photograph on the wall that shows the room at the time of its discovery—with a dead body on the bed and blood on the floor. The objects are not protected or cordoned off; no signs prepare the visitor for what is inside. As the *Lonely Planet* guidebook warns, 'Tuol Sleng is not for the squeamish' (Ray and Robinson 2008: 85).

The mirror effect of the old photograph in the empty room is unsettling; some visitors move round to capture the same angle as the photograph and compare details. Others find the stains on the pillow, the proximity of death and the raw photograph repulsive. The shock value is obvious and so is the staging of objects and pictures. The display of physical horrors clearly served political goals earlier: it helped to justify the Vietnamese presence in Cambodia and its image as liberators from the 'genocidal clique' of Pol Pot and others (who were tried and condemned in absentia in 1979) and to legitimize the People's Republic of Kampuchea (PRK), the new government that had been installed by the Vietnamese. Now it operates as a major tourist attraction that counts on the horror on display to generate substantial income.

In the second wing hang hundreds of black-and-white photographs that look like police mug shots: these are of the prisoners of Tuol Sleng, photographed before, during or after torture. Many faces reflect physical pain, terror, anger, despair or panic. They now stare at the tourists who try to make sense of what happened. This building also contains thousands of pages of forced confessions obtained under torture or with the false hope that they could ease a prisoner's fate.

The third wing's classrooms are divided with brick walls into minuscule individual cells for important prisoners. The fourth wing includes pictures of the perpetrators and paintings made by survivors, including Vann Nath's (1998)

depictions of torture scenes. One room is used to display a gigantic map of Cambodia made of skulls and bones, with blood-like streaks representing rivers. 'The map is shocking and disturbing, the emotional climax of the tour,' writes Ledgerwood (1997). It was removed in 2002 and replaced by a photograph of the map. However, skulls, under glass cases, are still on display at Tuol Sleng. According to David Chandler, the map—the work of Mai Lam—was supposed to describe more than the scope of the crime:

> It was important for the Vietnamese and the PRK to label Democratic Kampuchea a 'fascist' regime, like Nazi Germany, rather than a Communist one, recognized as such by many Communist countries. Finally, it was important for the Vietnamese to argue that what had happened in Cambodia under [Democratic Kampuchea], and particularly at S-21, was genocide, resembling the Holocaust in World War II, rather than the assassinations of political enemies that at different times had marked the history of the Soviet Union, Communist China, and Vietnam' (2001: 29).

The post–Khmer Rouge discourse is very similar to that of the German Democratic Republic after the Second World War. This state aligned itself with the Soviet Union in denouncing the fascist crimes of (West) Germany and siding with the liberators. In the case of Cambodia, the Vietnamese forces and the new DRK government divorced the labels 'communist' or 'socialist' from Democratic Kampuchea, in favour of 'Pol Pot's genocidal clique', 'traitors of the people' and 'fascists', so as to position themselves as liberators, even though they were communists.

The Tuol Sleng Museum also served to divert national and international attention from the need for justice. Instead of addressing the past, the new regime—the People's Republic of Kampuchea—promoted national 'reconciliation', an effective strategy to turn the page and avoid accountability. The reason had to do with the Cambodian political cadres who joined the new government: most of them were former Khmer Rouge officials who participated in or witnessed crimes. Prime Minister Hun Sen is no exception. A former member of the Khmer Rouge elite, he escaped to Vietnam and joined a rebel army. After the Vietnamese takeover in 1979, he was naturally appointed foreign minister; in 1985 he was appointed prime minister, a position he has held ever since. Like many of his fellow ministers, he refers to the Khmer Rouge with great caution and clear distancing.

102

Not surprisingly, Hun Sen publicly stated that the United Nations–backed tribunal on Khmer Rouge atrocities should not prosecute additional suspects besides the five already indicted.[3] 'Under these circumstances, it is easy to see why no process resembling "denazification" ever occurred in Cambodia,' writes Suzannah Linton (2004: 12).

> None of the reformed Khmer Rouge/CPK who now form the backbone of the Establishment has ever expressed contrition or regret about the past. They have adjusted their memories in ways that many victims find impossible to do. 'Then was then', they seem to be saying, 'and now is now'. For many victims of the Khmer Rouge, on the other hand, 'then' recurs, traumatically, every day (ibid.).

Another reason to understand Tuol Sleng as a promotional tool for the post–Khmer Rouge government is confirmed by the types of visitors allowed inside. Whereas the museum did not open to the general public until July 1980, it offered private tours to guests as early as March 1979, barely two months after the Vietnamese discovered dead bodies and fresh blood. The first guests were mostly members of socialist parties from abroad. The rush to turn a death site into a gallery for visitors is another indication that the new leadership had less concern about the memory of victims than about using the site for immediate political purposes. 'A 1980 report from the Ministry of Culture, Information, and Propaganda said that the museum was "used to show the international guests the cruel torture committed by the traitors of the Khmer people" ' (Ledgerwood 1997: 88). When nationals were allowed to visit on Sunday, thousands came to Tuol Sleng, many to find information about lost relatives.[4]

In the course of time, the number of Cambodian visitors decreased, whereas statistics for foreign visitors increased. Since 1993 and the establishment of the Kingdom of Cambodia, the prison has seen thousands of tourists from capitalist countries (Australia, Japan, South Korea, United States, France, Germany, etc.). Consequently, it has adapted its offering to mass tourism: a US$3 entrance fee charged to foreign visitors, guided tours, marketing with travel agents, pamphlets in various languages, bathrooms, a souvenir shop, a food and drink stand, and parking areas. The neighbourhood too has developed accordingly, with numerous shops selling arts and crafts, rickshaw drivers hailing potential customers and beggars working for their daily pittance.

The current guestbook in which visitors can write comments shows a uniformity of messages that can be sorted in five categories: feelings of sadness;

bewilderment at human evil ('I can't believe this country had to suffer such a terrible fate'); variations on 'never again' and 'do not forget'; praise for the exhibit and the learning experience; and positive messages of hope, peace, reconciliation and love, sometimes with a religious reference.[5] Visitors often mention other regions of the world where human rights are or were violated—Myanmar, Angola, Chile and others. These stereotypical messages, whether written in English, Spanish, French, Hebrew, Korean or German, can describe many other sites of terror, from Auschwitz to Kigali to Srebrenica to Buenos Aires. Just as tourism is available to the masses, memory and memorialization are becoming globalized, inspiring the same emotions, standardizing architecture and curatorial practices, and blurring the uniqueness and specific historical context of each tragedy.

Thirty years after Tuol Sleng became a museum to document, archive and educate about the Khmer Rouge genocide, it has also become a bestseller in the international tourism industry, but not a memorial for locals who suffered from the Khmer Rouge. It has become a symbol for 'thanatourism', defined by A. V. Seaton as 'traveling to a location wholly, or partially, motivated by the desire for actual or symbolic encounters with death, particularly, but not exclusively, violent death' (1996: 240). Thanatourism is a subgenre of tourism, an industry usually dedicated to leisure, time out and escape. Its goal is to market attractions and pleasurable experiences rather than moral uplift. Marketing a memorial requires a delicate negotiation between staying true to the serious purpose of the memorial and promoting it as an attractive destination that recounts a country's negative history. Tuol Sleng is still struggling to find a sensitive balance.

The same can be said of the other main site of the Khmer Rouge genocide, the killing fields of Choeung Ek, also discovered by Vietnamese troops and turned into a tourism site by Mai Lam in the early 1980s. Located 10 miles southeast of Phnom Penh, Choeung Ek is described, on the official flyer, as 'hell on earth in the 20th century'. A former orchard and Chinese cemetery, Choeung Ek was the main killing field in 1977–78 where prisoners from Tuol Sleng were transported to be murdered. When the Vietnamese troops discovered the site, they found about 9,000 bodies in mass graves; many were headless, naked, their hands tied; the separated heads were blindfolded. The skulls and bones showed traces of bullets and evidence of the use of knives and other forms of violence inflicted upon men, women and children. Babies were thrown against trees and instantly killed.

Choeung Ek opened to the public in 1989, after Lim Ourk was commissioned to build a monumental stupa where 8,000 skulls and bones would be preserved. A stupa, according to Hughes, is 'a sacred structure that contains the remains of the deceased—especially those of greatly revered individuals—in Buddhist cultures. The construction of stupa is a significant activity that produces merit for the living and encourages the remembrance of the dead' (2006: 261). This stupa was inspired by Khmer religious motifs, such as the snakes (*naga*) and lions that guard the edifice, and by traditional architecture—the roof and pediments resemble the Royal Palace in Phnom Penh. However, contrary to stupas in other parts of the country, this one contains the anonymous remains of ordinary people.

Through the glass doors, one can see hundreds of skulls and human bones stacked almost to the top of the 62-metre-high structure. The glass doors are ajar, and the skulls stare at the visitors. Foreign tourists constitute over 90 per cent of the total visitors, according to the statistics for 2007 and 2008 released by the administration of the memorial.[6] In line with these statistics, the development and management of the site seem to be entirely geared towards international tourism. The mission statement on the official flyer announces, 'Choeung Ek Killing Field became a historical museum for humankind and is one of the most popular attractions for both domestic and foreign tourists in Phnom-Penh.'[7]

The official management policy lists the following goals: 'Preserve genocide history [. . .]; make Choeung Ek an international symbol of genocide; bring Choeung Ek to the attention of the world; make Choeung Ek a model for conservation.'[8] The means to achieve the goals include improving communication with tourists, generating income by attracting more tourists, finding alternative sources of income aside from the entrance fee and developing ties with other tourism sites such as Tuol Sleng. The strategic plan recommends 'the progressive enhancement of the facilities so as to increase income by providing resting chairs, a coffee shop, a restaurant, a souvenir and bookshop and toilets; the development of a calendar of special events, information projects, [and] lectures that will eventually attract 1,000 visitors per day.' The notions of remembrance or memory are almost absent from the official document; so are Cambodian nationals, who do not seem worthy of much attention, as opposed to paying international tourists.

This situation may have to do with the 2005 takeover of Choeung Ek by a Japanese corporation, JC Royal, which obtained from the Cambodian government

a 30-year license to operate the site in exchange of an annual US$15,000 fee and the award of a few scholarships to needy Cambodian students. The agreement between the government and the private company created a major controversy; to this day, the profit made from Choeung Ek remains a mystery, as do the operating budget and the number of scholarships allotted (see Chheang 2008). What is clear is that the killing fields are a source of profit whose beneficiaries are neither survivors nor relatives of victims.

Meanwhile, some effort has been spent on beautifying the site—the lawns and flowers are well kept, the tar road and the gate are recent additions—and adding amenities such as toilets, a gift shop, a cafe as well as an air-conditioned screening room with comfortable chairs where a short documentary about the genocide is shown every half hour. Besides the traditional arts and crafts, books and postcards, the Choeung Ek gift shop also sells the complete Khmer Rouge attire—red checkered scarf, black uniform, rubber sandals—as well as T-shirts that depict the stupa, or landmines, or bones over the Cambodian map. According to the management policy, beggars are kept outside the entrance gate so as not to disturb the tourists.

FIGURE 12. Entrance to the Choeung Ek stupa (killing fields). Phnom Penh, Cambodia, 2009. Photograph courtesy of Brigitte Sion.

Visitors wander freely in the vast compound that includes excavated pits with signs bearing minimalist descriptions: 'mass grave of 166 victims without heads'. There is no trail to follow, no itinerary. Some excavated pits are fenced, other graves are untouched, and people often walk on clothes and bones that stick out of the ground. Nobody pays attention to the rules displayed at the entrance, such as 'please dress suitably while remaining at the center' or 'bones and other items in the center are not allowed to [be] take[n] out'. In fact, most foreign visitors wear light summer clothes such as shorts and sleeveless T-shirts; some stand by the stupa drinking soda or smoking, while others touch the skulls through the open door (figure 12).

Next to the stupa, there is a small and outdated outdoor exhibition with photographs and didactic panels translated in poor English:

> Even in the 20th century, on Kampuchean soil, the clique of Pol Pot criminals had committed a heinous genocidal act. They massacred the population with atrocity in a large scale. It was more cruel than the genocidal act committed by the Hitler fascists, which the world has never met . . .
>
> The method of massacre which the clique of Pol Pot criminals was carried upon the innocent people of Kampuchea cannot be described fully and clearly in words because the invention of this killing method was strangely cruel so it is difficult for us to determine who they are for. They have the human form but their hearts are demon's hearts. They have got the Khmer face but their activities are purely reactionary. They wanted to transform Kampuchean people into a group of persons without reason or a group who knew and understood nothing, who always bent their heads to carry out Ankar's orders blindly.

The new management has barely updated the narrative, the panels, or the leaflets available on premise, except for the non-credited paragraphs plagiarized from Hughes's article. Little historical background is given on how the Khmer Rouge came to power, what drove their ideology, how they implemented their genocidal policy or how they were later defeated.

Not surprisingly, a recent survey among foreign visitors showed that 'victims at this site are represented as a vague aggregation of grim experiences. None are individually named, and no victim's biography is recounted . . . The perpetrator is represented as a barbaric "genocidal clique" without further definition,

biography, or images' (Bickford 2009: 13). Despite the sustained increase in tourists and the additional exposure gained from Duch's trial taking place minutes from Choeung Ek, the management has made minimal improvements to the site.

The high point of Choeung Ek is not didactic but visual—the stupa and its stacks of skulls at a hand's reach. Skulls are aestheticized—clean, neatly arranged in a window case—and their endless accumulation turns the victims into statistics. The shock value of this raw display lies both in the proximity of death and in the objectification of human remains, in the tension between the educational agenda of the memorial site and the commodification of genocide. A national debate arose after the discovery of thousands of unidentified and often incomplete dead bodies: Should they be preserved? Cremated? Buried? The government argued in favour of preserving and exhibiting human remains as evidence of the crimes perpetrated by the Khmer Rouge and as a pedagogical resource to educate the Cambodian population. This attitude served the propaganda of the time, which emphasized the crimes of the Khmer Rouge regime so as to affirm the control of the country by the 'clean' PRK party. As seen in the writings of Ian Harris, the king held the opposite view:

> Sihanouk and prominent members of the Buddhist order have given quite vocal support to the idea that all the bones of the dead should be gathered together and given a mass incineration in tune with Buddhist values. The resulting ashes would then be enshrined in a national stupa envisaged as offering the possibility of rebirth both to the individual victims and the nation as a whole. In February 2004, the King made the following characteristically robust statement on his website: 'What Buddhist man or woman accepts that, instead of incinerating their dead relatives [. . .] one displays their skulls and their skeletons to please "voyeurs"? (2007: 233).

According to Khmer Buddhism:

> The souls [. . .] of persons who die sudden deaths, (that is, deaths) considered to be [. . .] untimely deaths, deaths which are not good, will remain around the place where they died. They will not be reborn as is ordinarily the case. Villagers fear (these souls) very much, fear that the spirits of those who died sudden deaths [. . .] will haunt [. . .] them or cause good people to fall ill (Anusaranasasanakiarti and Keyes 1980: 14).

Traditionally, people who die suddenly or violently are cremated or buried as quickly as possible, on the site where they died. A violent death is particularly inauspicious; cremation immediately following death allows the spirit to move into the next karmic realm, instead of haunting the place of death forever. However, in the case of mass murder, where bodies were often dismembered, putrefied, impossible to identify, mixed with others in mass graves and discovered years after the death, many Cambodians faced a religious dilemma and eventually seemed to support the preservation of skulls and human remains. 'This support is reinforced by an underlying belief in Buddhist tradition that people can cremate only the remains of their family members. Because virtually no individuals in the country's killing fields have been identified from their remains, cremation could pose some obstacles in Cambodia' (Cougill 2007: 37).

If traditional rituals cannot be performed, one can understand that Cambodians have no personal or religious stake in the human remains on display at Choeung Ek. This would also explain the relative lack of interest from Cambodians in Choeung Ek as a memorial. As Mary Brooks and Claire Rumsey observe:

> Both religious relics and bodies in museums are recontextualized human remains, removed from the graveyard or tomb, sites often associated with both literal and metaphorical pollution, into another sacred context where they are preserved for a different function. [. . .] Museums objectify the bones conceptually for research and display. Whether the motivation is theological or analytical, macabre or morbid, the display of dead bodies is an increasingly contested issue. Displaying bodies can serve as connection of the past with the present, and the dead with the living, offering succor, solace, inspiration, or information, but it also renders them ambivalent, both 'persons and things' (2006: 261).

The bones in Choeung Ek have lost their spiritual value and elicit only mild interest from locals. They serve a higher purpose as evidence or educational tool than as an improbable vehicle for karmic reincarnation and personal closure. For tourists, the skulls still carry a shock value, but it is sanitized by the transformation of human remains as objects typically on display behind glass.

However, in villages where people were killed and buried on premises, the bones retrieved from local mass graves have kept their spiritual connection. As my driver, Vann, recalled from his youth, the whole community took part in the excavation and transfer of remains into a stupa, often near the village's

temple. This participatory act was not always spontaneous and sometimes responded to repeated government calls, which asked 'all local authorities at the province and municipal level [to] cooperate with relevant expert institutions in their areas to examine, restore and maintain all existing memorials, and to examine and research other remaining grave sites, so that all such places may be transformed into memorials' (in Cougill 2007: 40). The excavation of pits and transfer of human remains into a stupa was not a sheer forensic act; it was a religious ritual that had to be performed by spiritual leaders.

In the years following Democratic Kampuchea, meeting the required quorum of monks to lead such ceremonies became a challenge. Over 60,000 monks had been killed or left Cambodia under the Khmer Rouge rule. According to Harris, 'Ordination in the early post–Khmer Rouge period proved difficult. [. . .] Some took to shaving their head and wearing white and, in this way, Buddhist ceremonies, particularly those commemorating the dead, were performed' (1999: 66). The responsibility for completing the physical transfer of bones and for the religious rituals fell to laypeople—who were all survivors and mourners. As of 2007, the Documentation Center of Cambodia has identified close to 20,000 mass graves and 81 memorial sites located throughout the country (Veneciano and Hinton 2007: 109).

One such local memorial stands at Kampong Tralagh, in the Kampot province, southwest of Phnom Penh, not far from the Vietnamese border. Most villagers work in the adjacent rice fields. In the heart of the village is a majestic old pagoda, tall, well kept and beautifully decorated. Its typical Khmer architecture echoes the Royal Palace and the Choeung Ek stupa: the four receding roofs each have an ornate triangular pediment that is guarded by erect snakes. The white, gold and orange pagoda is surrounded with lush greenery; the area is very quiet, even with workers toiling in rice fields.

A few feet away stands a much more modest edifice—a little house painted white, with a traditional roof and erect snakes. It is small, almost invisible in the shadow of the impressive pagoda. The door is open. The single room is split into two, one side for skulls, one side for bones. Hundreds of bones piled up. If my driver had not asked about it, I would not have known about the village and the bone repository, though dozens of them can be found in Cambodia, often built near a pagoda so as to balance good and evil. The local ossuaries were built by villagers who are believed to have reclaimed their dead, their history and their spiritual lives.

Penh Samarn, patriarch monk at the Kroch Seuch pagoda, who initiated the construction of a memorial, combines a spiritual and a practical perspective:

I do not want to lose the evidence, so that people from various places can come to pray and pay homage to the dead. [. . .] I am thinking of having monks stay there and for people to come and pay homage because some souls of the dead have made their parents or children dream of them, and told them that they are wandering around and have not reincarnated in another world. I want to have monks meditating there so that the souls of the dead will rest in peace. In Buddhism, when someone dies and their mind is still with this world, then their souls wander around (in Cougill 2007: 40).

Local villagers honour the dead on various occasions, often individually. In Rithy Panh's (2003) film on S-21, in which he interviews former Khmer Rouge criminals, the parents of a former soldier beg him to hold a religious ceremony to chase the evil spirits. 'Hold a ceremony so that we never see those men again. Become a new man [. . .]. Tell the truth, then have a ceremony. Make an offering to the dead so that they find peace, so there is no more bad karma in the future. Ask the dead to remove the bad karma' (ibid.). A communal occasion to commemorate the dead takes place on the Day of the Ancestors, Prachum Benda or Pchum Ben, a 15-day period that falls some time around September and October according to the lunar calendar.

Throughout this period that begins on the first day of the waning moon, people go to the temples and stupas with offerings for the spirits of the ancestors. The monks serve as intermediaries between the living and the spirits of the dead; they chant daily prayers that are also broadcast on the radio. On the last day, people bring dozens of Cambodian cakes wrapped in banana leaves and have a *bansolkaul* performed for their ancestors—a ceremony 'in which four monks recite texts while connected by a white cord to an urn containing ashes of ancestors. In this way, merit is transferred to the departed. [. . .] Most families visit seven wat over the festival period to ensure the goodwill of their hungry and restless ancestors' (Hughes 2007: 269–70).

For many Cambodians, remembrance of relatives killed under the Khmer Rouge regime takes place during the Festival of the Ancestors and at the local wat. A traditional Buddhist holiday, Pchum Ben took additional significance after the genocide, since it gave people an opportunity to grieve and commemorate the dead even without proper funerary rites. This ancient ritual is widely

followed in Cambodia, in contrast to two other holidays established by PRK rule, 7 January and 20 May.

Victory Day (variously known as 'Victory over Genocide Day' or 'Nation Day'), observed on 7 January, commemorates the fall of the Khmer Rouge regime and the liberation of Cambodia by the Vietnamese army in 1979. Similarly to the Tuol Sleng exhibit that aimed at denouncing the crimes of the Pol Pot genocidal clique and legitimizing the new Cambodian government, the 7 January date is a political holiday that does not commemorate the victims but rather praises the saviours. It consists of a patriotic parade followed by a speech from a top-ranked party official who celebrates national unity, as did Senator Chea Sim in 2004, for the twenti-fifth anniversary:

> It was no doubt that our homeland was on the brink of extinction if there was no salvation in a timely manner.

> The coming into existence of the Kampuchea National Salvation and Solidarity Front, which was the forerunner of the Cambodian People's Party, on 2 December 1978 fully responded to the aspirations of the Cambodian people and peace and justice loving people in the world as a whole. Under the leadership of 2 December Front, the people throughout Cambodia stood up and united as the greatest national solidarity force coupled with the sincere and timely support from the Vietnamese volunteer army as well as our friends both near and far, had fiercely fought against the Pol Pot genocidal regime (in *Asia Africa Intelligence Wire* 2004).

In 2009, for the thirtieth anniversary, the Cambodian People's Party celebrated the day in an Olympic stadium filled with 50,000 attendees—party members, civil servants and students from all Cambodian provinces—who gathered to hear slogans and speeches glorifying the party (see Sokha 2010). This commemoration has never caught on with the Cambodian population, for which Vietnam was not only a liberator but an occupier, and the event has remained a day of self-congratulation for the Cambodian People's Party, which has been in power ever since.

The other holiday instituted by the party is the Day of Anger, or *tivea chang kamheng*. It falls on 20 May, the day when, according to Linton:

> the Khmer Rouge adopted the 'cooperative scheme', a policy of total agrarian collectivization that transmuted the [Khmer Rouge] from

progressive communist revolutionaries to an extremist regime [. . .]. It was the beginning of the people's starvation [. . .]. It was the day the Khmer Rouge began to kill people by forcing them to accomplish labour-intensive works with little food allowance (2004: 63).

This is another example of a negative date that is politically motivated and based on the Gregorian calendar; it is not associated with the Khmer calendar or an existing religious tradition. 'This unusual holiday has effectively focused public opinion on the "otherness" of the Khmer Rouge, solidifying popular support for the regime' (Etcheson 2005: 150).

When the commemoration was instituted in 1984, it comprised public condemnations of Khmer Rouge crimes organized by official institutions— political rallies and speeches, banners and posters bearing slogans, songs and prayers recited in schools, and wreath laying at memorial sites such as Choeung Ek. Survivors were asked to tell their individual stories, and villagers often carried knives, axes, clubs or placards saying things like 'Defeat the Pol Pot, Khieu Samphan, Ieng Sary clique' or 'Remember Life under Pol Pot who tried to destroy the Cambodian Lineage'. These orchestrated activities reinforced the core message of the day: be aware of the crimes committed by the Khmer Rouge and be vigilant against their possible return. At the time, Pol Pot and his comrades were still hiding in the jungle near Anlong Veng, engaging in guerrilla warfare against the government.[9]

This official holiday was suspended after the 1991 Paris peace agreement, so as 'not to arouse a spirit of revenge' (ibid.). It was quietly promoted again around 1999 but is not often observed except by faithful party members. A news article from 2010, with the headline 'A "Day of Anger" Less and Less Attended in Cambodia', described the religious ceremony that took place at Choeung Ek in the presence of a few hundred people (see Chheang 2010). Some Cambodians say that over the years they have shed their anger; others feel less concerned by events that occurred 30 years ago. For the most part, however, 20 May does not constitute a meaningful date nor is the acting out of hatred an effective way to mourn the victims, fulfil religious obligations vis-à-vis the dead and find closure. The ceremonies have been too politically charged and have never explicitly acknowledged the responsibility of the state in the genocide. As Nath, the painter who survived Tuol Sleng, argues, 'No word of forgiveness, of acknowledging that something wrong was done by the leaders, only "reconciliation". They don't even say it was wrong! Why ask for forgiveness if they did nothing wrong?'[10]

These official ceremonies neither remember victims nor comfort survivors; they are self-serving spectacles that feed the ambiguous discourse of the government and its manipulation of commemorative performances and memorial sites for political and economic purposes. The post-1979 Cambodian leaders turned Choeung Ek and Tuol Sleng into efficient money-makers benefiting from international tourism. They considered piles of skulls and bones as a sheer commodity that, once publicly exhibited, covered up the involvement of the former Khmer Rouge still active in public affairs and enjoying complete impunity. They established artificial commemorations that did not acknowledge the suffering of the Cambodian people, the responsibility of the state in the genocide, or the need for mourning rituals, moral and material reparations and complete accountability.

Instead, a hungry strategy of profit-making has prevailed, to the detriment of human dignity and memory. As Youk Chhang, director of the Documentation Center of Cambodia, confided, 'There is nothing in Cambodia that is not for sale.'[11] The most recent illustration of this statement is the official announcement that the government had decided to 'preserve and develop' Anlong Veng, the last Khmer Rouge stronghold, and transform the town and the area into a 'historic tourism site for national and international guests to visit and understand the last political leadership of the genocidal regime' (in Buncombe 2010). The head of the Anlong Veng district, Yim Phana, mentioned 14 sites, among them Pol Pot's cremation site, Ta Mok's grave, his former house, an ammunition depot, and other decrepit buildings and abandoned vehicles located in the northern part of the country near the Thai border. A circular from the prime minister dated 14 December 2001 already announced this agenda (see Royal Government of Cambodia 2001).

At the time, a few blue signs in Khmer and English were affixed near Khmer Rouge sites, sometimes indicating a 'historic attractive site'. There is still a decrepit shack called the 'Tourism Information Office of Anlong Veng', where a woman nursing her young children charges US$2 to foreign visitors. A faded map of the province hangs next to a list of sites divided into four zones: the first round Ta Mok's house, the second round Pol Pot's cremation site, the third round the Son Sen's house and the fourth round Pol Pot's and Khieu Samphan's houses. Among the eight sites I visited in August 2009, none offered any kind of historical description; I relied on my local driver and my *Lonely Planet* (which gave detailed instructions on what to see and how to reach these far-flung ruins.)

The sites to be promoted have little interest per se. Ta Mok's secret house, or the three walls that are still standing, is lost in high grass and covered with graffiti, including 'Ta Mok assassin de l'histoire' (Ta Mok, history's assassin). The last house in which he lived after the fall of Democratic Kampuchea is empty, except for large naive frescoes that depict Cambodian landscapes— Angkor Wat, wild animals in the jungle, the rice fields. The windowless house faces a desolate view of dead trees and muddy swamps, the result of Ta Mok's flooding of the fields to create an artificial lake. The Khmer Rouge radio command is a rusty truck abandoned in a courtyard. These ruins are neither informative nor moving; the plan to transform them into 'attractive' sites of tourism betrays yet another commercial venture rather than the need to preserve and teach history.

Until now, most visitors of these Khmer Rouge relics were Cambodians who felt some nostalgia for the regime (especially in the Anlong Veng region), pilgrims who believed that a prayer on Pol Pot's or Ta Mok's grave would bring good omens, and a handful of tourists.[12] With the construction of the new road, the announcement of the prime minister's office, the prospect of generating profit and the commercialization of sites associated with the genocide, one can expect more traffic in this province in the years to come. At the same time, a former Khmer Rouge soldier and photographer, Nhem En, now an elected official of the Anlong Veng district, is attempting to raise US$300,000 to build a museum to display 2,000 of his own photographs depicting the leaders of Democratic Kampuchea, 'so that the world knows why Pol Pot ruled the country and massacred people'.[13] Nhem En's project encapsulates the larger political situation, in which the guiltless former Khmer Rouge enjoys impunity, currently sits on city councils and uses Cambodia's darkest history to generate personal income.

Today, Cambodians find themselves torn between religious traditions and national politics, between memorialization efforts and economic demands. National memorial sites and holidays have been co-opted by a government in constant quest for legitimacy and forgetful of its past responsibility. Whether in Tuol Sleng, Choeung Ek or Anlong Veng, whether on 7 January or 20 May, the Cambodian people have been left out of the picture. The establishment of the international court allowed for a public and genuine expression of memory, but future trials are uncertain, and the next generations feel less concerned about the past.

In Cambodia, memory and memorialization are not performed either in the main sites of murder such as Tuol Sleng and Choeung Ek or on official

holidays such as 7 January and 20 May. It is clear that these government-sponsored memorials primarily serve other purposes—political legitimacy, economic development and profit-making ventures. They are not directed towards locals who have a personal connection to memory but towards international travellers who feed the global tourism industry and the national economy. To this end, all strategies have become acceptable, even if they involve commodifying skulls, capitalizing on human suffering, promoting sites associated with criminals and ignoring religious traditions.

In Cambodia, remembrance of the genocide does take place, but quietly, traditionally and locally—in each village, in each stupa, next to the pagoda, on religious holidays. There, human dignity is respected, mourning rituals have meaning and the spirits of the murdered can eventually find rest.

Notes

1 This essay was written with the support of 'Transitions', a centre for international research in the humanities and social sciences established between New York University and the Centre National pour la Recherche Scientifique (CNRS, France). I thank the directors of Transitions, Emilienne Baneth-Nouailhetas, Edward Berenson and Christophe Goddard, for suggesting and financing a research trip to Cambodia in August 2009. This article was originally published in *Humanity: An International Journal of Human Rights, Humanitarianism, and Development* 2(1) (Spring 2001): 1–8, 14–21. Reprinted with permission of the University of Pennsylvania Press.

2 It is worth noting that this article has been almost entirely plagiarized by the Choeung Ek Memorial—full paragraphs were extracted and used on the panels of the indoor exhibition and on the official website, without ever giving credit to the author or to the journal in which it was originally published.

3 See, for example, the press release published by Human Rights Watch (2009).

4 Judy Ledgerwood (1997) writes that 32,000 Cambodians came the week of 13 July 1980. From January to October 1980, 11,000 foreigners and 309,000 Cambodians visited Tuol Sleng.

5 Note written by Amber Martin, from Perth, Australia, in August 2009, for the long citation.

6 In 2007, 13,000 Cambodian and 181,000 foreign visitors were recorded; in 2008, 15,000 Cambodians and 195,000 foreigners visited. See 'Statistics' for the detail by month from 2005 to 2008 on the official Choeung Ek Genocidal

Center website: http://www.cekillingfield.com/ statistics.htm (last accessed on 10 July 2010).

7 See 'About Choeung Ek' on the official Choeung Ek Genocidal Center website: http://www.cekilling- field.com/aboutchoeungek.htm (last accessed on 10 July 2010).

8 'Management Policy for Choeung Ek Genocide Center', document in Khmer given by Choeung Ek deputy director Ros Sophearavy on 12 August 2009 and translated into English by Sin Saroeun.

9 The choice of a negative date such as 20 May echoes Argentina's commemoration of 24 March, based on the 1976 military coup that led to the Dirty War and the policy of forced disappearances. However, the day was appropriated early on by human rights activists as a day of *repudio*, or repudiation, and used to advance their agenda—prosecution of criminals, reparations to survivors and relatives, memorialization efforts and education. In 2006, this date was made official as a national holiday by the government.

10 In an interview in Rithy Panh's film *S21: The Khmer Rouge Killing Machine* (2003).

11 Youk Chhang, private interview by the author, Phnom Penh, 10 August 2009.

12 It is interesting to note that Hitler's Berlin bunker, in which he died, was never marked as such, so as to prevent pilgrimages from neo-Nazis; the opposite approach seems to prevail at Pol Pot's cremation site.

13 Nhem En, private interview by the author, Siem Reap, 13 August 2009.

Works Cited

ANUSARANASASANAKIARTI, Phra Khru, and Charles F. Keyes. 1980. 'Funerary Rites and the Buddhist Meaning of Death: An Interpretative Text from Northern Thailand'. *Journal of the Siam Society* 68(1): 1–28. Available at: http://www.siamese-heritage.org/jsspdf/1971/JSS_068_1b_PhraKhruAnusaranasasanaKiartiKeyes_Fune raryRitesAndBuddhistMeaningOfDeath.pdf (last accessed on 13 September 2013).

ASIA AFRICA INTELLIGENCE WIRE. 2004. 'Chea Sim's Speech at Cambodian Victory Day Celebration', *Asia Africa Intelligence Wire*, 8 January. Available at: http://www.access-mylibrary.com/ coms2/summary_0286-19930942_ITM (last accessed on 10 July 2010).

BICKFORD, Louis. 2009. *Transforming a Legacy of Genocide: Pedagogy and Tourism at the Killing Fields of Choeung Ek*. New York: International Center for Transitional Justice.

BROOKS Mary M., and Claire Rumsey. 2006. 'The Body in the Museum' in Vicki Cassman, Nancy Odegaard and Joseph Powell (eds), *Human Remains: Guide for Museums and Academic Institutions*. Lanham, MD: Altamira Press, pp. 261–8.

BUNCOMBE, Andrew. 2010. 'Cambodia Puts the Cremation Site of Pol Pot on "Historic" Tourist Trail'. *The Independent* (London), 11 March. Available at: http://www.independent.co.uk/news/world/asia/cambodia-puts-the-cremation-site-of-pol-pot-on-historic-tourist-trail-1919472.html (last accessed on 14 September 2013).

CHANDLER, David. 1999a. *Brother Number One: A Political Biography of Pol Pot.* Boulder, CO: Westview Press.

————. 1999b. *Voices from S-21: Terror and History in Pol Pot's Secret Prison.* Berkeley: University of California Press.

————. 2001. 'Tuol Sleng and S-21'. *Searching for the Truth: Magazine of Documentation Center of Cambodia* 18: 29.

CHHEANG, Bopha. 2008. ' "Killing Fields": Pas de trace d'aménagement du site après trois ans de gestion privée' ('Killing Fields': No Trace of Site Development after Three Years of Private Management). *Ka-Set*, 21 May. Available at: http://ka-set.info/actualites/khmers-rouges/cambodge-actualite-khmers-rouges-choeung-ek-killing-fields-memorial-080521.html (last accessed on 10 July 2010).

————. 2010. 'Une "Journée de la haine" de moins en moins suivie au Cambodge' ['A "Day of Hatred" Less Followed in Cambodia']. *Ka-Set*, 20 May. Available at: http://ka-set.info/breves/breves/cambodge-actualite-journee-haine-khmers-rouges-choeung-ek-080520.html. Accessed 10 July 2010.

COUGILL, Wynne. 2007. 'Remains of the Dead: Buddhist Tradition, Evidence, and Memory' in Jorge Daniel Veneciano and Alexander Hinton (eds), *Night of the Khmer Rouge: Genocide and Justice in Cambodia.* Newark: Paul Robeson Gallery, pp. 32–48. Available at: http://www.muslimpopulation.com/pdf/Night%-20of%20the%20Khmer%20Rouge.pdf (last accessed on 13 September 2013).

ETCHESON, Craig. 2005. *After the Killing Fields: Lessons from the Cambodian Genocide.* Westport, CT: Praeger.

HARRIS, Ian. 1999. 'Buddhism in Extremis: The Case of Cambodia' in Ian Harris (ed.), *Buddhism and Politics in Twentieth Century Asia.* London: Cassell, pp. 54–78.

————. 2007. *Buddhism under Pol Pot.* Phnom Penh: Documentation Center of Cambodia.

HINTON, Alexander L. 2005. *Why Did They Kill? Cambodia in the Shadow of Genocide.* Berkeley: University of California Press.

HUGHES, Rachel. 2006. 'Memory and Sovereignty in Post-1979 Cambodia: Choeung Ek and Local Genocide Memorials' in Susan E. Cook (ed.), *Genocide in Cambodia and Rwanda: New Perspectives.* New Brunswick, NJ: Transaction Publishers, pp. 257–79.

HUMAN RIGHTS WATCH. 2009. 'Cambodia: Political Pressure Undermining Tribunal'. Available at: http://www.hrw.org/en/news/2009/07/22/cambodia-political-pressure-undermining- tribunal (last accessed on 10 July 2010).

KIERNAN, Ben. 1996. *The Pol Pot Regime: Race, Power, and Genocide in Cambodia under the Khmer Rouge, 1975–79.* New Haven, CT: Yale University Press.

LEDGERWOOD, Judy. 1997. 'The Cambodian Tuol Sleng Museum of Genocidal Crimes: National Narrative'. *Museum Anthropology* 21(1): 82–98.

LINTON, Suzannah. 2004. *Reconciliation in Cambodia.* Phnom-Penh: Documentation Center of Cambodia.

NATH, Vann. 1998. *A Cambodian Prison Portrait.* Bangkok: White Lotus Press.

PANH, Rithy. 2003. *S21: The Khmer Rouge Killing Machine*, DVD. New York: First Run Features.

POEUV, Socheata. 2006. *New Year Baby*, DVD. Vancouver: Broken English Productions.

RAY, Nick, and Daniel Robinson. 2008. *Cambodia.* Footscray, Australia: Lonely Planet.

ROYAL GOVERNMENT OF CAMBODIA. 2001. *Circular on Preservation of Remains of the Victims of the Genocide Committed during the Regime of Democratic Kampuchea (1975–1978), and Preparation of Anlong Veng to Become a Region for Historical Tourism.* Phnom Penh: Royal Government of Cambodia. Unofficial English translation available at: http://www.eccc.gov.kh /sites/default/files/legal-documents/Circular_on_remains.pdf (last accessed on 14 September 2013).

SAIDNATTAR, Roshane. 2009. *Survive: In the Heart of the Khmer Rouge Madness*, DVD. Neuilly-sur-Seine, France: Morgane Productions.

SEATON, A. V. 1996. 'Guided by the Dark: From Thanatopsis to Thanatourism'. *International Journal of Heritage Studies* 2(4): 234–44.

SION, Brigitte. 2001. 'Conflicting Sites of Memory in Post-Genocide Cambodia'. *Humanity: An International Journal of Human Rights, Humanitarianism, and Development* 2(1): 1–8, 14–21.

SEN, Hun. 2001. 'Government Circular on the Preservation of Victim Memorial'. Documentation Center of Cambodia. Available at: http://www.d.dccam.org/Projects/index.htm (last accessed on 10 July 2010).

SOKHA, Duong. 2010. 'Des celebrations du 30e anniversaire du 7 janvier au Cambodge sur un air de louange au PCC' (Thirtieth Anniversary Celebration of 7 January in Cambodia Praise the PCC). *Ka-Set*, January 7. Available at: http://ka-set.info/actualites/pouvoirs/cambodge-politique-7-janvier-vietnam-khmers-rouges-liberation-occupation-090107.html (last accessed on 10 July 2010).

UNG, Loung. 2006. *First They Killed My Father: A Daughter of Cambodia Remembers.* New York: HarperCollins.

VENECIANO, Jorge Daniel, and Alexander Hinton. 2007. 'Social Memory' in Jorge Daniel Veneciano and Alexander Hinton (eds), *Night of the Khmer Rouge: Genocide and Justice in Cambodia*. Newark: Paul Robeson Gallery, pp. 108–17. Available at: http://www.muslimpopulation.com/pdf/Night%20of%20the%20Khmer%20Rouge.pdf (last accessed on 13 September 2013).

WILLIAMS, Paul. 2004. 'Witnessing Genocide: Vigilance and Remembrance at Tuol Sleng and Choeung Ek'. *Holocaust and Genocide Studies* 18(2): 234–54.

Resisting Holocaust Tourism:
The New Gedenkstätte Bergen-Belsen, Germany

RAINER SCHULZE

On 28 October 2007, after more than seven years of work, a new permanent exhibition opened at the Gedenkstätte Bergen-Belsen,[1] the site of the notorious Nazi camp in northwest Germany. Housed in a building specifically commissioned for this purpose, it documents the history of this site. The redevelopment followed from the 1998 Final Report of the Select Committee on German Unity, which assigned concentration camp memorial sites a crucial role in the formation of a German cultural memory (Deutscher Bundestag 1999: 616–30). Bergen-Belsen was identified as one of seven memorial sites of international importance inside Germany to receive special funding to update their information and documentation centres.[2] One important reason behind this decision was the attempt to allay fears of a 'Fourth Reich' emerging after German unification and to demonstrate that Germany would not forget her recent history.

Bergen-Belsen is arguably one of the better-known Nazi camps on German soil, but it is also one of the camps that is often misremembered. This is not least because of the photographs and film footage produced by the British Army Film and Photographic Unit (AFPU) immediately after the camp's liberation in April 1945, which have become iconic images of the Holocaust.[3] The AFPU was set the task of documenting the appalling conditions in the concentration camp uncovered by the British troops, and the frequent use of their images in the world media since 1945 has contributed to a memory of Bergen-Belsen that has become detached from the historic site and the actual historical events, making Bergen-Belsen, in the public perception, a symbol and exemplification of all the atrocities of Nazi rule: the very model of a Nazi 'horror camp' (Kushner et al. 1997: 3–16; Schulze 2011; Haggith 2005; Caven 2001; *Daily Mail* 1945).

In fact, Bergen-Belsen was not the archetype of a Nazi camp. The concentration camp was only established in spring 1943; it started out as a camp for 'privileged Jews' who were to be temporarily exempted from deportation to

the death camps in the East and held under somewhat better conditions because the SS and the German Foreign Office felt they might serve as bargaining chips (Friedman 2005; Schulze 2005). Only in the final months of the war, when Bergen-Belsen became a reception camp for the death marches from the East, did it turn into the hell uncovered by the British troops, which is now associated with its name. Moreover, it is usually overlooked that Bergen-Belsen, from 1940 to early 1945, was also a prisoner-of-war camp mainly for Soviet PoWs, thousands of whom perished under the most appalling conditions. Finally, from 1945 to 1950, Bergen-Belsen was a camp for displaced persons, set up in the German Wehrmacht barracks only a mile away from the Nazi camp. Initially for the survivors of the concentration camp, Bergen-Belsen later became the largest Jewish DP camp in Germany (Stiftung niedersächsische Gedenkstätten 2010; Kolb 1962, 1985; Wenck 2000).

The contradictions between the historical Bergen-Belsen and public memory are the result of the protracted process of remembering and forgetting over the past 65 years (Schulze 2006). For many years, visitors to Bergen-Belsen saw mass graves which were testimony to the estimated 50,000 concentration camp prisoners and 20,000 prisoners of war who died there, but they were given little to no information about the camps or the crimes. In October 1945, the British Military Government had ordered the German Provincial Government in Hannover to set up an appropriate memorial at Bergen-Belsen 'to ensure that the memory of the infamy of the concentration camps does not fade'.[4] At that point, most of the wooden huts of the prisoners had already disappeared—torn down and torched by the British in order to prevent a further spread of disease as soon as the liberated inmates had been moved out (Shephard 2005; Reilly 1998: 19–49; Margry 1995). However, the fences round the former camp, the watchtowers, the crematorium and the buildings of the SS compound were still there, and the topography of the camp continued to be recognizable amid the mounds of the mass graves.

When the memorial at Bergen-Belsen was formally dedicated in November 1952, all structural remains of the concentration camp had been dismantled and either removed from the site or covered with a layer of topsoil (Wolschke-Bulmahn 1995, 2001; Woudstra 2002; Schulze 2003: 233–7). This had been done in agreement with the British authorities who had suggested in July 1946 that the proposed memorial to those murdered at Bergen-Belsen 'should not, by intention, invoke painful memories of the manner of their death'.[5]

Following this guidance, the German authorities decided to erect a monument in the form of an obelisk and a wall of remembrance.[6] All nations that had suffered losses at Bergen-Belsen were invited to mount a plaque on the wall with an inscription 'of a non-religious nature' and of no more than 200 letters.[7] However, even these inscriptions made only a vague reference, if any, to why people were buried there. The British plaque, for example, reads: 'To the memory of all those who died in this place'; the other plaques are similarly non-specific.[8] The site was surrounded with a belt of shrubs and trees native to the region, and the original topography of the camp disappeared beneath a completely new layout of circular pathways. Bergen-Belsen had become 'a place of beauty, and of reverence, where those who had died could rest in peace', as the British had requested,[9] but at the same time it was all but invisible to the uninformed visitor as the site of a prisoner-of-war and a concentration camp. The mass graves had been turned into silent witnesses.

It was only in 1966 that some very basic information about the concentration camp was provided at the historic site (Bischoff 1966). In April 1990, on the 45th anniversary of the liberation of the concentration camp, a small exhibition on the history of Bergen-Belsen, based on the limited range of research available at the time, opened to visitors (Niedersächsische Landeszentrale für politische Bildung 1990). For the first time, a small permanent staff welcomed visitors, looked after survivors and their relatives, and engaged in educational work.

Following the recommendations of the Select Committee on German Unity, the Minister for Culture of the state of Lower Saxony (Niedersachsen), Renate Jürgens-Pieper, responsible for the upkeep of the state's Gedenkstätten, authorized the then managing director of the Gedenkstätte Bergen-Belsen, Wilfried Wiedemann, to appoint an international team of researchers to undertake the extensive research on the history of the camps which was necessary to update and expand the existing exhibition. At the same time, an architectural competition was held for a new information centre to present the findings to the general public. The funding provided by the German federal government was matched by funding from the state of Lower Saxony. I was part of the redevelopment of the Gedenkstätte from the beginning: as one of the project leaders in the development of the new exhibition, member of the management team and, from 2005, member of the International Commission of Experts, which had been set up to advise the Minister for Culture on the progress of work.[10]

The fundamental question facing us was how to recover and present the multifaceted history of Bergen-Belsen at the actual historical site in a way that

would be accessible for ordinary visitors without becoming sensationalist. After more than 65 years since the liberation of the camps, visitors to Holocaust memorial sites fall roughly into two groups: those who come to mourn the people who died and suffered at the camps, honour their memory and learn more about the context and practice of their incarceration, and those who come because the site exists and often is on a tourist trail or who are fascinated by the deaths that occurred there. Tim Cole coined the terms 'pilgrims' and 'tourists' for these two groups (2000: 113–19; Pollock 2003: 176–7).

There was consensus from the beginning among all involved in the redevelopment of the Gedenkstätte Bergen-Belsen that we would not propose the reconstruction of any part of the former prisoner-of-war and concentration camps, nor the reconfiguration of the landscape in any way that could be regarded as turning the historic Bergen-Belsen site into a 'Bergen-Belsen-land'.[11] Instead, the destruction of all physical remains of the former concentration camp in the immediate post-war period, so often lamented in the past, provided an opportunity: the Gedenkstätte did not have to worry about preserving historic buildings that had not been designed to last for an indefinite period, and the new permanent exhibition (and all other new facilities) would have to be housed in a newly constructed building, thus avoiding the multitude of problems arising with the modern use of a building originally set up for a completely different purpose (often for holding or administering prisoners).

Because of the large number of Jews among the thousands of deaths in the final weeks of the concentration camp, the whole area of the historic site of Bergen-Belsen was declared a Jewish cemetery. This made it impossible to build on the actual historic site, which also supported the attempt to avoid the creation of a Bergen-Belsen-land: the new building to house the exhibition had to be constructed just outside the historic site; the design chosen in the competition included a seven-metre extension which 'floated' freely over the former camp's boundary.[12] As a result (and in contrast to Auschwitz, for example), the Documentation and Information Centre and the historical site are clearly separated at Bergen-Belsen[13] (figure 13).

The historic site remained undisturbed by new building developments and no attempt was made to interfere with the layout of the garden-cemetery and the forestation of the site as it had developed in the decades following the liberation. Newly found foundation stones of some prisoners' huts and watch-towers and remains of the water reservoir, the old delousing facility and the main camp road have been preserved as they were found, but apart from that,

FIGURE 13. The new Documentation and Information Centre with the 'stony path' that leads to the exhibition, through the building and into the historic site. Copyright Klemens Ortmeyer, Braunschweig, and Stiftung niedersächsische Gedenkstätten, Celle. Reproduced with permission.

the layout of the former camp is only indicated by a strategic cutting down of shrubs and trees. Minimal clearings in the woods on the site of the former camp and in the surrounding forest provide glades and groves to indicate the boundaries and the different areas of the former camp, and a central corridor marks the entire length of the former main camp road.[14]

The actual situation in the camps, including Bergen-Belsen, can never be recreated nor adequately described, and when redeveloping the Gedenkstätte we therefore deliberately and consciously did not aim for this as we felt that this would only result in trivialization or sensationalization. The reconstruction of Bergen-Belsen can only occur in the mind of each visitor, and for this the exhibition is crucial, providing the available information that the visitors can put together in their minds. However, even the most detailed and in-depth documentation is inevitably fragmented and incomplete and is not sufficient to answer each and every question that visitors might have. It is up to each visitor

to draw their own conclusions and form their own images about conditions at Bergen-Belsen on the basis of the evidence that the exhibition presents.

The new permanent exhibition is source-driven and follows a broadly chronological approach, documenting, in three main sections, first the prisoner-of-war camp (1940–45), then the concentration camp (1943–45) and finally the displaced persons camp (1945–50) (Wiedemann 2008). The focus throughout is on Bergen-Belsen, first as a crime scene and later as a place of rehabilitation for survivors. There are no separate 'national histories' in the main exhibition displays, as in Auschwitz, even though in the final months before liberation, when the camps in the East were hurriedly cleared in the face of the advancing Red Army, members of more than 20 different nationalities ended up at Bergen-Belsen: instead, it is the experiences at Bergen-Belsen that guide the narrative of the exhibition.

The architecture and design of the exhibition[15] are functional to the point of being austere or almost clinical: nothing distracts attention from the narrative. The walls are bare concrete and the prevailing colours in the exhibition are black, grey and white. There are no artificially blown-up photographs nor eye-catching fonts or colour schemes; there is no clutter in the presentation of documents and artefacts. The narrative is quiet and the events are deliberately documented with what one commentator summed up as 'cool detachment' (Bardgett 2008: 5): the texts are short, the style is factual and there is a conscious lack of pathos and an overly pedagogical approach. Throughout, the historians prevailed over the exhibition designers with their request that the design had to be subordinate to the content of the exhibition.

After long discussions and visits to other Holocaust memorial sites and exhibitions, we decided to put witness testimonies at the centre of the exhibition's narrative, guiding all three sections. We were confident that the moral authority of the individual survivor would cut through all the elements and features of edutainment which no exhibition can avoid and that the dignity and humanity of the testimonies would have both a rational and an emotional impact on the visitors (Gring and Theilen 2007, 2009). The history of the site is told as far as possible from the perspective of those who were imprisoned there and those who lived in the displaced persons camp after their liberation. The narrative focuses on the conditions under which human beings existed at Bergen-Belsen and on basic human rights violations inmates had to endure during their incarceration and survivors attempted to reclaim for themselves after their liberation.

In the exhibition, the testimonies of the survivors form the audio–visual counterpart to the historical photographs and film footage of the liberated concentration camp. In the images of 1945, the individual is hardly recognizable in the anonymous mass of the dead and the barely alive. The images of survivors 55–60 years later recalling their experiences at Bergen-Belsen underline that it was people like everyone else who were incarcerated at Bergen-Belsen. The survivor testimonies shown on video screens often provide the only colour element in the exhibition. The contrast between the historical and the more recent images is intended to underline the dehumanization that prisoners experienced in the concentration camp system. Moreover, the recent images help visitors relate to those who suffered at Bergen-Belsen in a way that the historical images do not permit.

The exhibition aims to avoid both trivialization and simplification. It is a *tour de force*: rigorously designed as a straightforward and sober documentation that sets out what occurred at Bergen-Belsen but does not prescribe visitors how to feel. This open-endedness is intended to deconstruct the 'myth of the Holocaust' as it has developed in the past two or three decades and avoid a process of distancing from and ossification of the Holocaust (Cole 2000: 5–6). Visitors need to come to their own conclusions, and this is demanding a lot more of the visitors than many other exhibitions do. However, visitors are firmly in command and decide themselves how much of the exhibition they want to absorb, and into how much detail they want to go. They can walk through all the three sections of the exhibition, without studying anything at great length, to get a general overview; the exhibition is also conceived in a way that makes sense even if not all sections are visited. Visitors can choose what they want to explore more closely and can stop at specific sections of the open displays in the exhibition. In addition to the open displays, there are areas for further study in each of the three sections. Those who want to learn even more are invited to visit the archive of the Gedenkstätte and the specialized library. When setting up the exhibition, we had envisaged that the average visitor would spend 60–90 minutes there. However, to our surprise, many visitors have been spending considerably more time in the Documentation and Information Centre, and on any given day quite a few are using the available computer terminals to obtain additional information and listen to the survivors on the video screens, sometimes more than once.

The same 'detached' approach displayed in the exhibition holds true for the architecture of the new building that houses this exhibition. It is an

unpretentious-looking building that does not deflect attention away from what is exhibited inside, but instead is designed to reinforce the narrative in subtle ways. The long and narrow building invites visitors to walk through it (and thus through the new permanent exhibition) on their way from the parking area to the historic site, thereby forming a kind of gateway to the historic site. The floor of the building ascends slightly, taking the visitors out of their normal everyday reality where everything is square and level. The lone window at the far end provides the first opportunity for visitors to view the historic site. They see a seemingly peaceful and pleasant-looking landscape, covered in heather and interspersed with birch trees and junipers, but in fact they look out to the former *Appellplatz* of the Star Camp, which is also the site of one of the mass graves. The window almost draws the historic site into the building: the exhibition rigorously focuses on what visitors see but would not understand without the exhibition providing them with the information which the site itself cannot relate any more (figure 14).

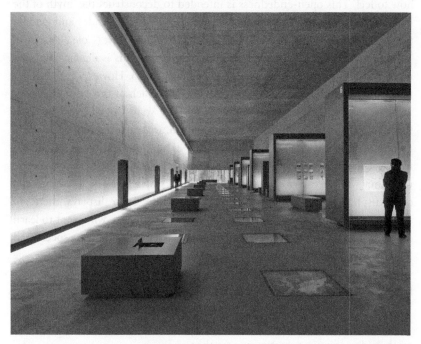

FIGURE 14. The new Documentation and Information Centre, concentration camp exhibition: on the floor are displays with archaeological findings; the window in the rear overlooks the historic site. Copyright Klemens Ortmeyer, Braunschweig, and Stiftung niedersächsische Gedenkstätten, Celle. Reproduced with permission.

The new permanent exhibition met with much approval by fellow Holocaust historians and professional critics when it opened (Bardgett 2008; Kimmelman 2009; Watts 2007). The wide consensus was that this new exhibition sets new standards for exhibitions of this kind both in the broader approach and in the specific manner in which it presents historical documents, and that the cornerstones for the new exhibition were well chosen. An independent jury awarded the 2008 Niedersächsische Staatspreis für Architektur, the most important and most prestigious architectural prize in Lower Saxony, to the architects of the new Documentation and Information Centre and the Stiftung niedersächsische Gedenkstätten for demonstrating 'how minimalistic architecture can have maximum impact, appropriate for the large and sad importance of this site, ensuring that the chain of memory does not break' and for 'finding a deeply moving response' to the challenges facing research and documentation of Nazi crimes in the twenty-first century.[16]

Visitors' reactions have also been positive overall[17] and visitor numbers at the Gedenkstätte Bergen-Belsen have increased since the opening of the new permanent exhibition—from about 200,000 to 300,000 visitors annually.[18] Impressive as this increase looks at first sight, it is significantly lower than what had been projected when the exhibition was developed: the expectation was that the new exhibition would attract more than half a million visitors annually, at least in the first two or three years.

The large majority of visitors to the Gedenkstätte tend to know why they come to see the exhibition. Visits to the Gedenkstätte form a regular part of the school curriculum, activities of youth groups and the programme for German and international soldiers stationed at the nearby Bergen-Hohne NATO military training ground. The staff of the Gedenkstätte currently provides guided tours of the exhibition and the historic site for about 1,000 groups annually, and another 1,000 groups visit the Gedenkstätte each year independently. The new Gedenkstätte has a dedicated learning centre, and, in addition to guided tours, the staff offers away-days for schools and youth groups as well as seminars for teachers and youth workers; they also run international youth camps in collaboration with other organizations.[19]

The emphasis of the Gedenkstätte is on offering better facilities for education and commemoration, with only little thought given to considerations such as tourism and whether it could help Belsen-Belsen reach beyond its traditional core audience and attract a new range of visitors. Until very recently, linking Holocaust memorial sites and tourism was frowned upon in Germany; in the

RAINER SCHULZE

land of the perpetrators, it was regarded as almost unethical to suggest that the two could be mentioned together or could possibly benefit from each other. Outside Germany, this uneasiness about linking the two has long subsided, if it ever existed; for non-Germans, visiting at least one former concentration camp site is now on the to-do list of both the organized and the individual tourist trek across continental Europe, 'something to sandwich in between a quick art museum visit in the morning and a session at the Hofbräuhaus in the evening' (Hawley 2005; Cole 2000: 111–12, 115–16; in contrast, see Gilbert 1997).

This presents Holocaust memorial sites, particularly those located at historic sites of Nazi crimes, with a dilemma. On the one hand, they see their task as providing documentation rather than entertainment, as expressing a clear moral and ethical position, and as counteracting the assumption of the Holocaust becoming a historic topic like any other. On the other hand, they probably do not have much choice but to accept that they are tourist attractions and that they have to cater at least to some degree to tourists' needs and expectations to fulfil their primary mission and survive financially as places of education and remembrance. However, Holocaust memorial sites are not the only ones that need to reconsider how they position themselves; so do local authorities who try to attract tourism to their regions after years of regarding the Holocaust memorial sites as an embarrassment or as something that could have a negative impact on the region's reputation.

The Gedenkstätte Bergen-Belsen is a case in point. Those who campaigned for many years for the establishment of a proper and comprehensive documentation centre at Bergen-Belsen were driven by pedagogical motivations and the imperative that Germany and the world must not forget what happened at this historic site. They advocated that scholarly rigour needed to remain at the very heart of the Gedenkstätte and warned against any 'toning down' or 'sexing up' of the exhibition to attract visitors, since this would dishonour the memory of the victims. Tourist considerations did not play much of a role in the discussions about the redevelopment of the Gedenkstätte and the new permanent exhibition: if anything, the team in charge was intent on resisting the trend towards 'Holocaust tourism'. The Gedenkstätte hardly featured in the official publications and brochures of Landkreis Celle, the administrative district where Bergen-Belsen is situated. Instead, the Landkreis emphasized the natural beauty of the Lüneburg Heath and the wide range of leisure activities in the region, as well as 'positive' historical sites such as the military airport at Faßberg from where relief flights to Berlin took off during the 1948–49 blockade by the

130

Soviet Union (Pröve, Ricklefs and Paul 1959; Mielke 1985, as well as brochures and other publications of the tourist offices held in Kreisarchiv Celle).

However, the location of Bergen-Belsen meant that the redevelopment of the Gedenkstätte could not focus exclusively on the exhibition. Until today, Bergen-Belsen has remained a fairly remote place, and it is difficult (if not impossible) to reach it by public transport.[20] The only practical way of getting to the Gedenkstätte is by private car. Bergen-Belsen is 20–25 miles away from the Hamburg–Hannover motorway, so one does not pass the Gedenkstätte by accident. Because of its remote location, the Gedenkstätte has to provide some amenities to visitors, such as a cafeteria, spaces for reflection and recuperation and possibly a shop, but being the site of a Nazi concentration camp, this needs to be handled with great sensitivity (Schulze 2008: 13–18).

During the development of the new Documentation and Information Centre, the need for non-exhibition spaces for visitors was occasionally raised but never received proper attention or funding; whenever historians requested more space for their exhibits, areas earmarked for non-exhibition purposes were reduced. The cafeteria, initially located at the end of the exhibition, was moved to the main lobby, which made it more easily accessible, but it is no longer on the intended pathway through the new building. At the other end of the main lobby is a small bookshop that sells books (and a few DVDs) on Bergen-Belsen, the Holocaust and the Third Reich. Merchandise that one would find in typical museum shops, such as pens, key rings or T-shirts, is not available at the Gedenkstätte. Many visitors look into the bookshop, but spend little time, as they cannot sit to thumb through the literature. The only other amenities for visitors are a water fountain in the foyer and small lockers for personal items.

The cafeteria is the only space where visitors can rest and reflect. However, although there is plenty of seating, there is only a vending machine for beverages. The kitchen—fitted out to the highest standards—is only open on special occasions when an outside caterer comes in. So far, no private subcontractor has been interested in running the cafeteria, for obvious reasons: advertising for such a place is a challenge and the viability of a business plan is uncertain given the fluctuating number of visitors. The alternative would be for the Gedenkstätte to run the cafeteria as part of its commercial activities, but at the moment this is not under consideration.[21]

The cafeteria illustrates the inherent problems that tourism presents to Holocaust memorial sites such as Bergen-Belsen. The large entrance area of

the Documentation and Information Centre which houses the main lobby, cafeteria and bookshop is in the same functional design as the exhibition halls. On the one hand, the austere character is in line with the general effort against a Disneyfication of the Gedenkstätte; on the other hand, it is probably one of the main reasons why relatively few people use the cafeteria, and those who do tend to spend little time there. The experience of 'tourists' in a cold and uninviting cafeteria, which could be addressed with different furniture and warmer colours, stands against the explicit expectations of the 'pilgrims' to honour the memory of those who died and suffered at Bergen-Belsen: they, therefore, resist any hint of a 'fun day out' atmosphere. Today's visitors expect proper amenities such as refreshments and comfortable spaces to reflect on their experience, rather than having to do so in their cars or drive to the next town, Bergen.[22] However, there exists an in-built tension between the need for amenities that meet the basic needs of visitors, some of whom travel a long distance, and the fact that Bergen-Belsen was a place where prisoners were deprived of exactly these basic human needs of food and drink.

There is no established model or best practice as to how a Gedenkstätte at the historic site of a Nazi camp should address the question of amenities for visitors. At the core is the question of how comfortable the tourist experience should be or how much of the persecution and suffering experienced by the prisoners should be reflected in the visitors' experience. At the moment, nothing seems really appropriate, and this holds particularly true for memorial sites inside Germany.

The new Gedenkstätte at Bergen-Belsen tries to resist Holocaust tourism as far as possible, but at the same time has to cater to the legitimate needs of visitors. Failure to do the latter might ultimately impact its future: if the Gedenkstätte does not attract sufficient numbers of visitors, it might at some point become unviable. Bergen-Belsen—just like other Holocaust memorial sites—is still searching for the right balance between commemoration, education, accessibility and recreation.

Notes

1 The German term *Gedenkstätte* is normally translated into English as 'memorial' (even the English website of the Gedenkstätte Bergen-Belsen uses this term), but this translation does not catch its full meaning in German. A *Gedenkstätte* is usually the site of an important historical event, and the site is preserved, even though often landscaped, to keep the memory of this event

alive. Information provided at a *Gedenkstätte* can range from a small memorial marker or plaque to a comprehensive museum. I will use the term 'memorial site' rather than 'memorial' throughout this article.

2 See also Deutscher Bundestag, 14. Wahlperiode, Drucksache 14/1569 (27 July 1999): 'Konzeption der künftigen Gedenkstättenförderung des Bundes' (German Federal Parliament, 14th Legislative Period, Document 14/1569: 'Conception of Future Federal Funding for Memorial Sites'), section 2: 4. The other camps were Neuengamme, Dachau and Flossenbürg in former West Germany, and Buchenwald, Ravensbrück, Sachsenhausen and Mittelbau-Dora in the former German Democratic Republic.

3 The photographs are today held by the Photographic Archive of the Imperial War Museum and the film footage by the Film and Video Archive of the Imperial War Museum. On the work of the AFPU at Bergen-Belsen, see Toby Haggith (2006: 89–122).

4 The National Archives of the UK (TNA): Public Record Office (PRO) FO 1010/168, CCG (BE), Office of the Chief of Staff (British Zone), to 229 'P' Mil Gov Det Hannover, 10 October 1945. This instruction was passed on to the Oberpräsident of Hannover, Hinrich Wilhelm Kopf, on 19 October 1945, who in turn passed it on to the German authorities in Landkreis Celle, the administrative district where Bergen-Belsen is situated.

5 TNA PRO FO 1010/168: M.F.A. & A. Section, Zonal Executive Office, CCG Bünde to HQ Mil Gov Hannover Region, 30 July 1946.

6 TNA PRO FO 1010/168: Minutes of a meeting held to consider designs for and the location of an International Memorial in Camp I Belsen, held at Hohne at 11:00 hours, 5 September 1946.

7 TNA PRO FO 1010/170: Note by PW/DP Branch, HQ Military Government, Land Niedersachsen, 13 January 1947.

8 The texts of all the plaques are included in an information leaflet issued by the Gedenkstätte Bergen-Belsen: 'Gedenkstätte Bergen-Belsen', typescript, undated, pp. 14–16.

9 TNA PRO FO 1010/168: HQ Mil Gov Hannover Region, note on Belsen Memorial meeting, 13 August 1946.

10 The following is based on my involvement in the redevelopment of the Gedenkstätte since 2000 and the papers and minutes of meetings of the project team, the management team and the International Commission of Experts. The International Commission of Experts (International Advisory Board) was chaired by Henry Friedlander (New York); members were David Bankier (Yad Vashem), Hagit Lavsky (Jerusalem), Elisabeth Morawek (Vienna), Herbert Obenaus (Hannover), Krystyna Olesky (Auschwitz-Birkenau), Joachim Perels

(Hannover), Jan Rydel (Oświęcim), Rainer Schulze (Essex), Irmgard Wilharm (Hannover) and Joachim Wolsche-Bulmahn (Hannover). Project leaders in the development of the new permanent exhibition included Rolf Keller, Karl Liedke, Thomas Rahe as well as Karin Theilen and Diana Gring, who were responsible for the audiovisual media concept and realization; the general manager and coordinator was Wilfried Wiedemann.

11 The term 'Bergen-Belsen-land' follows Tim Cole's description of Auschwitz I as 'Auschwitz-land'; for a scathing critique of 'Auschwitz-land', see Cole (2000: 97–120) and J. John Lennon and Malcolm Foley (2000: 46–65).

12 The building is designed by KSP Engel and Zimmermann Architects, Berlin/Braunschweig/Frankfurt (www. http://www.ksp-architekten.de).

13 In contrast to Bergen-Belsen, the visitor centre at Auschwitz I with all the tourist facilities such as the restaurant, cafeteria, toilets, shop, cinema, conference room and even a currency exchange and a post office, is not a postwar construction but an original building from the time when Auschwitz I was a concentration camp; it was the place where prisoners were 'systematically registered, tattooed, surrendered their valuables, undressed, shaved, showered, and were left to dress in the regulation striped uniform of incarceration' (Lennon and Foley 2000: 52). Past and present blur, without the visitors being made aware of this, and in his critique of 'tourist Auschwitz', Cole therefore concludes: 'Auschwitz-I's place of prisoners initiation has silently become the place of "Auschwitz-land's" tourist initiation' (Cole 2000: 110).

14 'Master Plan Bergen-Belsen', landscape design for the Gedenkstätte Bergen-Belsen by sinai.exteriors, Berlin (Schulze 2006: 230–1, plate no. 16).

15 The exhibition architecture and design is by Hans Dieter Schaal, Office for Architecture and Studio, Attenweiler, Germany (http://www.hansdieter-schaal.de).

16 Press Release 'Neubau der Gedenkstätte Bergen-Belsen erhält Niedersächsischen Staatspreis für Architektur 2008' ('New Building of the Gedenkstätte Bergen-Belsen is awarded the State of Lower Saxony Prize for Architecture 2008'), 30 September 2008. Available at: http://www.ms.niedersachsen.de/-ps/tools/download.php?file=/live/institution/dms/mand_17/psfile/docfile/5/M S502_Staa4ba1f353ad8b6.pdf&name=Pressemitteilung_vom_30.09.2008&disposition=attachment (last accessed on 26 June 2011).

17 The Gedenkstätte has not done any extensive research on visitors' expectations and experience.

18 About 100,000 of these visitors come from abroad, the largest number from the Netherlands and Scandinavia (information provided by Stiftung niedersächsische Gedenkstätten).

19 For more information on the international youth camps, see http://www.jugen-darbeit-in-bergen-belsen.de (last accessed on 26 June 2011).

20 Bergen-Belsen is situated on the southern edge of the Lüneburg Heath, about 35 miles north of Hannover. The closest railway station is in Celle, about 18 miles away. Only five buses a day pass the Gedenkstätte (two on weekends), and it takes more than an hour to get to the Gedenkstätte by bus from the railway station in Celle.

21 Addendum: In February 2011, the Gedenkstätte finally outsourced the management of the cafeteria to an independent contractor, and fresh food and drinks are now available during the opening hours of the Documentation and Information Centre.

22 Bergen, the closest place for a restaurant or a wider range of refreshments, is about 5 miles away from the Gedenkstätte; visitors who drive there are unlikely to return to the Gedenkstätte.

Works Cited

BARDGETT, Suzanne. 2008. 'Bergen-Belsen's Information Centre'. *History Today* 58(1): 4–5.

BISCHOFF, Friedrich (ed.). 1966. *Das Lager Bergen-Belsen: Dokumente und Bilder mit erläuternden Texten* (Bergen-Belsen Concentration Camp: Documents and Photographs with Explanatory Texts). Hannover: Verlag für Literatur und Zeitgeschehen.

CAVEN, Hannah. 2001. 'Horror in Our Time: Images of the Concentration Camps in the British Media, 1945'. *Historical Journal of Film, Radio and Television* 21(3): 205–53.

COLE, Tim. 2000. *Selling the Holocaust: From Auschwitz to Schindler, How History Is Bought, Packaged, and Sold*. New York: Routledge.

DAILY MAIL. 1945. *Lest We Forget: The Horrors of Nazi Concentration Camps Revealed for All Times in the Most Terrible Photographs Ever Published*. London: Associated Newspapers Ltd.

DEUTSCHER BUNDESTAG (ed.). 1999. *Die Enquete-Kommission 'Überwindung der Folgen der SED-Diktatur im Prozeß der deutschen Einheit' im Deutschen Bundestag: Besondere Veranstaltungen* (The Select Committee of the German Bundestag 'Overcoming the Consequences of the SED-Dictatorship in the Process of German Unification': Special Activities). Baden-Baden: Nomos Verlagsgesellschaft.

FRIEDMAN, Max Paul. 2005. 'The U.S. State Department and the Failure to Rescue: New Evidence on the Missed Opportunity at Bergen-Belsen'. *Holocaust and Genocide Studies* 19(1): 26–50.

GILBERT, Martin. 1997. *Holocaust Journey: Travelling in Search of the Past.* London: Weidenfeld & Nicolson.

GRING, Diana, and Karen Theilen. 2007. 'Fragmente der Erinnerung: Audiovisuelle Medien in der neuen Dauerausstellung der Gedenkstätte Bergen-Belsen' (Fragments of Memory: Audiovisual Media in the New Permanent Exhibition at the Gedenkstätte Bergen-Belsen) in Rainer Schulze and Wilfried Wiedemann (eds), *AugenZeugen: Fotos, Filme und Zeitzeugenberichte in der neuen Dauerausstellung der Gedenkstätte Bergen-Belsen—Hintergrund und Kontext* (EyeWitnesses: Photos, Films and Testimonies in the New Permanent Exhibition at the Gedenkstätte Bergen-Belsen; Background and Context). Hannover: Stiftung niedersächsische Gedenkstätten, pp. 153–219.

————. 2009. 'Fragments of Memory: Testimony in the New Permanent Exhibition at Bergen-Belsen'. *The Holocaust in History and Memory* 2: 37–52.

HAGGITH, Toby. 2005. 'Filming the Liberation of Bergen-Belsen' in Toby Haggith and Joanna Newman (eds), *Holocaust and the Moving Image: Representations in Film and Television since 1933.* London: Wallflower Press, pp. 33–49.

————. 2006. 'The Filming of the Liberation of Bergen-Belsen and its Impact on the Understanding of the Holocaust' in Suzanne Bardgett and David Cesarani (eds), *Belsen 1945: New Historical Perspectives.* London: Vallentine Mitchell, pp. 89–122.

HAWLEY, Charles. 2005. 'Touring a Concentration Camp: A Day in Hell'. *Spiegel Online International,* 27 January. Available at: http://www.spiegel.de/international/-0,1518,338820,00.html (last accessed on 26 June 2011).

KIMMELMAN, Michael. 2009. 'The Holocaust, Viewed Not From Then but From the Here and Now'. *The New York Times,* 22 January. Available at: http://www.nytimes.-com/2009/01/22/arts/design/22abro.html (last accessed on 26 June 2011).

KOLB, Eberhard. 1962. *Bergen-Belsen: Geschichte des 'Aufenthaltslager' 1943–1945* (Bergen-Belsen: The History of the 'Exchange Camp', 1943–1945). Hannover: Verlag für Literatur und Zeitgeschehen.

————. 1985. *Bergen-Belsen: Vom 'Aufenthaltslager' zum Konzentrationslager 1943–1945* (Bergen-Belsen: From 'Exchange Camp' to Concentration Camp, 1943–1945). Göttingen: Vandenhoeck & Ruprecht.

KUSHNER, Tony, David Cesarani, Jo Reilly and Colin Richmond. 1997. 'Approaching Belsen: An Introduction' in Jo Reilly, David Cesarani, Tony Kushner and Colin Richmond (eds), *Belsen in History and Memory.* London: Frank Cass, pp. 3–33.

LENNON, J. John, and Malcolm Foley. 2000. *Dark Tourism: The Attraction of Death and Disaster.* London and New York: Continuum.

MARGRY, Karel. 1995. 'Bergen-Belsen'. *After the Battle* 89: 1–25.

MIELKE, Jörg. 1985. *100 Jahre Landkreis Celle: Ein Beitrag zur Geschichte Niedersachsens* (100 Years Landkreis Celle: A Contribution to the History of Lower Saxony). Celle: Schweiger & Pick.

NIEDERSÄCHSISCHE LANDESZENTRALE FÜR POLITISCHE BILDUNG (ed.). 1990. *Bergen-Belsen: Texte und Bilder der Ausstellung in der zentralen Gedenkstätte des Landes Niedersachsen auf dem Gelände des ehemaligen Konzentrations- und Kriegsgefangenenlagers Bergen-Belsen* (Bergen-Belsen: Texts and Pictures of the Exhibition in the Central Memorial of the Federal State of Lower Saxony on the Site of the Former Concentration Camp and Prisoner of War Camp Bergen-Belsen). Hannover: Niedersächsische Landeszentrale für politische Bildung.

POLLOCK, Griselda. 2003. 'Holocaust Tourism: Being There, Looking Back and the Ethics of Spatial Memory' in David Crouch and Nina Lübben (eds), *Visual Culture and Tourism*. Oxford: Berg, pp. 175–89.

PRÖVE, Heinrich, Jürgen Ricklefs and Wolfgang Paul. 1959. *Heimatchronik der Stadt und des Landkreises Celle* (Chronicle of the Town and Landkreis Celle). Celle: Schweiger & Pick.

REILLY, Jo. 1998. *Belsen: The Liberation of a Concentration Camp*. London: Routledge.

SCHULZE, Rainer. 2003. ' "Germany's Gayest and Happiest Town"? Bergen-Belsen, 1945–1950'. *Dachauer Hefte: Studien und Dokumente zur Geschichte der nationalsozialistischen Konzentrationslager* 19: 216–38.

———. 2005. ' "Keeping Very Clear of Any Kuh-Handel": The British Foreign Office and the Rescue of Jews from Bergen-Belsen'. *Holocaust and Genocide Studies* 19: 226–51.

———. 2006. 'Forgetting and Remembering: Memories and Memorialisation of Bergen-Belsen' in Suzannah Bardgett and David Cesarani (eds), *Belsen 1945: New Historical Perspectives*. London: Vallentine Mitchell, pp. 217–35.

———. 2008. 'Documentation or Edutainment? Holocaust and Museums'. *The Holocaust in History and Memory* 1: 7–19.

———. 2011. 'Britain's Finest Hour: Bergen-Belsen in der britischen Erinnerungslandschaft—eine Annäherung' [Britain's Finest Hour: Bergen-Belsen in the British Memory Landscape; An Approach] in Wilfried Wiedemann and Joachim Wolschke-Bulmahn (eds), *Landschaft und Erinnerung: Bergen-Belsen, Esterwegen, Falstad, Majdanek* (Landscape and Memory: Bergen-Belsen, Esterwegen, Falstad, Majdanek). Munich: Meidenbauer, pp. 51–74.

STIFTUNG NIEDERSÄCHSISCHE GEDENKSTÄTTEN (ed.). 2010. *Bergen-Belsen: Wehrmacht POW Camp, 1940–1945; Concentration Camp, 1943–1945; Displaced Persons Camp, 1945–1950*. Göttingen: Wallstein.

SHEPHARD, Ben. 2005. *After Daybreak: The Liberation of Belsen, 1945*. London: Jonathan Cape.

WATTS, Greg. 2007. 'News in Brief: A Museum Has Opened'. *The Times*, 2 November. Available at: http://www.thetimes.co.uk/tto/opinion/article2036248.ece (last accessed on 26 June 2011).

WENCK, Alexandra-Eileen. 2000. *Zwischen Menschenhandel und 'Endlösung': Das Konzentrationslager Bergen-Belsen* (Between 'Bargaining Chips' and 'Final Solution': Bergen-Belsen Concentration Camp). Paderborn: Ferdinand Schöningh.

WIEDEMANN, Wilfried. 2008. ' "Earth Conceal Not the Blood Shed on Thee": The New Documentation and Information Centre at Bergen-Belsen'. *The Holocaust in History and Memory* 1: 41–58.

WOLSCHKE-BULMAHN, Joachim. 1995. '1945–1995: Anmerkungen zur landschaftsarchitektonischen Gestaltung der Gedenkstätte Bergen-Belsen' [1945–1995: Comments on the Landscape Design of the Gedenkstätte Bergen-Belsen]. *Die Gartenbaukunst* 7: 325–40.

———. 2001. 'The Landscape Design of the Bergen-Belsen Concentration Camp Memorial' in Joachim Wolschke-Bulmahn (ed.), *Places of Commemoration: Search for Identity and Landscape Design*. Washington, DC: Dumbarton Oaks Research Library and Collection, pp. 269–300.

WOUDSTRA, Jan. 2001. 'Landscape: An Expression of History'. *Landscape Design: Journal of the Landscape Institute* 308: 42–9.

From Evidence to Relic to Artefact:
Curating in the Aftermath of 11 September 2001

MARK SCHAMING

The first day I stood on the hill at Fresh Kills, I felt a sense of intimidating privilege and a nagging dread. This was a very different place from the World Trade Center (WTC) site. On that day, in October 2001, I drove to an industrial New York City (NYC) sanitation site just off the Staten Island Expressway with the entrance blocked by concrete blocks that funnelled me to a small booth manned by a detective from the New York Police Department (NYPD). It was a crime scene. Even at the bottom of the hill it smelt bad. After a credential check, I proceeded to the hill above.

The road wound up a hill to a 175-acre plateau unseen by the world, where barges and trucks brought the remains of the WTC. I could see little until I reached the top that overlooked Staten Island, New Jersey, to the west and the distant skyline of Manhattan about eight miles away to the north. In late October 2001 a smoky haze still hung over lower Manhattan. Fresh Kills was not like Ground Zero and not as I expected. The place smelt like the after-burn of a fire, methane gas, ground-up cement and the pungent sickening odour they called the smell of death. It is often hard to accept what you are in the midst of. When I smelt it, reality set in.

The recovery operation at Fresh Kills had a steady and controlled work pace, with a general sense of suspicion and disregard towards me at first. Working for the New York State Museum in Albany, I was an anomaly there. On my first day there a detective noted that the skies were oddly still and, looking towards New Jersey, I saw only a few planes in the distance in the sky near Newark. America was still in shock. A constant flow of people moved around the site, all with something to do. I couldn't tell if I was seeing the police, Federal Bureau of Investigation (FBI) agents, mechanics, sanitation workers, the Red Cross or priests. The place had a military-like practicality and established a tangible bond between people. We were at the outskirts of an attack, as if behind the front lines of a war.

I toured the sorting fields with an NYPD detective assigned to escort our small group. We were silent in the van as the detective spoke. Across endless fields I saw rubble, rebar, concrete, steel and hills of the finer remains of the towers. Except for a thousand vehicles stacked together in a field, the only identifiable object I saw on the first day in the vast fields was a single FedEx envelope. No chairs, desks, doors or anything with a recognizable feature. Recovery workers raked, picked and moved through the fields dressed in anonymous white Tyvek suits. They seemed to be finding things.

I returned the following week with museum curator Craig Williams, and again the week after, and spent 40 days at the site over the next 9 months. On the third visit we saw the large white buckets that the recovery workers carried off the fields with human remains and personal property. In the evidence shed, an FBI evidence technician picked up and handed me a small damaged sign that said 'Evacuation Plan'. This modest artefact looked ancient—bent, scraped and pitted with the letters still readable. It was what we hoped to see. A few weeks earlier, it was perhaps in a stairwell where thousands walked out of the towers in one of the greatest mass flights to safety in human history.

Seeing and handling these ravaged objects recovered along with the remains of the people killed had a profound impact on me. It evoked a powerful sense of fragility in everything around me, and I tried impossibly to process the fact that what was in the next bucket was all that was left of someone killed. No one should ever see sights like these, but in this context the artefacts and human remains had a power unlike anything I could reference. This small sign would begin to tell an otherwise unimaginable story. The artefact, touched by the horrible tragedy of the day, with the lives of thousands of people literally embedded in it, had an incredible resonance. It propelled us to see more and to preserve what we could.

Museums Respond

Museums follow typical although idiosyncratic protocols about collecting artefacts, dealing with people, handling access, documenting history and organizing exhibitions. From a museum's perspective there were two ways to approach the situation. One was to wait, the other to act. It is typical practice for museums to observe history with a distance of time, look at an event with a historical perspective, put the event in context, and collect, write papers and form exhibitions. With this approach one benefits from the filter of historians, the

thoughtful actions about collecting and the avoidance of missteps in terms of access protocols and provenance. Artefacts and images are acquired through known channels, and objects that are collected are deposited in the museum and eventually used in exhibitions. But the gravitational pull of the place, the evident enormity of death and the drive of the men and women working there made it impossible to stand aside. Typical museum protocols were suspended, if not forever changed. There was no model for what faced us. This required working relationships with the police, firefighters, FBI agents, sanitation workers, Red Cross volunteers, widows, fathers and mothers. Beyond permission we needed their collaboration.

On 6 October 2001, a group of museum professionals, community organizers, photographers and others in the NYC area met at the museum of the City of New York to discuss how to address collecting, exhibiting and preserving the history of 9/11. We reacted to the undeniable surge of media, public interest and a common drive to know more about what happened. There was (and continues to be) a need to understand better the context and events of 9/11 and their aftermath. It was a very different issue to be collecting, documenting and interpreting events in real time while history was unfolding. For many, this seemed to be a ghoulish undertaking. Information was unstable; in many cases, emotions—grief, anger, sympathy—were shaping actions and history. However, if no action was taken the images might be lost, artefacts destroyed and people's stories forgotten. The voices and images formed a collective documentation of the events. For museum professionals, it took many months, even years, to sort out these accounts, collect and research the many aspects of the events and, ultimately, interpret this recent history.

In 2001, I was a 13-year employee of the New York State Museum, where I directed the exhibitions division and worked with historians, artists, curators and scientists to interpret the human and natural history of the state. I was involved closely with every aspect of the public side of the museum. Immediately after the attacks, I reached out to New York State officials to request access first to the WTC site and then to Fresh Kills. People in the New York Governor's office wondered aloud whether it was macabre to even consider photographing or collecting anything. Nevertheless, they agreed to help us with access and clearance. A complex set of contacts with the Port Authority of New York and New Jersey (PANYNJ), the Fire Department of New York (FDNY) and the NYPD helped me make a web of connections that facilitated access. In late October 2001 I toured the WTC site and a week later, Fresh Kills.

After the first day I had a powerful compulsion to return. If only to watch the operation, but hopefully, eventually, to save something that was evidence of the people who were killed and the life at the moment of the attacks. We were told that when they were done, there would be nothing left. This impending timeframe set an urgency in motion and defined a relatively brief window to collect artefacts and photograph the historic operation.

On the first few visits, museum historian Craig Williams and I were treated with polite suspicion and a dismissive attitude by the FBI agents and police in charge of the recovery operation at Fresh Kills. This was understandable. Their job was to find the remains of those killed and evidence of the terrorists. We were looking to see what was available to museums. That paled in contrast to looking for human remains and the black boxes of the aeroplanes. I persisted and we toured Fresh Kills every week, talked with the men and women who were working at the site and slowly gained their trust. As they worked to find a small belonging to return to a family, they began to save artefacts for our return each week, objects touched by the violence of the day and often describing the story of the attacks and the aftermath.

Rescue turned quickly to recovery after the attacks; the mission was to recover human remains and the belongings of the thousands who were either dead or alive at the WTC. Over the next 10 months, the clean up at the WTC site as well as the discreet recovery operation at the Fresh Kills landfill continued. It is there that we recovered most of the artefacts from the remains of the WTC.

I had no specific idea of what we were looking for, and the recovery teams had no idea of what was to be found. The point was to see what had survived. The more we saw, the more we realized that there was less than we had imagined. I expected thousands of pieces of everyday life to be hiding in the piles of grey rubble. Surely something would emerge the harder one looked. But little did. Anything that was found was by pure chance. Surreal as it was, the unspoken understanding was that the remains of almost 3,000 people killed were embedded in every inch of the piles. An NYPD detective told me that there were difficulties with the team of cadaver dogs brought in to find human remains. As evidence of human remains was all over the piles, underfoot, embedded in the finest material, the dogs, trained to react when sniffing a location containing human remains, were frantic and fatigued with the overwhelming presence of remains everywhere. They ceased to work after just a few weeks.

Fresh Kills, like Ground Zero, had a sense of critical immediacy. We were not waiting for news reports of what happened during recovery. I was in it, as a participant observer. Unlike Ground Zero, this was not the aftermath but felt like history unfolding, with only the participants watching. Agents talked of raids being conducted around New York and overseas, the airspace was still under stringent control with the expectation of another attack, and it seemed that one needed credentials to access even low-priority sites. The activity of recovery was historic in itself and at first they estimated it would take well over a year to accomplish. Time seemed suspended.

The recovery seemed to change every day and followed no pattern. The smallest object was often the most interesting to me. We asked that they save for us objects about the evacuation, artefacts of everyday life and things that reflected the individuals lost. The artefacts were brought to the evidence shed where FBI technicians cleaned and processed everything. Typically, the sorters brought from the fields buckets of human remains, of personal property like identification cards and of 'neutral' objects often morbid, uniformly destroyed. It was impossible not to look at the human remains. For me the reality set in a few hours later as we drove back to Albany. The smell did not leave right away and, given the intimacy with the dead, the artefacts had an almost tangible reverence. It was numbing and within a day of being away I felt the draw to return. The people at Fresh Kills were there to find these terrible things. I was there to help save what was left.

In museums it is possible to channel the actual moments of history and present it in a larger perspective so viewers can come to terms with the history that might be otherwise unfathomable. The images and artefacts served as direct historical evidence—the smallest object could be embedded with the biggest story. The artefacts were not collected merely for exhibition value, but rather for documentation and evidence of the events. The idea was to save anything recognizable and find out the story attached to an artefact later. I had no preparation for what I saw. The FBI agents and technicians would admit later that they too had difficulty processing the images of what was left of innocent people. They were used to seeing 'bad guys' dead, and I was unaccustomed to seeing any human remains whatsoever, especially this scope of death. It coloured our days and we talked about the impact with the people who were there. For curators, the artefacts were historical evidence, rather than criminal evidence, as well as immediate transmitters of history as we arranged to make the material available to the public in ways different from the news media.

The World as Witness

Arguably, 9/11 is the most witnessed and documented event in history. The moment when the first plane, American Airlines Flight 11, struck the North Tower was documented by only a few. The media swarmed and millions watched on television as United Airlines Flight 175, the second plane, struck the South Tower. The world then watched with disbelief as the Pentagon burned after it was struck by American Airlines Flight 77, the South Tower of the WTC fell, United Airlines Flight 93 struck the ground in Shankesville, Pennsylvania and, finally, the North Tower of the WTC collapsed completely. It is estimated that over 1 billion people watched the attacks, witnessed the fall of the towers and saw images of the aftermath at the three sites. Filmed and photographed by professionals and amateurs alike, the world could do nothing but watch as the tragedy unfolded. News cameras at the WTC had to quickly edit film as people fell from the towers. Moments before the crash in Shankesville, United Airlines Flight 93 was photographed by a woman from her porch nearby. A security camera captured one of the only images of American Airlines Flight 77 that crashed into the Pentagon. These became the defining images of 11 September. As recovery operations continued over the months after, the cameras dimmed.

This media saturation served to fuel the need to see more, know more and understand the complex and tragic events. While cameras focused on Ground Zero and the Pentagon, images of the WTC prior to 9/11 were almost immediately being eradicated from films, ads, television and media in general. At the site, visual barriers were erected to prohibit the public from seeing the carnage. The press obsessed about broadcasting images of the attacks, while the images from New York, Shankesville and the Pentagon during rescue and recovery operations were tightly controlled. People from across the world witnessed the attacks in a media-driven way that was perhaps a sterilized view of the events and the aftermath.

It was evident by the pace of work, the overwhelming response and the rate of recovery and processing material at the sites that within weeks or months there would be little or nothing left. The media surge created an enormous public awareness and offered an avenue to collect many testimonials. While New York witnessed remarkable public demonstrations of support and sympathy near Ground Zero, the actual recovery sites at the WTC and at Fresh Kills remained hidden from public view. There, physical evidence of the attacks would be found. As the recovery teams were searching for evidence of these

crimes, we would search for historical evidence. It was a rare opportunity to witness, document and, finally, collect as history was unfolding.

Initially, we had little sense of what was being found at the WTC site. The issue was whether to collect anything at all, and eventually what to collect. These decisions involved problems of ownership of personal property, vehicles, architectural elements and street memorials that still had purpose. Every artefact raised a set of questions about ethics, memory, human dignity and other sensitive issues, which made our work all the more challenging and interesting.

Collecting at a Crime Scene: After 11 September 2001

The decision to bring the remains of the WTC to Fresh Kills was made by NYC Mayor Rudolph Giuliani, and approved by Governor Pataki, on the day the towers collapsed. They had to reopen the landfill at Fresh Kills, give the site a crime scene designation, and transport and inspect the remains of the WTC in an extremely controlled environment that law enforcement was accustomed to.

By 2.00 a.m. on 12 September, trucks began arriving at the WTC recovery operation at Fresh Kills with the first load of material to be immediately searched for remains by the FBI agents and NYPD detectives. Careful inspection of the material determined a threefold mission: find every possible human remain, recover personal effects and search for evidence from the 19 terrorists.

> When we [found] a hand with a wedding band, a hand or foot with manicure[d] nails, you [knew] it's some woman who went to work, you could see the manicure of the nails, in some instances you could see the colour of the nails, which hopefully leads to identification down the line, plus, you had the fingerprints. Those are the thoughts that you have. And you see a lot of life interrupted.[1]

Fresh Kills became the largest crime scene in US history. FBI evidence recovery teams (ERTs) that recover material at bombing sites and plane crashes were called on from across the country to work at Fresh Kills. Working alongside the NYPD reassigned from their regular jobs as detectives in NYC precincts, FBI agents regular assignments were also suspended as they searched the piles over the next 10 months. The agents, trained to comb sites of destruction, nevertheless stood in awe before the daunting task.

The scene of destruction at Ground Zero and Fresh Kills was the equivalent of two plane crashes and two major bombings. The death toll was expected to be very high and they knew the causes of the plane crashes. Still, along with

human remains, there was sensitive material from federal law enforcement offices (such as the US Customs House, Bureau of Alcohol, Tobacco and Firearms, and other agencies that occupied many floors in WTC Tower 6) and objects that belonged to thousands of people, vehicles, toxic material and building remnants, and even predatory animals all complicating the recovery scene.

The operation at Fresh Kills quickly became a recovery effort of a historic scale. While looking for evidence of the hijackers, the main thrust of the work was to find human remains and personal belongings. FBI agents and police detectives, officers, PANYNJ police and volunteers from the FDNY spent long days and nights searching methodically through the material that arrived without interruption.

According to NYPD Lieutenant Bruce Bovino, the recovery operation became as much a humanitarian operation as a crime scene: 'It was designated a crime scene. That's how we treated it. That's the police department's policy, it's a crime scene, protect evidence. But I don't know how many days went by, and it just dawned on us: it's really a humanitarian effort.'[2]

For many people, the only item from a loved one might have been a credit card, a ring or a driving licence. These small objects were buried amid millions of tons of what remained of the towers. Within a few weeks, the police and the FBI developed a new method to sort through the millions of tons of material to find the smallest remains. The material was separated by size and type, sorted in the fields, sorted again by mechanical 'shakers' and, finally, inspected by hand on conveyor belts in large sheds by FBI agents, technicians and NYPD detectives. At Fresh Kills, objects as small as a marble were found and inspected by NYPD and FBI evidence specialists. Personal belongings were catalogued by the FBI and sent to the NYPD Property Unit at the NYPD Headquarters in NYC for processing, with the goal of returning them to their rightful owners or families. After initial inspections at Fresh Kills by the FBI and by forensic anthropologists, human remains—large and small—were sent to the NYC Chief Medical Examiner with the hope of a DNA match. Over a thousand vehicles were brought to the hill and carefully inspected by the FBI and the PANYNJ police from the parking garages under the towers and from the roads round the WTC complex (figure 15).

From the first day, we began seeing the recovered material through the eyes of the FBI and NYPD specialists. It was best when they handled the material and then made it available to us, as at first we saw little until they began showing us identifiable objects. In most cases, the object first went through the hands of an evidence recovery professional. Objects were found in

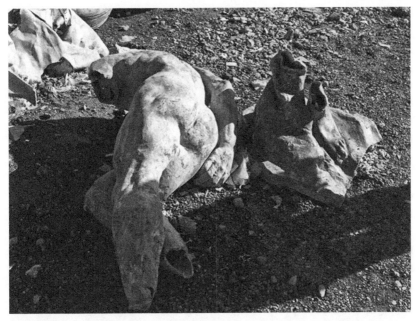

FIGURE **15.** The World Trade Center (WTC) recovery operation at Fresh Kills, December 2001. Several fragments of Rodin bronze sculptures from the Cantor Fitzgerald collection were recovered at Fresh Kills. Cantor Fitzgerald, a firm that occupied floors 101–15 in the North Tower lost 658 employees on 11 September. Photograph courtesy of Mark Schaming, New York State Museum.

the sorting sheds, on the field and in vehicles alongside human remains. Things were saved for their general visual interest, for possibility of ownership or just out of intuition. Property was recovered for a number of basic reasons: as evidence that may lead to the identification of a perpetrator for use in indictment or trial, as evidence that may be critical in identifying a person killed, as evidence to be returned to a grieving family sometimes in place of remains never found or to be returned to one who had survived the attacks.

I developed a good relationship with the FBI and NYPD recovery teams. The FBI ERTs had worked crime scenes such as Fresh Kills at major bombings and plane crashes across the world, wherever Americans were involved. They tracked the terrorist attacks by Al Qaeda from the 1993 WTC bombing to 9/11. It was fascinating to listen to their perspective on the WTC attacks in comparison to other bombings they had investigated, including the 1996 Khobar Tower bombings in Saudi Arabia, the 1998 Nairobi Embassy bombing and the 2000 USS *Cole* attack in Yemen.

An FBI agent admitted to me that she did not think it was appropriate for us to collect artefacts. This was a common reaction. A number of the agents and police told us later that it was unorthodox to allow 'outsiders' at a crime scene. On site, we noted two things right away: the NYPD and the FBI tended to keep their hands in their pockets. It was a subtle thing, but they resisted touching objects unless they needed to do so consciously. Many of them chewed tobacco. I learnt it was to mitigate the smells that permeated Fresh Kills. Following their lead, I too resisted the urge to handle things without asking.

As suspicions lessened we learnt a great deal about how things (evidence) and human remains were found, handled, cleaned and catalogued. The agents dealt with the materials in a methodical way and identified artefacts that would have never been recognized. One example was what at a glance looked like a molten mass of plastic and metal but was identified to be a fused mass of floppy disks. They saved those for us, an important artefact to collect. As disturbing to me as it was, I absorbed their reactions to the sight of human remains—respectful and subtly clinical. I tried not to look, but it was impossible

FIGURE 16. The WTC recovery operation at Fresh Kills, December 2001. Personal property, including building passes, was found in the remains of the WTC. Many were eventually returned to owners or families. Photograph courtesy of Mark Schaming, New York State Museum.

not to. This was a stark reminder that everything we saw or handled was covered in the remains of those killed (figure 16).

The personal artefacts left us very sad. I saw hundreds of driving licences, employee ID cards, credit cards, photographs and other small items that survived destruction. Photographs of people always left us with the lingering thought about their fate—the people in the pictures often looked like someone you know, all innocents. Unusual objects, some small and delicate, were found as were other everyday objects—a small desk clock with its hands fixed at the time of the collapse, wedding rings with inscriptions, desk-top dedication plaques, clothing or shoes with a name. Each item identified left me wondering whether its owner was dead or alive. It was impossible not to personalize the experience. I looked, rarely touched and often photographed some of these objects.

From early 2002, I was regularly allowed into the sensitive sorting tents in the fields and the evidence sheds in the FBI/NYPD compound. In the early days, we were not allowed to even photograph the sheds from the outside, let alone access the operation. Inside, we saw up close how the 1.8 million tons of material was being processed. Agents worked intensely to inspect the rubble placed on conveyor belts, in extremely loud conditions as the belts rolled and loaders added material to the feeder piles outside the tents and sheds. Buckets at their sides, they picked out suspected remains, objects as small as a dime, placed them in buckets and continued. They rarely spoke, working in silence. It was remarkable how the sorters found anything in the medium grey-brown shapeless objects moving past them. As the buckets filled, someone would remove them for inspection in the FBI evidence shed. It was an organic but thorough process. Many of the objects that we collected as artefacts were found this way (figure 17).

Until they began saving objects for the museum, much of what was recovered and that could not be identified with a specific individual was buried at the landfill. By January 2002, the FBI and NYPD had a broad understanding of what we were looking for. They often led us to specific objects. We found a number of objects in the field, mostly in the vehicle-processing areas, that we saved for collections. Vehicles, we were told, not only contained the ruins of an automobile but acted as vessels for everything included in the destruction, with personal belongings, papers and remains all having been blown into the many vehicles parked around the site. Any object we found we returned to the evidence shed where they were stored (usually in a bucket) until a decision was made that objects could be removed. Objects found by agents were kept there for us

FIGURE 17. An evidence recovery specialist reviewing objects found at the WTC recovery operation at Fresh Kills, January 2001. A process was developed to search the 1.8 million tons of material at Fresh Kills. Photograph courtesy of Mark Schaming, New York State Museum.

to examine. By March 2002, we were given permission to begin removing arte-facts. The first artefact was the small sign marked 'Evacuation Plan'.

In February 2002, the New York State Museum curators and I arranged for the removal of a nearly complete but destroyed FDNY fire engine. After weeks of inspecting, photography and research, and meetings with the FDNY, we decided to remove and preserve the FDNY Engine 6 pumper. This was a complex arrangement and the process assured us that the FBI understood our vision and determination to preserve artefacts. Until then, I had only photographed a large number of personal artefacts, vehicles and the overall operation, while agents had begun to save non-personal artefacts for our inspection each week. I described to them the categories of artefacts that would be important to save: objects that reflected the evacuation, everyday life, and rescue operations and told personal stories. The ability to separate and remove objects accelerated over time. I tried to look at the material they separated for us as they might—detached, questioning the origins and thinking about what historical record they might add.

With the cooperation of the FBI and the NYPD, we began successfully identifying and eventually removing artefacts for museum collections. Objects were saved because they were visually compelling or had an immediate identifying feature (e.g. souvenirs, FDNY fire hose). With the assistance of FBI ERTs we were able to understand what some of the recovered objects were. The evidence teams became our curators in the field. The stories associated with many of the objects would take months, perhaps years, to unlock.

Beyond identification, as an object associated with an individual becomes a powerful relic especially when no remains are found of that individual, similarly for many families of those killed, the artefact became a surrogate remain. In a number of cases, only a driving licence or credit card was presented to family members instead of human remains. On at least one occasion, an FDNY turnout coat with the smallest remain embedded in it was buried. The objects became precious relics touched by a person's life, evidence of their death. And just as museums depend on artefacts to transmit stories and confirm the loss of a life, so did many families.

I never got used to seeing human remains and the horror of it was heightened each time I saw photographs on ID cards looking directly at me. Making that connection everyday was difficult to process, and it seemed to affect the FBI and the NYPD in the same way as they would talk about it often and at great length. Despite their distant attitude at the outset, these men and women were devastated by what they were seeing. We were also beginning to know family members of those killed, and I tried hard to suppress images of what I had seen. Although Fresh Kills was hardly a place where people shared emotions, everyone expressed something. Everyone agreed it was better to talk about what they saw and felt on the hill than at home.

Thus, artefacts, especially from an event of this magnitude, carry enormous sensitivity that affects their handling, possession and return/ownership. When personal property becomes part of a crime scene or recovery operation, ownership becomes the responsibility of the investigating authority. In this case, there was a long process to identify and return personal objects to owners or relatives. In general, objects with no identifying feature of ownership (a name or an address) obtained from such sites are considered non-personal and are available to us curators. In the case of all neutral objects (i.e. material without clear ownership) recovered from the remains of the WTC, the authorities decided the materials were non-usable evidence and thus could be transferred to museums as discards.

To us, rather than being criminal evidence or personal property these artefacts were historical evidence that could tell important stories and document the life of the WTC and the events of the day. A tattered cloth doll, tickets for a PATH train, WTC souvenirs that may or may not have been owned by an individual—as it was often impossible to identify an owner for such objects, we requested to keep them as artefacts in the museum. About 80 guns were found in the fields; while some were service weapons, others were probably from arrest or trial evidence stored in WTC Tower 6. The guns, now untraceable or altered, were rendered useless as criminal evidence but gained an important role as historical evidence about the men in service who were killed and the WTC complex itself. Aircraft pieces, typically used to investigate the cause of a crash, became primarily touchstones, again tangible historical evidence of the planes that struck the towers.

Within a month of us having begun work, we sensed a greater collaboration with the police and the FBI. I asked an agent to think about what a person might need to see 50 years later that would tell the story of what happened on 11 September 2001. It helped them look back to reconstruct events. We would too, through the artefacts we collected.

Questions arose about human remains and hazardous materials embedded in objects. This had tremendous impact on handling, storing and, eventually, exhibiting the artefacts. Since many of the people killed were missing (the remains of almost half of those killed in New York were never found or identified), it was presumed that human remains were part of the dust and embedded debris attached to most objects found. Concerns also arose about toxic contaminants such as asbestos, lead and mercury, both airborne and on the surface of artefacts, and the possibility of biohazard contamination. These contaminants proved to be quite harmful. While airborne particulate protection was made available to everyone, all artefacts were considered contaminated and washed before being removed to the NYPD property unit, the FBI or the museum.

The numbers of artefacts were small in comparison to the amount of material processed from the WTC site. As mentioned, as curators we initially developed lists of critical types and categories of objects that could be collected as artefacts. However, we had to depart from a logical plan. The objects actually found and saved determined the categories.

Aircraft Remains

Many pieces of the planes that crashed into the towers were brought to Fresh Kills. Unlike a typical aircraft crash investigation scene, the fragments of the planes were not inspected to determine the cause of the crash but were saved as evidence, possibly to be used in future trials of terrorists or collaborators.

FBI technicians with experience at plane crash sites, along with experts from airline maintenance, identified the fragments of fuselage, engine and other pieces. Fuselage pieces were recognizable by the bright green interior coating (fireproofing) typical of aircraft remains. Two aircraft seat belts were found, one with a section of an armrest. Most of the approximately 75 pieces found showed little or no signs of smoke damage or fire. ERT technicians explained that many of the pieces were blown from the tower just before the jet-fuelled explosion that occurred seconds after the planes actually entered the building. Many of the pieces we saw were blown several hundred feet away, and parts landed on streets and rooftops of buildings nearby and even many blocks away. These also included engine pieces, wheel assemblies and landing gear sections, many weighing several hundred pounds each. In terms of numbers, most of the pieces were fuselage.

With the exception of engine parts with serial numbers and one of the landing gear pieces that struck a building a few blocks away from the WTC site, it was not possible to determine from which plane most of the fuselage fragments or aircraft pieces originated. Towards the end of the recovery operation, we found a very heat distressed piece of what is presumably 'impact steel' with an aircraft fragment embedded in it. It is a very different experience to read a line about a plane striking the WTC when one sees a piece of historical evidence associated with the fact. The object verifies the fact, illustrates the tangible nature of the event and is memorable in a powerful way.

Everyday Objects

At the recovery scene, we began to see simple objects that were intact. Those objects that could be associated with an individual were cleaned, catalogued and sent to the NYPD property unit for eventual return to an owner or relative. Ownership of the material was either 'personal' (i.e. identified with an individual) or 'neutral' (i.e. without an identifiable owner). While some objects were simply evidence of everyday life in the complex prior to 9/11, others offered a touchstone to a specific time of the day and aftermath.

Destroyed mobile phones were a specific issue. Many weeks after 11 September, mobile phones continued to ring in the fields. Families continued to call phones of those lost, in a desperate act of contact. We were instructed not to touch or answer phones ringing in the piles at Fresh Kills. All mobile phones were saved, since one might have been used by a hijacker (evidence) or have belonged to a victim (personal property). These specific artefacts would help establish a time demarcation and tell the story. In 2007, the museum was given a recovered mobile phone, whose owner is still unknown.

We requested that any object that showed the image of the WTC or included the words 'World Trade Center' be saved, as well as any sign or artefact that indicated the evacuation routes, floor numbers or commerce in the towers. At each visit we saw more artefacts available, many unexpected. Signs that directed the evacuation, souvenirs from the shops high up in Tower 1, and simple artefacts like a damaged cigar-store Indian, the fused floppy discs, pieces of file cabinets and the rare emblem from a company were saved. These would be important to describe life before 9/11. Approximately 20 small metal signs that designated each of the 110 floors at the 99 elevators of the Twin Towers were found. These plaques have been used in a number of exhibitions to help explain the impact and tell human stories of the minutes after the attacks.

The Evidence of Rescue

Three hundred and forty-three firefighters died at Ground Zero. Over 100 rescue vehicles were destroyed. A number of FDNY air tanks (Scot Packs) were recovered. (The air tank is secured by a harness worn by firefighters and is equipped with a location device that detects when the individual is motionless. After a short time, the device lets out a regular high-pitched 'ping' sound that helps rescuers find the firefighter when he is down.) Early on at Ground Zero and Fresh Kills the recognizable 'ping' from the automatic location alarms rang out continuously while fruitless attempts were made to find or hopefully rescue firefighters. Six tanks, two complete with the harness, were found at Fresh Kills and saved; some with their specific labels indicated FDNY firehouses, which sometimes could be traced to individuals. While preparing a recovered harness and air tank for an exhibition in 2003, we learnt from retired FDNY firefighter Lee Ielpi that the number '288' painted on the Scot Pack harness indicated it belonged to FDNY Squad 288. This FDNY unit lost eight men on 11 September 2001, including Lee's son, firefighter Jonathan Ielpi, who was eventually profiled in the museum exhibition accompanied by the air tank and harness and other

artefacts found with him at the site. Along with the air tanks, many pieces of fire hose couplings and other equipment found have specific number and code information that we continue to research to tell a more complete story.

Vehicles

> In a bombing, a car is like a sponge [. . .] it will absorb tremendous amounts of debris. We recovered airplane parts, parts of the engines, parts of the landing gear, [even] parts of the buildings embedded inside the cars that were parked on the street near the Trade Center.[3]

Almost all of the vehicles damaged or destroyed at the WTC site were brought to Fresh Kills for inspection. Agents sought evidence of collaborators on the ground, including remains and other critical material. The search included personal cars, agency or official vehicles, and over 100 rescue and police vehicles. More than 1,300 vehicles were searched and documented and all but a few destroyed by the end of the recovery operation because of contamination and the amount of human remains found on and inside the vehicles (figure 18).

FIGURE 18. The WTC recovery operation at Fresh Kills, December 2001. Over 1,300 vehicles that were destroyed on 11 September 2001 at the WTC site were searched for evidence and remains. Photograph courtesy of Mark Schaming, New York State Museum.

The vehicles, in many cases, provided a window into an individual's life, the rescue that followed or a tragic moment of that day. Vehicles parked under and outside near the WTC complex were owned by both those killed and the many who survived. In some cases, the personal vehicles were the final containers of a person's life. If no body was found the belongings were especially important and the personal belongings located in a vehicle were often transferred to the families.

The vehicles from the rescue and law enforcement agencies were treated separately. This included about 100 FDNY vehicles, NYPD cars, PANYNJ vehicles and even a fleet of the president's US Secret Service vehicles parked in the lower levels. The vehicle used by FBI Special Agent Leonard Hatton, the lone agent killed on 11 September, was recovered, but no remains were found.

We spent much time photographing vehicles and working with the FBI agent in charge of processing them. Civilian cars showed the signs of a normal day tragically interrupted. One van was full of 2001 NYC primary day election posters and buttons. (The primary scheduled on 11 September 2001 was postponed.) Several vehicles were collected and a number of oral interviews were conducted. The sheer number of vehicles found at the site and their complexity and impact were overwhelming. The vehicles were at first evidence, then became part of the humanitarian search for remains and belongings, and, finally, were considered historic artefacts with powerful personal stories: taxis, a fleet of US Secret Service cars, civilian cars full of golf clubs, unread newspapers and children's books, a car with a wrapped gift that was never given but remained in the trunk were among the few telling stories at the hill.

At Fresh Kills and at the WTC site, recovery teams found massive 'composites', which were the result of fire and the pressure of the destruction from the collapses, comprising a variety of building material, office furnishings, paper, rings, cards and, among it all, human remains. A number of these masses were processed successfully at Fresh Kills, serving to identify people lost. The composite material, sometimes comprising several compressed floors of the towers, defied logic—as hot and powerful as the destruction was, paper, carpet fragments and other small items belonging to those who were killed or evacuated could be seen in the composite masses. As instructive as they pieces were, they had a greater value as containers of the remains of people killed. Thus, recovery trumped preservation.

Documenting the Recovery Operation

Over nine months I took hundreds of photographs of the site, the personnel, the mountains of debris, the recovery operation and the dramatic destroyed vehicle area where rescue apparatus, cars and trucks were searched and processed. Documenting this recovery operation was critical, since little other documentation (photographic or otherwise) by agency officials or by the press was underway and we had been granted privileged access.

The photographs documented an operation that, within a few months, would be complete with nothing left to see. By the end of the operation, the teams at Fresh Kills had sifted through 1.8 million tons, spent 1.7 million man hours, recovered 4,257 human remains and approximately 54,000 pieces of personal property, and inspected and processed 1,358 vehicles[4] at the expense of approximately US$100 million. By August 2002, I had spent over 40 days at the site and we had collected over 1,500 artefacts or approximately 30 tons of material—a relatively small amount.

Missing

The immediate public response to the attacks was directed at the victims, since it was not clear in the beginning whether people were killed or simply missing, and how many. Families looking for loved ones taped missing posters across New York City, and while they continued to search with rescue and search teams, it became evident that few would be found alive. Within days, these posters became memorials, with families determined to keep the faces of their loved ones in the public view. After the first year the posters, often damaged by weather conditions, became available to museums, morphing again, this time from memorial to documentation of the number and identity of those who were killed. As streets opened round the WTC, many memorials were destroyed and some were collected in fragments. In the early days after the attacks, museum curators were left facing issues of how to exhibit posters of the missing in a museum collection. Almost every poster included the phone number(s) of people connected to the person presumed lost or dead. Could documents with personal phone numbers be exhibited for public viewing in such an organized space? The posters were powerful documents, each with a photograph of the person lost. Posters exhibited within the first three years after the attacks were carefully scanned, with the phone numbers at least partially redacted. As phone

numbers change and given the lack of complaints we have had, complete posters have been exhibited since 2009.

Informal memorials rose spontaneously near Ground Zero, on street corners, in front of firehouses, police stations and places like Union Square and St Vincent's Hospital. For instance, an abandoned messenger bike that remained chained to a lamppost near the WTC site became a memorial to the unknown rider who was presumably killed. Across the nation, flags were flown both for mourning and as renewed patriotism, an impulse that quickly spread across the United States and Europe. Every major city in the US saw the spontaneous, and later official, construction of memorials to the 9/11 tragedy. Children sent art to Ground Zero and wrote letters to the firefighters, police and others involved in the recovery operations. The volume of messages was so great that many never made it to their intended recipients, but came to form a valuable documentation of public reaction, sympathy and support, probably uncollectible in its entirety.

Voices

Artefacts alone are mute. Many objects can serve as historical touchstones and most have stories embedded in them. Because of the ephemeral and fragile nature of artefacts, it was especially important to document the voices associated with the material objects and the stories. Working so near in time to the events allowed unprecedented opportunities for collecting oral histories, while raising sensitive issues of the ethics of documentation with grieving spouses, families and friends. Often, the voices were transient. Those documented can be categorized as the owner or next-of-kin (i.e. a survivor or participant), the evidence recovery technician (FBI, NYPD, FDNY, PANYNJ), and experts like engineers and architects. The general practice was to collect what was available, gather information and document the circumstances and opinions about an object, verifying facts afterwards. In many cases, specific information about an artefact was not known for many months, and in a few cases for years. Associated information was critical to documenting and understanding the artefact used in exhibitions.

One example is the artefacts and interviews of PANYNJ police canine officer David Lim. Officer Lim, who evacuated people from the WTC North Tower, is one of a group of 16 who survived the collapse of the tower in stairwell 'B'. His dog Sirius was killed in his crate as Lim evacuated the tower. Officer

Lim and his service dog were part of the detail of bomb technicians at the WTC site that was active after the 1993 bombing.

Officer Lim's destroyed PANYNJ K9 police car was found at Fresh Kills. Eventually, his dog's food bowl was found as well. The vehicle had a dog kennel at the back, now destroyed. The dog's mission, like Officer Lim's, was also to detect bombs at the WTC complex in the years after the 1993 bombing. The crushed vehicle thus serves as an extraordinary vessel to recount the officer and his service dog's story. Together, the vehicle, canine equipment and testimony about Officer Lim's role in a bomb detection unit bridge the story of the 1993 attacks to 11 September 2001.

Artefacts and Museum Exhibitions

People have a natural compulsion to be in the presence of death, perhaps to process the unthinkable scale of loss. Although horrific, the experience of seeing such artefacts in the context of a museum, deepened by images and first-person accounts, creates an internal tension between morbid curiosity and the opportunity to understand and remember. One is disturbed not by a particular object but by making the human connection. A firefighter's air tank, a torn leather police belt or a keepsake from someone's desk, all serve as connectors to a real story.

Many of the objects are shocking by association with the level of destruction and actual people who were killed, but unless the viewers understand the context of the artefact, the object is silent. One example is the fragment of an armrest and seatbelt from one of the planes that hit the towers. It is not possible to know to which plane the parts belong, but they are used generically. The label that describes the artefact is minimal: '8:46 AM'. The seat fragment is a compelling artefact that requires little explanation and is displayed low in a simple exhibit case. Neither is the case sensational nor is the object memorable, unless one knows the background. It is however a compelling experience that subjects the viewer to a more visceral understanding.

While many people were saturated with media images, few had seen an ordinary object from the site. In museum practices, this is a common way of transmitting a fact or story tangibly. One example is a small elevator sign with the number '78'. The four-inch-by-two-inch plaque tells the story of the impact on the South Tower where the seventy-eighth floor was hit. The floor being a 'sky lobby', many were killed and few survived as they waited for elevators in

the initial evacuation of the tower. The object, along with images, was used to tell the compelling story of Keating Crown, a survivor of Tower 2.[5] The small elevator plaque has thus become a visitor's touchstone, evidence of the moment.

Most of the artefacts exhibited were not attributed to any individuals, thus rendering interpretations at the outset more general. Since 2002, more families and survivors have collaborated with the New York State Museum to provide collections, documentation and advice about interpretation. Personal property was not collected without the permission of the owner. Objects were at first collected for documentation of 9/11. Most of the artefacts collected were 'contaminated' by the human remains likely embedded in all objects from the site, given that the remains of over 1,000 people were never recovered. While many objects found were of everyday life, they carried a deep emotional charge heightened by the relatively close proximity in time. Unlike an event from 50 years ago, collection, documentation and exhibition of history itself was happening in the immediate aftermath of the day, in real time relative to the recovery and public reaction.

Fromt the Sacred to the Historical

Because of the immediacy in time, the exhibitions were at first seen as a memorial experience, but they are now experienced as didactic, perhaps as stories become records, as the sacred becomes historical. In the first exhibitions developed in 2002 at the New York State Museum, we maintained a distance, a historical perspective that would inform visitors about the specific moments, scale and implications of the attacks. Each fact had at least two (we strived for three) sources, as initial information was often incorrect. Text was written in a neutral, factual voice. Image selection was complicated. Although we saw a media saturation of film and photographs of the attacks and collapse of the towers in New York, many of the images were difficult for visitors to process in a museum setting. Images were used sparingly, never sensationalizing the events, and were associated with artefacts wherever possible. Visitors were given choices about what to see by the design and visitor path in the gallery. Because of the proximity in time however, the exhibitions became memorial experiences for the visitors. Artefacts, displayed simply yet engagingly, seemed to have an even greater power with audiences.

Although we strived to present the material in a non-emotionally loaded environment, the exhibits created a platform ripe for a memorial experience.

In the first few days, visitors browsing the gallery were regularly observed crying, distressed and in anguish. Minimal information was required. Whether or not people knew someone personally, their reactions were similar. The exhibits were organized in a historical, chronological scheme to ensure the visitor experienced mourning and learning simultaneously. Many also treated the exhibits as mere platforms to experience the events, otherwise not possible except perhaps at the sites.

Exhibition of Personal Artefacts

A significant issue of debate was the collection and exhibition of personal versus neutral artefacts. Beginning in 2003, a few individuals approached the museum to donate artefacts of family members killed, objects recovered at the WTC site or Fresh Kills. They considered the museum a long-term repository better equipped than the family to document the history of an individual. Normally, donors relinquished control of handling and access to material once in the museum collection. To mitigate the discomfort of control, the museum chose to maintain contact with these donors, offering regular access and including them in decisions, updates and reviews. The relationship with families ultimately provided a rich record of many of the lives lost.

As mentioned, in early exhibitions in 2002 and 2003, great attention was paid to what was or might be a personal object as this was a sensitive issue. Since almost half of the people killed were never found, personal objects became of extreme importance. In many early exhibitions, a deliberate effort was made to display only artefacts that could never be associated with an individual unless a family or survivor had lent or donated an item or photograph. This also included the identification of aircraft remnants as to which plane it belonged. These ad hoc rules have since been relaxed as families increasingly began to deposit personal items in museum collections and to appreciate the opportunity to tell this history. An example is a United Airlines mileage card owned by Lisa Frost,[6] killed on 11 September. Her family donated the card to the museum in 2005. The card and one identifiable remain was recovered at Fresh Kills. The family felt that the item had a greater purpose in the museum collection for study and exhibition than being kept as a personal memento. The card has been used in the US and Europe in travelling exhibitions as more stories of the people killed in the attacks are being told.

In France and in the US, a select number of individuals—those killed and those who survived—are included in museum exhibitions. This has provided visitors a more personal connection with an event of this scope that is difficult to wholly comprehend. It also heightens the impact of the larger story of death and escape. To include stories and belongings of those lost (or even those who survived), a trusted collaboration with families and those affected is required.

Visitor response to exhibitions of this kind has changed since 2003. Whereas earlier one would regularly see open displays of emotion as well as a silent reverence for the events, now people talk in galleries, prompted by the exhibitions to discuss the events, share memories and even offer opinions. Children born after 2001, who see this as a truly historic event to understand, can today, over 10 years later, be seen visiting the museum. This reinforces the museum's role as a platform for education.

Reactions to the exhibition by visitors in Europe have been very similar to American audiences. In France, we were surprised to hear many visitors talk about where they were on 11 September that fateful year, when they learnt about the attacks. We anticipated a more distant reaction. To many Europeans, this was an attack on the Western world that happened in the US.

When exhibitions are developed so close in time to an event of such magnitude, the government and individuals being critical and the risk of offending heroes are issues of concern. For instance, the image of President George W. Bush learning of the attacks and a text about his immediate reaction was used in a 2002 exhibition. We felt this was a significant moment in that day's events. Although museum texts use minimal adjectives and adverbs and never include editorial text (unless essential), there was an almost immediate public reaction to the inclusion of President Bush's image and related text in the exhibition. The public damaged the label a number of times, and we received emails arguing against the merit of the image. The text was scratched and removed, leaving only the time and place. Public objection was mainly about the use of the word 'promptly' in the sentence about the president's reaction to the attacks on 11 September. The text was changed eventually, removing the adverb but keeping the facts of the day intact. This reaction has not occurred in later exhibitions.

An ongoing debate is about the inclusion of pictures of the terrorists in exhibitions. In 2001, there were strong feelings against it. In 2004, the WTC Memorial Center Advisory Committee was formed by the Lower Manhattan Development Corporation to make a formal report that would guide the development of the

Memorial Center Museum. The report concluded that the museum should provide 'an appropriate sense of the context, background and aftermath of the terrorist attacks'.[7] Long discussions continued about whether or not (and how) to exhibit background information about the attacks and attackers, who they were and why the attacks were perpetrated. The biggest concern was not about textual exhibits but about the use of images of the terrorists. Many felt at the time that including images of the terrorists in the museum was to, from their vantage, provide a platform of support, indirectly if not directly. Could a terrorist or supporter feel proud to have the images of these men included? It questioned the very purpose of a museum, its exhibitions and whether the inclusion of such visual evidence served to sensationalize the profile of the terrorists or simply narrate history. Family members of those killed tended to be against the use of these images whereas historians generally supported their inclusion. To this day, the question remains unresolved.

The practice of using artefacts imbued with history remains at the core of the stories museums tell through curators. The artefacts, images and stories collected in 2001 are older than a decade already, and we are now transmitting the stories to a new generation of those born after 2001 or who were too young to recall. I realize now that the objects have a life much greater than us. It is impossible for me to see the artefacts in a museum or sterile collections setting and not feel a physical connection that brings back a very textured image of the days immediately after 11 September. With time, as sacred and criminal evidence becomes historical document, the means to tell these painful stories will be less clouded by the immediate pain and shock of the event and will result in an increase in its pedagogical impact.

Notes

1 FBI Special Agent Bomb Tech Gerald C. Fornino, interview by the author, Fresh Kills, May 2002.

2 NYPD Lieutenant Bruce Bovino, interview by the author, Fresh Kills, March 2002.

3 FBI Special Agent Bomb Tech Gerald C. Fornino, interview by the author, Fresh Kills, May 2002.

4 New York Police Department (NYPD) Report ('The World Trade Center Recovery Operation at Fresh Kills') by NYPD Deputy Inspector James Luongo, 6 August 2002.

5 Keating Crown was an Aon employee in WTC Tower 2 at the time of the
 attacks. He was one of a few who survived the impact zone on the sventy-
 eighth floor when United Airlines Flight 175 crashed into the tower at 9.03
 a.m.

6 Lisa Frost, aged 26, was killed on United Airlines Flight 175 that struck the
 WTC South Tower on 11 September 2001 en route to Los Angeles.

7 World Trade Center Site Memorial Center Advisory Committee final report,
 April 2004. Available at: http://www.renewnyc.com/content/pdfs/MCAC_-
 Recs_FINAL_081204.pdf (last accessed on 23 September 2013).

Negotiating Return

Noshing at the Necropolis:
Trauma, Gastrotourism and Jewish Cultural Memory

S. I. SALAMENSKY

Tourism related to the Jewish past tends to focus on trauma, suffering and death. In this essay, I examine a topic that may seem deeply trivial or insensitive in terms of such catastrophes: food. Although we must never forget what Jews have lost, it is also crucial to remember what they have created, what they have loved and how they have lived. Food and foodways provide crucial ties to that past. In what follows, I examine three provocative cases involving food: travel (metaphorical or literal), memory (a play by a performance artist raised as a Holocaust refugee) and 'real-life' scenarios of what might be called 'gastrothana-tourism', in North America and in East Central Europe, in which the truest means of communion with a vanished world appears to be to eat it. I conclude with a brief discussion of issues surrounding food, foodways and gastrotourism as they manifest with regard to Jewish cultural memory today.

In(di)gesting Identity

In her two-person play *Sounding to A: Reverberations of the Holocaust*, Eva Ungar Grudin takes her audience on a whirlwind tour of her childhood, largely gastronomic. As she explains in the performance piece, born in Shanghai to Jewish refugees from Vienna, she spent most of her youth in Cleveland, where, from the German 'Ava', she became the American 'Eeeva' (Grudin 2003: 6), with agonizing results. As tour guide, Grudin is also fellow traveller. In the character of her younger self, she explores the Old and New Worlds of her troubled, split identity. As an adult narrator, she returns to the site of her own history to survey its wreckage.

Nearly all of the traumatic aspects of little Eva's youth in America are represented and/or mediated, in the play, through food. Her parents' difficult relationship, for instance, is manifested through a kitchen table scene acted out

with dolls, in German accents. 'How do you like the schnitzel?' the mother doll timidly enquires. 'I'll let you know if I didn't like it,' grunts the angry, often cruel father doll. 'I don't live to eat, I eat to live.' Eva's own growing food addiction, as she confides to the audience, arises in this troubled context: 'Not me. I . . . lived to eat!' Although, in Cleveland, Eva may technically be safe, she remains psychically unsettled, finding her sole refuge in food. As Grudin's partner in the performance, Austrian Israeli violist Yossi Gutmann, shows a video of all-American junk-food delights, Grudin exclaims, 'So much good food [in America]! She recalls her childhood treats: the 'Hershey bar' that was 'free' when the grocer 'wasn't looking', 'Hostess cupcakes', glowing pink coconut 'Snowballs'. Grudin 'wav[es] bags of marshmallows' (ibid.: 7–9) above her head, followed by an airy loaf of Wonderbread. She then frantically thrusts them down her dress. 'I loved to eat,' she continues, 'and to cook too. [. . .] My best, my favourite, my most secret recipe [. . .] I am willing to share with you: take *schmaltz* (you know, chicken fat) (Jewish) [*stage-whispered*] and lather it onto rye bread. Salt to taste. Then add American cheese and, if you feel like it, top it off with Hershey's chocolate syrup.'

Grudin samples the alimentary offerings of her native and adopted worlds, symbolically melding them into a sandwich and absorbing them as one. However, just as she chomps into her private spoils, air-raid sirens sound, as if in warning against such easy assimilation. She takes cover under the table, then, on second thought, reaches up for her full plate, enclosing herself, with her rations, beneath the theatrical 'curtain' (ibid.: 11–12) of the tablecloth. In *Sounding to A*, the kitchen table functions, literally, as a site for revisiting, restaging and re-enacting Holocaust-related trauma.

Victim of all-too-material tragedies and displacements of which she has little understanding and over which she has no power, the young Eva—unable to act, only to react or act out—negotiates her situation through the only material means at her disposal: food. In a scene set at an annual immigrant Fourth of July picnic, Grudin describes refugee women with 'long-sleeved shirts over their bathing suits' reaching for the potato salad, only to reveal the 'long, dark blue number' running down the inside of [their] arm[s]' (ibid.: 12). The only way she found to redeem this dour celebration of a nation only by force of circumstance her own was to winning the annual marshmallow-eating contest. In a similar attempt at redemption, bullied at camp for her 'baby fat' (ibid.: 29), she bites another child. While eating may provide the character of young Eva a temporary sense of power, the play, as written and performed by

the adult Grudin, suggests the opposite. Recounting the ship ride from Europe with a bunkmate in close quarters retching and the taste of a delousing chemical sprayed, upon arrival, at the refugees—scenes recalling concentration camps and gassing—Grudin indicates a conflict between her need to express feelings and pressure to stifle them: at one point, instead of food, she thrusts her arm in her mouth as a 'gag' (ibid.: 22). The inconsolable grief of her family and refugee community and the tumultuous events of her young life have left Eva starved emotionally: a void no *schmaltz*, cheese and chocolate sandwich can fill.

Through the course of the performance, Grudin—now svelte—gradually reveals that she nearly fed herself to death, becoming, until just before the writing of the play, morbidly obese. Near the end, in a scene in which Eva eavesdrops on a relative who survived a concentration camp, the audience learns that her grandmother voluntarily starved herself to death so that others might eat, and so have a chance to live. Eva's overeating stands in marked opposition to her grandmother's refusal of food, yet it is also aligned with it. If 'fat', as in the formative women's rights manifesto, 'is a feminist issue', *schmaltz*— that chicken-specific lipid—is a Jewish one, a staple of vaudevillian cliche. As a post-war, post-traumatic manifesto, *Sounding to A* pursues the old joke into the more treacherous battleground of the Jewish body: scientized, sterilized, starved, infinitely tortured and brutalized and nearly wiped out. For a population threatened, even before the war, by not only majoritarian oppression and sporadic forced nomadism but also its own small numbers, the child was an object of anxiety, a material product to be reproduced and maintained as well as loved. With the Holocaust, the stakes grew even higher. As the purported physical weakness of the Jew was not only a central tenet of eugenic theory but proved the very real effect of subsequent Nazi abuse, 'strengthening the race' became an issue of actual life or death as well as a psychological one. In psychoanalytic literature on children of survivors, 'eating disorders' and the more recent term 'disordered eating' appear on nearly every symptom list (Zohar, Giladi and Giladi 2007). The cheap, mass-produced food attractions of peacetime life in a brave new world of plenty further aggravated the conflation of survival with sheer surfeit. The only way the young Eva finds to restore the annihilated Jewish body of the past is to permit her own all the nurturing substances it craves—accepted when given, sneaked off or shoplifted when not, and more. With all the will and cunning of those who should have survived as well as those who did, she builds the sole material at her disposal—her small, fragile, live Jewish body—into a grand, solid Holocaust memorial, 'invested'—

as in James E. Young's characterization of the monument in general—'with soul and memory' (1994: 2).

Sounding to A concludes with the lighting of a *jahrzeit*, or death memorial, candle into which Grudin thrusts a marshmallow skewered on a chopstick, 'roasts it in the candle until it catches fire', brings it, 'burning, [. . .] to her mouth' and eats it. Gutmann plays the note of 'A' for 'Ava'. Grudin, singing the note, then 'blows out the candle' (2003: 16) with an evident mixture of regret and respect for that lost, brave girl. Eating the last marshmallow, she attempts to make her peace with the dead in Europe, her youth in America, her body and herself. Grudin now divides her time between the United States and Vienna, where she participates in dialogues between children of Nazis and of Holocaust survivors, and mounts activist performance pieces in public, often highly touristed, spaces as interventions against historical denial and ongoing prejudice. Once a passive gastrotourist of her past, Grudin has become an active force in the present, nourishing her famished spirit and that of her homeland with art and hope for the future.

Destination: Deli

Grudin's Cleveland, like New York, Montreal and other areas of major Jewish North American settlement, is famed for its Jewish delicatessens. For roots seekers of northeast European, or Ashkenazi, heritage, as well as other gastro-tourists, the deli—once simply a *heimish*, or homely, restaurant catering to local communities—has gradually become a central site of tourist pilgrimage. In the popular imagination, the deli has come to appear the ur-source—beyond the synagogue or any other institution—of information, both culinary and cultural, on the Ashkenazi diaspora. And a trip to the deli may be, in Jenna Weissman Joselit's words, 'as hallowed and highly regarded in some quarters as Sabbath [is] in others' (1996: 204).

Some classic delis, like Katz's in New York, dating to 1888, retain much of their cosy, if dowdy, decor and basic menus, but are packed with nostalgic suburbanites, international tourists—holding classic guidebooks that would once have scorned to list 'ethnic' establishments—and iPhone-toting foodies in search of 'the real thing'. Others, like New York's Carnegie, founded in 1937, hyperbolize cliches of Jewish generosity and excess with cartoonishly large offerings and exorbitant prices to match. Yet others, like the Los Angeles chain Jerry's, opened in 1978, long after the deli heyday, rely heavily on simulacra,

with decor vaguely evoking one or more idealized Jewish American 'golden ages', such as the early-twentieth-century mass-immigration era, represented by brassy fixtures and sepia photos of pushcart market scenes; or the formica-and-vinyl–heavy 1970s, a period, for American Jews, of general prosperity, positive visibility and tolerance, as well as, at once, ongoing cultural connection and increasing flexibility. Common to such delis are jokey transliterated Yiddish glossaries on placemats or menus, for insiders in the know and for outsiders who wish to be, as well as stereotypically 'gruff', 'pushy', 'warm' and/or 'wise-cracking' wait staff, not always Jewish themselves but seemingly performing as such, in a mild form of what might be termed Jewface minstrelsy. The allure of this sort of 'Disney deli', as a mini theme park of Ashkenazi culture, is the promise of an 'authentic', immersive tourist experience, piquantly exotic or cosily familiar—if only, in the latter case, from past visits to the deli or others. Disney delis tend to replicate themselves, often resembling one another more than their purported models. While prized for a general sense of historical, culinary and cultural authenticity, little about such a venue or its menu may tie it to past restaurants or foodways. Disney delis tend to double as diners, serving common North American and non-Jewish ethnic foods in addition to old standards: Jerry's, for instance, has nachos, themselves an American invention. And while specifically Ashkenazi cuisine in Europe is kosher, whether or not all Jews strictly observed the laws of *kashrut*, the Disney deli is decidedly non-kosher, centrally featuring the corned-beef-and-Swiss-cheese Reuben as well as often, more discreetly, including ham, bacon and shrimp on the menu.[1] As Hasia Diner notes, the compromise designation 'Kosher-style' arose in North American contexts in which *fleischig*, or meat-based, and *milchig*, or dairy-based, products were not kept entirely separate; this honorific, she writes, may have 'counted more' (2003: 135) to Jewish patrons (as a nod to tradition and identity) than to religious adherence. The phrase kosher-style is now frequently used in extra-Judaic contexts, such as guidebook restaurant listings, where calling food 'Jewish'—a term of religion rather than national origin or culture—might appear politically incorrect.[2]

Similarly, Midwestern, Southern and West Coast delis have long tended to advertise as 'New York-style'—to some extent, perhaps, as an euphemism for 'Jewish' in locales where 'New York' may already connote something sufficiently egregious.[3] Indeed, the deli memorializes Ashkenazi Europe to a lesser extent than New York's Lower East Side, even on the Lower East Side, where Katz's remains a rare remnant in an area increasingly given over to youth-oriented

bars and boutiques. Further, given that the majority of Ashkenazi households in Europe and on the Lower East Side were poor and thus fairly 'meat-scarce' (Ziegelman 2010: 177), delis representing typical Ashkenazi cuisine may be fewer than dairy restaurants serving a wide range of traditional non-meat dishes, such as cold fruit soup and *milchreis* or rice with sugar and milk. Although kosher non-meat restaurants still exist, they tend to rely more heavily on Middle Eastern dishes than on traditional Ashkenazi dishes; the classic dairy restaurant and many of its menu items are now essentially extinct. Also absent, or nearly so, are venues such as *knish*, or potato-pastry, parlours, Jewish socialist workers' cafes, ladies' tea-and-mahjong salons, and bakeries featuring items such as charlottes russes, fruit-and-whipped-cream shortcakes in push-up cardboard tubes that, for want of demand, are themselves no longer manufactured.

The deli thus remains only a metonym for a once far richer, more diverse culinary and cultural tradition; this may be all that the tourist—whether arriving by commuter train or international flight—is positioned to perceive. By way of the process Joseph Roach describes as 'surrogation' (1996: 2), the deli in its current form serves to display and obscure that which came before. Yet, the tourist may not wish for too much more or may fear it. The security of the deli excursion—across the world or across town, just once or once a week—lies in that it requires investment in no context, such as Yiddish courses or in-depth study of Jewish history and culture—more intellectually or emotionally rigorous than a meal. At least some of the attributes listed by Barbara Kirshenblatt-Gimblett as those of the museum can be seen as those of the deli:

A vault [. . .]; [a] cathedral of culture, where citizens enact civic rituals [. . .]; a school dedicated to the creation of an informed citizenry [. . .]; a laboratory for creating new knowledge [. . .]; [a] cultural center for the keeping and transmission of patrimony [. . .]; [a] theater, a memory palace, a stage for the enactment of other times and places, a space of transport, fantasy, dreams; [a] party, where great achievements and historical moments can be celebrated; [a]n advocate for preservation, conservation, repatriation, sovereignty, tolerance; [a]n artifact to be displayed in its own right, along with its history, operations, understandings, and practices; [a]n attraction in a tourist economy [. . .] (1998: 138f).

Although another of the attributes Kirshenblatt-Gimblett lists, 'a place to mourn', would seem anomalous in this context, the deli may well stand as a

locus of grief for an essentially lost culture. Yet, as with what Marita Sturken describes as 'comfort culture' in general, the deli 'doesn't promise to make things better; it promises to make us feel better about the way things are' (2007: 7). A vast, largely past culture may or may not be glimpsed from a vinyl booth or savoured in a canned celery tonic. Yet, the fact that tourists, from near and far, continue to flock, believing that it can, attests to a longing, in itself meaningful, for communion and connection with the lost world of Ashkenaz, wherever and whatever it may be.

Jewfacade Food Tourism

The North American Jewish deli, Disneyfied or not, is a relatively innocuous phenomenon. In East Central Europe and Eurasia, more questionable developments in Jewish heritage tourism are on the rise. These include increasing sites of Jewface minstrelsy—music, theatre, visual arts and extra-theatrical performance, generally by non-Jews impersonating Jews, as historically imagined—as well as what might be termed 'Jewfacade' display: the construction of environments, also generally by non-Jews, meant to convey a sense of the Jewish past, again as imagined. Jewfacade displays often take the form of what is known as the Jewish-style restaurant.

Much neo-Judaic activity is well intentioned, respectful and informative. A standout, in this regard, among restaurants is Krakow's Klezmer Hoys, or House, decorated to recall the stately dining rooms of upper-class families like the former residents of the area, showcasing accomplished musicians and other well-curated Jewish-related events. Other Jewfacade restaurants may simply represent historical confusion and/or flights of fancy. The only Jewish element evident in the Freylekhs ice cream parlour in Birobidzhan—a Stalin-era colony for Jews in far-eastern Russia—is a mural in which the characters in the grotesque hells of mediaeval Dutch artist Hieronymus Bosch appear to have been painted over with stereotypically hook-nosed, gremlin-like Jewish figures. As Jewish heritage—the sole feature that distinguishes Birobidzhan from other small towns in the region—is generally treated as a point of community pride by townspeople of Jewish background and others alike, it is likely that the scene depicted carries little more symbolic weight than a similarly ill-conceived Russian folkloric motif.

However, much neo-Judaic activity is insensitive or cynical in nature. Unlike Klezmer Hoys, the Once Upon a Time in Kazimierz cafe is crammed

with bric-à-brac, little of it specifically Jewish—sewing machines, washboards, Victrolas, nightgowns, violins—piled randomly on floors and windowsills and festooning walls and ceilings. Although the scene may recall the oneiric imagery of the Ashkenazi painter Marc Chagall, it rather misrepresents and short-changes the culture and people from whose absence it profits. The Anatewka restaurant in Lodz, Poland—named after the *shtetl* in *Fiddler on the Roof* (1964)—features, at one of its tables, a mannequin costumed as a religious Jew and positioned as praying, Shylock-like, over a bowl of money. Guests throw coins in the bowl as they walk out. Anatewka is a mini-chain, its secondary outlet located in the food court of a combined cultural centre and shopping mall fashioned out of a formerly Jewish-owned factory, where it shares an out-door dining deck with Panda Express and Pizza Hut. As at any mall food court, the visitor—local or from afar—may thus snack on more than one relatively exotic cuisine and experience projected elements of more than one such culture within one meal or shopping trip. Rarely, however, may thanatourism and casual dining be found so closely linked. The Under the Golden Rose restaurant in Lviv, Ukraine—encroaching on the grounds of a ruined synagogue—provides patrons broad-brimmed, black Chasidic hats with attached foot-long *payess* side locks to wear. No prices are printed on the menu. After eating, the patron is expected to bargain or to 'Jew' the waitstaff down. As Jewish residents of Lviv have protested the restaurant's painful practices, to no effect, it may be assumed that religious–cultural respect is not among the management's prior-ities. The same proprietors run two other theme restaurants a few blocks away. The first based upon the Lviv historical figure of Leopold von Sacher-Masoch. The entry for that in a tourist pamphlet salaciously intimates: 'If your husband is having difficulties deciding on a meal, he's probably too distracted by the pornography that appears on the menu [. . .]. He's sure to appreciate the bull's testicles [. . .]. [T]he waitresses will handcuff and whip you free of charge' (*In Your Pocket* 2011a). The second is a patriotically folkloric–styled bar serving as the unofficial headquarters for adherents of Ukraine's neo-fascist nationalist movement. This troika of establishments at once airs, distorts, mocks and rejects notions of tolerance for cultural difference while turning a brisk profit.

The tourist pamphlet insidiously confides that, at Under the Golden Rose, 'for the right price you can arrange to have your waiter smuggle in some pork dishes' (*In Your Pocket* 2011b). The most disrespectful of Jewfacade eateries make little attempt to mimic actual Ashkenazi cuisine. While running a kosher restaurant in these areas is near impossible, as supplies are nearly non-existent,

the best of Jewish-style restaurants, such as Klezmer Hoys, serve exhaustively researched and carefully prepared traditional dishes, including some rarely found today even in New York. On my own journeys from North America through East Central Europe and Eurasia, a glass of cold strawberry soup and a spoonful of rice-pudding-like *milchreis*, favourites from the time before my grandmothers died, were in a great sense more authentically tied to my own memories and heritage than any dishes I had come across in any deli, and provoked deep associations that permitted me to revisit, mourn and honour those long lost, in a 'living' way, in the once-homeland so meaningful to them.

If we may take the artificial or approximated to be real, and experience it almost as if it were, perhaps issues of what is real or not do not wield the import they might. Perhaps others, even those once coded as enemies, harbouring a people's legacy, culinary or cultural, may protect and return it, relatively unscathed. And if death memorials are to be touristed with due respect, perhaps there is also room for a place where one may shake off necro-culture to seek memorial regeneration.

Recipe for a Ruptured Repertoire

In his 1918 *fin-de-siècle* travelogue *Oriental Encounters*, the British explorer Marmaduke Pickthall recounts a bizarre tale of Jewish mourning, tourism and eating (cited in Stratton 2004: 78). A Jew in 'Stambûl' begs an Ottoman judge en route to 'the Holy Land' to carry 'a basket of *bastirma*'—a form of pastrami—for his son in Jerusalem. After one surreptitious taste, the judge's servant, a great 'rogue', overcome by its deliciousness, wolfs down the whole thing. Upon arrival, sheepishly presenting the empty basket to the young Jew, the servant offers to reimburse him for the food. Instead, the young Jew flings the servant 'to the ground', attempting to 'tear' and bite 'the soul out of his body'. Following a ferocious struggle, the young Jew 'point[s] his tallow finger' at the confused offender: 'that man contains my grandfather,' the young Jew informs the crowd. Three weeks before, as it turns out, his grandfather had indeed died. While 'it had ever been' the grandfather's 'dearest wish to be buried in the Holy City', the cost of transporting a Jewish corpse overseas was prohibitive. Thus, the young Jew's father had 'cured' his own father's 'dead limbs, and sent him hither' in the basket. When, to his great shock and chagrin, the servant realizes what he has ingested, he reforms and becomes 'the saintliest of men'. When the servant dies, he is 'buried in the Holy City as the Jew [had] desired',

with the Jew within him (Pickering 1918: 174–9). However gruesomely, this anecdote evokes the historic longing of the wandering Jew for *home* and *home-land*. Thus, the old Jew may be transported to the Holy Land of yore only through the alimentary canal and merge with it only when transubstantiated into the body of a non-Jewish traveller. Food resonates as a potent material link between self and place as well as self and other.

In today's mainstream North American Jewish (i.e. northeastern European or Ashkenazi) cultural imagination, the biblical Zion has to a great extent been replaced by East Central Europe as home to the largest Jewish population in history and as site of the genocide that has largely come to shape notions of Jewish history and heritage. In this case, the barrier to travel may be less physical than psychic, and, in that, even more problematic. For latter-day pil-grims—particularly those born and raised in the modern diaspora of the twen-tieth century—the old world of Jewish East Central Europe may feel like an origin and homeland to which one might return. Yet it no longer exists, if it ever did in the form it has absorbed as myth.

Marianne Hirsch discusses what she terms 'postmemory':

[T]he relation of children [. . .] to the experiences [. . .] that they 'remember' only as the stories and images with which they grew up, but that are so powerful, so monumental, as to constitute memories in their own right [. . .]. Postmemory is a powerful form of memory precisely because its connection to its object or source is [more] medi-ated [than first-hand memory] through projection, investment, and creation [. . .] (1998: 8).

In the postmemorial paradox, 'an enormous distance must be bridged', yet 'that distance *cannot* ultimately be bridged; the break between then and now, between the one who lived it and the one who did not, remains monumental and insurmountable, even as the [. . .] imagination struggles to overcome it' (ibid.). Owing to both calamitous and ordinary events, Jews are nearly absent from East Central Europe, those who directly remember that world are disappearing and few authentic vestiges of the culture of that world remain. Nonetheless, the desires of those left behind for connection with that world fail to cease and, in fact, appear to increase as the full extent of its endangerment becomes clear.

In any culture, seemingly, food—remembering it, imagining it, receiving it, cooking it, eating it—may appear to bridge postmemorial gaps. However, difficulties abound. The schisms Diana Taylor (2003) describes between the

'archive' or inscriptive historical–cultural record and the 'repertoire'—the alternate mode of transmission effected through performed, embodied, often otherwise inarticulable, material and sensual practice—are well borne out in the culinary realm. The recipe as a fixed document—a record of past culinary performance and a blueprint for future ones—always already exists at a remove from the basic nature of food, 'perishable' and 'ephemeral' (Kirshenblatt-Gimblett 1991: 77), as well as from actual culinary practice, which is geo-culturally and materially grounded, and, like other forms of performance, subject to site-specific variation and improvisation—the vagaries of staging in different times and places. Compounding the difficulty of Jewish culinary transmission, in particular, is the fact that, although in the nineteenth and twentieth centuries Jewish eateries, taverns and stores existed in some European urban centres and larger towns, Jewish food preparation of the past—preservation processes such as pickling, often performed by men, as well as cooking, primarily done by women—was largely home-based. Apart from rare ethnographic and family accounts, recipes were rarely written down and were generally loose approximations. In the New World, translation from Yiddish and other languages and variation in food sources resulted in further alterations. In addition, as Kirshenblatt-Gimblett (1991) suggests, in an overview of Jewish American cookbooks with agendas beyond mere transcription—elevation; modernization; cultural fusion; fashion; commercial product placement; religious, social and/or health reforms; trans-generational education and more—the editorial and narratological complexities of recipe collection have engendered further distortion of historical information.

Moreover, with the Holocaust, those most familiar with traditional foodways and lifeways (i.e. elders) were, along with children, those least likely to survive. The poet Herman Herbert Granek, born in a post-war refugee camp, has movingly spoken of his mother—trained to cook at her own mother's side before all but her brother were murdered—preparing and serving treasured dishes as a sacrament of memory. For her brother, taken away at a much younger age—to emerge, five years later, after internment in five concentration camps, with seventy pounds on his five-foot-nine-inch frame—teaching himself to cook, and then running a series of restaurants dishing out cheap, fresh home-style meals to workers in New York's industrial district, producing food has proven both a painful and restorative act.[4] As in Sidra DeKoven Ezrahi's discussion of diasporic literature, in which 'writing the exile' symbolically functions as 'a form of repatriation' (2000: 10), to cook, serve and eat may be to

perform a more embodied return to a disrupted cultural repertoire. If, as with other types of cultural performance and re-performance, one can learn by doing, perhaps one can also learn by cooking, serving, eating and travelling— in reality or in the imagination—to taste what nurtured, strengthened and pleased those we wish to know and honour in past times and distant places. And if, as with tourism in general, we may pursue understanding through the faculties of sight and sound, perhaps we might as well do so through those of touch, smell and taste.

Food and foodways contain intangible but vital memorial communications. Lorna Sass (2009) describes an exchange overheard between an 'elegantly dressed lady' and a 'waiter'. Referring to a cold sorrel, or sour-grass soup, the woman enquired, 'What is *shav*?' [*sic*] to which the waiter replied: 'Lady, if you don't know what it is [. . .] you're not going to like it' (ibid.). Few diners, Jewish or non-Jewish, know what *schav* is today. And as familiarity with an item declines, demand for it and, hence, supply of it fall away. In a plaint recalling Kirshenblatt-Gimblett's discussions of the problems of the ethnographic museum 'fragment' (1998: 55) displayed divorced from context, Granek has decried the disappearance of a custom of his childhood: dairy served on glass plates. In Granek's recollection, 'dairy tasted better on glass plates'.[5] Like a theatrical prop, the glass plate functions as a vital and 'volatile [. . .] sign' (Sofer 2003: 6) within the gestalt of the meal: with different props, a production may follow the same script as another, yet, finally, not be quite the same play. As neither archival research nor consultation with Jewish food scholars[6] revealed mention of the glass plate practice, one may infer that it may be a repertory entity so common or banal-seeming as to escape note in archival records. As Roach suggests, the impulse of preservationists to freeze 'intangible' heritage, such as performance, at any particular moment of its journey falsifies its ameliorative nature (2007: 182). Like cultural practices, foodways are always in flux. Gottleib's, a Chasidic-, or ultra-orthodox-, run Jewish restaurant in Brooklyn, features pastrami-filled Chinese eggrolls. Several recently established Jewish delis, such as Saul's Deli in San Francisco, use organic and/or locally sourced meats and vegetables; whether in a deviation from tradition or a return to it is unclear. For many of Ashkenazi heritage today, the prime site of postmemorial longing may, in fact, be neither the Old Country or the Lower East Side but the suburban home stocked with the long-shelf-life packaged items purchased in supermarket 'ethnic' sections, where a Manischewitz matzoh-ball mix rubs shoulders with Ortega taco kits, and 'La Choy makes Chinese food swing

American!' (Coe 2009: 240); as a store sign in a *New Yorker* cartoon reads, 'Takeout just like Momma used to order' (Smaller 2011). These foodstuffs may appear more viable cultural 'souvenirs' (Stewart 1993: 132–50) or memorial metonyms than the from-scratch versions. As homesites and lifeways change, so do the objects of nostalgia we long to revisit, authentic or not. And with 'pastrami [. . .] served shrink-wrapped between stale slices of white bread in Nebraska gas stations' (Sax 2009: 2), Ashkenazi cuisine has become a much-diluted concept. Yet, without efforts, at least, to 'seize hold of memory before the break with the past [is] irretrievable' (Berelowitz 2011), otherwise ephemeral, traceless knowledge, both culinary and more broadly cultural, is threatened with permanent loss. The elegant gastrothanatourist, served dairy on china, will most likely not have the sense Granek conveys of what she has missed. But, sampling *schav*, she may find—*pace* the pessimistic proclamation—that she likes it and read up on the people for whom it was a treat, travel to the places where they not just died but lived, plant sorrel like they once did in their gardens, and speak of them as she serves the green soup each spring. As with tourism in general, with gastrotourism too cultural transmission may be highly distortive. Yet, even imperfect recall of the past may be preferable to none at all and may be productive of new, yet still meaningful, memorial and cultural practices.

Jewish practice has a significant practice of self-privation as a marker of and aid to solemnity. Observance of Yom Kippur, or the annual Day of Atonement, involves a 24-hour fast, as does that of Tisha b'Av, the anniversary of several major calamities befalling the Jewish people, from the destructions of the First and Second Temples of Jerusalem in biblical times to the expulsion of Jews from Spain and the mass deportation of Jews from the Warsaw Ghetto to Treblinka. Physical self-denial may decrease distraction from spiritual priorities; bodily self-punishment mimics the atrocities meted out upon others who came before. In each case, however, the fast is limited and followed by a regenerating meal. The burial of a loved one is followed by a 'meal of comfort' in which the bereaved are commanded to eat a meal supplied by neighbours and friends, including 'the bread of others', and an egg, as symbol of the cycle of life. Jewish tradition also dictates that, however painful it may be, after an extended period, the mourner resume all normal engagements (Heilman 2001: 182–201). And even the most respectful tourist will eventually need to depart the site of suffering and death for rest and nourishment, and will return, however painfully, to life.

So it may be, historically. We cannot forgive or forget the past, nor would we ever wish to do so. We cannot relieve the pain of those who have suffered in the past, nor save those who have been lost. Perhaps, all we can hope to do is to revisit and remember them as best we can. Shall we laugh or shall we cry? Or shall we eat?

Notes

1 The Gorbals, a cutting-edge Los Angeles eatery of Scottish Jewish pedigree, even flaunts its intentionally cheeky signature fusion dish, matzoh balls wrapped in bacon.

2 What makes a food—not unlike a person—Jewish has, historically, been open to debate. One author codifies Jewish cuisine as, simply, 'international cooking based on [kosher] dietary laws' (Mildred Bellin, quoted in Kirshenblatt-Gimblett 1991: 86). Another asserts that 'almost every dish we know as Jewish can be traced' to the 'table' of a nation in which Jews resided (Sax 2009: 25). With intra-cultural blending and assimilation, once-diverse Ashkenazi food-ways have been syncretized and standardized, their specificities erased. And, with time, much, like *schav*, has been forgotten.

3 In Canada, 'Montreal-style' holds that place, while in New York, 'Montreal' deli is the latest trend.

4 Herman Herbert Granek, private conversation with author, 6 March 2011.

5 Granek, private conversation with author, 6 March 2011.

6 I am grateful to Eve Jochnowitz and David Sax for attempting to answer this enquiry. Any basis for the custom Granek recalls remains a mystery. No apparent kosher law exists regarding the material of dairy tableware. As glass is considered non-porous, it may be used interchangeably for meat- and dairy-based meals: a money-saving device, perhaps, for the very poor, but one requiring, in Ashkenazi interpretation, three days of immersion in water in between, and thus not a convenient one; and meat, to Granek's memory, was served on china plates. Perhaps, the propensity of glass to hold a chill served a preservative purpose in the days before widespread electrical refrigeration. Perhaps, with the inception of the notion of the dairy meal as health food, vegetarian (see Ziegelman 2010: 178), though not low-fat, glass was seen to convey, optimistically, an air of weightlessness.

Works Cited

Berelowitz, Jo-Ann. 2011. 'A Contrast in European and US Approaches to the Jewish Culinary Heritage: Claudia Roden's and Joan Nathan's Jewish Cookbooks'. *Journal of Modern Jewish Studies* 10(2): 155–83. Available at: http://www.tandfonline.com/doi/full/10.1080/14725886.2011.580974 (last accessed on 23 September 2013).

Coe, Andrew. 2009. *Chop Suey: A Cultural History of Chinese Food in the United States*. Oxford: Oxford University Press.

Diner, Hasia. 2003. *Hungering for America: Italian, Irish, and Jewish Foodways in the Age of Migration*. Cambridge, MA: Harvard University Press.

Ezrahi, Sidra DeKoven. 2000. *Booking Passage: Exile and Homecoming in the Modern Jewish Imagination*. Berkeley: University of California Press.

Grudin, Eva. 2003. *Sounding to A: Reverberations of the Holocaust*. Unpublished performance manuscript.

Heilman, Samuel C. 2001. *When a Jew Dies: The Ethnography of a Bereaved Son*. Berkeley: University of California Press.

Hirsch, Marianne. 1998. 'Projected Memory: Holocaust Photographs in Personal and Public Fantasy' in Mieke Bal, Jonathan V. Crewe and Leo Spizer (eds), *Acts of Memory: Cultural Recall in the Present*. Lebanon, NH: University Press of New England, pp. 2–23.

In Your Pocket. 2011a. 'Masoch Café: Lviv in Your Pocket'. Available at: http://www.inyourpocket.com/ukraine/lviv/Where-to-eat/Cafes/Masoch-Cafe_48152v (last accessed on 20 March 2011).

———. 2011b. 'Pid Zolotoiu Rozoyu: Lviv In Your Pocket'. Available at: http://www.inyourpocket.com/ukraine/lviv/Where-to-eat/Jewish/Pid-Zolotoiu-Rozoyu_48141v (last accessed on 20 March 2011).

Joselit, Jenna Weissman. 1996. *The Wonders of America: Reinventing Jewish Culture, 1880–1950*. New York: Hill and Wang.

Kirshenblatt-Gimblett, Barbara. 1991. 'Kitchen Judaism' in Jenna W. Joselit and Susan L. Braunstein (eds), *Getting Comfortable in New York: The American-Jewish Home, 1880–1950*. Bloomington: Indiana University Press, pp. 77–105.

———. 1998. *Destination Culture: Tourism, Museums, and Heritage*. Berkeley: University of California Press.

Pickering, Marmaduke. 1918. *Oriental Encounters: Palestine and Syria, 1894–96*. London: W. Collins.

Roach, Joseph. 1996. *Cities of the Dead: Circum-Atlantic Performance*. New York: Columbia University Press.

————. 2007. 'World Bank Drama' in Wai-Chee Dimock and Lawrence Buell (eds), *Shades of the Planet: American Literature as World Literature*. Princeton, NJ: Princeton University Press, pp. 171–83.

SASS, Lorna. 2009. 'Where Are the Old Jewish Waiters?' Available at: http://lornasassatlarge.wordpress.com/2009/01/26/where-are-the-old-jewish-waiters/ (last accessed on 20 March 2011).

SAX, David. 2009. *Save the Deli: In Search of Perfect Pastrami, Crusty Rye, and the Heart of Jewish Delicatessen*. New York: Houghton Mifflin Harcourt.

SMALLER, Barbara. 2011. 'Takeout Just Like Momma Used to Order'. *The New Yorker*, 17 January. Available at: http://www.condenaststore.com/-sp/Sign-TAKE-OUT-just-like-momma-used-to-order-New-Yorker-Cartoon-Prints_i8476233_.htm (last accessed on 20 March 2011).

SOFER, Andrew. 2003. *The Stage Life of Props*. Ann Arbor: University of Michigan Press.

STEWART, Susan. 1993. *On Longing: Narratives of the Miniature, the Gigantic, the Souvenir, the Collection*. Durham, NC: Duke University Press.

STRATTON, Lawrence M. 2004. 'Tory Muslim: The Conversion of Marmaduke Pickering'. *Koinonia* 16: 78–100.

STURKEN, Marita. 2007. *Tourists of History: Memory, Kitsch, and Consumerism from Oklahoma City to Ground Zero*. Durham, NC: Duke University Press.

TAYLOR, Diana. 2003. *The Archive and the Repertoire: Performing Cultural Memory in the Americas*. Durham, NC: Duke University Press.

YOUNG, James E. 1994. *The Texture of Memory: Holocaust Memorials and Meaning*. New Haven, CT: Yale University Press.

ZIEGELMAN, Jane. 2010. *97 Orchard: An Edible History of Five Immigrant Families in One New York Tenement*. New York: HarperCollins.

ZOHAR, Ada H., Lotem Giladi and Timor Giladi. 2007. 'Holocaust Exposure and Disordered Eating: A Study of Multi-Generational Transmission'. *European Eating Disorders Review* 15: 50–7.

Sites of Absence and Presence: Tourism and the Morbid Material Culture of Death in Brittany

MAURA COUGHLIN

'The Breton nation is remarkable for its piety for the dead,' declares Jacques Cambry in his famous travelogue of Brittany, published in 1799 in the wake of the French Revolution (in Badone 1989: 1). Ever since this first account of modern travel in Brittany, France, the region has been celebrated as a repository of Celtic culture and vestigial death ritual lost to metropolitan France.[1] From the 1840s until the mid-twentieth century, tourists were drawn to view, represent and repeat anecdotes about, and sometimes participate in, Breton ritual observances of the cult of the dead. Figuring prominently in images and narratives produced by travellers are the communal particularities of Breton burial practices, morbid commemorative rituals and memorials. Although the term 'thanatourism' is a recently coined neologism, an emerging form of this postmodern phenomenon can be seen in modern tourist practice in Brittany.

Visual and textual representations of ritual festivities and everyday memorial material practices on the Brittany coast have often been considered as simply traces (no matter how exaggerated) of encounters between outsiders to the region and incidents of rural life. However, this fascination with the Breton cult of death involves a form of touristic desire and a discourse of representation far in excess of the visual model of the pre-framed, institutionalized and nostalgic 'tourist gaze' formulated by John Urry (1990) in the early years of tourism studies. To sketch out a history of Breton thanatourism, this essay considers the modern social phenomena of tourism broadly, to include Bretons, Parisians and other nationals who produced travel representations. Both experiential and material encounters are considered in this sampling of responses to exemplary sites, objects and images.

In his travel notes *Over Strand and Field: A Record of Travel in Brittany* from a trip in 1847–48 with Maxime DuCamp, Gustave Flaubert (1904) admits

being fascinated by the bodily engagement of Bretons with their faith and their death rituals. Observing worshippers in a chapel dedicated to the Virgin in the port town of Pont L'Abbé, he describes their religious devotion as a form of 'sensuousness' that speaks to an 'unquenchable longing for love and enjoyment' with an appeal to 'carnal sensations' (ibid.: 46–7). At this chapel, Flaubert imaginatively participates in a paradoxical, corporal experience of faith: its pleasurable pain, its indulgent deprivations, its pre-modern, idolatrous relationship with the graven image. His fascination with Breton piety, however, is more akin to horror, when describing a scene of intense grieving that he witnessed at the funeral of a drowned man. While staying in a quiet country inn near the famous Neolithic site of Carnac and finding nothing to do after dinner, he stumbles upon a dramatic scene in the village church. Flaubert's language is at once condescending, ironic, sensual, grotesque and sympathetic as the mourning ritual becomes increasingly strange before his eyes. The drowned man's widow he reads as a spectacle of primal emotion: 'her staring eyes, framed by lids that looked as if they had been scalded, so red were they; her idiotic and contracted mouth, trembling with despair, and her whole pitiful face, which was drenched with tears' (ibid.: 23–4). Both 'idiotic' and 'pitiful', the widow's sobbing is excessive, involuntary and almost animal-like. Yet, he muses distantly, this strange gurgling might also be mistaken for joy. Kneeling together, a collective group of mourning women seems to conjure forth for him an uncanny spectre of death: 'throwing back their hoods and their big white caps, the starched wings of which fluttered in the wind, appeared at a distance like an immense winding-sheet hovering over the earth' (ibid.). Ending his anecdote on a savage note, Flaubert notes that 'a young fellow passed us and said in French to a companion: "Heavens! Didn't the fellow stink! He is almost completely mortified! It isn't surprising, though, after being in the water three weeks!" ' (ibid.). This display of grief and the physical, visual (and even olfactory) aspects of death in Brittany receives far more attention in Flaubert's tourist narrative than the prehistoric aligned stones of Carnac—the presumptive reason that the author might have stopped in this village. Flaubert thus narrates one individual's grief as both bizarre (and almost grotesque) and of a regional type. Following the logic of Cambry from half a century earlier, Flaubert implies that the primary cultural narrative of Brittany is a fusion of death and piety.[2]

Like Flaubert's interest in the anti-rational and absolute devotion of Bretons to their saints and rituals, many other nineteenth-century travel accounts remark on the apparent survival of pre-modern faith and practice in the superstitious

present. In this way, the Breton culture of death continued to serve tourists as a marker of regional difference. Breton oral folk tales, collected avidly by ethnographers in the late nineteenth century, attest to the continued prominence of death in everyday life: these are grim tales of death omens, children stolen at night (replaced by changelings), evil old women and their curses, night demons, barques of death, howling unbaptized baby's souls and malevolent sirens who lure men to watery graves. Folklorists read this popular faith as resistant to official control from the church: as an independent survival of local culture, yet also as superstitious and primitive.[3] It was especially with regard to death at sea that Breton culture seemed obsessed with mortality, viewing the Atlantic as a devourer, a graveyard, 'a vast coffin that the priest comes to bless' (Benoist et al. 1852: 24).[4] In interwoven genres of travel writing, folklore and literature, the Breton coast and its offshore islands are presented as the most 'pure' or concentrated repositories of human culture, languages and even animal species that had died out elsewhere.[5]

Breton folklorist, novelist and scholar Anatole Le Braz, in his 1893 collected volume *Légende de la mort chez les Bretons Armoricains*, revised, expanded and published in 1902 as *La légende de la mort en Basse-Bretagne* (Death Legends in Coastal Brittany), definitively established the persistence of Breton faith in death omens, demons and the interpenetration of the worlds of the dead and living. Just after publishing this anthology of folklore, Le Braz travelled to the islands of Sein and Ouessant (both off the southwest coast of Western Brittany). These islands had a deadly reputation (for the many ships wrecked on their shoals) reinforced by the popular rhyming proverb: 'Qui voit Ouessant voit son sang, Qui voit Sein voit sa fin' (He who sees Ushant sees his blood, He who sees Sein sees his end). Le Braz's travelogue to Sein from 1893 was only published in a heavily edited version posthumously (Tanguy 1999). His notes for this project along with a full album of photos (taken by a photographer named Lemoine, who accompanied him), in the archives of the Celtic studies research centre (Centre de Recherche Bretonne et Celtique) at the University of Brest, articulates a desire to find, experience and express the culture of death, continuous with the modern age, on the outer islands. In this project, Le Braz was clearly looking to articulate the culture of death on Sein and to excavate a place mired in a *timeless* relationship to mortality. Yet, when he visited in 1893, this focus on the brevity of life was very much of the present for Bretons living on the coast and islands. Child mortality rates were far higher there than in the rest of France at the turn of the century, and devastating epidemics repeatedly

returned. So many residents of Sein died in the cholera outbreak of 1886 that the women of the island adopted a black, everyday costume that was only one degree away from the dress of full mourning. The black *coiffe* that the women wore—a sort of bonnet that in Brittany varied in shape by region—had two side flaps or *jibilinenn* that, when folded down, indicated mourning. Elderly women on Sein often left them this way for good (ibid.: 22). The Sein *coiffe* was a prominent motif of travel imagery; photo postcards and travel texts up to the present repeatedly mention this as a feature of local culture that commemorates mass death on the island.

Marriage, death and mourning customs on Sein are detailed in Le Braz's notes and collected photos. He recounts that for the islanders, a widow had just two goals in life: the maintenance of her husband's grave and the prospect of joining him in the hereafter.[6] Several photographs of black-clad widows attending to graves in the island's main cemetery were shot for Le Braz by Lemoine (their predominance in the album in Brest shows they are the focus). In selecting

LE JOUR DES MORTS EN BRETAGNE

FIGURE 19. Moreno, *The Day of the Dead in Brittany*, illustrated supplement to *Le Petit Journal*, 31 October 1897. Photograph from author's collection.

these views, he most likely had a very prominent Salon painting in mind: Emile Renouf's massive canvas *The Widow of the Isle of Sein* (1880), which had definitively marked this as an island of tragic widows (figure 19). This site is mislabelled in a postcard from the turn of the century as the 'Cimetière des Naufragés' (Shipwreck Cemetery), and actually was a cholera cemetery on the outskirts of town. Renouf chooses this lonely and seemingly remote cemetery (nothing is distant on an island this small) so melodramatically close to the water to suggest that it is the ever-present, voracious sea that has taken the man who was both husband and father to the island's survivors. Le Braz knew this painting well, and, as he mapped out the human geography of the island, he wondered, in his notes, whether Renouf's composition might not be a creative concoction of anecdote rather than a testimony to actual practice (Tanguy 1999: 28).[7]

One photo in Le Braz's album depicts a shyly smiling island woman posed in a diminutive, yet tidy domestic interior (figure 20). She is costumed in the black dress of the island, with her *coiffe* flaps down and her hands clasped

FIGURE 20. Joséphine Menou on the Isle of Sein from the album of images shot by Lemoine for Anatole Le Braz in 1893. Photograph courtesy of Maura Coughlin, taken with the permission of the Centre de Recherche Bretonne et Celtique, University of Brest, Brest, France.

187

before her. Her gaze, as it meets the angle of the photographer's lens, speaks of this moment of contact with visitors from the 'continent' (as islanders spoke of the mainland). Le Braz's handwritten caption tells us that this islander, Joséphine Menou, died of typhoid fever at the age of 24, on the very day that she was to be wed. Caption and image work together in the album to compound the tragic sense that death pervades all aspects of life on this tiny island. The woman's outfit, on the one hand, displays a local particularity of costume; on the other, it declares her state of mourning and shelters her within it. She mourns, yet we understand that she will soon be mourned. The handwritten text, left blank in a space for the year of her birth and later amended, tells the story that post-dates the photographic encounter (many other images of women in the album are unnamed).

Photography had, from its early-nineteenth-century origins, been intimately acquainted with death—staging its representation and disavowing its demate-rialization of the body (Mirzoeff 2009: 119–25). The image of Menou is marked doubly by death: her death to Le Braz, reflecting upon her fleeting image in his caption, and the death of the moment suspended in the image. In *Camera Lucida: Reflections on Photography*, Roland Barthes famously reflects on a pho-tograph of his deceased mother, and suggests that

> [d]eath must be somewhere in a society; if it is no longer (or less intensely) in religion, it must be elsewhere; perhaps in this image which produces Death while trying to preserve life. Contemporary with the withdrawal of rites, photography may correspond to the intrusion, in our modern society, of an asymbolic Death, outside of religion, outside of ritual, a kind of abrupt dive into literal Death. Life/Death: the para-digm is reduced to a simple click, the one separating the initial pose from the final print (1981: 92).

The image from Sein is saturated with Barthes's notion of photographic belat-edness; of 'what has been' and 'what is no longer' or, perhaps more aptly, it depicts a subject (in mourning) who lived not much longer beyond the moment of this photograph.

Unlike the shy glance encountered in this photograph, in Le Braz's later novel set on the island, *Le Gardien du feu* (The Lighthouse-Keeper), a fictional character, a commanding widow, cloaked in black, looks 'like the mute and black veiled figure of Fatality' (2000: 51).[8] This conflation of the widow with the spectre of death (as a female grim reaper) was a common visual trope

of international symbolist visual culture of the 1890s. However, Le Braz's widow may well be a compound of several literary precedents. A much earlier novel, *Les Vieilles femmes de l'île de Sein* (The Old Women of Sein, 1826) by Hippolyte Bonnellier describes the older women of the island as 'veiled in black, in fatality' (in Salomé 2003: 51). An even earlier novel introduced Sein's mythic femme fatale, Velléda, the Druid 'sorceress' of François René de Chateaubriand's *Les Martyrs* (The Martyrs, 1809).[9] Following the illogic of the burgeoning revival of Celtic culture in Brittany, Bonnellier extols the islanders' 'pure' Druidical customs and pathologizes the women of Sein as monstrous and degenerate savages who lure passing boats to wreck and then loot the remains (1826: 148).[10] Historian Jules Michelet had also conflated past and present in his description of the Breton coastal islands as savage wastelands; Sein he calls a

> sanctuary of the Celtic world . . . a desolate, treeless, and all but unshel-
> tered sand-bank, the abode of some poor and compassionate families,
> who yearly save the shipwrecked mariners. This island was the abode
> of the sacred virgins who gave the Celts fine weather or shipwreck.
> There they celebrated their gloomy and murderous orgies; and the
> seamen heard with terror, far off at sea, the clash of barbaric cymbals
> (1851: 1.152).

Lamenting that he had omitted the singular death folklore on Ouessant, France, from *La Légende de la mort*, Le Braz, in an article from 1895, notes that on the isle of Ouessant a unique, 'venerable and poignant' death custom was observed: this was known as '*proëlla*':

> In a country where all the men are sailors, the sea demands a tribute of
> many of this people. The corpses which one always finds have their
> humble mausoleum somewhere, be that at the extreme edges of the
> world. But the list is long of those that the Ocean never returns, those
> it keeps, tossed about at the whim of the waves, an infinite and moving
> burial. They are the absent eternal ones, lost 'without news', sunk with
> their ship or their boat, body and goods. One resigns oneself with dif-
> ficulty, in Brittany, with the thought that the 'missing' will never taste
> in the blessed earth the peace of the last rest. The anguish of the
> survivors seems to take on, in Ouessant, an even more obsessive nature
> than elsewhere in Brittany. So, as a sort of pious subterfuge, Ouessantines
> have invented a simulacrum of burial designed to give to the spirits of
> the dead the appearance of satisfaction. This is the *proëlla* (1895: 195).

Proëlla is a local neologism formed of the Breton words 'bro' (land or country) and 'elez' (repatriation) and is particular to a place that experienced a high death rate from disease, child mortality and especially from lives lost at sea. Only on the island of Ouessant were the lost at sea mourned in this compensatory, simulacral ritual in which a small, handmade wax cross symbolically repatriated a lost body (Le Braz 1994: 193). *Proëlla* home wakes began in 1734 with the use of small wooden crosses. Wood was replaced by wax in the mid–nineteenth-century and the practice carried on until 1962. Echoing the symbolic substitutions and transformations of transubstantiation, the ritual object stood in for the lost body at the wake and funeral. When a family learnt that one of theirs was definitively lost, a *proëlla* wake occurred that night at home, where a senior widow, known as the *veilleuse* or *diseuses de grâces*, recited traditional prayers for the dead in a mixture of Latin and Breton.

Le Braz fictionalizes the essentials of this ritual in his melodramatic short story of 1901, 'Le Sang de la Sirène' (The Blood of the Siren). In this tale, the ominous *veilleuse* incants: 'the bad waters have kept your remains, your bones will not rest in the soil of Ouessant. But your soul is here, in our midst. We feel your breath on our faces' (in ibid. 1994: 200). A mass was held the day after the wake in the village church, with the cross again standing in for the body. It was then transferred to an urn mounted on an interior wall of the church; the crosses that accumulated in this urn were later transferred (either on All Souls' Day or on the occasion of a bishop's visit to the island) to the miniature mausoleum (built in 1868) in the cemetery. This structure bears the inscription: 'Here lie the *proëlla* crosses in memory of sailors who have died far from the land, in wars, in sickness and in shipwrecks.' Descriptions of the *proëlla* wake are featured in several literary accounts such as Le Braz's tale, but very few visual representations of this ritual object exist. It is the small tomb, charged with the memories of so many, whose scale we understand by reference to our bodies that tower above it, that repeats in narratives and images of Ouessant as a poignant reminder of the island's losses (e.g. see Anet 1908: 546; Le Goffic 1908: 15).[11] Many visitors to the island, who repeatedly draw, describe, and photograph it, claim to have seen nothing but women's names in the cemetery. Again, this death practice is described up to the present day as a feature of local culture (of the past).

Le Braz's most widely read ethnographic text, *Au pays des pardons* (1894), was published in multiple editions, translated into English as *The Land of Pardons* in 1906, and was responsible for encouraging French, English and

American tourists to search for experiences of 'authentic' Breton folk culture (such as those he described) that still survived intact (see Young 2007: 284). At once a travelogue of a journey through the Breton countryside, a prospective itinerary and a demonstration of the pervasiveness of local beliefs that *La Légende de la mort* had earlier catalogued, *The Land of Pardons* weaves together a landscape of ancient Celtic and Christian monuments and a living people whose everyday culture is preoccupied with death rituals, memorials and living superstitions (ibid.: 271).

Popular fiction also encouraged a form of thanatourism in coastal Brittany. The dangerous and doomed lives of Breton fishermen from the North Coast area (Cotes d'Armor), who departed from the port of Paimpol to fish during the long cod season on the banks of Iceland or Newfoundland for the better part of a year, are romanticized in the best-selling novels *Mon Frère Yves* (My Brother Yves, 1887) and *Pêcheur d'Islande* (Iceland Fisherman, 1888) by Pierre Loti (the pen name of Jules Viaud). In the latter sad tale of frustrated love and loss, a young fisherman Yann, like so many of his family, dies at sea far from home as his new bride, Gaud, almost hopelessly awaits his return, looking to sea from a high point in the village of Ploubazlanec beside a stone monument known as the Widow's Cross. On the North Coast, as on Ouessant, many men died at sea and their bodies never returned to home soil; mourners here too lacked the emotional closure of a proven death and a physical body as ritual focus. In response to this bodily absence, Ploubazlanec's cemetery has a Wall of the Disappeared at Sea to which were affixed homemade cenotaphs and plaques. In the novel, as part of her tormented waiting, Gaud goes to the wall and the nearby chapel, obsessively reading the family names that repeat for several generations. In her daily, repetitive visits to this site of memory and mourning, the premonition seizes her that a new plaque will soon be added for her missing husband (ibid.: 82).

Loti's wildly successful, melodramatic novel so marked this place that many subsequent representations of the Ploubazlanec cenotaphs reference his text as a mythic, yet authoritative representation of everyday life and the omnipresence of death in coastal communities. Journals often reproduced images of women mourning at this wall to coincide with the autumnal observation of Toussaint (All Souls' and All Saints' Days) commonly seen in Brittany's churchyard cemeteries (figure 21). Within a few years of the publication of Loti's *Pêcheur d'Islande*, travel accounts of Toussaint pilgrimages made to the wall told of the spectacles of grief, mourning and intergenerational memory at this site (e.g. see Janvrais

FIGURE 21. Georges Poilleux-Saint-Ange. Translation de l'ossuaire de Trégastel, 1895, oil on canvas, Musée d'Art et d'Histoire, Saint-Brieuc. Photograph courtesy of the Musée d'Art et d'Histoire, Saint-Brieuc.

1893).[12] Describing his travels, Swiss regionalist writer Adolphe Ribaux in 1901 encounters this wall as the culmination of a long walk on the coast and becomes overwhelmed by the spectacle of mass death encountered there: 'To be lost at sea, this is surely the worst of deaths! ... It is not necessary to be old to be in the middle of this funeral wall, covered in names, cruel symbol of the vanity of the dreams and the falsity of joy!'[13] Early-twentieth-century postcards repeatedly depict the wall with and without mourners and popular journals such as the illustrated Parisian papers *L'Illustration* (1891) and *Le Petit Journal* (1924) feature the spectacle of collective grief at this wall on Le Jour des Morts (All Souls' Day, November 2).[14]

The illustrated picture postcard, as Naomi Schor (1992) has outlined, had its golden age (of being produced and avidly collected) between 1895 and 1920.[15] Some postcards, such as those originating in French colonial Algeria may have allowed the viewer a symbolic assertion of ownership of the places and people depicted. Others (depicting, for example, architectural monuments and boulevards of the Third Republic, Paris) were a form of mass culture that allowed viewers to participate in nationalist pride. Regional imagery, such as postcards from Ploubazlanec, could have been collected and filed under a range of potential categories such as topographical views, images of women, mourning, memorials and cemeteries or seasonal images. Postcards depicting the Wall of the Disappeared were published at the moment of the postcard's golden age and speak to

a collective desire to scrutinize, inventory and record all aspects of the French nation that is entirely consonant with the transparency associated with the desires of the modern tourist (ibid.: 215), and in this case, the thanatourist.

As Patrick Young remarks in the case of Breton pardons, encounters with Breton rituals were 'of course simultaneously [. . .] act[s] of self-definition and distinction on the part of the tourist' (2007: 281). Being a spectator of a Breton mourning ritual might enable a sense of superiority in one viewer while evoking an empathetic sense of loss and longing in another. The collector of a postcard depicting Breton death rituals would not have necessarily been unfamiliar with the scene depicted; these cards were undoubtedly collected by Bretons as well as outsiders to the region. Nostalgia for rural origins, as historian Michael S. Roth writes, was a much-discussed nineteenth-century 'disease' (1993: 32). As a symptom of modernity, nostalgia was particularly associated with internal immigrant groups such as Bretons in Paris who had left home for work in urban centres as part of the great rural exodus. Postcards of local Breton practices, such as grieving for the lost at sea, might well have appealed to viewers who identified with their family connections to the region and might have perceived themselves as living in a state of economic exile, as symbolically absent from home, as those missing at sea.

Viewers of popular imagery that represented Breton burial practices might have a wide range of potential visual literacy; sharply varying readings of these images are quite likely. For instance, many *seemingly* old-fashioned customs that observers noted in nineteenth-century Brittany (as evidence of the past surviving unchanged) did, in fact, follow their own logic of modernization. Sociologist Ellen Badone demonstrates that Breton death beliefs gradually substituted the outright macabre (such as the legendary Grim Reaper of Brittany named Ankou) with images and symbolic spaces encouraging reflection (1989: 137). Her argument is pertinent to my reading of one unusually graphic popular image. In a full-page image titled 'Le Jour des Morts en Bretagne' (1897), published in the topical, widely distributed illustrated French newspaper *Le Petit Journal*, a young Breton woman grieves on a grave, and behind her, within the cemetery, is a stone ossuary whose arcades frame skulls in boxes. To better understand its references and to situate possible contexts for the viewing of this image, I will now turn to a relevant range of texts, histories of practice and images.

In the cemeteries of Western Brittany (Finistère), monumental charnel houses or ossuaries mostly date from the sixteenth century: Brittany's high point of maritime trade, relative prosperity and independence from France

(Walker 2001: 251; Badone 1989: 136). It was during this time that larger Breton communities built compounds—visited by pilgrims—known as *enclos paroissal* (roughly translated as 'parish closes') that were walled and set apart from the everyday space of the village. The faithful entered the *enclos* via a triumphal arch to find a collection of buildings clustered round the central stone pilgrimage church. These structures might include an ossuary, fountain, oratory, sculpture-covered cross known as a *calvaire* and, of course, the graveyard. All of these structures had a ritual focus in pilgrimage practices.[16]

In *Over Strand and Field*, Flaubert (1904) writes that the rural churches of Brittany have a rooted sense of place; the peasants who pray there each Sunday are repeatedly reminded of the presence of departed relatives to such a degree that the church feels like an extended family circle. In an entry from the town of Quimper, he contrasts this continual presence of the dead at the heart of everyday life to the Parisian exile of the dead to the city's abject margins—the space of slaughterhouses and night-soil manufacture (ibid.: 44). By contrast, in his entry on the Quiberon peninsula, Flaubert notes that its past

> is concentrated in a massacre. Its greatest curiosity is a cemetery, which is filled to its utmost capacity and overflows into the street. The head stones are crowded together and invade and submerge one another, as if the corpses were uncomfortable in their graves and had lifted up their shoulders to escape from them. It suggests a petrified ocean, the tombs being the waves, and the crosses the masts of shipwrecked vessels (ibid.: 26).

The 'massacre' to which Flaubert only obliquely refers occurred in the aftermath of the Battle of Quiberon in 1795 in which over 750 royalists were executed by revolutionary troops; this is commemorated in the expiatory chapel of 1829 in Auray. He quickly moves from this historical instance of mass death to a description of the excessive, grotesque overcrowding of the burial ground in his day, which follows the traditional practice of removing bones from overcrowded graves to an open ossuary that 'contains skeletons that have been exhumed in order to make room for other corpses. Who has said: "Life is a hostelry, and the grave is our home?" But these corpses do not remain in their graves, for they are only tenants and are ejected at the expiration of the lease' (ibid.).

For many centuries in Brittany, the ossuary was the receptacle of bones of the dead exhumed from graves in the church floor itself. Breton folklorists like Charles Le Goffic and Anatole Le Braz frequently made claims that Brittany's

cultural attitudes towards death had been the same for many centuries: death rituals were often presented in their quasi-ethnographies as testimony to the pervasiveness of age-old local superstition. One recent history of religious practice in France in the wake of the Council of Trent presents a very different story: Joseph Bergin's encyclopaedic study, *Church, Society and Religious Change in France, 1580–1730*, shows that, all over France, in the seventeenth century there was a push to end the burial of all but the clergy and aristocracy beneath the paving stones of church floors (2009: 214). The enforced use of the cemetery rather than the ultra-sanctified space of the church encountered great resistance in Brittany.[17] Cemetery burial in the immediate churchyard, even as it was being resisted in Brittany, was then further reformed in the Enlightenment, as new official concerns for hygiene encouraged the removal of cemeteries to the edges of populated areas (ibid.: 215).[18] Up until the First World War, it was still common practice in Brittany for a body to temporarily occupy a grave in the parish close (for about five years before the bare bones were exhumed) (Le Goffic 1896: 581; Badone 1989: 135).

However, this physical proximity of death to everyday life was not treated casually. Almost without exception, Western cultural associations with rotting corpses invoke the categories of abjection, filth and taboo (Miller 1997: 49). Le Braz tells of a Breton superstition relating to improper exhumation in the 'Story of a Grave-Digger' that he claims to have collected in 1886 in Penvénon (Brittany): a grave digger had ' "dug six times round the churchyard", which is the same as saying that he had dug in the same place six graves, he was a man who knew, almost to a day, how long each corpse had been buried, and how much it had become decomposed' (1898: 133). He is asked by the rector to go against his own better judgement, by digging a new grave where the previously interred body had lain for only five years. He protests that, in that corner of the graveyard, the worms would not yet have 'attacked' the corpse, but, upon the rector's insistence, he digs it up. His pickaxe pierces not only the coffin, but also the chest of the corpse within. Rudely disturbed, the ghost of the dead man visits the grave digger, and, finding him lacking malice, he then wreaks revenge on the rector. Despite Le Braz's literary embellishments, this macabre folk tale demonstrates a Breton belief in burial as a stage (with carefully monitored boundaries) in a physical process of bodily de-materialization.[19]

Breton practices of exhumation and reinterpretation of bodily remains were also a focal point for Le Goffic, a Breton-born poet, who, like Le Braz, collected Breton folklore and was fascinated by local death practices.[20] In *L'Ame*

Bretonne (*The Breton Soul*), a multivolume compilation of texts inspired by Frédéric Mistral's call for the preservation of regional culture, Le Goffic states that Breton ritual culture has remained unchanged for 200 years and that a visitor to Finistère might yet experience its living, archaic culture (see Le Goffic 1902: 25). His own experiences of thanatourism in Brittany are narrated in an article first published in 1896 in the left-wing Parisian journal *La Revue politique et littéraire* (better known as *La Revue Bleue*): these are tales of 'Three Death Vigils' from coastal Brittany. In the last and most dramatic tale, he tells of coming into 'full contact with Breton death' ('en plein contact avec la Mort bretonne') when he is persuaded to stay on a week longer than planned in the hamlet of Landrellac to witness the 'translation of relics' from the very full ossuary to the churchyard in the town of Trégastel (Le Goffic 1896: 580). (Le Goffic explains that in Breton practice *reliques*—relics—refers to the bones of any of the dead, without making distinction between the ordinary and the sanctified.) He protests that this ritual must have already happened, for he had seen it depicted in a painting by the artist Georges Louis Poilleux Saint-Ange (*The Translation of Bones in Trégastel*) shown at the Paris Salon that very year. His host replies that this is yet another Parisian falsehood ('Encore quelque menterie de Parisien!'; see ibid.) and that the artist had merely heard that the rare event was to happen and had concocted the image in advance. The town rector confirms this, explaining to the Le Goffic that he awaited the arrival of missionary Franciscans who would perform this 'second funeral' (ibid.). Sure enough, the elaborate ceremony takes place a week later. Prominent at this event are numerous black-clad widows (the sea makes many widows in this region, he explains), and the elderly, infirm men present (already marked by death) inevitably think of their coming ends. Children, believed to be protected from the vengeful spirits of the dead (by virtue of their innocence), first handle the bones as they are taken from the ossuary. They are stacked in grisly patterns in the catafalque of the church, given a full funeral, carried in procession and, then, taken in hand by members of the community. A procession with these bones goes round the cemetery twice, and after being laid carefully in the grave, they are sprinkled with holy water as prayers and hymns are sung and incense is swung in the four cardinal directions. Le Goffic tells us that even though he cannot make out what the Franciscan monk says in Breton at the grave side, he imagines that the crowd is being told that all of these bones once made up individuals, and that their remains cry out to the living the *grand pitié* (great sadness) that it is to die. Before heading to the cafe to drink

with the crowd, Le Goffic concludes that 'on the edge of this infinite grave, in this country of eternal mourning, like a supreme evocation of the death that is always hateful and present, and, at the same time, nostalgically calling out its secret pleasures'.[21] If we are to believe Le Goffic's eye-witness account—presented as the authoritative narrative of a Breton travelling within his own province— then the painting by Poilleux Saint-Ange (often referenced as a naturalistic illustration of Breton death practice)[22] is utterly a creative fantasy, no more a documentary witness than Renouf's painting of the widow on Sein. The naturalist and realist painting, is, of course, a genre of representation that interprets observations of the everyday world with its own codes and constructed formats. In the painting, at the forefront of a procession, hooded and coiffed women and men of all ages carry only skulls to the trench-like grave in the foreground of an overgrown, haphazardly marked cemetery with an array of leaning wooden crosses, weeds and thistles. Perhaps Poilleux Saint-Ange, in imagining the coming ritual, was inspired by Flaubert's description of a Breton graveyard as a 'petrified ocean, the tombs being the waves, and the crosses the masts of shipwrecked vessel' (1904: 26).

In his account of the ritual at Trégastel, Le Goffic tells us that skulls are among the bones removed from the ossuary. Earlier in his text, he also mentions that it was customary in nineteenth-century Brittany, upon the first exhumation of the body after five years in the ground, to transfer the skull or 'chef' to an individual painted box that was displayed either in the church or the ossuary. This practice may date as far back as the sixteenth century; however, it seems to have been most commonly used in eighteenth- and nineteenth-century Brittany (Badone 1989: 136). Likewise Flaubert, in his entry on Quiberon, notes the contrast between the display of individually marked skull boxes and the unmarked, unruly chaos of the mixed bones contained in the ossuary:

> Around this charnel-house, where the heaps of bones resemble a mass of fagots, is arranged, breast-high, a series of little black boxes, six inches square, surmounted by a cross and cut out in the shape of a heart in front, so that one can see the skulls inside. Above the heart-shaped opening are the following words in painted letters: 'This is the head of _____ _____, deceased on such and such a day, in such and such a year'. These heads belonged to persons of a certain standing, and one would be considered an ungrateful son if, after seven years, he did not give his parents' skulls the luxury of one of these little black boxes. The remainder of the bodies is thrown into the bone-house,

and twenty-five years afterwards the heads are sent to join them. A few years ago they tried to abolish the custom; but a riot ensued and the practice continued (1904: 37).

With very different effect from the ethnographic narrative of Le Goffic, Flaubert uses this description to further embellish the rather savage, macabre and horrific image of Brittany that he initiates with the story of the fresh widow in Carnac.

Although it may have been shocking to many nineteenth-century visitors, the use of the Breton skull box, according to Badone (1989), is less a throwback to ancient Celtic barbarism in Brittany than part of a gradual, modernizing shift towards commemorating the individual (rather than losing the material trace of the dead in the unmarked collective repository of the ossuary).[23] To return to the *Petit Journal* image, *Le Jour des Morts en Bretagne* (published one year after Poilleux Saint-Ange showed his painting in Paris and Le Goffic published his essay on the 'death vigil' in Trégastel), the image of skull boxes (in the ossuary in the background) might read very differently depending on the viewer's relationship to Breton death practices. A Breton viewer might identify two phases of the body after death—the foregrounded recent burial and the implied second treatment of the body. For the tourist to the region, the ossuary in the background might signify macabre death practices of the past, juxtaposed with a much more familiar, romantic cemetery burial in the foreground. In most of late–nineteenth-century France, in the emerging modern funeral culture that professionalized, distanced and commercialized death practices, visiting a graveyard was increasingly marked by 'paradoxical feelings of absence and presence' (Kselman 2006: 212). It is here once again that the space of the cemetery conjures up a nostalgic sense of loss for a past relationship to place.

Michel Foucault lamented the accelerated loss of 'heterotopic' space in the modern understanding of cemeteries:

Until the end of the eighteenth century, the cemetery was placed at the heart of the city, next to the church. In it there was a hierarchy of possible tombs. There was the charnel house in which bodies lost the last traces of individuality, there were a few individual tombs and then there were the tombs inside the church [. . .]. This cemetery housed inside the sacred space of the church has taken on a quite different cast in modern civilizations, and curiously, it is in a time when civilization has become 'atheistic,' as one says very crudely, that western culture has established what is termed the cult of the dead (2002: 233).

Foucault noted that a shift in cultural meaning followed this spatial remove: '[t]he cemeteries [. . .] came to constitute, no longer the sacred and immortal heart of the city, but the other city, where each family possesses its dark resting place' (ibid.). Fascinated by a lost sense of familiarity (rather than squeamishness or horror) with the sight of the material remains of the mortal body, Breton thanatourism in the late nineteenth and twentieth centuries speaks of a longing for this lost centre—this place of the dead amidst the living.

Today, the *proëlla* of Ouessant, the mourning *coiffes* of Sein, the plaques of Ploubazlanec and the ossuaries of cemeteries in Finistère are featured in tourist literature as persistent signs of local identity: vestigial survivals of pre-modern Brittany served up to tourists (local, returning, foreign) still hungry for material, grounded signs of difference. History museums in Brittany and small eco-museums present many of the images and narratives discussed above as documentary traces of the recent past.[24] Few ossuaries contain bones any longer; many of the surviving structures have been converted to tourist souvenir gift shops. Like Trégastel or the islands of Sein and Ouessant today, the commune of Ploubazlanec is full of summer homes by the sea. In 1939, the graveyard wall was rebuilt and the homemade memorials to the lost at sea were moved into the sheltered porch of the nearby eighteenth-century chapel of Perros-Hamon. The original plaques have been replaced on the stone wall by durable marble slabs and simple, painted wooden plaques. The commune's website encourages visitors to make a tour of this open-air heritage museum of the past, to wander the streets now renamed to even better resemble Loti's novel, to follow trails from the high points of land where women scanned the horizon for returning fishing boats, to the rebuilt Wall of the Disappeared and the chapel that houses its older plaques, to the chapels by the sea dedicated to Our Lady of the Shipwrecked.[25]

As we have seen in this range of representation, many travelogues, images and ethnographic accounts of thanatourism in Brittany either repeat previous examples or offer to represent Breton death practices with an even greater sense of authenticity (for instance, both Le Braz and Le Goffic state that their experiences of Breton mourning and death are more authentic than well-known paintings of the same subject). The overlapping genres of fiction, folklore, documentary and popular imagery, Salon painting and oral culture are complex narratives that gathered strength from one another and inspired early forms of thanatourism in Brittany.

Notes

1 See Catherine Bertho-Lavenir (1980) and Patrick Young who notes that 'the early-twentieth-century traveller to Brittany followed in the footsteps of a nearly continuous procession of earlier visitors to the region; indeed, few local cultures can have been as thoroughly framed as Brittany's had become in France by the turn of the century' (2007: 278).

2 The obvious, misogynist disdain that Gustave Flaubert exhibits for rural women and their religious emotions threads through his later fiction, particularly in the novel *Madame Bovary* (1856) and the short story 'Un Cœur Simple' in the collection *Trois Contes* (1877).

3 Alain Croix and Fanch Roudaut argue conversely that death folklore in nineteenth-century Brittany attests to the persistence of both the local tendency to personify abstract concepts like death and to the continuing marshalling of these symbols by church authorities (1984: 84–5).

4 For a discussion of the ways in which the Atlantic was imagined as a deadly, devouring force, see Alain Corbin (1994: 8–10).

5 This theme is studied extensively in Karine Salomé (2003).

6 Le Braz's remarks on the status of widows on Sein are echoed in many ethnographic studies of his day: see, for example, Hyacinthe Le Carguet (1901–02: 268).

7 André Cariou, curator of the Quimper Museum of Fine Arts, has noted that the models used for Emile Renouf's painting were residents of Sein but were not in fact in mourning (from notes in painting files, Quimper Museum of Fine Arts, France).

8 See an analysis of Le Braz's text, first published in 1900, in Salomé (2003: 279); also see Corbin (1994: 225).

9 In the prose epic *Les Martyrs*, the tragic, suicidal Druid priestess Velléda is the sole survivor of nine virgins who inhabited the isle. For a summary of this mythic type, see Salomé (2003: 224).

10 For an overview of the literary stereotype of the island wrecker and looter, including Hippolyte Bonnelier's use of this type, see Corbin (1994: 225).

11 For a further discussion of the *proëlla*, see Maura Coughlin (2009).

12 For example of an American travel narrative that references Pierre Loti, see Francis Miltoun (1906: 357).

13 'Disparus en mer, ceux-là surtout, et c'est bien la pire des morts! . . . Non, il n'est pas nécessaire d'être vieux pour avoir au cœur ce mur funèbre, couvert de noms, cruel symbole de la vanité des rêves et du mensonge de la joie!' (Ribaux 1901: 525).

14 La Toussaint in France is a two-day festival with two holidays celebrated together: 1 November, All Saints' Day, in remembrance of the Catholic saints, and 2 November, All Souls' Day, day of prayer for the souls of the deceased.

15 On the craze for the picture postcard, also see Bjarne Rogan (2005).

16 Pilgrims would often circle the cemetery several times in their all-night rituals, as described by Charles Le Goffic (1902: 34).

17 In Brittany, burial within the church was not definitively banned until 1754.

18 For a comparative overview of churchyards and cemeteries in urban burial practices, see Vanessa Harding (2002: 46–84).

19 Many contemporary guidebooks to Brittany, such as the authoritative *Cadogan Guide Britanny* by Philippe Barbour (2009), reference Le Braz's cautionary folk tales about spirits of the dead to return to haunt the living and about the ways of the vengeful grim reaper by way of explaining the surviving monuments to the cult of death in Breton churches. The best example of this is the sculpted, skeletal figure of Ankou who stands, holding his scythe, ominously by the confessional booth in the village church at Ploumillau.

20 Both Le Braz and Le Goffic were prominent members of the conservative Union Régionaliste Bretonne or URB, founded in 1898. Although Le Goffic was a member of the conservative regionalist group Action Française, he remained a lifelong republican.

21 'C'était au bord de cette fosse infinie, dans ce pays de deuil éternel, comme une évocation suprême de la mort toujours présente et haïssable, en même temps qu'un nostalgique appel vers ses sécretes félicités [...]' (Le Goffic 1896: 583).

22 A detail of Poilleux Saint-Ange's painting is featured on the cover of Croix and Roudaut's historical study *Les Bretons, la mort et Dieu de 1600 à nos jours* (1984). The image is referenced in the text (ibid.: 213) as evidence of a survival of an older practice, rather than being discussed as an artistic construction of an event that was yet to happen. With its procession and foregrounded grave, the composition of the painting clearly puts a Breton spin on Gustave Courbet's famous realist painting *Burial at Ornans* (1849–50).

23 Very few skull boxes are on display in cemeteries today, although a side chapel in the Cathedral of St Pol de Léon is one of several churches where they can still be found. The skull boxes, like the Ploubazlanec plaques to the missing, share many attributes—the tears, dates, names, a handmade touch; but the plaques emphasize the absent body, whereas the skulls make the physical nature of mortality grimly literal.

24 For a lengthier discussion of these sites, see Maura Coughlin (2010, 2012).

25 The commune's website is http://www.ploubazlanec.fr/. For more images of the renaming of the streets of Ploubazlanec in honour of Loti, see Christian Genet and Daniel Hervé (1988).

Works Cited

ANET, Claude. 1908. 'Ouessant'. *Revue de Paris* 5: 338–52.

BADONE, Ellen. 1989. *The Appointed Hour: Death, Worldview, and Social Change in Brittany*. Berkeley: University of California Press.

BARBOUR, Philippe. 2009. *Cadogan Guide Brittany*, 4th EDN. London: New Holland Publishers.

BARTHES, Roland. 1981. *Camera Lucida: Reflections on Photography* (Richard Howard trans.). New York: Hill and Wang.

BENOIST, Félix, Hippolyte Lalaisse, Raymond Bordeaux, Amélie Bosquet, André Pottier and Antoine Charma. 1852. *La Normandie illustrée, Monuments, sites et costumes de la Seine-Inférieure, de l'Eure, du Calvados, de l'Orne et de la Manche* (Normandy Illustrated: Monuments, Sites and Costumes of Seine-Inférieure, Eure, Calvados, Orne and Manche Departments). Nantes: Charpentier.

BERGIN, Joseph. 2009. *Church, Society and Religious Change in France, 1580–1730.* New Haven, CT: Yale University Press.

BERTHO-LAVENIR, Catherine. 1980. 'L'Invention de la Bretagne: Genèse sociale d "un stéréotype" ' (The Invention of Brittany: The Social Genesis of a 'Stereotype'). *Actes de la Recherche en Sciences Sociales* 35: 45–62.

BONNELIER, Hippolyte. 1826. *Les Vieilles femmes de l'île de Sein* (The Old Women of Sein). Paris: Killian.

CAMBRY, Jacques. 1799. *Voyage dans la Finistère, ou État de ce département en 1794 et 1795* (Voyage in Finistère, or State of the Department in 1794 and 1795). Paris: Imprimerie-Librairie du Cercle Social.

CHATEAUBRIAND, François René de. 1809. *Les Martyrs* (The Martyrs). Paris: Larousse.

CORBIN, Alain. 1994. *The Lure of the Sea: The Discovery of the Seaside in the Western World, 1750–1840* (Jocelyn Phelps trans.). Berkeley: University of California Press.

COUGHLIN, Maura. 2009. 'Cloaks, Crosses and Globes: Women's Material Culture of Mourning on the Brittany Coast' in Maureen Goggin and Beth Tobin (eds), *Women and Things, 1750–1950: Gendered Material Strategies*. Farnham, England, and Burlington, VT: Ashgate.

———. 2010. 'Narratives, Images and Objects of Piety and Loss in Brittany'. *Material Culture Review* (Special Issue) 71: 54–66.

————. 2012. 'Representing Heritage and Loss on the Brittany Coast: Sites, Things and Absence'. *International Journal of Heritage Studies* (Special Issue: Memory in the Maritime Museum: Objects, Narratives, Identities) 18(4): 369–84.

CROIX, Alain and Fanch Roudaut. 1984. *Les Bretons, la mort et Dieu de 1600 à nos jours* (The Bretons, Death and God from 1600 to Today). Paris: Messidor-Temps Actuels.

FLAUBERT, Gustave. 1856. *Madame Bovary*. Paris: Revue de Paris.

————. 1877. 'Un Cœur Simple' (A Simple Heart) in *Trois Contes* (Three Tales). France: Charpentier.

————. 1904. *Over Strand and Field: A Record of Travel in Brittany* (Katharine Prescott Wormeley trans.). Chicago: Magee.

FOUCAULT, Michel. 2002. 'Of Other Spaces' in Nicholas Mirzoeff (ed.), *The Visual Culture Reader*. 2nd EDN. London and New York: Routledge, pp. 229–36.

GENET, Christian, and Daniel Hervé. 1988. *Pierre Loti l'enchanteur* (Pierre Loti the Enchanter). Gémozac: C. Genet.

HARDING, Vanessa. 2002. *The Dead and the Living in Paris and London, 1500–1670*. Cambridge and New York: Cambridge University Press.

KSELMAN, Thomas. 2006. *Death and Afterlife in Modern France*. Princeton, NJ: Princeton University Press.

LE BRAZ, Anatole. 1895. 'Traditions Populaires de l'île d'Ouessant' (Popular Traditions of the Isle of Ouessant). *Bulletin archéologique de l'Association bretonne* 3(14): 191–7.

————. 1898. 'Story of a Grave-Digger' in *Dealings with the Dead: Narratives from La légende de la mort en Basse-Bretagne* (A. E. Whitehead trans.). London: Redway.

————. 1902[1893]. *La légende de la mort en Basse-Bretagne* (Death Legends in Coastal Brittany). Paris: Champion.

————. 1906[1894]. *The Land of Pardons* (Frances M. Gosling trans.). New York: Macmillan.

————. 1994. 'Le Sang de la Sirène' (The Blood of the Siren) in Pierre Jakez Hélias (eds), *Gens de Bretagne* (Breton Folk). Paris: Omnibus, pp. 169–218.

————. 2000[1900]. *Le Gardien du feu* (The Lighthouse-Keeper). Rennes: Terre de Brume.

JANVRAIS, Théophile. 1893. 'Souvenirs de Bretagne, L'Ex-Voto' (Memories of Brittany: The Ex-Voto). *Société des bibliophiles bretons et de l'histoire de Bretagne* 10: 314–18.

LE CARGUET, Hyacinthe. 1901–02. 'L'île de Sein au XVIIIe Siècle: état de la population' (The Isle of Sein in the Eighteenth Century: State of the Population). *Bulletin de la Société archéologique du Finistère* 29: 268–84.

LE GOFFIC, Charles. 1896. 'Gens de mer: Trois vigils des morts' (Sea Folk: Three Death Vigils). *Revue Bleue* 19(4–6) 581.

———. 1902. *L'âme Bretonne* (The Heart of Breton), VOL. 1. Paris: Champion.

———. 1908. *L'âme Bretonne*, VOL. 2. Paris: Champion.

LOTI, Pierre. 1887[1883]. *My Brother Yves* (Mary P. Fletcher trans.). Paris: Vizetelly.

———. 1888[1886]. *An Iceland Fisherman: A Story of Love on Land and Sea* (Clara Cadiot trans.). New York: Gallsberger.

MICHELET, Jules. 1851. *History of France from the Earliest Period to the Present Time*, 2 VOLS (G. H. Smith trans.). New York: Appleton.

MILLER, William Ian. 1997. *The Anatomy of Disgust*. Cambridge, MA: Harvard University Press.

MILTOUN, Francis. 1906. *Rambles in Brittany*. Boston, MA: Page.

MIRZOEFF, Nicholas. 2009. 'Photography and Death' in *An Introduction to Visual Culture*, 2nd EDN. London and New York: Routledge, pp. 119–25.

RIBAUX, Adolphe. 1901. 'Le Mur des disparus en mer' (The Wall of the Disappeared at Sea). *La Semaine Littéraire* 409: 523–5.

ROGAN, Bjarne. 2005. 'An Entangled Object: The Picture Postcard as Souvenir and Collectible, Exchange and Ritual Communication'. *Cultural Analysis* 4: 1–27.

ROTH, Michael S. 1993. 'Returning to Nostalgia' in Suzanne Nash (ed.), *Home and Its Dislocations in Nineteenth-Century France*. Albany, NY: State University of New York Press, pp. 25–44.

SALOMÉ, Karine. 2003. *Les îles bretonnes: une image en construction, 1750–1914* (The Breton Isles: Constructing an Image, 1750–1914). Rennes: Presses Universitaires de France.

SCHOR, Naomi. 1992. ' "Cartes Postales": Representing Paris 1900'. *Critical Inquiry* 18(2): 188–244.

TANGUY, Alain. 1999. 'L'île de Sein en 1900: Les textes inédits d'Anatole Le Braz' (The Isle of Sein in 1900: Unpublished Texts of Anatole Le Braz). *Armen* 107: 20–9.

URRY, John. 1990. *The Tourist Gaze: Leisure and Travel in Contemporary Societies*. London and Newbury Park: Sage.

WALKER, Stephen. 2001. 'Accommodating the Apocalypse: An Examination of the Relationships between the Economics of Salvation and the Architecture of the Breton Enclos'. *The Journal of Architecture* 6: 249–77.

YOUNG, Patrick. 2007. 'Of Pardons, Loss and Longing: The Tourist's Pursuit of Originality in Brittany, 1890–1935'. *French Historical Studies* 30(2): 269–304.

The Navy Mechanics School (ESMA) and the Politics of Trauma Tourism in Argentina

CARA L. LEVEY

> Why the ESMA? Because the ESMA is the only place that if you ask people, for example, in the street [. . .] a concentration camp, people always say 'the ESMA'. Why? Because the building is well known, most people have passed the ESMA at some point.
>
> Walter Goobar[1]

The former Navy Mechanics School (commonly known by its Spanish acronym, the ESMA—Escuela Superior de Mecánica de la Armada) is undoubtedly the most notorious clandestine detention centre that operated during the last dictatorship in Argentina (1976–83). In addition to its recognizable facade, particularly the Pabellón Central (central pavilion), the large build-ing with four columns as its centrepiece (figure 22), one of the most striking character-

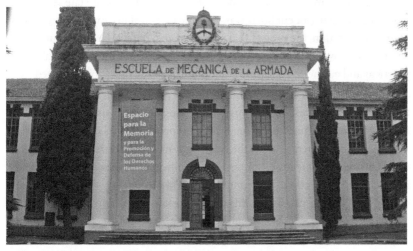

FIGURE 22. Pabellón Central, ESMA, Buenos Aires. Photograph by Brigitte Sion. Reproduced with permission.

205

istics of the ESMA is its visibility, owing to its location 'within the city' (Duhalde 2007: 27; translation mine). However, as Goobar continues, the ESMA's infamy is due to not only its recognizable facade and size but also the way in which, in the post-dictatorship context, it is representative of the cruelty and the systematic, methodological and hierarchically organized state repression and human rights violations committed during the dictatorship.[2]

On 24 March 2004, 28 years to the day since the 1976 coup which installed the military junta, incumbent president of Argentina, Néstor Kirchner, and then mayor of Buenos Aires, Aníbal Ibarra, were joined by representatives of the city and federal governments, thousands of members of human rights organizations and former prisoners and relatives of the dictatorship's victims in what would become a milestone in the ESMA's history. In an emotionally charged ceremony, during which President Kirchner requested his citizens' forgiveness for the state's failure throughout the previous two decades to condemn and confront past human rights atrocities, the ESMA was officially proclaimed 'a space for memory and the promotion and defence of human rights' and the creation of a 'museum of memory' (Ginzberg 2004) on the site was announced. Thus, 24 March 2004 marked a change in government stance and the beginning of state and societal collaboration in the administration of this site of trauma in order to oversee its transition to a site of tourism. For human rights, relatives' and victims' organizations, this was a particularly momentous occasion: the culmination of years of lobbying the state for the ESMA to be expropriated from the navy and dedicated to the victims of state terrorism. However, this sense of euphoria was, to some extent, short-lived. From the day of the recuperation, the project that aimed to open the ESMA to the public was beset with delays and obstacles which in turn point to the different ideological, practical and aesthetic issues and standpoints held by the actors involved.

This essay explores the ESMA's transformation from 'site of collective trauma' to 'site of tourism'—an ongoing process—by focusing on three areas: first, by tracing its trajectory from a site of repression to its conceptualization as a site of public memory and the role of government actors and civil society in this process; second, by examining the significance of the state's involvement in the ESMA project and the contestation within and between the state and civil society actors specifically with regard to state involvement; and third, by assessing the ESMA as a nascent site of trauma tourism in contemporary Argentina, addressing the issues of representation in, promotion of and visitation to the former clandestine detention centre.

Many of the debates and controversies that emerge on deeper analysis of the ESMA dovetail with those addressed in recent scholarly research on trauma tourism, particularly the matter of how sites of atrocity and violence should be treated and the role of the state and civil society in their recuperation and administration. Scholarly work on Argentina, and indeed Latin America, has been notably absent from the trauma/dark tourism canon, which is somewhat surprising, given that the ESMA appears to possess a number of key temporal and representative prerequisites necessary for John Lennon and Malcolm Foley's (2004) definition of 'dark tourism' and, as the *actual* site of atrocity, for Miles' (2002) notion of 'darker tourism'. Although the ESMA's recuperation for memory has been the subject of a number of academic works (Brodsky 2005; Vezzetti 2006) on public memory in post-dictatorship Argentina, it is rarely described as a site of tourism, either by academics or by those state and societal actors engaged in its recuperation and administration. By incorporating the Argentine ESMA into the scholarship on trauma tourism, I aim to deepen understanding of the tensions and challenges that emerge vis-à-vis sites of state repression and collective trauma.

From State Repression to State–Societal Recuperation: The ESMA, 1976 to Present

The ESMA was not always a place associated with repression, torture, murder, disappearance and unlawful imprisonment. In 1924, the City of Buenos Aires ceded the site to the navy on the condition that it was used for training officers. The agreement signed between the navy and the city government stipulated that in the event that the ESMA ceased to be used for training it would revert to the jurisdiction of the City of Buenos Aires,[3] a condition invoked in the recuperation of the ESMA 80 years later. The 34 buildings on the 17-hectare site thus had different functions ranging from accommodation and teaching to instruction and recreation. In 1976, its educational function changed dramatically as it became the site of systematic state repression.

Although not the biggest clandestine detention centre in terms of geographical size (this was Campo de Mayo, 30 kilometres from Buenos Aires), approximately 5,000 people were detained in the ESMA, the majority of who remain disappeared. The site's Casino de Oficiales (officer's mess; figure 23), originally used for hosting visiting navy officers, was one of approximately 500 clandestine detention centres operating in Argentina during the dictatorship, in premises previously used for detaining prisoners such as state penitentiaries

FIGURE 23. Casino de Oficiales, ESMA, Buenos Aires. Photograph by Brigitte Sion. Reproduced with permission.

along with police and armed forces headquarters and private properties.[4] Paradigmatic of the dictatorship's crimes as well as the desire to conceal, deny and subsequently avoid accountability, the ESMA was the headquarters of the notorious Task Force 3.3.2—the group of officers in charge of both the Argentine capital and the outlying areas known as Greater Buenos Aires—and was the nerve centre and starting point for the transfer of prisoners to death flights,[5] the site of clandestine births, kidnapping and forced labour ranging from the falsification of documentation to the translation of foreign newspapers.

It is therefore from the events that took place there that the ESMA gains its symbolic value. For, like Auschwitz, the ESMA has become a paradigm, a lexical and visual prompt of the trauma experienced during this period. As the Argentine sociologist Héctor Schmucler (2006) reminds us, when we say Auschwitz, we are expressing a concept, an image of something that has happened and not the place itself. Similarly, the acronym ESMA refers not only to the building or its physical features but also to state terrorism, death, disappearance, torture and deceit and denial on the part of the perpetrators. Thus, the site itself does

not necessarily convey the horror, but it has a connotative function, by stimulating the memories of those who have a vested interest or personal connection to the site, such as former prisoners and victims' family members, in addition to witnesses and neighbours, and is a site of individual *and* collective trauma. The significance of the ESMA is both its physical presence and its symbolism.

During the 1980s and 1990s—the aftermath of the dictatorship—the ESMA remained in the hands of the navy, much to the outrage and disappointment of many human rights organizations. Their goal was to return the ESMA to the jurisdiction of the municipality and recover the site for memory or a cultural/pedagogical project (Melendo 2006: 90). Proposals to use the ESMA for other purposes have sparked controversy; polarized views about what the site should be used for are suggestive of the contrasting ways in which the past is remembered and (re)constructed by different actors. For example, the decision in the mid-1990s to use the ESMA's swimming pool for a school sports competition resulted in the withdrawal of the team from one of Argentina's most prestigious schools, the Colegio Nacional, where a number of the dictatorship's victims had been pupils (Feitlowitz 1998: 174). The human rights community's hopes of claiming the site for memory were blocked during President Carlos Menem's second term in office, with his proposed bill in 1998 to convert the ESMA into a green space, demolish the buildings and construct a monument of 'national unity' in its place (Feld 2002: 126). Although the bill was met with opposition from human rights organizations and ultimately rejected by Congress, the navy continued to occupy the site.

However, from the late 1990s onwards, in an increasingly favourable political context, a number of developments took place at a local level as a result of continued pressure from the human rights community. The Buenos Aires parliament approved Law 392/00 stipulating that the ESMA would be ceded from the Argentine navy command to the City of Buenos Aires for the former's failure to comply with the 1924 agreement. The law also specified that buildings previously used for repression would be converted into a museum (Institute for Spaces of Memory 2006). However, it was not until 2004 when the plans for a museum or space of memory would begin to take shape. The Kirchner administration (2003–07) marked an unprecedented shift in federal government policy vis-à-vis the dictatorship and state repression, encapsulated in the March 2004 ceremony when the site was proclaimed 'space for memory' by decree and a commission made up of representatives from local and national governments and assisted by members of human rights organizations[6] created to oversee the

site's transformation and to ensure all navy personnel vacated the premises. However, the navy's withdrawal from the site was deliberately protracted and not completed until late 2007, at which point discussions over the proposed museum and use of other buildings were still underway.[7]

The trajectory of the ESMA proves complex, controversial and involves the interplay and convergence of actors from the state and civil society. The 2004 recovery of the site is a clear example of the way in which, in recent years, government actors have been increasingly involved in commemorative initiatives in Argentina. Although human rights organizations have played a key role in mobilizing sites of trauma, the case of the ESMA demonstrates how, in 2004, both local and national contexts were far more favourable to addressing the past and commemorating the victims of human rights violations than they had been in the mid-1990s. In a context in which the federal government was hostile to commemoration, the city government was significantly more respon-sive to these demands. The recovery of sites of repression, such as the ESMA, for public projects should be viewed as part of the broader policy to address the past, alongside judicial investigation and truth-seeking initiatives. The involvement of state actors reveals a delicate interplay between local and national governments in which the ESMA's transition to a site of visitation is not guar-anteed and remains highly contingent on the will of state actors, as well as the human rights community, most notably relatives' and survivors' organizations.

The Politics of Trauma Tourism: The Significance of State Intervention

Official intervention in the ESMA and other comparable sites can be understood as the result of lobbying from the human rights community, particularly the rel-atives' and survivors' organizations who, along with their supporters, have been central in petitioning and appealing to city and federal governments. Indeed, as this section will suggest, the support of state actors in sites of trauma is desirable and/or necessary for a number of reasons, both practical and symbolic.

State support (at either a local or a national level) may be sought to obtain funding and resources for projects. For many projects, state assistance is the only means of financing or undertaking such a venture. The funds, as much as the resources provided by the authorities for commemoration, are extremely important. In terms of the ESMA, the decision to involve the state was taken for several practical reasons. As one representative of the Argentine human

rights organization Servicio Paz y Justicia (Peace and Justice Service, SERPAJ) Argentina posits: 'If the state is not in favour of contributing money and ministries, then these projects are not viable.'[8] This is particularly true for the ESMA, which covers 17 hectares, includes a number of different projects and is reliant on a budget from federal and city governments. Moreover, the practical aspect of the state's role encompasses not only financial support but also institutional backing. As the ESMA was in the hands of the navy and, as a result, not open or accessible to the public, the support of the federal government was critical to ensure the handover. The cooperation and support of the Kirchner administration proved decisive in the expropriation of the site from the navy. State support may thus be sought to lay the institutional or legal framework, pressure actors in opposition to the site and ensure the long-term permanence of the site as well as provide the necessary fiscal and human resources.

However, if financial and institutional backing from the state can be viewed as *necessary*, it is the symbolic weight that state support gives a project which can often be classed as *desirable*. State support gives a degree of officialdom to the ESMA and one might ask what properties an official status gives these sites that unofficial sites of trauma tourism do not have. Given that the majority of repression in Argentina was committed by the state, the very act of supporting, facilitating and sanctioning the recuperation of sites of traumatic memory eschews the official message sustained and perpetuated by the upholding of post-dictatorship impunity and amnesty laws. The post-2004 trajectory of the ESMA is demonstrative of the federal government's increasing willingness to address the atrocities committed by previous governments. As a more victim-centred approach to addressing state repression, state support could be considered a form of symbolic reparation (Todorov 2001: 29). The recuperation of concrete sites of repression to be opened to the public, alongside the transfer of individual buildings to human rights organizations shifts the focus away from the perpetrators to the victims, their families and, to a certain extent, broader society. Significantly, state support for sites of trauma tourism provides governments with the opportunity to simultaneously condemn violence and to forge a new identity *in opposition to* prior state repression.

Local and national government actors prove crucial in offering support nominally or symbolically, providing financial assistance and ensuring the institutionalization and permanence of these sites through legal and institutional apparatus. In other words, the state has a role to play in terms of recuperation and administration. However, this role is not guaranteed, and state actors may

even obstruct or withdraw support for such projects in favour of alternative measures that suggest drawing a line with the past rather than reflecting on it.

State support for the ESMA project has not only been difficult to obtain but has also been complex and controversial. This is unsurprising given that the commission managing the site comprises a diverse group of actors: human rights organizations, including relatives' and survivors' organizations, local and national government representatives and those enlisted in a professional capacity. These actors hold different views on how the recuperated ESMA should be treated and who should be included in this process, as some are ideologically opposed to the state's participation. What is notable about the Argentine case is how this standpoint changed significantly by the time of the ESMA's handover.

Here, I contrast the case of the ESMA in 2004 with that of the Buenos Aires Memory Park, one of the first state-supported 'official' initiatives to venerate the victims of state terrorism. The project emerged as a state-societal initiative in 1997 when a coalition of 10 human rights organizations successfully petitioned the Buenos Aires parliament. In 1999, when these organizations congregated with representatives from the city government and other dignitaries to lay the park's foundation stone, Asociación Madres de Plaza de Mayo (Association of the Mothers of the Plaza de Mayo), Asociación de Ex Detenidos–Desaparecidos (Association of Ex-Detained and Disappeared Prisoners) and the group H.I.J.O.S. por la Identidad y la Justicia contra el Olvido y el Silencio (Sons and Daughters for Identity and Justice against Forgetting and Silence) boycotted the ceremony, a demonstration of their vehement opposition to working with the state. From the perspective of these organizations, working with *any* state officials was a problem, as the state had institutionalized and upheld judicial impunity through impunity laws and pardons and refused to support formal justice. As a statement issued by the Association of the Ex-Detained and Disappeared Prisoners made it clear, 'the wound is not only because of those who are no longer with us, but because the murderers are free' (in Ginzberg 1999: 6; translation mine). Thus, state involvement in sites of trauma tourism cannot be viewed in isolation from the matter of justice, in this case the *lack of justice*. The implication is that while the State was not advancing judicial investigation into the past, it had no place in the administration of sites of trauma, since its opponents did not make a distinction between local and national governments or between past and present government policy.

Since 2004, these groups have changed their stance and have been increasingly willing to work with the state, a response to the shift in federal government policy towards this past. However, this relationship is not without its problems. The three groups, along with other relatives' and victims' organizations did not enter the Pabellón Central on the day of the handover, preferring to remain outside, demonstrating their opposition to the continued presence of navy personnel and their hesitance in working with the state. Disagreements continue over the nature of these projects and how they will be negotiated, both administratively and aesthetically. Human rights organizations working with the state remain highly critical, particularly with regard to whether the governments (local and national) will fulfil their promises to ensure the works are completed, and, beyond the site, that judicial investigation continues to the fullest extent possible.

Indeed, the ESMA's transformation from site of trauma to site of trauma tourism has been fraught with obstacles and controversy, particularly in relation to state involvement. Since 2004, a key cause for concern from the perspective of the Argentine human rights community has been *how* (as opposed to *whether*) to work with the state. The need for a permanent institution building is a fundamental tenet of these debates, particularly as the convergence of state and societal actors in sites of trauma is a novel phenomenon. The challenge now for both human rights groups and national and local government representatives is to ensure that initiatives remain independent of 'political will',[9] that is, the specific policies or actions of political actors, which, in turn, is highly dependent on political personalities and thus vulnerable to change and instability with each elected local and national government.

In spite of the legal basis for the ESMA's recuperation and administration, political leaders and governments are instrumental in withholding funds or channelling them into other projects, when political support for sites related to state repression is low. The creation of the Ente (the Public Entity of Memory and the Promotion and Defence of Human Rights, the state-societal body which oversees the ESMA's administration) in late 2007 has in many ways addressed the issue of the ESMA's long-term administration. However, since the ESMA's Ente relies on funding from the city and the federal government, it remains to be seen how the project might successfully weather a period of economic crisis, as the case of the Memory Park and Monument to the Victims of State Terrorism in 2001 testifies.[10] The role of the state is often not only pivotal but also controversial. Along with decisions relating to intervention and representation in the

ESMA (considered in the following section), controversy regarding the partic-
ipation of the state, the organizational framework and the continuing presence
of the navy has resulted in much internal debate for those involved and lengthy
delays in opening the ESMA to the general public.

The ESMA as a Nascent Site of Tourism: Representation, Visitation and Promotion

As a site of (trauma) tourism, the ESMA is undeniably a work-in-progress.
Although the site is open to visitors, a number of different projects undertaken
by state and societal actors are ongoing. Several relatives' organizations have
been working on their own, separate projects within the site since 2007, when
buildings were given—in some cases, on request—to both branches of the Moth-
ers of the Plaza de Mayo (i.e. the 'Association' and the 'Founding Line') as well
as organizations such as Relatives of the Detained and Disappeared for Political
Reasons and H.I.J.O.S., in other words, those who were 'directly affected'
(Almeyda 2001–02: 12; translation mine) by state repression. The site now also
houses the National Memory Archive—an institution created in 2003 by presi-
dential decree and reliant on the Federal Government's Secretariat for Human
Rights—which collects and preserves documents, testimonies, photographs and
other forms of evidence related to human rights violations, and the Haroldo
Conti Cultural Centre, also dependent on the Secretariat for Human Rights,
where a broad array of cultural, musical and literary events are held. More
recently, in August 2013, the former Infirmary was opened to the public with
the inauguration of North American artist Brian Carlson's exhibition 'Aparecidos'
(Appeared). Significantly, plans for a proposed museum had, until recently,
been superseded by minimalistic and subtle intervention in the Casino de Ofi-
ciales—as the building most closely associated with repression.[11] The Institute
for Spaces of Memory (Instituto Espacio para la Memoria, IEM), created in
2002—the Buenos Aires government's administrative and directive body for
the city's recuperated clandestine detention centres—was placed in charge of
the Casino de Oficiales and the Pabellón Central, among other buildings on the
site.[12] Significantly, the entire ESMA site is considered a 'clandestine detention,
torture and extermination centre',[13] owing to the fact that prisoners were taken
to other parts of the ESMA and that repression was planned and facilitated in
other buildings; thus, the entire site has a relationship to state terrorism. However,
the main focus for visitors to the ESMA is the Casino de Oficiales, examined

vis-à-vis representation, intervention and visitation in the discussion in this section.

Since 2005, the IEM has run guided visits to the Casino de Oficiales and parts of the ESMA grounds. Tours are available by request for individuals and small or large groups. Visitors are given a choice of suitable times and dates to visit, joining up with larger groups to visit the site. Two- to three-hour-long visits may be undertaken in either English or Spanish, suggesting that the tours do not cater only to the domestic or Spanish-speaking tourist. After congregating at the main entrance and registering their name, nationality and personal or professional affiliation, visitors are escorted on foot by one or two guides past the Pabellón Central and to the former car park at the rear entrance of the Casino de Oficiales, where, following their abductions, blindfolded detainees arrived by car. The tours pause briefly at each spot, to allow the guides to contextualize what the tourists are viewing and to give the visitors time to read information boards and ask questions. Upon entering the Casino de Oficiales, visitors retrace the steps of former prisoners, visiting the basement, where many detainees were held and tortured on arrival, the so-called *huevera* ('egg box') or torture room where propaganda about the dictatorship was also produced, the 'maternity ward' in which pregnant detainees gave birth, and the *capucha* and *capuchita* or the attic spaces where prisoners were detained long term and tortured. The tour encompasses the navy's facilities including offices and sleeping quarters, an aspect which highlights the proximity of victims and perpetrators and the juxtaposition of the extreme cruelty of repression and the mundane.[14] For visitors, the tour entails a combination of identification with victims (as they partially trace the journeys of detainees) and detachment (through factual information and historical reconstruction provided by guides and signposts). The visitor's experience in the ESMA is thus dependent on aesthetic intervention and the role of the guide, now to be discussed as they both highlight the challenges that beset its transformation from a site of trauma to a site of tourism.

For the most part, (re)construction and restoration have been rejected in the Casino de Oficiales, in pursuit of limited aesthetic intervention. However, state and societal views on how to treat the former detention centre have varied a great deal, even between the human rights organizations. Here emerges a dilemma pertinent to many sites of past repression and human rights violations: whether to leave the building as it was, to convert it, to demolish and/or to reconstruct it or to construct something entirely different. Initial suggestions

for a museum in the Casino de Oficiales (or indeed any other part of the site) were vehemently rejected by a number of relatives' organizations, particularly the Association of the Mothers of the Plaza de Mayo, on the basis that museums were associated with death and reinforcing their view that a cultural centre was more appropriate.[15] The argument for leaving the Casino de Oficiales untouched was echoed by H.I.J.O.S., who argued that the best option was to do 'the minimum possible'.[16] The decision was undoubtedly shaped by a sense of duty to treat the memory of the disappeared appropriately and the belief that sites of radical evil inherently convey the atrocities committed there, thus requiring little, if any, intervention. Although this may be true for those visitors to the site who experienced the dictatorship either directly or indirectly, the Argentine public and school or university groups who have studied the dictatorship, the same cannot necessarily be said for the uninitiated visitor, foreign tourists or even future generations who may require signposting or partial reconstruction. This assertion is supported by James E. Young: 'As an inert piece of stone, the monument keeps its own past a tightly held secret, gesturing away from its own history to the events and meanings we bring to it in our visits' implying that there are limitations to the power of a site to 'speak' (1993: 14). On the contrary, he adds that it is important 'to make visible the activity of memory in monuments' (ibid.), pointing to not only the significance of visitation to and interaction with such sites but also the necessity for intervention. The Casino de Oficiales, to an extent, adheres to this maxim. Structural amendments made to the detention centre by the navy during the dictatorship in an attempt to conceal evidence from the investigative visit of the Inter-American Commission on Human Rights in 1979, such as the removal of cells, have not been reversed (see Inter-American Commission on Human Rights 1980). Although the building has been left as it was, the signposts, added in 2005, are a notable exception. Survivors' accounts of the ESMA are incorporated into factual information on the methodology of state terrorism, and the broader context in which human rights violations were committed on some of the signposts as well as those which focus on the specific room or sector and its function. Bringing together the informational and the testimonial, aesthetic intervention has been minimal to ensure the tours cater to the uninitiated and the informed; for, those who come to learn and those who come to reflect, remember and pay homage to the victims.

Subtle aesthetic intervention has been complemented by the guides employed by the Ente, who accompany visitors on their tours and have a crucial role to play in terms of how visitors understand and experience the site. These

guides are often students from the University of Buenos Aires, enrolled on a variety of degree programmes, employees of the IEM or, less frequently, survivors.[17] Chris Ryan and Rahul Kohli propose that 'the role of human interaction thus becomes paramount in the story-telling' (2006: 225). The guides are required to relate the experiences of victims in the ESMA and offer a broader narrative regarding the antecedents and consequences of state repression, particularly when this is not self-evident in the site. The intervention of guides also gives a 'human presence' (ibid.) and authenticity to the tour of the 'empty' Casino de Oficiales and reduces the need for more elaborate and visible aesthetic intervention. From a practical perspective, given that the ESMA is the focus of ongoing judicial investigation for crimes against humanity and constitutes material proof of these crimes, their decision not to allow visitors to roam the site freely is undoubtedly based on pragmatism.

However, although guidance has been deemed necessary in the ESMA, these individuals are entrusted with a grave responsibility: to provide a context to the human rights violations without imparting a master narrative. Visitors are invited to interact with the tour guides and each other from the beginning of the tour, when each member of the group is prompted to give their reason for visiting and share their interest, and is given the opportunity to ask and answer questions and both time and space in which to reflect on their experiences, particularly at the end of the tour when they are encouraged to comment in the guestbook. Striking a balance between narrating on the one hand and allowing visitors to experience the site themselves on the other must be negotiated by the guides, allowing for the provision of contextual information along with space for debate, critical analysis and individual interpretation. As Jonathan Huener points out, interpretations of sites of trauma tourism vary significantly, dependent on the individual's (both visitor and guide) 'knowledge', 'experiences', 'prejudices' and the rationale for their visits (2003: 118). Faced with a group of foreign tourists, the guides may need to provide more information regarding the longer trajectory of military intervention in Argentine history. A researcher examining the case of the ESMA may require less historical information about the dictatorship and more of a focus on the changes made to the Casino de Oficiales. These experiences are rather different from that of the former prisoner who may not require a tour or broader information. Therefore, a key challenge for the guide is to decide to what extent they should have a standard, 'practised' narrative or cater their narrative to each group. Meanwhile, it is imperative to avoid biased or narrow perspectives on the dictatorship and narratives that

neither trivialize memory or history nor simplify the past. This is just as relevant for the narratives included on the signposts and in information leaflets distributed by the IEM. Bearing in mind the ESMA's role as a 'space for the promotion and defence of human rights', less attention is devoted to the relevance of past repression in the present in the two-hour tours which generally focus on past repression. This is a shortcoming yet to be addressed, several years after the site has been open to the public, and one that remains outstanding as the site continues its transition to an established site of tourism.

Visitation to the ESMA in the form of guided tours has been steadily increasing since 2007—when the navy fully vacated the site—despite the site not being accessible without a prior appointment. In 2008, the first full year that the site was open to the public, the IEM received 5,677 visitors, a significant increase from the 1,433 visitors in 2007. These modest numbers increased steadily in 2009 (7,867 visitors) and 2010 (12,702).[18] It is also interesting to examine the cross-section of visitors participating in tours in the ESMA. Visitor statistics from 2008 reveal that over half of the 5,677 visitors were from schools (mainly Argentine) and universities (both Argentine and international institutions), with visits totalling approximately 3,000. The remaining (approximately) 2,600 consisted of survivors and relatives of victims and visitors from various foreign delegations including the Dutch, German and South African embassies. A significant number of media visits were from the BBC and ENDEMOL (the international independent television production company) as well as from the Argentine press.[19] In other words, not only former prisoners, family members and human rights organizations visit the site (they, in fact, make up a very small proportion of visitors) but also schools, students and those with a research-related interest tour the ESMA. This is indicative of the site's pedagogical aspect. And not only Argentine visitors but also a significant number of international visitors and representatives (particularly researchers, students and institutions like UNESCO) pay a visit, which suggests that even those without a personal connection to the dictatorship or even Argentina visit the site.

However, one type of visitor remains notably absent: the leisure tourist. As the ESMA remains geographically remote from the main tourist areas of Buenos Aires, the foreign tourist is more likely to have passed by the excavation site and memorial at the former Club Atlético Detention Centre in the neighbourhood of San Telmo than the ESMA. Unlike the recently opened Memory Park and historic Recoleta Cemetery, to date the ESMA has not been included as a site of tourism and visitation in recent versions of international travel

guides to Argentina and Buenos Aires such as *Frommer's*, *Time Out* and the *Rough Guide*.[20] In the 2008 edition of *Lonely Planet Buenos Aires*, mention of the ESMA was confined to the historical overview of Argentina rather than as a site to visit per se (see Bao and Mutic 2008: 29). Tours to the ESMA are not widely promoted and information about booking visits is available on the website of the Federal Government's Secretariat of Human Rights rather than on domestic and international tourist websites and forums. This underlines the role of the state in the site's recuperation and administration alongside its lack of promotion (and potential appeal) to broader society. Meanwhile, given that the site has only been recently opened to the public and that visits must be pre-arranged, significantly fewer speculative or casual visits have been noted. Prior knowledge thus becomes a necessary precondition for visitation and tourism, suggesting limitations to the ESMA's impact in attracting both domestic and foreign visitors. According to Gerardo Young (2008), a number of the challenges regarding wider visitation in the ESMA were being addressed in the hope that the site would be more accessible to the general public and that individuals and small groups could take a guided tour without prior arrangement. Although this was expected to be implemented by 2010 and visitor numbers were noted to have significantly increased, tours must still be requested beforehand by email and many of the visitors are those with a vested interest or professional motivation for visiting.

The fact that Gerardo Young's concerns regarding the promotion of the ESMA to a wider audience remain unattended serves as a reminder that the transition from a site of trauma to a site of trauma tourism is not straightforward, as it involves the negotiation of promotion, marketing and accessibility (ensuring facilities for the general public such as bathrooms, a reception area, refreshments and clear signposting in the locality) alongside continuing judicial investigation of the crimes committed there, as well as ensuring that the former detention centre does not become a house of horror. As Lennon urges, 'we have to guard against the voyeuristic and exploitative streak that is evident in so many' of these sites (Lennon 2005), particularly actual sites of repression. Balancing this imperative with a 'commercial ethic' (Lennon and Foley 2004: 11) is particularly relevant in contemporary Argentina, where, less than three decades after the dictatorship ended, many family members of victims are still alive and the legacy of state repression remains very much a part of the country's collective memory. In this sense, the ESMA has remained on the periphery of Lennon and Foley's conceptualization of dark tourism as a practice in which 'the educative

elements of sites are accompanied by elements of commodification' (ibid.), the latter a feature that the ESMA lacks. It is perhaps desirable that, in seeking to widen promotion of the ESMA to visitors (if this is even desirable), the state and societal actors involved in the ESMA sharpen their goals for the site and avoid attracting the death tourist who may visit for the 'thrill of coming into close proximity with death' (Lennon 2005) and that the space remains one for learning about, remembering and reflecting on the atrocities committed and for promoting broader understanding of human rights issues and tolerance.

Although the ESMA is emblematic of state terrorism and individual and collective trauma, as an emerging site of trauma tourism, it has thus far remained outside the Buenos Aires tourist circuit. The case of the ESMA is instructive for other cases of sites of trauma tourism and how they are treated by state and societal actors in the aftermath (immediate or after a significant hiatus) of repression and atrocity, and is indicative of the tensions that emerge over state involvement (particularly when the state has been the main perpetrator of violence and repression) as well as aesthetic and practical concerns of representation and promotion. Meanwhile, as the ESMA's pre- and post-recuperation trajectory illustrates, debates over treatment of former clandestine detention centres prove volatile, not only because these are the actual sites of trauma but also because they tend to require the involvement of state actors to provide funding or to sanction or recover the sites for them to be opened to the public. However, the contestation between and within state and societal actors as to how (and whether) sites of trauma are converted into sites of tourism is also suggestive of the responsibility that proponents have to ensure that their (distinct) objectives for the site are reached and that disagreements do not prevent the striking resonance beyond those directly affected by repression. As we have seen, there is much more to the ESMA than its role as tourist site. The victim-centred approach pursued in the recovery of the former clandestine detention centre, supported by the state, can be viewed as a form of reparation for the victims, whereas the inclusion of informational and testimonial signposts as well as minimalistic aesthetic intervention and reconstruction is indicative of the ESMA's educational role. As a site of visitation, the Casino de Oficiales can be viewed as a 'memorial museum' which reflects, according to Paul H. Williams, 'an increasing desire to add both a moral framework to the narration of terrible historical events and more in-depth contextual information to commemorative acts' (2007: 8). Beyond its symbolic and educational functions, the ESMA also has a direct relationship to judicial proceedings as judges have visited the site

as part of the ESMA Megacausa trial,[21] and the National Memory Archive houses documentation related to state terrorism, for investigative, educational and judicial purposes. During 2009, the *capuchita* was closed to visitors because of the discovery of inscriptions on the walls, which required investigation. Given its multifaceted role, the ESMA can be viewed as a site for visitation which stands on the nexus of truth, memory and justice and takes an important step towards societal *and* state condemnation of state repression and violations of human rights, without yet having been commodified as a popular site of leisurely tourism.

Notes

1 Walter Goobar is one of the filmmakers responsible for the documentary *ESMA: The Day of the Trial* (1998), filmed during a period of heightened public interest in dictatorship (Feld 2002: 127)

2 Estimates of the number of disappeared have ranged from a prudent 20,000 to 30,000 people. In the concluding chapter of the report of the Comisión Nacional sobre la Desaparición dé Personas (National Commission on Disappeared Persons, 1984), the total number of disappeared is cited at 8,690, with the acknowledgement that this could be much higher. Furthermore, a significant number of babies born in captivity or kidnapped alongside their parents were 'adopted' by military families or government sympathizers. According to their website, the Abuelas de Plaza de Mayo (Grandmothers of the Plaza de Mayo, 2010) estimate this number to be around 500, of which close to 100 have had their identity recovered and been reunited with their families.

3 Details provided by information boards seen on visit to the ESMA, 19 June 2009.

4 In Pilar Calveiro's work , the number of clandestine detention centres quoted is '340' (2004: 29). However, in 2006, the Secretariat of Human Rights, on the basis of further investigation, increased this figure to '498' (Ginzberg 2006). For more information on clandestine detention centres, see Nacional sobre la Desaparicion dé Personas (1984).

5 During and since the dictatorship, it was widely suspected that, while drugged, prisoners had been transported from the ESMA to aircrafts at the nearby Jorge Newbery airport and then thrown from the planes into the Río de la Plata. Adolfo Scilingo was the first member of the Argentine navy to publicly denounce the junta's conduct and to admit having participated in death flights (Verbitsky 1995).

6 The commission was replaced by the Public Entity for Memory and the Pro-
motion and Defence of Human Rights (known as the 'Ente') in 2007. The
Ente is made up of an executive body and a directive body. The tripartite
executive body is made up of a member of the executive branch of the federal
government, a member of the government of the City of Buenos Aires and a
member of the directive body, which is constituted by members of human
rights organizations.

7 The navy's stalled withdrawal from the site led to delays with the works
between 2004 and 2007, sparking disagreements within the human rights
movement regarding whether groups should move in to begin working on
the site while navy personnel continued to occupy the premises.

8 Juan de Wandelaer, SERPAJ representative, interview by the author, Buenos
Aires, 15 June 2007. Translation mine.

9 Two representatives of 'Memory and Struggle against Impunity Programme',
Centre for Legal Studies (CELS), interview by the author, Buenos Aires, 18
June 2007.

10 After the 2001 economic crisis, funding for the plaques to bear the names of
the dictatorship's victims in the Memory Park was scarce, and the works were
temporarily delayed.

11 In late 2011, the project for a museum/exhibition space in the Pabellón Cen-
tral—the destination for a museum as stipulated in the creation of the Ente in
2007—began to gather steam, when a competition for proposals was
announced by the Institute for Spaces of Memory (IEM). The winning pro-
posal, designed by the architects Mariano González Moreno, Ana Paula Sac-
cone, Sebastián Batarev and Pablo Villordo preserves many of the original
features of the building and modifies the interior for permanent and temporary
exhibitions (information gathered from author's interviews with two IEM
representatives, Buenos Aires, 26 August 2013).

12 The IEM is also in charge of overseeing the following buildings: the Coy
Pavilion, the infirmary, the garage and the printing works.

13 See the IEM website: http://www.institutomemoria.org.ar/exccd/esma.html.

14 Author's personal notes and observations from series of visits to the ESMA
between 2007 and 2009 and, more recently, in 2013.

15 For a complete list of proposals, see Marcelo Brodsky (2005).

16 'Jorge', member of H.I.J.O.S. Capital, interview by the author, Buenos Aires,
August 2009 (translation mine; name changed at request of interviewee.)

17 In a recent visit to the ESMA, organized to mark the inauguration of the
Infirmary and Brian Carlson's exhibition, the tour was conducted by Víctor
Basterra, one of the few survivors of the former clandestine detention centre.

18 Visitor numbers for the IEM tours of the Casino de Oficiales provided by the IEM. January 2011. Statistics show a steady and significant rise in visitation, indicating larger groups of visitors. In my first visit in 2007, I was the only visitor, and liaised with the guide beforehand to agree to a suitable time. Two years later, in June 2009, I was given a choice of times when tours were taking place, and attended one with around 20 other visitors. A visit in August 2013 involved a group of more than 30 visitors.

19 Statistics provided by the IEM. September 2010.

20 *Frommer's*: http://www.frommers.com/destinations/argentina, http://www.-frommers.com/destinations/buenosaires/; *Time Out*: http://www.timeout.-com/travel/features/687/argentinas-perfect-places, http://www.time-out.com/-buenos-aires/; *Rough Guide*: http://www.roughguides.com/destinations/south-america/argentina/, http://www.roughguides.com/destinations/south-america/argentina/buenos-aires/

21 Openings in the domestic judicial system have paved the way for increasing opportunities for formal justice, which had been largely blocked after the dictatorship. The 1986 Full Stop Law, which imposed a time limit for cases against perpetrators to be brought to court, and 1987 Due Obedience Law, which granted impunity to lower-ranking officers on the grounds that they followed orders, were followed by Presidential pardons in 1989 and 1990 for the military leaders convicted in 1985. The trials that have taken place or are underway since 2007 and relate to human rights violations committed in the ESMA are grouped under the 'Megacausa ESMA', which involves hundreds of victims, witnesses and defendants.

Works Cited

ABUELAS DE PLAZA DE MAYO. 2010. 'History of Abuelas de Plaza de Mayo: Children Who Disappeared or Who Were Born in Captivity'. Available at: http://www.abuelas.org.ar/english/history.htm (last accessed on 7 August 2010).

ALMEYDA, Tati. 2001–02. 'Quiero tocar el nombre de mi hijo . . .' (I Want to Touch My Son's Name . . .) (Dossier Memoria). *Ramona* 9–10: 10–12.

BAO, Sandra, and Anja Mutic. 2008. *Lonely Planet Buenos Aires*, 5th EDN. Melbourne: Lonely Planet Publications.

BRODSKY, Marcelo. 2005. *Memoria en construcción: debate sobre la ESMA*. Buenos Aires: La marca editora. Available in English as *Memory under Construction: The ESMA Debate* (David [William] Foster trans.). Buenos Aires: La marca editora.

CALVEIRO, Pilar. 2004. *Poder y desaparición: los campos de concentración en Argentina* (Power and Disappearance: The Concentration Camps in Argentina). Buenos Aires: Colihue.

CARA L. LEVEY

COMISIÓN NACIONAL SOBRE LA DESAPARICION DÉ PERSONAS. 1984. *Nunca Más* (*Never Again*): *Report of CONADEP*. Available at: http://www.desaparecidos.org/nuncamas/web/-english/library/nevagain/nevagain_001.htm (last accessed on 7 August 2010).

DUHALDE, Eduardo L. 2007. 'La ESMA y las encrucijadas del olvido y la memoria' (The ESMA and the Crossroads of Forgetting and Memory). *Caras y Caretas* (August): 26–8.

FEITLOWITZ, Marguerite. 1998. *A Lexicon of Terror: Argentina and the Legacies of Torture*. New York: Oxford University Press.

FELD, Claudia. 2002. 'El Diario del Juicio en imágenes (1995)' (*El Diario del Juicio* in Images) in Claudia Feld, *Del estrado a la pantalla: Las imagines del juicio a los ex comandantes en Argentina* (From Witness Stand to Screen: Images of the Trial of the Former Commanders in Argentina). Madrid: Siglo XXI de España Editores, pp. 113–22.

GINZBERG, Victoria. 1999. 'La hora del desencuentro' (The Hour of Disagreement). *Página 12*, 26 March, p. 6.

———. 2004. 'Un 24 de marzo diferente' (A Different 24th March). *Página 12*, 24 March. Available at: http://www.pagina12.com.ar/diario/elpais/subnotas/33199-11697-2004-03-24.html (last accessed on 24 June 2010).

———. 2006. 'De los dos demonios al terrorismo de Estado (From the Two Demons to State Repression). *Página 12*, 15 May. Available at: http://www.pagina12.-com.ar/diario/elpais/1-66922-2006-05-15.html (last accessed on 24 June 2010).

HUENER, Jonathan. 2003. *Auschwitz, Poland, and the Politics of Commemoration, 1945–1979*. Athens: Ohio University Press.

INSTITUTE FOR SPACES OF MEMORY. 2006. *Un espacio para la memoria* (A Space for Memory). Buenos Aires: Instituto Espacio para La Memoria.

INTER-AMERICAN COMMISSION ON HUMAN RIGHTS (IACHR). 1980. *Report on the Situation of Human Rights in Argentina*. Buenos Aires: Organization of American States. Available at: http://www.cidh.oas.org/countryrep/Argentina80eng/toc.htm (last accessed on 31 March 2011).

LENNON, John. 2005. 'Journeys into Understanding'. *The Observer*, 23 October. Available at: http://www.guardian.co.uk/travel/2005/oct/23/darktourism. observerescape-section (last accessed on 25 June 2010).

LENNON, John, and Malcolm Foley. 2004. *Dark Tourism: The Attraction of Death and Disaster*. London: Continuum.

MELENDO, María José. 2006. 'Acontecimientos estéticos ejemplares en el presente de la memoria' (Notable Aesthetic Developments in Memory's Present) in Cecilia Macón (ed.), *Trabajos de la memoria: Arte y ciudad en la posdictadura argentina* (Works

of Memory: Art and the City in Post-Dictatorship Argentina). Buenos Aires: Lado-sur, pp. 76–97.

MILES, William F. S. 2002. 'Auschwitz: Museum Interpretation and Darker Tourism'. *Annals of Tourism Research* 29(4): 1175–8.

RYAN, Chris, and Rahul Kohli. 2006. 'The Buried Village, New Zealand: An Example of Dark Tourism?'. *Asia Pacific Journal of Tourism Research* 11(3): 211–26.

SCHMUCLER, Héctor. 2006. 'La inquietante relación entre lugares y memoria' (The Disturbing Relationship between Places and Memory). Paper presented at the workshop 'Public Use of Historic Sites for the Transmission of Memory', Memoria Abierta, Buenos Aires, 8–10 June. Available at: http://www.memoriaabierta.org.ar/-materiales/pdf/hector_schmucler.pdf (last accessed on 15 June 2008). Also see http://www.-memoriaabierta.org.ar/ pdf/uso_publico.pdf (last accessed on 15 June 2008).

TODOROV, Tzvetan. 2001. 'In Search of Lost Crime: Tribunals, Apologies, Reparations and the Search for Justice'. *The New Republic* 29: 29–36.

VERBITSKY, Horacio. 1995. *El vuelo*. Buenos Aires: Planeta. Available in English as *The Flight: Confessions of an Argentine Dirty Warrior* (Esther Allen trans.). New York: New Press, 1996.

VEZZETTI, Hugo. 2006. 'Memoria histórica y memoria política: las propuestas para la ESMA' (Historical and Political Memory: The Proposals for the ESMA). *Punto de Vista* 86: 37–42.

WILLIAMS, Paul H. 2007. *Memorial Museums: The Global Rush to Commemorate Atrocities*. Oxford and New York: Berg.

YOUNG, Gerardo. 2008. 'El Museo de la ESMA recién estará terminado para 2010' (The ESMA Museum Will Be Completed by 2010). *Clarín*, 23 August. Available at: http://edant.clarin.com/suplementos/zona/2008/03/23/z-03115.htm (last accessed on 31 January 2011).

YOUNG, James E. 1993. *The Texture of Memory: Holocaust Memorials and Meaning*. New Haven, CT, and London: Yale University Press.

From Shrine to Theme Park:
The House of Terror in Budapest, Hungary

ANIKO SZUCS

'House of Error', 'House of Terror in Taste', 'Historic Kitsch', 'Alibi Museum', 'Past-Technological Plaza', 'Terror Plaza', 'House of Horror', 'Pop Art Education Centre'—these are some of the labels that critics used to describe the House of Terror after its opening on 24 February 2002. It is one of the most controversial institutions in post-communist Hungary; yet, it has successfully operated for over a decade. Whether it succeeds as a communist theme park, a memorial, a museum or an education centre is hard to tell. Critics were right as each label describes the House of Terror individually, but they were also wrong as these labels also describe the House of Terror collectively. In the convergence of these different features and functions, the institution becomes more than a house of error, historic kitsch or an alibi museum. The impact of the House of Terror is undeniable; it has significantly changed the aesthetics and politics of post-communist commemoration in the former Eastern bloc and transformed the tourist maps of Hungary.

Walking down Andrássy Boulevard, it is easy to understand why Budapest is often referred to as the 'Paris of Eastern Europe' in a number of tour guides and travel books. The parallel tree-lined esplanades, impressive nineteenth-century neoclassical and art nouveau palaces, luxurious coffee houses, prominent offices and expensive apartments in brightly coloured buildings turned this iconic boulevard into a World Heritage Site in 2002. This elegant and serene area is disrupted by the jarring facade of the House of Terror, its grey walls and the wide black-metal ledge round the edges of the building with the perforated capitalized letters T-E-R-R-O-R, with an arrow cross and a five-pointed star side by side. This eye-catching frame breaks the aura of Andrássy Boulevard (figure 24). Until the opening of the museum, the terror and violence that occurred in the headquarters first of the Hungarian Fascist Party (the Arrow Cross Party) between 1940 and 1944 and then of the State Security Department[1] (communist Hungary's political police, ÁVO) between 1945 and

FIGURE 24. Facade of the House of Terror, Budapest, 2006. Photograph by Éva Vadász. Reproduced with permission.

1956 were invisible and forgotten. Only a few Hungarians knew about or remembered the horrendous history of the building. Most passers-by had no idea of the violence that had taken place in this grandiose mansion. The terror, and its memory now are in plain sight; the enlarged letters T-E-R-R-O-R scream what that building once stood for.[2]

The alteration of the facade at 60 Andrássy Boulevard highlights the guiding concept behind the museum: to offer an affective experience of terror and history through compelling symbolic installations and powerful visual materials. At the same time, the juxtaposition of the 'Hungarian swastika'—the arrow cross—and the five-pointed star on the ledge also forecasts a major controversy: Did the House of Terror rightly equate fascism and communism? Was the juxtaposition of the two totalitarian regimes fair and impartial? Although much has been written about this fiery debate, this is the starting point of this article as well, for two reasons: first, I believe that the seemingly

innocent juxtaposition inevitably encourages the comparison of the two regimes, thereby legitimizing the questions of fair treatment of the two dictatorships; second, and more importantly, the comparative approach may help us to unravel and understand what the exhibition does. However, in opposition to several earlier reviews (Szőnyei 2002; Karsai 2002; Varga 2002; Mink 2002), I argue that the basis for this comparison should not be primarily facts and numbers, which may indicate a disproportionate representation of the two dictatorships; rather, I ask how the themes of the exhibition, its design and use of historical documents compare with one another. How does the institution display these violent regimes and what often invisible and unacknowledged forces shape— even manipulate—visitors' perceptions of communism and fascism?

This essay argues that the House of Terror approaches the exhibitions of the two dictatorial regimes in two radically different ways. While the rooms dedicated to fascism present a condensed narrative of the *history* of the Hungarian Arrow Cross, the extensive section on communism offers an all-encompassing view of the workings of a repressive state apparatus and the everyday lives of people suffering from it. The result of this thematic breakdown, however, is not only that communism is 'overrepresented' in comparison to fascism; it also means that outside of the rooms displaying the history of the Hungarian Arrow Cross, the House of Terror morphs into a theme park of post-communist *memory*, where the use of popular and populist iconography, simplistic and stereotypical symbols and memorabilia shift the effect from terror to irony. Terror, an abstract notion, primarily functions as an organizational framework for the House of Terror; it starts in the rooms on the Arrow Cross, and ends in the reconstructed basement prison cells and the Hall of Tears. In-between, however, the grandiose and creative symbolic design often conceals the real terror behind this beautiful and rich cascade of images and imageries. The total experience of the House of Terror appeals more to post-communist nostalgia than to grief and remembrance; the symbolic, fragmented evocation of individual and collective memories does not make it possible for visitors to confront and perhaps even come to terms with the double burden—the true terror—of the past.

The Limits of Co-memoration: The Alibi Museum

The idea of an institution that would commemorate Hungary's two totalitarian regimes was first conceived in 2000 by the then governing conservative party Fidesz (Hungarian Civic Union). Soon, they hired the Public Foundation for the Research of Central and East European History and Society, an organization

closely tied to the party, to materialize the grandiose plans. Prime Minister Viktor Orbán appointed his chief advisor, Mária Schmidt, as director general of the institution. In December 2000, the foundation purchased the building at 60 Andrássy Boulevard; the House of Terror Museum opened on 24 February 2002, two months before the parliamentary elections.[3] In his opening speech, Prime Minister Orbán said:

> We shut two dictatorships in-between the walls of this building. Although they grew from different roots, we can see how nicely they get along next to each other. This is not an accident. We don't need to shirk our responsibility, but our children need to know that both dictatorships were regimes that could not have won the power in our nation without the support of foreign armies (2002; translation mine).

From its conception, the museum was meant to commemorate the victims of *both* fascism and communism. The creators claimed that given the particular history of the building, which first served as the 'House of Loyalty', the centre for the Hungarian Arrow Party and later as the headquarters of the Hungarian State Security, the new institution would simultaneously commemorate both regimes. The two eye-catching totalitarian symbols on the ledge are the first manifest signs of this conceptual juxtaposition; and later, after entering the building, we are repeatedly confronted with the co-presentation of fascism and communism.

At the entrance a non-figurative sculpture consisting of two impressive shiny granites welcomes visitors. One plaque says, 'To the Memory of the Victims of the Arrow Cross Terror', with an arrow cross carved into a black stone; and the other reads, 'To the Memory of the Victims of the Communist Terror', with a five-pointed star on red background. Two plaques of the same size, shape and material with symmetrical salient edges on the two sides; the careful design at the entrance suggests that both regimes are treated (by the curators) and expected to be treated (by the visitors) equally. This straightforward and perhaps seemingly insignificant artwork as an invitation for commemoration, alongside the perforated ledger, is emblematic for the whole museum in their mode of engagement with visitors. The meaning is simple; no multi-layered or controversial representations blur the essentialist message in the House of Terror—both fascism and communism were brutal regimes that repressed and crippled Hungarian society.

Nonetheless, a closer look at these seemingly straightforward artefacts and installations inevitably further complicates, and in some cases contests, the simplistic meanings. The juxtaposition of the two dictatorial systems reveals

the irresolvable contradiction in the curators' guiding concept: although the cautiously identical renditions of fascism and communism at the entrance create the fiction of one, ultimate and undifferentiated totalitarian evil, this symbolic equation also prompts visitors to compare one regime to the other.

Art historian András Rényi points out that by 'taking advantage of the undoubtedly sensual fact that the two terror regimes used the same building for its wicked purposes, [. . .] the design uses all sensual tools to blend them together and stigmatize them simultaneously' (2003; translation mine). The merger of the two regimes leads to the 'mutual obliteration of their earlier particular ideological meanings (the irredentist Hungarian nationalism and the historic principles of the world freedom)' and establishes 'the mythical icon of the atemporal, pure terror' (ibid.; translation mine).

Consequently, victims of this pure, abstract terror also coalesce, and the House of Terror asks visitors to treat and remember them with equal respect and empathy. This is a meritorious request, a legitimate purpose of the museum and something that Hungarians should indeed learn. However, what the carefully designed, two-winged, fully symmetric and proportionate sculpture also performs in the hallway is a false equality between the victims of the two totalitarian regimes. In this abstract representation, victims of fascism or communism suffered from the same abstract pure terror. It conceals the essential fact that victims of the Arrow Cross were Jews and Romas (who, despite their Hungarian national and/or cultural identities, were not considered Hungarian by the majority of society), whereas victims of communism were Hungarian people. Should visitors remember—and be reminded of—this fundamental distinction? Should the victims be commemorated differently because of their real and/or projected ethnic identities? The plaques that incite the commemoration at the entrance choose to blend all victims together, as if the condition of an impartial, unbiased empathy towards the sufferers would be to disregard their ethnic and religious diversity and the two regimes' ideological differences.[4]

The invitation to commemorate victims of the Arrow Cross and communism together demonstrates genuine intentions at the entrance of the House of Terror; the symmetric and carefully proportionate displays show curators' attempts to avoid the construction of a narrative that would claim one regime to be more harmful or evil than the other. This forced fairness results in an artificial equilibrium, a contrived equalization of the two dictatorial regimes that soon changes with the exhibition.

Performing the History of the Arrow Cross: The House of Error

The museum, which spreads out on two floors and an extensive basement area, starts on the top floor with the room labelled 'Double Occupation'; it is divided by a wall in the centre; each side represents the Nazi and the Soviet occupations. The English and Hungarian flyers available in this room put the 'double occupation' into context:

> From the mid-thirties onward, Hungary found herself in the buffer zone between the increasingly more aggressive Nazi Germany and the Soviet Union, which by the end of the decade once again became a power to reckon with. Allied with one another, and subsequently locked in a life-and-death battle, the two totalitarian dictatorships strove for a new order that had no place of an independent Hungary. After the outbreak of World War II, Hungary made desperate attempts in order to maintain her—albeit limited—elbow room and avert the worst scenario: German occupation. It was a great achievement that this eventuated only in the fifth year of the war, on March 19, 1944 (Terror háza 2011).

The room's visual effect and the catalogue's text concur; they both suggest that two superpowers—Germany and the Soviet Union—competed simultaneously to tear apart this weak and innocent country, symbolically positioned as the centre wall. Because the museum's curators chose to start the exhibition with the rise of the Hungarian Nazi Party—the Arrow Cross—to power, seven months into the German invasion, the installation rightfully positions Hungary as a nation violently oppressed by both powers. Nevertheless, it is important to differentiate between the progress of the two occupations: whereas Nazi Germany's occupation was directed against Hungary in March 1944, the primary aim of the Soviet occupation, which took place between October 1944 and May 1945, was to fight and triumph over the German army (supported by Ferenc Szálasi's government and a small number of Hungarian soldiers). What is called the 'Soviet Occupation' in this room was actually the process of Hungary's liberation from German oppression. The totalitarian communist regime did not gain full power until 1947, therefore the Soviet occupation of 1945 did not immediately transform into the communist dictatorship as this first room may falsely suggest.

Starting the exhibition with Szálasi's rise to power allows the curators to avoid some of the more controversial themes of the past. One such issue is Hungary's relation with Germany. Although the catalogue describes the Nazis

and Soviets as allies (by which the authors presumably refer to the short-lived Soviet–German Non-Aggression Pact of 1939), it fails to acknowledge that Hungary sided with the Third Reich until the spring of 1944. What the prospectus characterizes as a 'desperate attempt' to maintain independence was actually a long-term alliance. The Second Vienna Award of 1940, arbitrated by Nazi Germany and Fascist Italy, re-assigned Transylvania to Hungary;[5] Hungary became the first country to join the German–Italian–Japanese Three-Power Act and fought the war on the side of the Axis until German occupation in 1944. The exhibition also ignores the discrimination of Jews by the democratically elected Hungarian governments before and during German alliance. The catalogue does mention that Jews 'had already suffered from the restrictions of the Jewish Laws enacted in 1938, 1939, and 1940', before 'the final solution took its course with the active co-operation of Hungarian authorities', which they describe as the 'puppet-government' installed by the Nazis (ibid.). What is left out, however, is the 1920 Quota Act, the first legislation in Europe that limited to 6 per cent the number of Jews admitted to institutions of higher education. By starting the exhibition in 1944, the museum also avoids detailing the discrimination laws that deprived Hungarian Jews of their rights and properties. A number of historians and intellectuals criticized the House of Terror for this omission. By ignoring these facts, the museum contributes to the forgetting—and even the erasure—of this history from Hungarian national narrative. Schmidt addressed the critique in the following terms:

> We had serious debates about where this story should start: whether the summer of 1944, the Holocaust, or the German occupation should be part of it. At the end we consciously decided that the building's history starts with 15 October 1944. The Holocaust Museum will introduce the preceding events and the Holocaust, and it is inevitable that there will be some overlaps in the two exhibitions' coverage of the Arrow Cross. We thought it would be rather unfortunate, if we used up the few footage and photos that are left from this era (in Seres 2002; translation mine).

This peculiar choice of the starting date of the exhibition also allows curators to leave out the Jewish and Roma genocide from the narration. Schmidt also explains, 'We don't want to talk about the persecution or the deportations. What we want to talk about is the phase of terror that started on 15 October 1944.[6] Had we not known that there would be a Holocaust museum, we would have probably decided differently' (ibid.; translation mine).[7] Although the symbolic

juxtaposition of the two terror apparatuses at the entrance invites visitors to simultaneously commemorate victims of both regimes, the museum's narrative does not include both stories. Not all phases of terror are integrated into the institution, argues Schmidt, and as a result certain victims are excluded from the commemoration. It is more or less accidental which victims of Hungarian fascism will be remembered in the House of Terror: the tragedy of those Jews from Budapest who were shot into the Danube (presumably after 15 October 1944) is evoked in a powerful installation, whereas the deportation of the Hungarian Jewry in the country is only briefly mentioned in the exhibition room's flyer.

The question arises: Can visitors notice the absence of some victims in the Hall of the Arrow Cross—the room that commemorates Nazi terror in Hungary? Because of the overabundance of objects, screens and audiovisual equipment, visitors will inevitably miss out on some parts of the historical narrative that curators squeezed into a cluttered exhibition room. Six monitors show simultaneous footage of interrogations once conducted by the Arrow Cross in the building, the deportation of Jews, the return of war criminals and propaganda materials. Arrow Cross and SS uniforms hang under the monitors; on the other side, visitors can listen to speeches and newscasts through two telephones installed under the black-and-white war photographs. A large table is set with empty white plates in the centre, with a life-size mannequin of the Arrow Cross government's leader, Ferenc Szálasi, presiding it. The icy Danube flows in the background, a reminder of the winter of 1944, when Hungarian members of the Arrow Cross shot thousands of Jews into the freezing river. The effect is intensified by the words of the Hungarian pro-Nazi news that periodically interrupt other audio pieces.

Little is factual in this spectacular and powerful multimedia performance of history; the most informative section is the interactive screen that includes posters, flyers and statistics about the anti-Jewish laws. In the Hall of the Arrow Cross, the persecution of Hungarian Jewry starts where it ended in reality: the long and excruciating lines to the freight trains, the thud of the ice-cold Danube as lifeless bodies fell into it, and the faceless numbers of those who perished; what the exhibition does not show is the process that resulted in this tragedy. Furthermore, just as a great number of victims have been left out from this narrative, many of the perpetrators also get away. The two groups of perpetrators mentioned are the members of Szálasi's government and the Arrow Cross members who carried out the orders and pulled the triggers. However, those who started and conducted the 'final solution' in Hungary—the politicians

who voted for the anti-Jewish laws, the Hungarians who willingly cooperated and carried out all these discriminatory policies, and the crowd of indifferent bystanders—are not held responsible for the crime.[8]

The lack of any mention of Jewish and Roma deportations from the summer of 1944 becomes even more evident as the room adjacent to the Hall of the Arrow Cross powerfully evokes the deportation of Hungarians to the Soviet forced-labour camps, which also started before October 1944. The long rectangular room with screens on both sides mimics a train heading to the Gulag, with the familiar monotonous clickety-clack. Visitors advance quite literally towards the dreary Siberian countryside as the carpet represents a gigantic map of the former Soviet Union and its labour camps. On the window screens, survivors recall their memories of the deportations and Soviet camps; their testimonies, which are conspicuously missing from the earlier rooms, dominate the space here. Their stories shift one's attention from world history and war to individual tragedy and suffering.

The train leads into the Changing Room. In the centre of the confined space, the uniforms of the Arrow Cross Party and the Communist Party swivel back to back (figure 25). Once again, the two regimes are represented as equals, with the two strikingly similar-looking uniforms; at the same time, the two repressive regimes here are not only equivalent to but also a continuation of one another. The flyer states that this room 'symbolizes the continuity of dictatorships' by showing 'how an entire society was forced to "turn coat", i.e., switch alliances' (Terror háza 2011). What the uniforms in reality refer to are those newly recruited members of the Communist Party, who had been 'small Arrow-crossers' during the war, who then 'had to state that their membership had been a mistake for which they were willing to make amends' (ibid.). Except for these young men, who, according to the catalogue and the flyer, volunteered to serve both regimes, no other explanation is offered about why communism should be considered as a continuation of fascism. The juxtaposition of the two uniforms evokes the idea of the undifferentiated pure terror; they embody the faceless fascist and Communist Party members by blending them and erase all ideological and historical differences.

Performing the Memory of Communism: A Pop Art Education Centre

The Changing Room marks a break within the museum, not only because everything that follows commemorates the communist era but also because

234

FIGURE **25.** Uniforms of the Arrow Cross Party and the Communist Party displayed in the Changing Room, 2011. Photograph courtesy of Aniko Szucs.

chronology as an organizing principle is suspended here. While the first three rooms depict the years 1944–47 consecutively, the rest of the exhibition presents different aspects and themes of the 1950s and early 1960s.[9] Although many of the reviewers criticized the institution for its disproportionate representation of the two totalitarian regimes—only two rooms display the history of the Arrow Cross; the other 18 focus on communism—it is important to emphasize that only a few of the 18 rooms explore communist terror literally and explicitly; the rest of the museum morphs into a communist theme park about everyday life in communist Hungary in the 1950s.

From here on each room is organized thematically: elections, resettlement, church, secret police and Hungarian aluminium among many others. The styles of these installations follow three different design trends within the iconography of post-communist commemoration: some rooms feed into the fashionable contemporary sentiment of post-communist nostalgia through the accumulation

235

of overused communist icons and memorabilia; others depict the mythical moments of communist terror through *in situ* installations;[10] and a few rooms represent extreme horror with hyper-realism; the carefully authentic and precise reconstruction of these spaces offers visitors a simulated experience of disgust and suffering.

The room called The Fifties looks at the staged elections of the one-party system and then morphs into the room called Workaday Communism, a random accumulation of communist memorabilia from party notebooks to earbuds and typewriters, and to unforgettable masterpieces of socialist realism. The artefacts create the atmosphere of a post-communist souvenir shop filled with nostalgia rather than terror.

The rooms Hungarian Aluminium and Hall of Propaganda and Everyday Life create similar effects. The latter, an extraordinary collection of colourful social realist posters, worn-out slogans and cliché iconography, fits perfectly into the aesthetics of commoditized post-communist ephemeral memorabilia (figure 26). The connection between aluminium and communist state repression will most likely be unclear to foreigners and to young visitors. The leadership used the production of Hungarian silver (though cheap and of poor quality) to demonstrate the success of the new communist industry. Though the background is probably unknown to most visitors, the retro design of the coffee makers, flasks and other kitchen appliances creates the same light-hearted atmosphere as the other post-communist halls.[11]

The rooms labelled 'Resistance', 'Resettlement and Deportation' and the (Peasants') 'Compulsory Deliveries' include installations in which a central concept or image guide the design; each installation is in metonymic relation with the theme it represents: every room describes the atrocities of communist repression, but the essential design makes a full and visceral engagement impossible. In the Resistance Room, run-down and shabby tables, with a single bulb hanging from the ceiling, symbolize the underground movement and its heroic attempts to fight communism. The austerity of the space should evoke the restrained circumstances in which the resistance movement was forced to operate; nevertheless, the intentional simplicity backfires and the room remains neutral and characterless—a general and unimaginative evocation of the dark 1950s.

The overabundance of artefacts and information in the Resettlement and Deportation Room results in the opposite effect. This area is intended to tell the stories of those Hungarians, Germans and Slovaks who were resettled because of the new country borders as well as of the thousands of aristocrats who were

deprived of their properties and forced to move to the countryside or to forced-labour camps. The dominating symbol for this is a large black ZIM automobile, a typical vehicle with which the political police *invisibly* kidnapped its victims in the middle of the night.[12] The installation playfully twists this invisibility by making the car hyper-visible, but only in the dark: the curtain covering the automobile becomes transparent once the lights go down, and the car is illuminated from inside. The documents on the walls also fade out; only small screens telling survivors' testimonies pop out from the darkened background.

The communist government's unfair treatment of the peasants, the punishment of the richer kulaks and the obligatory communalization are symbolically evoked by a tortuous labyrinth built of a wall of plastic bricks that imitate the blocks of animal fat, the only food that was available in the most severe poverty of the 1950s. These cubes of animal fat symbolize shortage of food and the unhealthy, repulsive nourishment that people relied on during this time. The documents exhibited on these walls include posters, food stamps and governmental files; here again, only personal stories of the once persecuted peasants on the screen engage visitors in a highly theatrical but almost indecipherable space.

The tamed and generic installations in the Resistance, Resettlement and Deportation, and Compulsory Deliveries rooms do not evoke the visceral

FIGURE 26. Posters in the Hall of Propaganda and Daily Life, 2011. Photograph courtesy of Aniko Szucs.

experience of communist terror. Only the survivors' recollections on the screens mediate to visitors what it really felt like living under such oppression—to be subjected to torture (for being part of the resistance movement) or forced resettlement (for being part of the aristocracy). Thanks to the oral history testimonies, these rooms are more engaging and effective than many others. History morphs into shared experience (similarly to the Gulag Room) through the testimonies and the exhibited memorabilia, such as notebooks, letters or a piece of clothing. These subjective voices and personal objects perform very differently from the faceless figures and historical footage in the section of the Arrow Cross; in this mediation history becomes memory—a memory that we all share and we all need to come to terms with.

The House of Terror places the period of fascism within the cultural memory and history of Hungary; at the same time, the use of oral history and personal memorabilia situate communism in Hungary's communicative memory.[13] While the years 1944 and 1945 are constituted as a solidified historical narrative, the years between 1945 and 1991 are evoked through oral history testimonies and, as such, are presented as recently experienced, still open wounds.

The various uses (or lack thereof) of oral history testimonies highlight the complexity of communicative memory and show how easy it is to manipulate the memory of the recent past by initiating communication between or mediation of survivors and those who aspire to participate in this act of commemoration. The use of personal recollections implies that those who lived these tragic events are still among us—they are our contemporaries. This creates a sense of community and communality, in which visitors empathically share history, memory and even the experience of the tragic past. As a result, as Paul Williams points out, such engagement may be inappropriate and harmful, as it 'encourage[s] bogus similarities between spectators and victims' (2007: 152). In stressing that victims are 'just like us', Williams further explains, 'an emphasis on likeness disguises real differences, and privileges the visitor by making him or her the implicit standard against which "likeness" is measured' (ibid.). Moreover, emphasizing that the victims are our contemporaries suggests that so are the perpetrators. This means that those who committed these crimes could and should be held responsible for their past actions.[14]

The display of personal narration is essential not only in maintaining communicative memory but also in maintaining the connection between communism and terror The elegant installation in the vaulted chapel-like room labelled 'Religion', with a lit large cross on the floor and sacred religious relics

in the windows, radiates balance and calmness. Only the monitors that show documentaries about persecuted clergy disrupt this harmony. Again, individual voices mediate the repression and engage visitors on a visceral level with the experience of terror.

Performing 'Pure Terror': The House of Horror

The stimulation and mediation of terror amplifies as visitors approach the subterranean prison. The symbolic descent into hell takes place in a slow-moving elevator. On a screen, the former cleaner of an execution site describes the details of how prisoners were hanged and then taken away. The elevator opens onto the basement, where the reconstructed prison cells, with wet walls, dirt, solitary confinement and even a gallows, can be seen.[15] The curators let this powerful reconstruction speak for itself; visitors have to bend down when entering a cell or trying to fit into a so-called foxhole—the local version of solitary confinement. They also struggle with the nauseating humidity and the depressing lack of light; the hyper-realistic reconstruction (only the bedbugs are missing) provides a deceptively authentic experience of the prison.

In the prison cells that display photos of victims, however, the lack of information is misleading. The portraits on the walls suggest these men and women suffered in this building, although the catalogue clarifies that many of them were held elsewhere. The victims on display are grouped thematically: victims of the Arrow Cross, of communist dictatorship, of the Revolution of 1956 and the persecuted clergy. The exhibition in the basement reveals the challenge of displaying two competing, sometimes separate, sometimes overlapping, narratives: the history of this building and the history of the totalitarian regimes. Affective authenticity collides with factual authenticity: although the visceral experience of the prison is authentic, what the victims' photos imply in their juxtaposition on these cell walls may not be true.

The exhibition ends right where it began: with the undifferentiated commemoration of victims of both fascism and communism. The organization of the photos follows the same principle as the walls of the prison cells, and in the solemn Hall of Tears a dimly lit forest of metal crosses invites visitors to commemorate the victims of both regimes. The names on the wall include only those who were arrested and persecuted as political criminals; but the bright stars of David on the metal crosses (a disturbing oxymoron that mirrors the undifferentiated curatorial perspective) make the Jewish victims of the Arrow Cross visible

as well. The exhibition concludes with the Wall of Perpetrators, where photos of perpetrators of both regimes are hung, treating them equally. That they are all guilty is an undeniable fact, but the question still remains: Should Hungarian society judge and condemn them with an equal hand? Do they deserve the same place in the Hungarian historical narrative and cultural memory?[16]

The basement of the House of Terror fulfils the main function that the creators originally assigned to it: it is a memorial, a shrine commemorating the victims of the two repressive regimes. The question arises again: what function does the institution in its totality fulfil? What could best describe this multi-dimensional house? Istvan Ihász points out that '[t]he building has become the museum of public discourse, although without fulfilling any of the classical museum functions—collecting, cataloguing, storing, preserving—it cannot be characterized by any of the categories of "memorial–collection–exhibition space–museum" ' (2002: 97). Ihász lists the numerous functions the House of Terror may not fully accomplish. Nevertheless, I argue here that in its magnificent theatricality the House of Terror does perform all these functions and perhaps more. Can a museum *perform* but still not fulfil certain functions? In my view, this is an ongoing challenge for the House of Terror. The spectacle has outgrown its functionality. Visitors encounter a historical exhibition of Nazism in communism, a collection of artefacts featuring post-communist nostalgia, a theme park of communism and a shrine that commemorates the victims of terror. These are four different sections of the museum, and at the same time many of the rooms are a little bit of all. They all morph into one grandiose performance that may present too many gaps and misconceptions to the amazed audience.

Notes

1 Unless otherwise indicated, the English translations of all Hungarian organizations and historical terms are borrowed from the House of Terror's English-language catalogue.

2 The design of the facade, as many other architectural elements, is inspired by the United States Holocaust Memorial Museum in Washington DC. Similarly to the curved portico at the Holocaust Museum's entrance with its squared arches and window grating, the shadow of the ledge of the House of Terror also changes with the sun's movement, and in the middle of the day, passers-by can see the shadow of the perforations, the word 'terror' and the two symbols reflected on the building's walls (for details of the similarities between

the House of Terror and the United States Holocaust Memorial Museum, see Ihász 2002; Radnóti 2003).

3 Because of this conspicuous timing, a number of politicians from the opposition parties as well as pandits criticized the Fidesz for building the House of Terror as part of their re-election campaign. The conservative political advisor and general director Mária Schmidt responded:

> It was one of the recurring arguments of the attacks against the House of Terror that its creation served the interests of party politics, and its opening (24 February 2002) was timed for the beginning of the election campaign. However, many feel the opposite: that the unending and devious series of attacks preceding and following the opening of the House of Terror perfectly fitted into the Hungarian Socialist Party's violent and aggressive campaign; they conjured up the memories of leftist power-demonstrations well known from the old party's times. To many elderly, this awoke old fears, and the old reflexes returned: 'it is still not advisable to discuss these things' and 'it's better to remain silent' (2003: 197–8; translation mine).

4 This undifferentiated approach towards the victims becomes conspicuous again as we pass the hall and enter the inner courtyard of the museum building. A monstrous T-55 Soviet tank stands in the rectangular courtyard, surrounded by black-and-white photographs of hundreds of victims on the tall inner walls of the building. No information is provided about these distant faces; we do not know if they were victims of the fascist or communist regime. It is the monumentality of the walls with the endless rows of photographs of deceased men and women that expresses the utmost terror this institution is devoted to commemorate.

5 Hungary lost two-thirds of its territories and population after the First World War, which severely traumatized the nation's economy, industry and self-esteem. For this reason, the main interest of the Hungarian government was to regain the lost territories via the new war. Germany, recognizing this early on, offered Transylvania to the Hungarians and thereby secured a committed ally in the Central European region.

6 The deportation of Jews started on 15 May 1944. In the following 56 days, 437,402 Jews were sent to forced labour and/or extermination camps by the collaborating German army and Hungarian authorities.

7 According to Schmidt, the Orbán government decided on the foundation of *a* Holocaust museum before the creation of the House of Terror. However, according to the Holocaust Memorial Center's website (http://www.hdke.-hu/en), the government only established the museum in 2002, while the official opening took place in 2004.

8 At the time of opening, the website of the House of Terror (http://www.ter-
 rorhaza.hu/en/museum/first_page.html) displayed the following description
 of German occupation: 'During World War II, Hungary found itself in the
 middle of the crossfire between the Nazi and Communist dictatorships. On
 19 March 1944 the Nazis occupied Hungary and raised the representatives of
 the extreme right, unconditionally faithful to them, into power. The new, col-
 laborating Hungarian government no longer guarded the life of its citizens
 with Jewish origin' (quoted in Rév 2008: 60). After the public uproar in
 response to the outrageous implication that the Hungarian government pro-
 tected Jews until 1944, the museum changed the wording.

9 Interestingly, the chronological order returns towards the end of the exhibition:
 the last installations in the basement are dedicated to the Revolution of 1956
 and to the retaliations and mass emigrations that followed. This is where the
 exhibition ends chronologically; the last room brings visitors back to the
 recent past/present with an image of the final departure of the Soviet army
 from Hungary, a display about the grand opening of the House of Terror and
 the inaugural speech by the prime minister.

10 Barbara Kirshenblatt-Gimblett (1991) differentiates two curatorial approaches
 in relation to exhibited objects. Installations can place objects 'in context'
 and '*in situ*': whereas the first one is based on the mimetic recreation of the
 object's original context and environment, the latter establishes a metonymic
 relation; thus, 'the object is a part that stands in a contiguous relation to an
 absent whole that may or may not be recreated' (ibid.: 388).

11 Even according to the curators, this room is just an auratic installation within
 the museum. The catalogue only includes a three-line description/explanation:
 'The exhibited objects are made of the "Hungarian silver", of bauxite, which
 is the raw material of aluminum. The objects on the shelves are typical shabby
 pieces of poor quality reflecting on the period's design and culture; they were
 part of our everyday life and determined our well-being' (Schmidt 2002: 46).

12 According to historian Istvan Ihász, who oversaw the project development as
 an advisor, this car is actually Soviet party leader 'Nikita Khrushchev's elegant,
 armored ZIS car' (2002: 101; translation mine). Although Ihász acknowledges
 the value of this acquisition, he also remarks that 'this [car] cannot substitute
 the real Pobedas [the Soviet car manufacturer that provided the Hungarian
 secret police with its black vehicles], which kept everyone in fright' (ibid.).

13 I am using Jan Assmann's (1992) distinction between cultural and commu-
 nicative memory. 'Cultural memory' constitutes the 'solid foundation of
 society' that incorporates myth, tradition and historic narratives. 'Commu-
 nicative memory' on the other hand 'embraces memories of the recent past,
 memories that one shares with his or her contemporaries' (ibid.: 52; translation

mine). Communicative memory, for this reason is a more malleable form of reminiscence, which contemporary society can still influence and manipulate. The Hungarian cultural theorist, Sándor Radnóti (2003) also writes about the importance of communicative memory in the construction of the House of Terror. While Radnóti emphasizes that both regimes are still part of what Assmann coins as the 'communicative memory' phase, he does not explore how traces of this are displayed in the exhibition.

14 This is another reason why the House of Terror was seen as part of the Fidesz campaign in 2002. The implication that 'the perpetrators are still among us' could have hurt the popularity of the Hungarian Socialist Party (MSZP), as a number of its members were earlier part of the Hungarian Socialist Labour Party (MSZMP), which ruled in the one-party system until 1989. For this reason, the MSZP's opponents (including House of Terror General Director Mária Schmidt) often label the party 'post-communist'. By emphasizing the lineage between the MSZP and MSZMP, the right wing suggests that the perpetrators—those who were past party members—'are still among us' (i.e. within the MSZP).

15 In this building, there were no executions, only interrogations and fatal beatings.

16 I have experienced first-hand the challenge of this undifferentiated representation. The grandfather of my best friend from elementary school is both on the tableau of the ÁVO staff in the so-called Anteroom of the Hungarian Political Police and on the Wall of Perpetrators. Neither of these illustrations provides any information regarding his duties and responsibilities; his granddaughter may never learn the nature of her beloved grandfather's collaboration.

Works Cited

ASSMANN, Jan. 1992. *Das Kulturelle Gedächtnis: Schrift, Erinnerung und Politische Identität in Frühen Hochkulturen* (The Cultural Memory: Writing, Memory, and the Political Identity in the Early High Cultures). Munich: C. H. Beck.

IHÁSZ, István. 2002. 'Gomb és kabát. A profán valóság bemutatásának kísérlete a Terror Háza Múzeumban' (Button and Coat. The Experiment of Displaying Profane Reality in the House of Terror Museum) in János Pintér (ed.), *Történeti Muzeológiai Szemle. A Magyar Múzeumi Történész Társulat Évkönyve 2* (Historical Museology Review. The Annals of the Hungarian Museum Historians' Society 2). Budapest: Magyar Múzeumi Történész Társulat, pp. 97–105.

KARSAI, László. 2002. 'Az igazság bonyolultabb' (The Truth Is More Complicated). *nol.hu*, 6 March. Available at: http://nol.hu/archivum/archiv-49008 (last accessed on 18 June 2011).

KIRSHENBLATT-GIMBLETT, Barbara. 1991. 'Objects of Ethnography' in Ivan Karp and Steven Lavine (eds), *Exhibiting Cultures: The Poetics and Politics of Museum Display*. Washington, DC: Smithsonian Institution Press, pp. 386–443.

MINK, András. 2002. 'Alibi Terror: egy bemutatkozásra' (Alibi Terror: To an Introduction). *nol.hu*, 20 February. Available at: http://nol.hu/archivum/archiv-51660 (last accessed on 18 June 2011).

ORBÁN, Viktor. 2002. 'Ebben az épületben hatalmas erő van: A nemzet ereje' (There Is Big Power in This Building: The Power of the Nation). *Gondola.hu*, 24 February. Available at: http://gondola.hu/cikkek /4416Orban__Ebben_az_epuletben_hatalmas_ero_van__a_nemzet_ereje_.html (last accessed on 21 June 2011).

RADNÓTI, Sándor. 2003. 'Mi a Terror Háza?' (What Is the House of Terror?). *Élet és Irodalom* 47(4), 4 March. Available at: http://es.hu/radnoti_sandor;mi_a_terror-_haza;2003-01-28.html (last accessed on 18 June 2011).

RÉNYI, András. 2003. 'A retorika terrorja: A Terror Háza mint esztétikai probléma' (The Terror of Rhetorics: The House of Terror as an Aesthetic Problem). *Élet és Irodalom* 47(27), 4 July. Available at: http://www.es.hu/print.php?nid=4896 (last accessed on 4 April 2011).

RÉV, István. 2008. 'The Terror of the House' in Robin Ostow (ed.), *(Re)Visualizing National History: Museums and National Identities in Europe in the New Millennium*. Toronto: University of Toronto Press, pp. 47–90.

SCHMIDT, Mária. 2002. *House of Terror: Catalogue*. Budapest: The Public Foundation for the Research of Central and East European History and Society.

————. 2003. 'A Terror Háza első éve' (The First Year of House of Terror) in *Egyazon mércével: A visszaperelt történelem*. Budapest: Magyar Egyetemi Kiadó, pp. 176–207.

SERES, László. 2002. 'Andrássy út 60' (60 Andrássy Boulvard). *Élet és Irodalom* 46(6), 18 February. Available at: http://www.es.hu/seres_laszlo;andrassy_ut_60;2003-01-03.html (last accessed on 18 June 2011).

SZŐNYEI, Tamás. 2002. 'Épül a Terror Háza: Árnyékvilág' (The House of Terror: Shadow). *Magyar Narancs* 14(3), 24 January. Available at: http://www.mancs.hu/index.-php?gcPage=/public/hirek/hir.php&id=7089 (last accessed on 18 June 2011).

TERROR HÁZA. 2011. Official Flyers (undated). Budapest: The Public Foundation for the Research of Central and East European History and Society.

VARGA, László. 2002. 'A kommunizmus áldozatai' (The Victims of Communism). *Élet és Irodalom* 46(10), 8 March. Available at: http://es.hu/varga_laszlo;a_kommunizmus_aldozatai;2003-01-04.html (last accessed on 18 June 2011).

WILLIAMS, Paul. 2007. *Memorial Museums: The Global Rush to Commemorate Atrocities*. Oxford: Berg.

Identity Politics

Borderline Memory Disorder: Trieste and the Staging of Italian National Identity [1]

SUSANNE C. KNITTEL

The first time I visited Trieste, Italy, to research its Second World War history and memory was in the summer of 2007. Driving on the Autostrada 4 that leads from Venice to Trieste, I passed signs pointing visitors to all the major sites of the region: landmarks such as the Grotta Gigante, the world's largest tourist-accessible stalactite cave; the small coastal town of Duino with its steep cliffs that inspired the poet Rainer Maria Rilke; the romantic Miramare Castle built directly on the Gulf of Trieste; and of course the many attractions the city itself has to offer, from the ancient Roman ruins and the mediaeval castle to the splendid seafront and Piazza Unità d'Italia, lined with majestic buildings from the Habsburg era. But try as I might, I could not find any signs to the Risiera di San Sabba, a former Nazi-Fascist death camp that is now a memorial. I knew it was located in the industrial district in the city's south. But as soon as I left the Autostrada, my GPS stopped working and showed me nothing but an undifferentiated, green, no-man's land. It took numerous attempts to eventually reach my destination.

While most tourists come to see the crumbling splendour of the former Habsburg seaport, I had come looking for an altogether different Trieste, whose remnants spoke of Fascism, the Nazi occupation and the cold war. Two sites in particular had sparked my interest because they seemed to be competing with one another, not only for visitors but also for a definitive version of local (and ultimately national) history. One of these sites was the Risiera di San Sabba, where thousands of Slovenes, Croats, Jews and Italian anti-Fascists were imprisoned, killed or interned pending deportation between 1943 and 1945. The Risiera was declared a national monument in 1965 and the memorial in its present form, designed by Triestine architect Romano Boico, was inaugurated in 1975. It receives approximately 100,000 visitors a year, primarily Italians, 50–60 per cent of whom are school groups, between 12 and 18 years old. The

remaining comprise groups of adults (seniors, parish groups etc.), families and individual visitors, including a few foreign visitors. Most of the school groups come on a four- or five-day trip accompanied by several teachers, stay in Trieste and visit other historical sites as well. The locals come to the Risiera mainly on 25 April, Liberation Day, to commemorate the end of the Second World War, and on 27 January, International Holocaust Remembrance Day, which in Italy is known as 'Giorno della memoria', to commemorate the Holocaust, but also the deportation of political and military prisoners to Nazi concentration camps.[2] Of the sites that narrate Trieste's younger history, the Risiera was for the longest time the site that received the most visitors.

Over the past two decades and especially since 2007 this has changed, for another memorial in the immediate vicinity has been attracting tens of thousands of visitors every year. Just a few kilometres away from the Risiera is the Foiba di Basovizza, the main memorial to commemorate a series of mass killings carried out by Yugoslav partisans in 1943 and 1945. The bodies of the victims, including Italian civilians, were disposed of in deep, cavernous pits, called *foibe*, in the mountains of the region.[3] Situated on the karst plateau towards the east of Trieste, the Foiba di Basovizza was declared a national monument in 1992 and underwent a significant artistic and architectural overhaul in 2006–07. Since then it has been attracting tens of thousands of visitors every year: in May 2011, *Il Piccolo* reported that 254,000 people had visited the Foiba di Basovizza since the documentation centre opened in February 2008, with over 51,000 visitors in the first four months of 2011—roughly twice as many as in 2008 (Tonero 2011). The vast majority of visitors to the site are school groups: 3,737 on one day in April 2012—a record, but not an anomaly. Well over 12,000 students visited the site in that month alone (Dorigo 2012). Like the Risiera, Basovizza receives mostly Italian visitors and the same school groups that visit the Risiera also go to Basovizza, often on the same day. However, the opposite does not seem to be the case, as the Foiba now receives more visitors annually than the Risiera: evidently, not everyone who visits the Foiba also goes to the Risiera.

The Foiba di Basovizza has also been the main site to host the Giorno del ricordo, a recently introduced national memorial day that takes place only two weeks after the Giorno della memoria, on 10 February, and that commemorates the *foibe* killings and the mass emigration, prompted by the intimidations of the Yugoslav government, of 200,000 to 350,000 Italians from Istria and Dalmatia in the decade after 1945. The chronological proximity of the Giorno della

memoria (27 January) and the Giorno del ricordo (10 February) as well as the fact that they have similar names may seem confusing, and in fact there is reason to assume that this resemblance is quite deliberate. Modelled after the international Giorno della memoria, the Giorno del ricordo is a home-grown, specifically Italian day of remembrance, which presents the Italians who died in the *foibe* as victims of genocide: following Silvio Berlusconi's electoral victory in 1994 a campaign grew to establish the *foibe* as the 'Italian Holocaust', an act of genocide perpetrated against Italians, which had been suppressed by the Italian Left. This narrative of Italian victimhood blots out the historical events that preceded these killings, namely the persecution of Slovenes and Croats under Italian Fascism and the atrocities committed during the Italian occupation of Yugoslavia. Furthermore, the narrative presented plays down the fact that Italian partisans as well as German troops used the *foibe* to dispose of enemies and that the remains of German soldiers were also found there (Cogoy 2007: 17–18). The renovated Basovizza memorial and the Giorno del ricordo are the result of a continuous effort, on the part of Berlusconi's centre-right government, to create a new national site of memory (see Ballinger 2000). Formerly a memory upheld mainly by members of the extreme right, the *foibe* killings and the 'exodus' have moved from the margins to the very centre of Italian cultural memory in the space of just a few years. All appearances to the contrary, the geographical and temporal proximity of these two commemorative projects is not historically organic but rather motivated entirely by memory and political concerns and the conscious attempt to shift the framework of national memory towards a specifically Italian narrative of innocence and victimhood.

In what follows, I will examine in more detail the conceptions of local and national history, memory and identity that these two sites reveal. By analysing the documentary exhibition at each site, I show how each memorial is primarily concerned with presenting a specific, unified memory of the Second World War and its immediate aftermath. They present two perspectives of the region's memory that, although not mutually exclusive, nevertheless continually seek to undermine each other's relevance in the public sphere. As a consequence, both narratives serve to marginalize not only the memories of other groups in this multi-ethnic border region but also the broader context of the Fascist politics of Italianization prior to and during German occupation as well as tensions during the cold war. As anthropologist Pamela Ballinger writes, 'the ritual performances of identity in Trieste enacted at the Risiera and *foibe* sites make a claim for suffering and victimhood as exclusive' (2004: 146).

Visiting the Risiera di San Sabba

The Risiera, which, as the name suggests, was originally a rice-husking factory, is a complex of several brick buildings nestled amidst a disorienting labyrinth of intersecting city highways, construction sites, large factory buildings and the nearby soccer stadium. Once the heart of Trieste's booming industry, the San Sabba district now reveals the city's steady decline since the fall of the Habsburg Empire, the neglect and mismanagement during the inter-war years and under Fascism, and the post-war insecurity about the city belonging to Italy or to Yugoslavia, all of which led to its slow economic marginalization.

The entrance is a long and narrow passageway framed by tall concrete walls. At the end of this imposing corridor, visitors step through an archway into a larger walled-in courtyard framed by similar concrete walls on the north and west sides and by three of the Risiera's original buildings on the south and east sides. The only colours are grey and brick-red; the glassless windows are gaping holes. At the far end of the open space, a tall needle-like sculpture made up of black iron girders pierces the sky. On the ground is a rectangular inden-tation paved with dimly reflecting metal plates, and a long narrow path (also paved in metal) leads straight up to the iron sculpture. This metal imprint out-lines the crematorium, the smoke channel and the base of the chimney, which the Nazis dynamited before abandoning the site at the end of April 1945. On the spot where the chimney stood, black smoke, symbolized by the wrought iron of the sculpture, rises eternally into the sky. The outline of the crematorium is still visible on the front of the main building—a pale, ghostly silhouette that stands out against the red-brick wall. Between 1943 and 1945, the Nazis killed and cremated between 3,000 and 5,000 people here. In what looks like a door in the wall is a white stone slab with the inscription 'ashes of the victims' in four languages: Italian, Slovene, Croat and Hebrew. Behind the stone is an urn containing ashes and bone remains found in 1945 among the rubble of the blasted crematorium. Apart from the iron sculpture and the metal imprint, the courtyard is empty, which reinforces the austerity of the place (figure 27).

Of the complex that the Nazis used as a concentration, work, transit and killing camp, only a fraction remains: a small building with 17 prison cells, in which partisans and political prisoners destined for torture and execution were held; a large building that temporarily housed the deportees (more than 20,000 Jews and Italian and Yugoslav partisans passed through the Risiera on their way to the camps in Poland or Germany); the main building, containing the

FIGURE 27. The courtyard of the Risiera di San Sabba memorial. The steel sculpture (*La Pietà P.N. 30*) symbolizes the smoke from the crematorium. Photograph courtesy of Kári Driscoll, 2010.

kitchen, barracks and offices of the SS and the guards; as well as the former garage. The main building houses a small museum with drawings, letters and objects found in the rubble of the camp. The former garage contains a documentary exhibition that tells the history of the site.

Created by the Triestine historian Elio Apih in 1982, and revised and expanded in 1998, this exhibition consists of 50 panels that offer a rough sketch of the historical context of the Risiera, the rise of Fascism and Nazism, the Holocaust, the German occupation and the Resistance. This history is narrated by means of a large number of archival documents (photocopies of maps, photographs, newspaper clippings, letters, tables, lists and so on) with very brief explanatory texts in six languages (Italian, Slovene, Croat, English, German and French). The Fascist regime is presented as oppressive but ultimately somewhat inept or inconsistent: it ruined Trieste's economy and was unable to solve the minority 'question' in the region. Anti-Semitism was imported wholesale from Germany (Apih 2000: 80). Unlike Fascism, the exhibition suggests, Nazism was a mass movement based on a broad popular consensus in Germany, and

an efficient and merciless machinery of death that spread all over Europe and in the end also over Venezia Giulia. Much space is dedicated to the photographs of the Nazi perpetrators and their crimes. Just as much space is reserved for the Resistance, which was well organized in the region. But no mention is made of Triestine collaboration or involvement with the Nazis.

Apih's account specifically emphasizes the role of the pro-Italian, anti-Fascist Resistance (Comitato di Liberazione Nazionale or CLN), which acted independently of the Communist, pro-Yugoslav Resistance in the liberation of Trieste. Most historical accounts credit the Yugoslav army for liberating Trieste (Fogar 1988: 91; Pupo 2005: 87–98), but Apih suggests that it was in fact the CLN-led uprising against the Nazis on 30 April that did it, neglecting to mention that the Yugoslav army had already reached the outskirts of the city (see Apih 2000). By emphasizing the role of the CLN in the city's liberation, a hierarchy is established that posits the CLN as the 'authentic' liberation force and thus implicitly justifies why Trieste should indeed be under Italian and not Yugoslavian rule (Sluga 1996: 404–05). Both the documentary exhibition and the post-war history of the Risiera establish a narrative of Italian sovereignty not only over the city but also over the memory of the war and the German occupation.

The documentary exhibition does not explain what exactly happened at the Risiera in the 18 months of its operation, who the victims were or where they came from. Only one panel explains the different functions of the Risiera, but nowhere does it say how many were killed or how exactly the killings were carried out (Apih 2000: 120). A photograph of an iron-tipped mace found in the rubble, a copy of a list of names from a Slovene newspaper and a photograph of the arrest of one of the Risiera perpetrators, SS-Obersturmführer Franz Stangl in Brazil, are presented on another panel as evidence of the events at San Sabba (ibid.: 126). Nowhere is there a precise account of these events. The crematorium, one learns, was ordered from an unnamed company in Trieste, which, it is emphasized, was not aware of the purpose of the oven. But who helped the Nazis run the camp? Who helped them administrate the entire region? Who translated for them? Who identified the Jews and partisans for them? None of these questions are answered or even raised. There is also no information about the post-war history of the site. What has been done to preserve the Risiera? How did it become a memorial? Visitors learn nothing about the struggle for memorialization in the aftermath of the war. For an answer to these and other questions, one must turn to the historiography concerning the Risiera, Trieste and its surrounding region.

The Risiera in the Past

The Risiera memorial itself does not have a library or a bookshop where one could find materials for further reading. Besides the local libraries, the best place to get more information about the Risiera and its history is the Istituto Regionale per la Storia del Movimento di Liberazione nel Friuli Venezia Giulia (Regional Institute for the History of the Liberation Movement in Friuli-Venezia Giulia), which has its main office in the city centre. Reading the more recent historiographical publications on the Risiera, one learns that a large number of Triestines, including so-called *Volksdeutsche* (ethnic Germans living outside the Reich) but also Italians, Slovenes and Croats, worked for the Nazis as interpreters, drivers, informants, secretaries, telephone operators and administrators. The industrial elite in Trieste did not hesitate to collaborate with the Germans, keen on gaining access to new markets. The press were quick to issue praise and publish propaganda. Many of the local Fascists who had been the leading agents of the persecution of Slovenes and Croats saw the solution to the 'Slav' question as the most valid reason to collaborate with the Nazis. Alongside this more explicit collaborationism, there was also the tacit consensus among the bourgeoisie in particular, and the public in general, that the Germans would guarantee their safety from the Yugoslav threat (Fogar 1988: 54).

The Risiera was established in October 1943 and was used as a barracks, a prison and extermination camp for partisans, political prisoners and Jews, a labour camp, a transit camp for deportees to Poland or Germany and a depot for seized goods. Some 22 deportation convoys left Trieste between October 1943 and November 1944. Almost all the Jews still living in Venezia Giulia were deported, with more than 1,200 from Trieste alone (see Bon Gherardi 1972: 221; Picciotto Fargion 1991: 55–60). The majority of those killed directly at the Risiera were Yugoslav partisans and civilians suspected of collaboration with the partisans.[4] Ultimately, it proved impossible to keep the events at the Risiera a secret. Situated in the busy industrial area with factories, refineries, repositories and working-class housing, it was well within city limits and thus the news of the goings-on at the Risiera gradually spread (Fogar 1988: 87).

The Allied military government, which administrated the city from 1945 to 1954, showed no interest in investigating the crimes of the Risiera; instead it pursued a politics of normalization, which was extremely lenient towards ex-Nazis and Fascists, and focused on preventing the spread of Communism to the Italian peninsula. Until 1965, the Risiera had been considered almost exclusively a site of memory for the Communists and the Left. This changed

on 15 April 1965 when Italian president Giuseppe Saragat officially declared it a national monument. According to the president's decree (n. 510), a copy of which is exhibited in the Risiera museum, the site was to be preserved because of its status as 'the only example of a Nazi Lager in Italy' (Civici Musei di Storia ed Arte 2003: 8, translation mine; Galluccio 2002: 136–54).[5] This formulation ignores the fact that several Nazi concentration camps existed in Italy between 1943 and 1945 (such as the one in Bolzano-Gries) as well as more than 40 other concentration camps were established much earlier by the Fascists and then taken over by the Nazis (such as Fossoli near Carpi or Arbe in Istria). In erroneously insisting on the Risiera's uniqueness, the law tacitly affirms the commonly held notion that the persecution of Italian Jews and anti-Fascists was carried out exclusively by the Nazis, and that the Risiera needs to be preserved as a memorial to the victimhood of the Italian people. It further seems to suggest that Fascist concentration camps are not worth preserving. In fact, to my knowledge, not a single Fascist concentration camp site has received national monument status.

When the Risiera memorial was inaugurated on 24 April 1975, a day before the 30th anniversary of the liberation of Italy, the public was invited by *Il Piccolo*, the major Triestine newspaper, to 'undertake pilgrimages to the Risiera in order to pay homage to the martyrdom of the victims of Nazism that took place here in one of the darkest times in the history of this region' (in Viola 1998: 37; translation mine). And indeed, architect Romano Boico's memorial design presented the Risiera as a shrine. His concept rested on the transformative power of the authentic structures of confinement, torture and mass murder and on the placement of the recovered ashes as a sacred relic at the heart of the space. The most important aspect of his design was the complete 'silence' in the memorial: not a single explanatory sign was to be placed. The architectural space and the authentic structures were to speak entirely for themselves. The Risiera was to be understood as a mass grave, a site of supreme sacrifice and of mourning. This narrative of sacrifice was taken up by the press and by the speakers on the day of the memorial's inauguration. The mayor of Trieste, Marcello Spaccini, declared: 'This place is sacred. [...] Here, thousands of men gave their lives to safeguard the universal values of mankind' (in Mucci 1999: 23; translation mine). Italian president Giovanni Leone similarly emphasized that these victims were the founding fathers of the Italian Republic, which was born of their sacrifice. These speeches excluded all non-partisan victims of the Risiera in favour of a narrative of national sacrifice and redemption. The

differences between racial and political persecution were erased; it was suggested that the murders in the Risiera, including the murder of the Jews, served some greater purpose, namely, the liberation of Italy from the Nazi occupier. The fact that women and children were also among the Risiera's victims was completely ignored. Furthermore, the role played by Communist partisans was suppressed. The architectural conception of the Risiera as a shrine lends itself to such readings of the dead as fallen soldiers, whose glorification as war heroes is reminiscent of First World War memorials, as well as martyrs, whose remains become sacred relics. Re-conceived as a de-politicized, secular site of mourning, the Risiera no longer belonged to the Communists. However, the lack of historical context and specificity left the site open to re-politicization by the Italian Resistance who appropriated it for their narrative of anti-Communist and anti-Fascist liberation.

The Risiera Today

After its completion, the Risiera memorial was incorporated into the administrative system of the Musei Civici of the City of Trieste. This meant not only that the Risiera was one among many museums the city had to administrate and finance but also that it did not have a dedicated curator. In 1986, historian Galliano Fogar wrote a polemical article in the local history journal *Qualestoria* in which he raised two main complaints, both of which had to do with the fact that the memorial was severely underfunded. As the Risiera was conceived as a site of mourning and a tomb, no entrance fees were charged. Thus, income was relatively limited and the Risiera depended on funds from the city, the region and the state and on donations. Besides criticizing the lack of funding for the training of tour guides, Fogar addressed structural problems at the Risiera itself: the small conference room that could not accommodate groups of visitors or scholars, the absence of a heating system at the Risiera to make the offices and the small meeting room usable in the winter, and the fact that there was no efficient way of distributing and re-printing the exhibition catalogue and booklet (1986: 106–7). The Risiera, Fogar claimed, was leading a marginal existence in Trieste, not only geographically but also administratively and culturally, all of which fundamentally prevented it from fulfilling its educative role as a memorial. The Risiera, he continued, was more or less entirely ignored by the local population (ibid.: 108).

What has changed in the years since Fogar published his critique? The site is still in need of funding, a heating system and even an adequate meeting

facility to accommodate the ever-increasing number of visitors. The memorial space was opened to cultural events to encourage Triestines to come to the Risiera. Art and documentary exhibitions were displayed and musical or theatrical performances were organized, such as the opera *Brundibár*, composed by the Bohemian musician Hans Krása, who was killed in Auschwitz, and a scenic reading of *I me ciamava per nome: 44.787*, a play about the Risiera and the deportation of Italian Jews, based on historical materials and testimonies, written and produced by Triestine director Renato Sarti.[6] In addition, a few general improvements were made in the mid-1990s. Explanatory signs were put up in each of the buildings. A multilingual exhibition catalogue and booklet to accompany the exhibition, which gives historical context as well as basic explanations of the memorial complex, and an educational film, which is available in multiple languages and can be screened upon request, were produced. (When I visited the Risiera in 2010, both the catalogue and the booklet were out of print.) During the late 1990s, the number of visitors reached a new high of 50,000 a year. A firm selling household goods caused a scandal in 1994, when it organized group excursions to the Risiera to promote its linens (Matta 2000: 516–17). Despite these efforts at updating and improving the site, the local population still considered the Risiera ultimately extraneous to the city's everyday life. In May 2004, the moderate daily *Trieste Oggi* published a survey it had conducted among Triestine high-school children, asking them about the Risiera memorial and museum. Only 5 per cent had visited the memorial and most of the children did not even know what the Risiera was (Viola 1998: 142).

While most of the locals still seem to prefer to forget about the Risiera, the number of visitors from all over Italy has doubled over the past decade. In an interview I conducted on my visit to the Risiera in 2010, Francesco Fait, one of the Risiera's historians, explained that in the months of April and May the memorial provides free guided tours for school classes (during the other months a tour costs €2.70 per student), as a result of which most of the groups come in these two months and the guides at the Risiera have great difficulty accommodating all of them.[7] The Italian-language tours with the Risiera's historians take an hour—not enough time to discuss the historical background at length or to go through the long documentary exhibition, which has remained unchanged since the 1998 update.

The multilingual documentary film is shown upon request, but neither do many classes have enough time for the 26-minute screening nor is there enough space to seat more than 20 people in front of the TV screens. Directed by

Gianfranco Rados and Piero Pieri (1994) and awarded a national prize for video productions, the making of *La Risiera di San Sabba* was advised by local historians Elio Apih, Marco Coslovich and Giampaolo Valdevit. Along the lines of the documentary exhibition, the film focuses on the Nazi persecution of the Jews and gives minimal explanation of the historical background of Nazism and anti-Semitism, and basically no information on Italian Fascism and the pre-1943 history of the region. The film spends some time explaining the rise of Nazism in Germany and then shifts focus to Italy and Trieste, which was, the narrator explains, 'an environment more amenable' to the ideology of the Nazis than elsewhere. The viewers get a brief explanation of the Fascist racial laws and see photographs of the destruction of the Triestine synagogue in 1941. Three Risiera survivors tell their stories and describe the atrocious conditions during their imprisonment. The film ends with a brief overview of post-war efforts to prosecute some of the Risiera perpetrators and with a warning about the slow and 'uncertain march towards democracy. To be aware of this is therefore the real basis from which to look to a future of greater and more solid democratization.'

No connection is made in the film between the crimes of the past and problems in today's society. It remains unclear what relevance the events at the Risiera might have in our lives today. The post-war history of the Risiera is entirely left out, as is a reflection on the difficulties connected to the Risiera's memory. This lack of self-reflection is also a problem of the memorial itself. The site is successful in eliciting an empathetic response in visitors, but in-depth pedagogical work does not seem to have a place there. Without a guide or a teacher to prepare visitors and who knows how to connect the past and the present, the Risiera's relevance today is lost on most visitors to the site.

The Foiba di Basovizza

Visiting the Foiba di Basovizza is completely different from visiting the Risiera, mainly because there are no authentic structures, nothing that has remained and that could help establish a connection to the past. The site is integrated into the scenic landscape of hills, bushes and trees, five minutes outside the city by car. Unlike most of the other *foibe*, which are natural sinkholes created by water erosion, the one at Basovizza is actually the shaft of an abandoned coal mine, more than 250 metres deep, excavated between 1901 and 1908. Thus, 'Foiba di Basovizza' is in fact a misnomer and historians prefer to use the term *pozzo* (pit, well or mine shaft). In the northwestern corner is a small low-roofed stone

building which houses the documentation centre and from which extends a long line of stone or marble commemorative markers and plaques in different shapes and sizes that include names or prayers and were erected over the years by various interest groups or families. At the centre of the site is the mineshaft, covered by a large concrete block sheathed in metal, and behind it a looming black steel structure topped with a cross. The steel sculpture is meant to echo the crane structures that were used for the exploration of the *foibe*, and it lends an eerie sense of threat to the otherwise unimposing site. In the background is a large stone slab bearing a prayer for the victims (figure 28). Like the Risiera, the Foiba di Basovizza is conceived of as a shrine to the victims who, in both cases, are referred to as martyrs. Whereas the Risiera was to be a 'secular basilica' (Mucci 1999: 49), the cross and prayer at Basovizza inscribe it within a distinctly Christian framework. Nevertheless, the most striking feature of this site, with all its markers and stone slabs, is that it is effectively structured round an absence: the invisible mineshaft.[8]

The brand new documentation centre has a small documentary exhibition, site maps, a few art objects and a small but varied selection of books and other

FIGURE 28. The Foiba di Basovizza memorial. The sculpture by Livio Schiozzi looms over the covered mineshaft. Photograph courtesy of Kári Driscoll, 2010.

information materials for visitors to leaf through or buy. Like the Risiera, the site is free to visit but for a small fee visitors can receive a guided tour. The documentation centre is the only building on the site; there are no facilities for research, workshops, meetings or conferences. Like the Risiera, the documentary exhibition here consists mainly of reproductions of photographs and archival documents with explanations in Italian (international visitors can buy a multi-lingual exhibition catalogue that reproduces each panel with translations). The narrative begins in 1945, with the last days of the war, when Basovizza was at the centre of the combat between the Yugoslav liberation army and the Germans retreating from Trieste (Parlato et al. 2008: 11). After the end of the battle, the locals cleaned up the bodies, horse carcasses and munitions by throwing every-thing into the shaft. What remains unsaid is that, as various historical records and testimonies indicate, the mineshaft was used for the disposal of all kinds of refuse and to dispose of the bodies of political adversaries by the Fascists and the Nazis prior to the 1940s (Cernigoi 2005: 165–6). What exactly happened during the brief Yugoslav occupation of Trieste and its surroundings remains unclear. The exhibition cites a number of newspaper reports to support a claim that, besides German and Italian soldiers, hundreds of civilians were executed at the site in early May and their bodies disposed of in the mineshaft. In the months after the end of the war, the Allied and Italian information services made several attempts to exhume and count the bodies, and collect information about the executions, but to no avail. The actual number of victims is still unknown. Large reproductions of photographs of corpses and coffins serve to illustrate the exhumation attempts, but, upon a closer look at the captions, they all turn out to be victims from other *foibe* and not from the mineshaft at Basovizza. The acts of violence carried out by the Yugoslavs are described as characteristic of a 'pre-modern' type of violence: burning down of buildings and villages, lynching, rapes and *infoibamenti*.

The end of the war is narrated in strikingly similar terms as at the Risiera: isolated from the CLN in the rest of northern Italy and unable to unite with the Communist partisans because of their pro-Yugoslav stance, the Triestine CLN decided to free the city without help and thus be able to claim it for Italy. They occupied the city's major public buildings, including the town hall, but had to give way to the Yugoslavs the next day. This emphasis on the role of the CLN is an important point of intersection between the exhibitions at Basovizza and at the Risiera. The narratives at both sites depend on a de-legitimization of the Yugoslav liberation movement: at Basovizza in order to cast the Yugoslavs

as cruel occupiers, and at the Risiera in order to keep up the narrative of heroic sacrifice that gives birth to the new Italy. At Basovizza, a long description of the deportations and executions that occurred during the 40 days of Yugoslav rule in Trieste portrays the Yugoslav army on par with the Nazis: a process of violent purging began, during which all those who were 'enemies of the people'—tens of thousands of Italians—were killed or deported on 'death marches' to the 'concentration camps' near Ljubljana.[9]

The discourse on the *foibe* revolves almost exclusively round the number of victims because on it depends not only the historical relevance of the killings (and hence their status as the 'Italian Holocaust') but also the degree of attention in the media and the public. Scholarship by historians such as Jože Pirjevec (2009) and Nevenka Troha (1997) as well as the journalist Claudia Cernigoi (2005) has cast doubt on the number of victims reported at Basovizza and questioned whether the Foiba di Basovizza was ever the site of mass executions. In *Operazione 'Foibe' tra storia e mito* (2005), Cernigoi calls into question whether the Foiba di Basovizza was ever the site of mass executions. Quoting extensively from newspaper articles and reports published between 1945 and 1995, she illustrates how the number of victims reported has grown exponentially from 18 to more than 3,000, even though the shaft has never been completely excavated (ibid.: 190; see also Pirjevec 2009: 110–24, 131, 285–91, 309–15). The doubts and insecurities about the victims of Basovizza raise questions about the memorial: Why choose a site that is after all not an actual *foiba* as the central site of commemoration of all the *foibe* killings? The memorial at Basovizza is a site of constructed memory created round a mineshaft that may in fact not contain any bodies at all. It seems as if its proximity to Trieste was a determining factor in the decision, since the documentary exhibition makes explicit reference to the Risiera in its last panel. On this panel, which zooms out of the narrow historical focus of the years between 1943 and 1945 to provide the larger historical context, the history of the region before the Second World War is described as one of repeated occupation and constant battle between the Italians and the Slovenes and Croats in the region, followed by the violent Nazi occupation, of which the Risiera is the most prominent example: 'After the armistice on September 8, 1943 and the first persecutions against Italians in Istria, the German occupation of Venezia Giulia led to the Risiera di San Sabba' (Parlato et al. 2008: 65). Putting the 'persecutions' of the Italians side by side with the Risiera, the narrative presents these two different events as two sides of the same coin. In this sweeping overview, the region becomes a 'laboratory' of twentieth-century history,

[of] complex national and social conflicts; mass warfare; unforeseen effects of the dissolution of multinational empires; the rise of anti-democratic regimes intent on imposing their totalitarian demands on a deeply divided local society; the unleashing of racial persecutions and the creation of the 'universe of the concentration camp'; deportations that irreversibly changed the national make-up of the region; religious persecution in the name of state atheism; East–West conflicts along one of the fronts of the Cold War. A synthesis, in short, of the great tragedies of the past century (ibid.).

On the surface, all of these statements are indisputable. But what emerges from them is a narrative of an Italian population that has had to endure a series of occupations by external forces, including—depending on how one interprets the phrase 'anti-democratic regimes'—the Fascists themselves. The litany of twentieth-century tragedies—two world wars, the dissolution of the Habsburg Empire, the rise of totalitarianism, the Holocaust, the Istrian exodus, Communism and the Cold War—which have befallen the region and into which the *foibe* are inscribed implicitly places them all on the same level. And it is here that the ever-growing number of victims buried in the *foibe* begins to assert itself. The numbers must rival those of other tragedies, particularly, of course, those of the Risiera, Basovizza's direct competitor. How many died in the *foibe* may never be known. In fact, this does not appear to be a priority at Basovizza. Beyond the possible danger of unexploded ordinance among the detritus, concerns may arise that a real archaeological excavation of these sites would confirm the low estimates that some historians have put forward. In any case, Basovizza is not so much about the past as about the present. At a deeper level, the grand historical sweep of the exhibition's final panel paints a picture of Trieste as the staging ground of Italian national identity, a process in which the memorial itself plays an active part.

Each of these two memorials is primarily concerned with presenting a particular version of the events during and after the Second World War that blots out or ignores the one presented at the competing memorial as well as the memories of various other groups in the region. Instead of cooperating to provide a more comprehensive picture of the region's history, they each treat their narrative as definitive. This competition is especially problematic in light of the fact that both sites marginalize the broader context for the events they commemorate. Both leave out the history of Fascism. Following the collapse of the Habsburg Empire, growing preoccupations about the political and cultural

heterogeneity of this border region resulted in the eager embrace of Fascism. The Triestine *fascio* was among the first to be founded, only a few days after the one in Milan in April 1919. The Fascist government enacted a brutal policy of enforced Italianization and began campaigns designed to claim Yugoslavian territory for Italian *spazio vitale* (vital space). The Basovizza centre glosses over the fact that the *foibe* can also be seen as retaliation acts for the hundreds of thousands of Yugoslav civilians killed by the Italian occupying forces between 1941 and 1943 (Mantelli 2000; Del Boca 2005). The recent wave of interest in the *foibe*, spurred by the centre-right government, must be seen in relation to the ongoing rehabilitation of Fascism and its memory in Italy (Mattioli 2010). Ultimately, Italy never had to come to terms with its Fascist past because it could fall back on the Resistance as a founding myth for the new Republic, a narrative that still governs the presentation of Italian history at the Risiera. More recently, the image of the Italians as fundamentally *brava gente* (good people) who could never have been involved in persecutions and war crimes has come to include the Fascists as well: in comparison to the Nazis and the Yugoslavs, the Fascists were the lesser evil (Ben-Ghiat 2004).

At the same time, memory tourism, or rather educational memory tourism associated with the Second World War, is growing in Italy as evinced by the increasing visitor numbers at these two memorials. If these developments are representative of a broader trend in society, then they indicate that Italians are beginning to express more interest in their recent history. However, the version of history presented to tourists is incomplete at best and by no means challenges received notions of identity and heritage. The growing interest in the *foibe* and the increasing number of visitors that Basovizza receives annually are indicative of a broader shift in public attitudes towards Italian history and identity, which seems to be linked to political developments over the past two decades. The Risiera remains tied to the leftist glorification of the anti-Fascist Resistance, which is on the verge of being superseded by the predominantly right-wing anti-Communist *foibe* narrative. Both of these ideologically motivated accounts of Italy's role in the Second World War and its aftermath are inherently auto-exculpatory in nature. The ongoing competition between the two versions of Italian history embodied by these sites ultimately serves only to divert attention away from the crimes of Fascism. Until sites such as the Risiera di San Sabba and the Foiba di Basovizza begin to present a more nuanced and multifaceted version of Italian history, visiting these locations will remain an escapist fantasy rather than an opportunity for a critical engagement with the past.

Notes

1 Some sections of this article are based on Chapter 4 of my PhD thesis 'Uncanny Homelands: Disability, Race and the Politics of Memory' (Columbia University, 2011). Relevant details have been updated to reflect the latest information available.

2 For an extensive analysis of the origins of Giorno della memoria, the law that inaugurated it and media coverage of the event in 2001, see Robert S. C. Gordon (2006).

3 The word *foiba* (pl. *foibe*) was originally a term used only by geologists to describe deep natural sinkholes formed by water erosion. In 1943, the fascist press popularized the term in reference to these killings, which have been known since then collectively as *le foibe*. Whereas historical sources estimate the number of victims to be between 1,500 and 2,000, the numbers circulating in public discourse range between 10,000 and 30,000 (see Verginella 2007: 56–7).

4 Most accounts estimate the number of victims killed at the Risiera between 3,000 and 5,000 and the number of deportees between 10,000 and 20,000 (see Fölkel and Sessi 2001: 46).

5 The precise wording is 'unico esempio di Lager nazista in Italia', an ambiguous formulation because of the lack of a definite article: it would be possible to read it as 'a unique example' rather than 'the only example'. The Risiera was certainly a unique example, but it was not the only example of a Nazi lager in Italy.

6 Renato Sarti's play, staged on the occasion of the 50th anniversary of Italy's liberation in July 1995, was a great success and seen by more than 4,000 people. Consisting of testimonials and historical and documentary materials in Italian, Slovene, Croat and Hebrew, it presents not only a comprehensive introduction to the crimes of Fascism and Nazism in the region but also the personal stories of several of the Risiera's victims. The play has since toured through Italy's major cities and is mainly performed in schools.

7 The Risiera guides trained in the history of the site, Francesco Fait told me, are not the only guides who give tours in the memorial. Often, schoolteachers lead the classes by themselves or tourist guides include the Risiera as one stop on their list of cultural and historical sites. The problems with such guides, Fait explained, are that they are not necessarily able to present a nuanced picture of the events at the Risiera and are often not in a position to answer detailed questions (personal interview, 25 May 2010).

8 Several critics have used the image of a 'black hole' to describe the *foibe* and their history and memory, and argue that it is precisely this characteristic that continues to exert such a powerful hold over the people's imagination

because it invites them to fill this absence with meanings and associations of their own (see Ballinger 2003; Accati and Cogoy 2007).

9 The use of terms familiar from the discourse on the Holocaust is deliberate here, since the site aims to inscribe the *foibe* into the larger narrative of the genocidal persecutions of the twentieth century (see Parlato et al. 2008: 44–51).

Works Cited

ACCATI, Luisa, and Renate Cogoy (eds). 2007. *Das Unheimliche in der Geschichte. Die Foibe* (The Historical Uncanny: The Foibe). Berlin: Trafo.

APIH, Elio (ed.). 2000. *Risiera di San Sabba: Guida alla mostra storica* (Risiera di San Sabba: Guide to the Historical Exhibition). Trieste: Comune di Trieste.

BALLINGER, Pamela. 2000. 'Who Defines and Remembers Genocide after the Cold War? Contested Memories of Partisan Massacre in Venezia Giulia in 1943–1945'. *Journal of Genocide Research* 2(1): 11–30.

———. 2003 *History in Exile: Memory and Identity at the Borders of the Balkans.* Princeton: Princeton University Press.

———. 2004. 'Exhumed Histories: Trieste and the Politics of (Exclusive) Victimhood'. *Journal of Balkan and Near Eastern Studies* 6(2): 145–59.

BEN-GHIAT, Ruth. 2004. 'A Lesser Evil? Italian Fascism in/and the Totalitarian Equation' in Helmut Dubiel and Gabriel G. H. Motzkin (eds), *The Lesser Evil: Moral Approaches to Genocide Practices.* London: Routledge, pp. 137–53.

BON GHERARDI, Silva. 1972. *La persecuzione antiebraica a Trieste (1938–1945)* (The Persecution of the Jews in Trieste [1938–1945]). Udine: Del Bianco.

CERNIGOI, Claudia. 2005. *Operazione 'Foibe' tra storia e mito* (Operation 'Foibe' between History and Myth). Udine: Kappa.

CIVICI MUSEI DI STORIA ED ARTE. 2003. *Risiera di San Sabba: Monumento Nazionale* (Risiera di San Sabba: National Monument). Trieste: Stella Arti Grafiche.

COGOY, Renate. 2007. 'Einführung' (Introduction) in Luisa Accati and Renate Cogoy (eds), *Das Unheimliche in der Geschichte. Die Foibe* (The Historical Uncanny: The Foibe). Berlin: Trafo, pp. 9–24.

DEL BOCA, Angelo. 2005. *Italiani, brava gente? Un mito duro a morire* (Italians, Good People? A Myth That Refuses to Die). Vicenza: Pozza.

DORIGO, Fabio. 2012. 'Boom delle gite scolastiche: Alla Foiba 12mila studenti' (School Trips Are Booming: 12,000 Students at the Foiba). *Il Piccolo*, 20 April, p. 26.

FOGAR, Galliano. 1986. 'La Risierasepolcro. Breve storia di un lungo abbandono' (The Risiera Tomb: A Brief History of Long Neglect). *Qualestoria* 14(3): 106–12.

————. 1988. 'L'occupazione nazista del Litorale Adriatico e lo sterminio della Risiera' (The Nazi Occupation of the Adriatic Coast and the Extermination at the Risiera) in Adolfo Scalpelli (ed.), *San Sabba: Istruttoria e processo per il Lager della Risiera* (San Sabba: The Investigation and Trial of the Risiera Camp). Milan: Associazione nazionale ex deportati politici nei campi nazisti, pp. 3–138.

FÖLKEL, Ferruccio, and Frediano Sessi. 2001. *La Risiera di San Sabba.* Milan: Rizzoli.

GALLUCCIO, Fabio. 2002. *I lager in Italia: La memoria sepolta nei duecento luoghi di deportazione fascisti* (The Camps in Italy: The Memory Buried at the Two Hundred Fascist Deportation Sites). Civezzano: Nonluoghi.

GORDON, Robert. S. C. 2006. 'The Holocaust in Italian Collective Memory: Il "Giorno della memoria", 27 January 2001'. *Modern Italy* 11(2): 167–88.

MANTELLI, Brunello. 2000. 'Die Italiener auf dem Balkan 1941–1943' (The Italians in the Balkans) in Christof Dipper, Lutz Klinkhammer and Alexander Nützenadel (eds), *Europäische Sozialgeschichte. Festschrift für Wolfgang Schieder* (European Social History: Festschrift for Wolfgang Schieder). Berlin: Duncker & Humblot, pp. 57–74.

MATTA, Tristano. 2000. 'La Risiera di san Sabba: un "luogo della memoria" attivo' (The Risiera di San Sabba: An Active 'Site of Memory'). *Contemporanea. Rivista di storia dell'800 e del '900* 14(3): 513–17.

MATTIOLI, Aram. 2010. *Viva Mussolini! Die Aufwertung des Faschismus im Italien Berlusconis* (Viva Mussolini! The Rehabilitation of Fascism in Berlusconi's Italy). Paderborn: Schöningh.

MUCCI, Massimo. 1999. *La Risiera di San Sabba: Un'architettura per la memoria* (The Risiera di San Sabba: An Architecture for Memory). Gorizia: Libreria Editrice Goriziana.

PARLATO, Giuseppe, Raoul Pupo, and Roberto Spazzali. 2008. *Foiba di Basovizza: Monumento nazionale* (Foiba di Basovizza: National Monument). Trieste: Stella Arti Grafiche.

PICCIOTTO FARGION, Liliana. 1991. *Il libro della memoria. Gli Ebrei deportati dall'Italia, 1943–1945* (The Book of Memory: The Deportation of Jews from Italy, 1943–1945). Milan: Mursia.

PIRJEVEC, Joze. 2009. *Foibe. Una storia d'Italia* (Foibe: A History of Italy). Turin: Einaudi.

PUPO, Raoul. 2005. *Il lungo esodo. Istria: le persecuzioni, le foibe, l'esilio* (The Long Exodus: Istria, the Persecutions, the Foibe, Exile). Milan: Rizzoli.

RADOS, Gianfranco, and Piero Pieri (dirs). 1994. *La Risiera di San Sabba.* Trieste: Videoest, DVD, 26 minutes.

SLUGA, Glenda. 1996. 'The Risiera di San Sabba: Fascism, Anti-Fascism, and Italian Nationalism'. *Journal of Modern Italian Studies* 1(3): 401–12.

TONERO, Laura. 2011. 'Foiba di Basovizza, 51mila visite in 4 mesi' (Foiba di Basovizza, 51,000 Visitors in 4 Months). *Il Piccolo*, 7 May, p. 40.

TROHA, Nevenka. 1997. 'Fra liquidazione del passato e costruzione del futuro' (Between the Liquidation of the Past and the Construction of the Future) in Giampaolo Valdevit (ed.), *Foibe. Il peso del passato* (Foibe: The Weight of the Past). Venezia: Marsilio, pp. 59–98.

VERGINELLA, Marta. 2007. 'Geschichte und Gedächtnis. Die Foibe in der Praxis der Aushandlung der Grenzen zwischen Italien und Slowenien' (History and Memory: The Role of the *Foibe* in Negotiations over the Italo-Slovenian Border) in Luisa Accati and Renate Cogoy (eds), *Das Unheimliche in der Geschichte. Die Foibe* (The Historical Uncanny: The Foibe). Berlin: Trafo, pp. 25–76.

VIOLA, Gaia. 1998. 'Dalla rimozione alla riscoperta: la Risiera di San Sabba nella stampa locale (1965–1995)' (From Repression to Rediscovery: The Risiera di San Sabba in the Local Press [1965–1995]). MA Thesis. Trieste: Università degli Studi di Trieste.

Return to Alcatraz:
Dark Tourism and the Representation of Prison History

MARY RACHEL GOULD

The degree of civilization in a society can be judged by entering its prisons.

<div align="right">Fyodor Dostoyevsky (2004[1862]: 76)</div>

Since 1972, tourists have travelled to Alcatraz Island in San Francisco, California, to visit what remains of one of the most famous prisons in the world. Thus, in the same year (1972) in which the prison system first recorded unprecedented growth, non-incarcerated citizens collectively began to travel to a prison-turned-tourist-attraction. Contemporary prisons in the United States are geographically and ideologically removed from public space and consciousness, but the rise of the prison-turned-tourist attraction allows non-incarcerated citizens entry to the spaces that are most often only accessible through film and television. With Alcatraz Island as the setting, this essay explores the intersection of history, politics and consumerism at a popular tourist attraction, and how visitation to this site might contribute to the fear and apathy that has come to define America's contemporary relationship with the prison system.

In 1972, the same year Alcatraz Island welcomed the first boat of tourists, fewer than 300,000 men and women were incarcerated. Currently, the US incarcerates 2.2 million men and women; according to the Department of Justice's Bureau of Justice Statistics, 1 out of every 31 (or 7.2 million) adult citizens of the country is under some type of criminal supervision.[1] The US is the world's leading incarcerator, imprisoning more of its citizens than any other country in the world. Given the drastic and unprecedented shifts in prison populations in the country, and the public silence and apathy surrounding the growth and severity of the US prison system, a study of visitation to a historic prison can provide valuable insights. Mediated representations, including tourist attractions, of the prison system provide some of the raw material

that non-incarcerated citizens use to form opinions about incarceration in the US. An 'incarceration nation' has emerged in the US and tourists are willingly queuing up to witness its history.

Acceptance of mass incarceration is perpetuated by mediated representations and lawmakers and policies that simplify issues of incarceration into bipolar terms, generally focusing on violent transgression and not the systemic causes of crime and methods of rehabilitation. Sociologist Barry Glassner (1999) has written extensively about what he terms a 'culture of fear' that emerged in the US in the late twentieth century. The low-grade paranoia is fuelled by a media industry that capitalizes on fear to sell stories, on a political climate where politicians use fear to rally support and on a consumer culture that sells products to mediate that fear. Glassner contends that:

> [In] the 1990s, Americans were preoccupied, against all evidence, with fear of crime (as crime was falling), with possible plane crashes (of which there were very few), with diseases that they were unlikely ever to get [. . .] while the real threats to the American way of life— poor health care, poverty, and an unregulated access to guns—went unnoticed (in Sturken 2007: 48).

Extending upon Glassner's work, I argue that the culture of fear has perpetuated attitudes of silence and apathy about punishment, incarceration and the treatment of those classified as 'criminals'.[2] The result of living in a culture of fear is the emergence of a 'culture of silence', and the prison-turned-tourist attraction makes a contribution to the silent acceptance of mass incarceration in the US.

The fascination with travelling to sites of death and disaster, with the representation of history and, often, with the commodification of such spaces has garnered considerable attention of late in scholarly research (Lennon and Foley 2000; Stone 2006; Strange and Kempa 2003; Tarlow 2005), and these sites have come to be classified as sites of 'dark tourism'. Some of the more popular sites of 'dark tourism' round the world are former places of incarceration—the Eastern State Penitentiary in Philadelphia, Pennsylvania, Robben Island in Cape Town, South Africa, and the Tower of London in the United Kingdom. Alcatraz Island, one of the most popular tourist attractions in the US, represents the growing trend of converting historic prisons into tourist attractions, especially as outdated and deteriorating prisons are closed and replaced by more technologically advanced models.[3] As Marita Sturken claims in *Tourists of History: Memory, Kitsch, and Consumerism from Oklahoma City to Ground Zero,*

an exploration into how Americans have responded to national trauma through consumerism and tourism, modern tourists 'are often defined as innocent outsiders, mere observes whose actions are believed to have no effect on what they see' (2007: 10). Like Sturken, the analysis in this essay explores how the act of tourism—spectatorship, consumerism and apolitical distance—becomes a metaphor for an individual's relationship with the sociopolitical history of the site they visit. When tourists travel to the Auschwitz camps in contemporary Poland, Ground Zero in Lower Manhattan in the US, Robben Island in South Africa, the Killing Fields in Cambodia or Alcatraz Island, leisure and pleasure mix with death and disaster and the result is often a 'naïve political response to the events they have just witnessed as a tourist' (ibid.: 12).

Shades of Dark Tourism

'Dark tourism', a term coined in the mid-1990s by John Lennon and Malcolm Foley, defines the boundaries surrounding acts of travel and visitation to sites of death and disaster.[4] Although they are not the first to posit acts of visitation to sites of death and disaster for academic study, Lennon and Foley (2000) have been on the forefront of theorizing the key aspect of the practice, the relationship between the historical event and the contemporary sociopolitical context framing its presentation. They contend dark tourism is 'both a product of the circumstances of the late modern world and a significant influence upon these circumstances' (ibid.: 3). Accordingly, they establish three key features that must be present for a site to be considered a space of dark tourism. First, 'global communication technologies' must have 'a major part in creating the initial interest' in the site for domestic and international tourists. Second, sites of dark tourism 'appear to introduce anxiety and doubt about the project of modernity'. For example, visiting Dealey Plaza in Dallas, Texas, educates tourists about the assassination of President John F. Kennedy and raises concern about the threat to democracy posed by a presidential assassination and conspiracy. Third, sites of dark tourism are 'accompanied by elements of commodification and a commercial ethic (whether explicit or implicit) which expect that visitation (whether purposive or incidental) is an opportunity to develop a tour of some product' (ibid.: 11) Chronological distance is the key factor that excludes a tourist attraction featuring a history of 'death and disaster' for classification as a site of 'dark tourism'. Accordingly, the event being re-presented must occur in the 'recent past' in order to have validation from those still living (ibid.: 12).

Participation in dark tourism brings viewers face-to-face with some of the most pressing moral and ethical dilemmas a culture experiences and provides an opportunity for an embodied experience in a historical setting. In the case of Alcatraz Island, through the tourist experience of a historic prison, individuals come into contact with the prison system's legacy of death and disaster. Alcatraz Island offers a rare opportunity for non-incarcerated citizens to catch a glimpse of a world that most often only exists in the cultural imagination. Non-incarcerated citizens infrequently visit material (real) prisons in the US, a practice that was once common when prisons were located in town centres. Now, it is more common for non-incarcerated citizens to only see the prison system when represented in film or on television. On the basis of Lennon and Foley's definition of dark tourism, contending that visitation to sites of death and disaster provides valuable insight into the collective consciousness of a culture, this essay asks the following questions about visitation to Alcatraz Island: Do mediated representations of Alcatraz Island affect the experience of the tourist? What is the role of fear and anxiety in this experience? And how does the commodification of Alcatraz Island influence the tourist?

Little Island, Big Screen

> You've got to admit, it's a pretty piece of masonry, that Alcatraz, but it never was a choice spot for a vacation.
>
> Champ Larkin, *Seven Miles from Alcatraz* (1942)

The contradiction expressed by silver screen 'inmate' Champ Larkin is clear today.[5] But in 1942, only eight years after the official opening of the federal penitentiary on Alcatraz Island, the publicity and government secrecy surrounding the island made it one of the most feared and mysterious locations in the US (Godwin 1963: 3). Officially commissioned as a federal penitentiary on 1 January 1934, Alcatraz was the first 'super-prison' in the US (Esslinger 2003: 56). Modelled after the Quaker-inspired system of discipline, in which labour, silence and prayer pave the road to redemption, men on Alcatraz Island were to be seen, not heard. For 28 years Alcatraz held the worst of the worst in the US; this designation made the island a dominant focus of films, television shows and news reports.

In the mid-1930s, the Federal Bureau of Investigation (FBI) disseminated newsreels to enhance and perpetuate the 'worst of the worst' distinction for the island. By the 1940s, the press had dubbed Alcatraz 'America's Devil's Island',

and viewers could not get enough of the island and its new inhabitants. Non-incarcerated citizens turned to the small and silver screen to help imagine what was occurring less than two miles from the shore. By offering a picture of life on 'The Rock' (as the island is popularly called), Hollywood films helped increase public curiosity about the 22-acre island that was floating 1.5 miles off the coast of the San Francisco Bay. Four years after the opening of the prison, *Alcatraz Island* (1937) was released in theatres. One year later, *King of Alcatraz* (1938) premiered. Within the next 12 years, almost a dozen films about the prison had been produced and released in the US and the United Kingdom, including *Those High Grey Walls* (1939), *Seven Miles from Alcatraz* (1942), *Road to Alcatraz* (1945), *Train to Alcatraz* (1948) and *Experiment Alcatraz* (1950). The FBI knew that the news media and Hollywood machine could fuel and capitalize on public fear of crime and curiosity about the prison system. Four decades later, Glassner's concept of the culture of fear came to represent these same efforts by politicians to rally support for tough-on-crime policies and by the news media and consumer industry to sell stories and products.

The public's fascination with the island peaked in 1934, with the arrival of Al Capone (prisoner no. 85) and George 'Machine Gun' Kelly (prisoner no. 117). The influx of high-profile figures to the prison continued until the penitentiary was officially closed in 1963. Attorney General Robert Kennedy locked the doors to the penitentiary on Alcatraz Island on 23 March 1963, citing reasons of rising costs, the isolated location and deteriorating facilities. It is widely speculated that the 11 June 1962 escape attempt by Frank Morris and brothers John and Clarence Anglin was the actual cause of the closure. Although it is assumed that the men drowned, the failure to produce bodies, alive or dead, publicly embarrassed the FBI, it's then director (J. Edgar Hoover) and the Bureau of Prisons. The 1962 escape was made famous in popular culture by Clint Eastwood's *Escape From Alcatraz* (1979), based on J. Campbell Bruce's book of the same title, first published in 1963. The Morris–Anglin escape continues to linger in US popular imagination, as conspiracy theorists continually scrutinize the plot of the escape, its feasibility and the possibility that the men survived.

Once closed, Alcatraz Island was transferred to the United States General Services Administration; from 1963 to 1969, the island was uninhabited. In November 1969, the American Indian Movement, calling itself 'Indians of All Tribes', seized Alcatraz Island to highlight grievances against the federal government and to assert tribal rights to reclaim land. Lasting for 19 months with

more than a hundred Native Americans engaged in the occupation, the protest was eventually put down by United States Marshals. In October 1972, most likely moving more swiftly because of the native occupation, Congress created the Golden Gate National Recreation Area and the island became part of the National Park Service (NPS) network. When the NPS petitioned Congress for the land, it argued that the island was in need of stewardship and interpretation. Once granted the parcel, the challenge would be to turn a prison into a tourist attraction without sensationalizing the experience. According to George B. Hartzog Jr., director of the NPS during Alcatraz's transition, it was not the intention to 'present this island solely as a memorial to a century of military and civil confinement' (in Strange and Kempa 2003: 391). The problem the NPS faced was that native birds, one of the nation's oldest lighthouses and the story of the native occupation did not compare in popularity with the stories of Al Capone, the Birdman and the most epic prison escapes in US prison history. Tourists wanted to see the notorious prison.[6]

Tourists who travel to Alcatraz Island are never complete strangers; most come to the island having been tutored by Hollywood or a commercial presentation of the Rock. As one visitor told me in a survey I conducted on 29 September 2007: 'I want to see first hand what it looks like compared to the movie and television representation of it'. Her comment mirrored most responses I received when I asked, in the survey, 'Why did you want to visit Alcatraz Island?' Tourists to Alcatraz Island primarily reported being motivated by an interest in comparing what they have experienced in the media landscape with the *real* Alcatraz Island, thus wanting to *authenticate* the mediated representation. Few tourists suggested an awareness or appreciation for the mediated nature of their experience on Alcatraz Island.

The NPS and NPS rangers have an uphill battle in educating tourists. In a highly mediated culture with an oversaturation of representations constructing public knowledge, the island has always been out of the total control of the NPS. Hollywood is the most prolific interpreter of Alcatraz Island. Ranger Lori Johns knows her task is set against the backdrop of a mediated vision of Alcatraz as a curiosity, which she optimistically views as an opportunity and not a drawback. After welcoming a group of tourists to the island, and as we watch more than 200 newly arriving tourists by-pass the educational video and head directly to the Main Cellblock Audio Tour, Johns admits it is film and television that 'introduce' people to Alcatraz Island and that 'the number one aspect of that is they're curious about the escapes'; this is where she finds an opportunity. 'While

on the one hand you feel bad that that's all they know about, on the other hand, that's great, that's your hook, that's what brings them here. And then you have the opportunity to say, "there's a lot of other things here, too"; it is the role of the ranger to grasp the opportunity to educate the visitor,' says Johns.[7] As 'custodians of history', NPS rangers are responsible for translating and representing the story of Alcatraz Island, a story that they envision as encompassing more than the prison years.[8] The rangers I spoke with agreed that their responsibility is to show tourists aspects of the island that are not associated with the prison.

However, the 1962 Morris–Anglin escape attempt might be the single most important event in the history of Alcatraz Island and in its popularity as a tourist attraction. The escape attempt is the link that fixed Alcatraz Island in the public imagination. More than half the number of visitors I spoke with reported travelling to Alcatraz because of the mystery surrounding the attempted escape. As one visitor wrote in response to my survey: 'I came here to gain some sense of the reality of a place so famous. There is such a myth that surrounds Alcatraz, I am simply interested in seeing it for myself.' The NPS is well aware of the curiosity factor motivating visitation and is careful to feed it back to tourists in prodigious amounts. According to another tourist I spoke with, her reason for visiting Alcatraz was to 'learn the history of who was there [Alcatraz Island] and why my husband loves films about Alcatraz'.[9] For this visitor, the answer to her husband's fascination with films about Alcatraz can be found through the experience of visiting the actual site and validating the stories her husband has seen represented in film.

The highlight of the visit to Alcatraz Island is the self-guided audio tour, where the recorded voices of former correctional officers and incarcerated men take tourists on a step-by-step exploration of living and working on the island.[10] The telling and retelling of the stories adds to, reinforces and recreates the mystique of this space (Albright 2008; Bunting 1986; Vercillo 2008). Alcatraz Island is absent of the bodies that once filled its halls and cells, but they remain present through the stories told on the audio tour. Voices from the past narrate the history to tourists in the present without the possibility of engaging in a dialogue. The only choice given to tourists is to accept what they hear through the headphones as authentic.

Two of the most popular stops on the audio tour are Cell No. 1 on 'Avenue C', and Cell Nos. 138, 150 and 152 on 'Cellblock B' (Michigan Avenue). On Avenue C, tourists are invited by the tour narrator to enter Cell No. 1 and experience the inside of a typical cell. On Cellblock B, tourists see the cells of

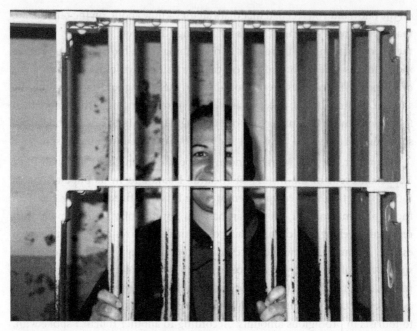

FIGURE 29. Cell No. 1, Avenue C, main cellblock, Alcatraz Island. Photograph by Mary Rachel Gould.

Frank Morris, Clarence Anglin and John Anglin, and hear the story of one of the most elaborate prison escapes in US history. I imagine that if the photos taken by visitors of Alcatraz were compiled and catalogued, the largest collection would be of these two locations. It is almost impossible to find a time when a crowd of visitors does not occupy the space round the cells. I watch as most tourists pause the audio tour at both stops to have extra time to take photographs. Watching visitors smiling behind the bars of Cell No. 1 as their companions, with cameras drawn to their faces, take photographs, I realize I have a similar photograph from my first visit to Alcatraz Island on 12 March 1999 (figure 29). As tourists smile and pose for the camera, it is difficult to experience the prison system as a form of entertainment and a sociopolitical institution. Entertainment trumps education. Knowing what I do now about the prison system, I find it impossible to enter Cell No. 1 and smile for a camera.

On Cellblock B tourists find the remnants from the 1962 Morris–Anglin escape, taken by the FBI in 1962 as evidence, and later returned to the NPS for the purpose of exhibition, staged as what Barbara Kirshenblatt-Gimblett

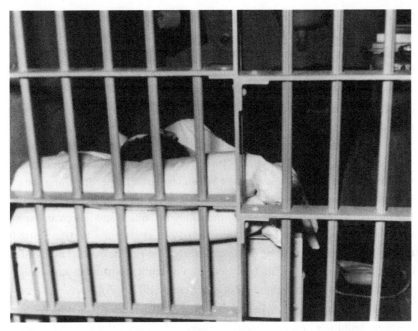

FIGURE **30.** Frank Morris's cell. Photograph taken by FBI agents on 12 June 1962. Reproduced with the permission of former FBI Agent Robert Nielson.

considers 'objects of ethnography' (1998: 21). Unlike most ethnographic objects that are 'detached' from their original space for exhibition in a 'more civilized' location, artefacts from the Alcatraz escape, the 'dummy head' and the fake ventilation cover used to deceive correctional officers, were 'reattached'—albeit, behind glass, in a pseudo-museum—and presented in their 'original' environment. While Kirshenblatt-Gimblett views the act of 'detachment' as significant to the display of the ethnographic artefact, the 'reattachment' and presentation of the Alcatraz artefacts are equally important (1991: 387–94).

In the context of Kirshenblatt-Gimblett's work, I read the objects from the 1962 escape as 'enshrined', where the audio tour and information placards serve to place the escape objects 'in context', creating a frame of reference for the tourist and exerting 'strong cognitive control over the objects' (1998: 22). The presentation blurs the lines between mediated and authentic experiences, which can be disorienting for the individual, especially in the context of the collapsed space and time of the tourist experience. The NPS re-presents the morning of the escape for tourists as if nothing has changed on the island since 1962 (figure

275

30). By framing artefacts of the escape as timeless and apolitical, the NPS satiates the desire and curiosity of tourists. Tourists who take photographs of the representations of history further have the potential of authenticating their experience as they are allowed to take with them, in the form of the photograph, evidence of their visit and proof that the scene of the crime has remained unchanged.

The camera is a primary technology in the operation of tourism as most tourist experiences are designed for the camera-carrying visitor. According to Susan Sontag, the camera defines reality by acting as 'an instrument for depersonalizing our relation to the world' (1999: 87). Sontag contends that the camera functions in the same way as a pair of binoculars 'mak[ing] exotic things near, intimate; and familiar things small, abstract, strange, much farther away' (ibid.). She theorizes that photographs have the ability to capture and flatten an experience or individual into a two-dimensional object that can be transported through space and time to be displayed, stored and/or discarded. The significance of the photographic image is found in its ability to provide 'knowledge dissociated from and independent of experience' (1977: 155).

On Alcatraz Island, tourists capture images of abandoned corridors, deteriorating buildings and uninhabited prison cells. They fill these spaces with the bodies of their friends and family members who position themselves in front of structures or behind bars, smiling and waving. Absent in their photographs are the bodies of the men who were kept on the island and the men and women who served as keepers. Placed in audio isolation, tourists proceed through the main cellblock with little opportunity to engage in conversations or participate in the kind of groupthink that might question, challenge or form resistance to the experience and practice of incarceration.

Hellcatraz

> To the astonishment of civic and business organizations who had protested violently against 'that blot, that human cesspool, that hellhole in our fair bay' The Rock was proving a magnificent tourist attraction. For reasons only psychiatrists pretended to understand the good people of the United States flocked by the thousands to get a distant glimpse of the place they would have hated to be on (Godwin 1963: 30).

Fifty years have passed since the federal penitentiary on Alcatraz Island officially closed in 1963 and this space, which was called a 'living hell', has transformed

into a large-scale tourist attraction. Alcatraz's history is consumed by stories of cruelty and suffering, a legacy that was encapsulated in its nickname, Hellcatraz. Yet, public representations of Alcatraz Island, specifically of the island as a tourist attraction, have never been particularly dark. As Carolyn Strange and Michael Kempa observe in their study of tourism on both Robben Island and Alcatraz Island, 'lighter and even light-hearted' interpretations of the penal past have circulated from their earliest days as attractions (2003: 391). They cite the 'criss-crossing' of expectations (of tourists) and representations (film, television, curators), the continued reshaping of political, cultural and economic forces associated with the prison system, and the 'multiple and sometimes con-flicted interpretations of the penal past' as primary factors contributing to the 'lighter' depictions of tourism on Alcatraz Island (ibid.). They contend that Alcatraz Island has experienced the 'lightest' reception by tourists and media outlets and that, much to the frustration of rangers, has not been able to avoid 'trivializing forces upon public consciousness' (ibid.). I argue that, in part, the trivializing or light-hearted outcome of visitation to Alcatraz Island comes as a direct result of being situated in the context of the culture of silence surrounding the US prison system. Because Hellcatraz is most often depicted as a means of entertainment (primarily in film and television), and not as a political system of state-sanctioned punishment, tourists' expectations of their visit are already reduced to that of a watered-down picture of the prison system's past and present. The combination of a sensationalized presentation of the prison and a multilayered approach to Alcatraz's history—including a focus on the natural habitat of the island, the history of the lighthouse and the importance of the military fort in relation to the California coast—contributes to the 'light' and apolitical reception of the prison's past.

Feedback from interviews and surveys in the course of my research clearly shows that visitation to Alcatraz Island potentially confuses the relationship between the past and the present condition of the US prison system. During a conversation about the 'severity' versus 'leniency' of the existing prison system in the US, a tourist told me: 'Today's system should be more, maybe not exactly, like this, then maybe there wouldn't be as many people in prison now.'[11] Although the tourist was aware of the growing prison population in the US, he did not reveal awareness about the contemporary prison experience being more severe and extended than during the time Alcatraz was in operation. For example, in a contemporary maximum-security prison it could be expected that 80 per cent of the population is serving a life sentence compared to the

five to eight-year sentences on Alcatraz Island, a maximum security facility (Bergner 1998: 4; DeNevi and Bergen 1974: 25).

Alcatraz Island is advertised round the world as a curiosity and not as a site that provides insight into the history, contemporary state and/or future of the prison system in the US. As another tourist told me: 'It's not important that it's a prison, more that it's a landmark that we couldn't miss in San Francisco.'[12] Visiting Alcatraz Island simply reconfirms for most tourists what they already know or have been told about the prison system, where in a culture of fear they are taught about violent offenders and lenient systems of justice. Alcatraz Island exists in a sociopolitical context that is continually in flux about the purpose of prisons (rehabilitation versus retribution) and in a media landscape that depicts prisons and the experience of incarceration as a popular form of entertainment and curiosity. The fame and notoriety amassed by Alcatraz Island through cultural lore and mediated representations does not work to make more complex the tourists' understanding of the contemporary prison system. In contrast, a visit to Alcatraz provides supporting evidence for the perpetuation of a culture of silence.

Life on the Rock was not easy or without pain or injury—physical, emotional and spiritual. As narrator Leon 'Whitey' Thompson tells tourists through the main Cellblock audio tour: 'Alcatraz was always classed as the end of the line, the point of no return, it was like going into the ground—you're buried, you're gone forever.' Men confined to cells on Alcatraz Island suffered. Alcatraz Island is a representation not only of the punishment of men but also of the origins of the US's *tough-on-crime* policies on crime and punishment. The US government has been clear and transparent in its intentions for the island. On 12 October 1933, nine months before the official opening of the US federal penitentiary on Alcatraz Island, US Attorney General Homer S. Cummings announced on a radio programme:

> For some time I have desired to obtain a place of confinement to which could be sent our more dangerous criminals . . . Such a place has been found . . . We have obtained the use of Alcatraz Prison, located on [an] island in San Francisco Bay, more than a mile from shore. The current is swift and escapes are practically impossible. Here may be isolated the criminals of the vicious . . . type (in George 1989: 17).

By filling the prison with some of the era's most notorious criminals, FBI Director Hoover and Attorney General Cummings added to the intrigue of the island prison. As Hoover's biographer Richard G. Powers writes, 'Cummings had judged the public mood perfectly. Alcatraz, whatever its merits as a prison, was an immediate public relations success, instant folklore, the new symbol of the ultimate penalty short of death' (1987: 188–9). The success of Cummings and Hoover's vision is evident today, where five decades after the closing of the federal penitentiary on Alcatraz Island, tourists smile, take photographs, purchase souvenirs and are entertained by the stories of the incarcerated men and guards.

Selling the Rock

Tourism has some aspects of showbiz, some of international trade in commodities; it is part innocent fun, part a devastating modernizing force (Victor Turner, in Stronza 2001: 261).

Foot traffic from over a million visitors a year and salt residue rolling off of the San Francisco Bay has not been kind to the century-old structures on Alcatraz Island.[13] In 2003, the Golden Gate National Parks Conservancy, the non-profit partner for the Golden Gate National Parks, launched a multi-year preservation project. Under the mission to 'restore the Rock to its former glory' and 'to save history', the Alcatraz Island Preservation Project intends to prevent the island from becoming a pile of debris. The 'Save the Rock' campaign is featured across Alcatraz Island and on Pier 33, primarily in gift shops. Mugs, T-shirts, hats, key chains and posters all contain the slogan 'Save the Rock', and, ironically, one of the feature items is a chunk of concrete, a by-product of the renovation project underway on the island (2011). For US$8.95 tourists can own a piece of the Rock. As described on the packaging, 'Each rock is unique. [. . .] This is not a toy. Not for children under age 5. Includes informational Brochure. Thank you for supporting our efforts to preserve Alcatraz Island.' The website for the Alcatraz Historic Preservation Projects describes the rationale for selling the pieces of debris as pragmatic.[14] Because Alcatraz Island offers 'no easy or conventional disposal options since it's in the middle of an ecologically sensitive bay, so the controversial decision was made to package and sell pieces of the Rock'. One of the benefits, according to the Parks Conservancy group, was that 'visitors could bring a piece of history home with them'.[15] On Alcatraz Island,

the 'Save the Rock' project is one of many ways in which visitors can preserve the Alcatraz experience.

The tension between commodification and the commemoration of history is played out to its greatest extent in the four gift shops located on Alcatraz Island.[16] Whether tourists enter through the Exhibit Hall to see the permanent exhibits on the island or through the Main Cellblock for the audio-guided tour, eventually they are guided into a gift shop. As is the case with most museum or tourist experiences, all activities end with an invitation to purchase a souvenir. Alcatraz provides no shortage of items to purchase, some standard and some specific to the 'Alcatraz experience'. In the gift shops, tourists can purchase T-shirts, hats, books, postcards, pens, magnets, candy, mugs and key rings. Items specific to Alcatraz include knitting needles and yarn because, as retold on a sign accompanying the needles and yarn, '[b]eginning in the 1950s, inmates could purchase craft supplies [. . .] many took up knitting and cro-cheting'. United States Penitentiary Alcatraz salt-and-pepper shakers are sold alongside the *Alcatraz Women's Club Cookbook* written by wives of penitentiary employees, and prisoner mug shots and records are packaged and sold as playing cards.

The commodification of Alcatraz is not limited to the area surrounding Pier 33 or to the island. In San Francisco, remnants of Alcatraz can be found throughout the city, including Chinatown, Golden Gate Park and in tourist-centric shops. Items associated with visiting Alcatraz are sold as a metonymic reminder of a trip to San Francisco. A visit to Alcatraz is based on the practice of consumption. In addition to the items that tourists purchase, Alcatraz Island is also a 'brand name commodity' metaphorically packaged and sold to the tourist by a network of entities, including the NPS, intending to profit from the fascination with death and disaster.

Similar to the material items—children's toys and supermarket produce—that cultural critic Susan Willis (1991) suggests are packaged as a way to entice the buyer, tourists can purchase an image of Alcatraz *before* visiting the island. The image of the island that is constructed for the tourist prior to their visit is perpetuated by mediated depictions and popular cultural lore. Packaging serves the purpose of prolonging the process of the consumer actually coming into contact with the item they have purchased. As Willis explains, 'packaging acts to separate the consumer from the realization of use value and heightens his or her anticipation of having and using a particular commodity' (ibid.: 4). On Alcatraz Island, the ability to directly interact with the entire facility is either

stalled or completely withheld from the tourist. Visitation to Alcatraz is rooted in a hurry-up and wait ethos. Visitors spend much of the time allocated for their visit travelling to and from the island or waiting in lines. Most visitors do not have the time to 'unwrap' the complete Alcatraz experience before having to return to San Francisco. Purchasing a pre-packaged reminder of the experience in the form of a souvenir or posing at a designated scenic photo-opportunity site on the island helps to account for the time lost and can serve as a lasting memory of the experience.

In late capitalist culture the tourist exists in a perpetual race against time. Objects of history are continually decaying and being erased from memory. James Clifford suggests it is this 'race against time' that drives the tourist to collect and take interest in a 'rescue of phenomena from inevitable historical decay and loss' (in Clifford and Marcus 1986: 26). Many tourists suggested that their visit to Alcatraz was motivated by an interest to see the site while it was still open as a tourist attraction. Taking photographs or purchasing a T-shirt or mug provides a tangible reminder of a physical space that one day will be gone. A first-hand experience of the decay of Alcatraz undoubtedly encourages a more immediate need to possess a reminder of the place.

Memory, and specifically the process of remembering and forgetting, is a significant component of the tourist experience, especially dark tourism. Alcatraz Island presents visitors with an opportunity to remember the prison system's past. The audio tour, ranger-led experiences and exhibits all tell pieces of Alcatraz's history, part of which is a history of the prison system in the US. To want to learn, and possibly remember, the history of a place or event requires a level of engagement that I did not observe in many tourists at Alcatraz Island. More often, tourists became involved with the spectacle of the island and the commodification of the experience and not with the history of the island (which is a primary focus of most ranger-led tours) or the prison system in the context of its sociopolitical location in the US (which is depicted in multiple exhibits in the Exhibit Hall). Few tourists reported participating in ranger-led tours and, often, I found the Exhibit Hall empty, while the halls of the Main Cellblock were always full of plugged-in tourists taking photographs. The design of the Alcatraz experience permits visitors to participate in a form of forgetting that serves as an agent of reification.

In a letter to Walter Benjamin in 1940, Theodor W. Adorno explicitly links memory with reification, the process of making an 'idea' into a 'thing'. In the case of Alcatraz Island, the history of punishment and the prison system in the

US is reduced to that of a souvenir purchased in a gift shop or a photograph taken behind the bars of a cell. 'Every reification is a forgetting [. . .] objects become thing-like at the moment when they are seized without all their elements being contemporaneous, where something of them is forgotten' (in Jay 1973: 229) Adorno explicitly links the process of reification and commodification with memory and the negative outcome of forgetting. Forgotten on Alcatraz Island are the men and women, incarcerated and employed, who suffered the sentence of time on the Rock.

The commodification of Alcatraz Island into a product to be purchased or a photograph to be taken transforms the experience of incarceration into a 'thing-like' item that precludes learning or remembering the totality of the history of the prison system in the US. History is no longer a lesson to be learnt, it is an object to be purchased, collected, catalogued and/or displayed. Only one tourist I spoke with suggested being aware of the tensions present in the commodification of the prison system. Taking the ferry back to San Francisco, I asked the empty-handed man standing next to me whether he had purchased anything during his visit. He responded: 'I wouldn't buy anything here because people suffered here. I came to Alcatraz to see the prison, I do not need a souvenir of someone's suffering.'[17] A few other tourists I spoke with on the ferry back to San Francisco also shared his sentiment.

Tourists are notorious for participating in the commodification of people, places and experiences, and officials designing tourist experiences cater to their needs. Making a profit from death and disaster is a tricky business, but it is not uncommon. For example, guided tours of Lower Manhattan include stops at Ground Zero and in New Orleans, Louisiana, visitors pay Grey Line Tours up to US$35.00 for a tour that includes a 'local's chronology of events leading up to Hurricane Katrina and the days immediately following the disaster.'[18] The commercialization of death and disaster is a growing phenomenon in the US and round the world. The proven financial success of sites such as Alcatraz Island, the Eastern State Penitentiary and the Wyoming Frontier Prison Museum together with the public's continued fascination with discipline will undoubtedly encourage a new generation of prisons-turned-tourist attractions.

Decades after the official closure of the US Federal Penitentiary on Alcatraz Island, the island is now, more than ever, a curiosity. On average, visitors pay US$26 to tour the slowly disintegrating slice of US history and popular culture. Alcatraz Island potentially serves as a site that educates visitors about the nation's past and, at the same time, continually informs about the present (one

of the most significant features of dark tourism). Like many other must-see elements of US history—Dealey Plaza, Ground Zero, the Lorraine Motel in Memphis—Alcatraz Island presents a darker side of the nation's past. The possibility exists that visitation to a former prison, one that confined the worst of the worst in the US, could breach the silence and pose a challenge to the culture of fear that surrounds the prison system as a political institution.

Visitation to a former penitentiary could encourage dialogue about the contemporary prison system, regardless of the perspective. Findings from two years of fieldwork reveal little evidence that few, if any, conversations about the modern condition of the state of mass incarceration occur. Tourists I met at Alcatraz Island seemed clear that the experience was apolitical, an outcome that many scholars studying death and disaster tourism suggest is a direct result of the way politically significant places and events are packaged and sold to the public. Mediated representations of the prison system, in the form of tourist attractions, exist in the context of a culture of fear that Glassner (1999) cites as beginning in the 1980s in the US. The result is a culture of silence in the twenty-first century where public apathy has given rise to draconian prison policies, including sentences for minor non-violent offences and drug use, resulting in an exponential rise in the number of men and women who are currently incarcerated.

Despite the state of mass incarceration that persists in the US, a visit to Alcatraz Island is festive. History and the modern state of the prison system at Alcatraz is packaged and sold as entertainment and a commodity. Experiences with dark tourism, as defined by Foley and Lennon (2000), connect to broader social contexts. Visitation to sites of death and disaster plays a role in constructing tourists' understanding of history and the modern condition. As discussed, surveys, interviews and participant observations confirm that many tourists are drawn to Alcatraz Island by a quest for an authentic and real experience of a historic and (in)famous prison. Additionally, tourists report travelling to Alcatraz Island to see how the *real* Alcatraz prison compares to the representations they have seen in popular culture.

Alcatraz Island has the potential to be a tourist experience with political significance, but because of the way it is scripted that potential is lost. Because most tourists come to Alcatraz Island with an existing impression of the prison system, often encouraged by film, television, books and magazines, it would require a concerted effort to challenge Hollywood's version of incarceration. The NPS plays an important role in scripting an experience that caters to the

mass-produced desires of tourists. What results from a Hollywood-inspired tourist experience is a further separation of the reality of the non-incarcerated individual in relationship to the currently incarcerated person in contemporary society. The result of a lighter experience of dark tourism on Alcatraz Island is the reduction of the connection between the past and the present. Because the historic prison is experienced as a space of entertainment, the contemporary prison, in metonymic fashion, is also imagined as an apolitical space.

Herbert Marcuse (1964) details one of the most significant effects of the loss of memory or history and the emergence of 'one-dimensional discourse'. He contends that everyday discourse, derived from everyday experiences, increasingly becomes characterized by self-validating hypotheses where it is difficult to differentiate between appearance and reality and the mediated facts and conditions. Without the ability to draw upon historical reason, Marcuse fears, 'language tends to express and to promote the immediate identification of reason and fact, truth and established truth, essence and existence, the thing and its function' (ibid.: 84). Visiting Alcatraz Island reflects Marcuse's concern, where without historical perspective or knowledge to engage in informed discourse, visitors are left with only the resources available or permitted in the immediate present.

Alcatraz Island has always been a grim location. The island, once one of the most dreaded locations in the US, is now one of the most visited. Tours of Hellcatraz introduce visitors to the places where men leapt to their deaths into the ocean, where incarcerated men and guards killed each other, where grenades thrown and bullets fired by federal agents marred the floors and walls of the main cell house and where men struggled, daily, against the physical and psychological traumas of incarceration. Visiting Alcatraz Island could also be a grim experience, commanding solemnity. Yet, tourists generally appear unaffected by the nature of Alcatraz's past. The former federal penitentiary known as a place for the worst of the worst is not a site that evokes critical engagement with issues related to punishment or state power, but, instead, as one tourist told me, is 'a great place to spend the day with [the] family'.

Notes

1 The term 'criminal supervision' classifies individuals held within jails or prisons and those on parole or probation. Parole is community supervision after a period of incarceration. Probation is court-ordered community supervision

of convicted offenders by a probation agency, where supervision requires adherence to specific rules of conduct while in the community.

2 It is necessary to draw attention to the language used to describe men and women who are incarcerated and the dehumanizing effect of commonly used words such as 'criminal', 'offender' and 'prisoner'. Using terms such as 'incarcerated person' or 'currently incarcerated people' reflects a recognition of the power of language in the process of identity formation and the effect language has on public perception.

3 According to *Forbes* magazine, Fisherman's Wharf and the Golden Gate National Recreation Area (including Alcatraz Island) in San Francisco host more than 17 million visitors each year, making this area the sixth most visited location in the world (Times Square is first with 37.6 million visitors). See http://www.consumertraveler.com/today/forbes-americas-top-tourist-attractions/ (last accessed on 30 October 2013). It is reported, by the National Park Service, that more 1 million tourists annually visit Alcatraz Island (http://www.nps.gov/alca/index.htm, last accessed on 3 September 2007).

4 The popular term 'dark tourism' evolved from its academic namesake 'thana-tourism'. Both terms refer to visitation to sites of death, disaster and suffering. Other terms used in the literature to describe dark tourism include 'morbid tourism', 'disaster tourism', 'grief tourism', 'black spot tourism' and 'phoenix tourism'.

5 For details of the context, see Edward Dmytryk (1942).

6 In 1769, Spanish explores named the island 'Isla de los Alcatraces' (Island of the Pelicans), after the large pelican colonies that inhabited the island; birds continue to be the primary residents of the island. Before being colonized, Alcatraz Island was a primary site of food gathering (bird eggs and sea-life) for the Ohlone Tribe. In 1853, the US government assumed control of the land and built a military fortress that became a central defence position for San Francisco. In 1854, a lighthouse was completed on the island; in 2010, the structure is considered the oldest functioning lighthouse in the US.

7 Personal interview, Alcatraz Island, 2 November 2008.

8 NPS rangers are classified as 'interpretive' or 'ecological'. Depending on which rangers are on the island each day determines what programmes will be made available.

9 Personal interview conducted by the author, Alcatraz Island, 1 November 2008.

10 As part of the $3.5 million Alcatraz Renovation Project, the original Alcatraz Cellblock Audio Tour (1987) was rerecorded and updated. The guided tour of the main cell block includes the voice of former Alcatraz Correctional

Officer Pat Mahoney (who spent seven years on the island) as the main narrator of the tour, who provides visitors with directions, facts about the prison, the history of Alcatraz and an introduction to the four 'incarcerated narrators'—Leon 'Whitey' Thompson (no. 1465), John Banner (no. 1133), Jim Quinlin (no. 586) and Darwin Coons (no. 1422)—and three 'correctional officer narrators'—Phillip Bergen, George De Vinicenzi and Ron Battles.

11 Personal interview, Alcatraz Island, 8 November 2008.

12 Personal interview, Alcatraz Island, 7 November 2008.

13 In 1850, the US military built the first building on Alcatraz Island, a barracks for the Pacific branch of the US military prison on Alcatraz Island.

14 'Alcatraz Historic Preservation Projects'. Available at: www.nps.gov/alca/alcatraz-historic-preservation-projects.htm (last accessed on 31 October 2013).

15 Additional benefits include: landfills received less waste and project costs could be defrayed (see www.parkconservancy.org, last accessed on 25 November 2008).

16 Two gift shops are located at the top of the island in the cellblock area and two others are on the lower level of the island near the landing dock and the Exhibit Hall. The two lower shops are the smallest of the four. Each of these sells a condensed selection of items sold in the main gift shop(s). The two upper-level shops are connected and one is called the 'Bookstore' and the other the 'Museum Exhibit Store'. Together, they are the endpoint of the guided audio tour.

17 Personal interview, en route to San Francisco, 7 November 2008.

18 One of the most widely advertised tours of the lower wards of New Orleans is the Grey Line New Orleans (see greylineworleans.com/Katrina.shtml, last accessed on 4 December 2008).

Works Cited

ALBRIGHT, Jim. 2008. *Last Guard Out: A Riveting Account by the Last Guard to Leave Alcatraz Island*. Bloomington, IN: Author House Publishing.

BERGNER, Daniel. 1998. *God of the Rodeo: The Quest for Redemption in Louisiana's Angola Prison*. New York: Ballantine Books.

BUNTING, Eve. 1986. *Someone Is Hiding on Alcatraz Island*. Berkley, CA: Houghton Mifflin Company.

CLIFFORD, James. 1986. 'Introduction: Partial Truths' in James Clifford and George Marcus (eds), *Writing Culture: The Poetics and Politics of Ethnography*. Berkeley: University of California Press, pp. 1–26.

DeNevi, Don, and Philip Bergen. 1974. *Alcatraz '46: The Anatomy of a Classic Prison Tragedy*. San Rafael, CA: Leswing Press.

Dostoyevsky, Fyodor. 2004 [1862]. *The House of the Dead and Poor Folk* (Joseph Frank introd., Constance Garnett trans.). New York: Barnes & Noble Classics Press.

Dmytryk, Edward (dir.). 1942. *Seven Miles from Alcatraz*. VHS Tape / DVD. USA: RKO Radio Pictures, black and white, 62 minutes.

Esslinger, Michael. 2003. *Alcatraz: A Definitive History of the Penitentiary Years*. San Francisco: Ocean View.

Glassner, Barry. 1999. *The Culture of Fear: Why Americans Are Afraid of the Wrong Things*. New York: Basic Books.

Godwin, John. 1963. *Alcatraz, 1868–1963*. Garden City, NY: Doubleday.

George, Linda. 1989. *Alcatraz*. New York: Grolier Publishing.

Jay, Martin. 1973. *The Dialectical Imagination: A History of the Frankfurt School and the Institute of Social Research, 1923–1950*. Boston, MA: Little Brown.

Kirshenblatt-Gimblett, Barbara. 1991. 'Objects of Ethnography'. In Ivan Karp and Steven D. Lavine (eds), *Exhibiting Cultures: The Poetics and Politics of Museum Display*. Washington, DC: Smithsonian Institute Press, pp. 386–443.

———. 1998. *Destination Culture: Tourism, Museums, and Heritage*. Berkeley: University of California Press.

Lennon, John, and Malcolm Foley. 2000. *Dark Tourism: The Attraction of Death and Disaster*. London: Thompson Press.

Marcuse, Herbert. 1964. *One-Dimensional Man: Studies in the Ideology of Advanced Industrial Society*. Boston, MA: Beacon.

Powers, Richard G. 1987. *Secrecy and Power: The Life of J. Edgar Hoover*. New York: Free Press.

Sontag, Susan. 1977. *On Photography*. London: Penguin.

———. 1999. 'The Image-World' in Jessica Evans and Stuart Hall (eds), *Visual Culture: The Reader*. Thousand Oaks, CA: Sage, pp. 80–94.

Stone, Philip. 2006. 'A Dark Tourism Spectrum: Towards a Typology of Death and Macabre Related Tourist Sites, Attractions and Exhibitions'. *Tourism: An Interdisciplinary International Journal* (Special Issue on Spirituality and Meaningful Experiences in Tourism) 54(2): 145–60.

Strange, Carolyn, and Michael Kempa. 2003. 'Shades of Dark Tourism: Alcatraz and Robben Island'. *Annals of Tourism Research* 30(2): 386–405.

Stronza, Amanda. 2001. 'Anthropology of Tourism: Forging New Ground for Ecotourism and Other Alternatives'. *Annual Review of Anthropology* 30: 261–83.

STURKEN, Marita. 2007. *Tourists of History: Memory, Kitsch, and Consumerism from Oklahoma City to Ground Zero*. Durham, NC: Duke University Press.

TURNER, Victor. 1974. *Dramas, Fields, and Metaphors: Symbolic Action in Human Society*. Ithaca, NY: Cornell University Press.

TARLOW, Peter E. 2005. 'Dark Tourism: The Appealing "Dark Side" of Tourism and More' in Marina Novelli (ed.), *Niche Tourism: Contemporary Issues, Trends and Cases*. Oxford: Butterworth-Heinemann, pp. 47–58.

VERCILLO, Kathryn. 2008. *Ghosts of Alcatraz*. Atglen, PA: Schiffer Publishing.

WILLIS, Susan. 1991. 'Unwrapping Use Value' in *A Primer for Daily Life*. London: Routledge, pp. 1–18.

Between Violence and Romance:
Gorillas, Genocide and Rwandan Tourism

STEPHANIE MCKINNEY

Gorillas and genocide, or the two 'G' words, are the terms most often associated with the insulated East African nation of Rwanda in contemporary public culture. While the presence of the highly endangered mountain gorilla and the horrific genocide of 1994 definitively distinguish Rwanda among African nations, these features have become solidified in Rwanda's tourist industry largely due to the popularity of two films, Michael Apted's *Gorillas in the Mist* (1988) and Terry George's *Hotel Rwanda* (2004). Apted's work depicts American primatologist Dian Fossey's life (and death) among the mountain gorillas (see Mowat 1987), and George's presents Hutu hotel manager Paul Rusesabagina as a heroic figure who saves the lives of 1,248 Rwandans, who were predominantly Tutsi, from repeated attempts by the *génocidaires* to seize them. As romance and tragedy, these films iterate the need for Western order in the face of barbarism. *Gorillas in the Mist* focuses on Fossey's single-minded, and often ruthless, campaign to study the mountain gorillas and preserve this vulnerable species. Similarly, *Hotel Rwanda* depicts the extensive machinations required by Rusesabagina to save the refugees in the Belgian-owned Hôtel des Mille Collines from certain annihilation. Both representations raise serious doubts as to the West's ability to contain violence in a continent that has long embodied the primitive in Western imagination.[1] These stories, with their Conradian overtones, have helped to bring this obscure nation to the world's attention and play pivotal roles in Rwandan tourism.

Since the gorillas and the genocide speak to Western notions of the primitive, Rwandan tourism accentuates these features to stand out in the highly competitive global tourist industry. Indeed, part of the appeal of genocide sites is their horrific nature. Rwanda's central position in Africa and the Western literary history of the larger region offer an authentic 'heart of darkness'. The personal, brutal nature of the violence in Rwanda singularizes it within the

larger category of atrocities and genocide, representing shocking barbarism even among the unprecedented bloodshed that defines the twentieth century. The fact that Western ideas of Rwanda's identity have been largely shaped by films helps define the tourist's expectations of Rwanda; therefore, the re-inscriptions of the primitive portrayed in the film must be reproduced. Furthermore, these expectations hinge on the 'public secret' inherent in all adventure tourism, which demands that the appearance of danger must be maintained so tourists can feel a sense of accomplishment.[2] At the same time, to attract Western tourists, their personal safety must be assured. Since the gorillas are powerful and potentially dangerous creatures, and the Rwandans have demonstrated they are capable of inhuman cruelty, there is much scope to stimulate the Western imagination.

Because *Gorillas in the Mist* and *Hotel Rwanda* are based on actual events, the films bring a presumed authenticity to tourists' understanding of Rwanda. This is exacerbated by the fact that both the gorillas and the genocide entered public culture and Western associations with Rwandan identity before the film's respective releases. The violent subplot of the Fossey story dramatically came to light on 3 February 1978, when CBS news anchor Walter Cronkite began his nightly newscast with the sentence 'Digit is dead' (Innominate Society, n.d.). This lead story highlighted the killing and subsequent decapitation of Digit, a silverback mountain gorilla and companion to Fossey. Because National Geographic funded much of Fossey's work, she was frequently featured in the magazine, including on a cover in 1970. Later photographs often included Digit and her interactions with him, particularly in the year preceding his death. Because of a 1975 *National Geographic* special featuring Fossey and Digit, the two attracted significant international attention and he was well known by the time of his death (Webber and Vedder 2001: 26). Furthermore, Digit was literally the poster child for Fossey's research. Much to her irritation, by 1972 he was featured in the Rwandan tourism board's posters, which included his image and the slogan 'Come and meet him in Rwanda', defining the experience as interactive through the use of the word 'meet'. Thus, their unique relationship was definitional in the story of the gorillas that is the backbone of Rwandan tourism, and the experience defined in terms of exchange rather than voyeurism.

Digit's killing also juxtaposed the innocence of nature and the brutality of man; Digit's victim status brought unprecedented awareness to the plight of the mountain gorillas and the nation of Rwanda. Not only was the gorilla killed by poachers, who allegedly sold his dismembered corpse, but his death also

represented collateral damage in the battle between Fossey and the impoverished local residents who were the greatest threat to the gorillas.[3] For many, their introduction to this tiny East African country was contextualized in violence. It fuelled Fossey's call for protection, which manifested in a charity dedicated to this aim. This same publicity ultimately generated gorilla tourism, which was officially adopted in 1979 and grew steadily until the genocide in 1994 (Neilson and Spenceley 2010: 233). The narrative of violence and vulnerability inherent in Digit's death would be re-inscribed by the highly publicized brutal murder of Fossey in the hills of Rwanda in 1985.[4]

Rwanda's association with violence was amplified again in 1994 when Hutu extremists targeted the Tutsi people for extermination, slaughtering an estimated 500,000 Rwandans in the course of a hundred days.[5] One of the stories that emerged from the genocide was Rusesabagina's, later inspiring George's film. The hotel represented in the film is now a distinct landmark in Rwanda (figure 31). It has become iconic, confirming Michela Wrong's assertion that Africa 'seem[s] to specialize in symbolic hotels which, for months or years, are

FIGURE 31. The pool and the back of the Hôtel des Mille Collines in Kigali, Rwanda. Photograph by Stephanie McKinney.

291

microcosms of their countries' turbulent histories' (2000: 16). For decades, it was the only hotel in the impoverished nation that met Western standards, making it a first-world oasis in the developing world. Prior to the genocide, this Belgian-owned hotel was the lodging of choice for visiting bureaucrats, diplomats and journalists.[6] Besides being the site of a siege during the genocide, the hotel was also used as a temporary headquarters for the United Nations Mission in Rwanda (UNMIR). As depicted in George's film, UNMIR held a meeting at the hotel just a few days before the genocide started. Apart from George's film, the Hôtel des Mille Collines is visible in several other stories from Rwanda that have reached Western audiences, and the locale is firmly implanted in the Western tourist's imagination.[7]

The Merits of Gorillas

Today, gorilla tourism, not genocide tourism, is the bulk of Rwanda's industry; however, it is difficult to spend any time in Rwanda without recognition of the genocide being part of the experience. As disparate as these appear, they consistently intertwine and reinforce a notion of primitivism that simplistically *explains* the genocide as tribal barbarism to many in the West. In addition, it justifies the privileging of the gorillas over Rwandans inherent in allocating such a significant portion of the land to animals. This is particularly striking given that the chronic shortage of land in Rwanda is cited among the causes of extreme poverty, if not the genocide itself. This prioritizing represents what Donna Haraway characterizes as 'simian Orientalism', the notion that, as our closest relatives, primates contain the 'raw material' for mankind and therefore their preservation is privileged (1989: 10–11). Africa has consistently been fetishized as the 'primitive past of the West', that is, the first link in the evolutionary chain that begins with untamed nature and ends with white, Western, heterosexual male-dominated civilization (Landau 2002: 3). Genocide represents a decisive moment away from the refined civilization that is the purported imperial goal, particularly when framed in terms of tribal conflict, as the Rwandan genocide was.[8] Thus, the apocalyptical nature of the genocide and the mythic regenerative potential of the gorilla represent a proverbial alpha and omega of humanity, all encompassed in a tourism that anthropomorphizes the gorilla against the backdrop of radical dehumanization inherent to genocide narratives.

Even in narratives explicitly dedicated to the genocide in Rwanda, gorilla tourism stands out. For example, the most comprehensive account of the UNMIR, written by United Nations Force Commander Lt. Col. Roméo Dallaire

(2003), details the logistical challenges of putting the mission together. Among the numerous problems he encountered were his staff's requests to visit the gorillas rather than work on required reports (ibid.: 75). Later, he was chagrined by civilian employees' use of the limited gasoline supply to travel to the gorillas (ibid.: 107). Even in the midst of a devastating humanitarian crisis, gorilla tourism remained a visible factor in Rwandan identity. This Western fascination with the primates also emerges in Samantha Power's (2002) narrative about United States' policy during the Rwandan genocide. Power points out that, in some cases, the animal rights activists concerned about the well-being of the mountain gorillas lobbied Congress for intervention more effectively than advocates for Rwandans (2002: 375). These anecdotes mirror the prioritization of the gorillas that characterizes Fossey's perspective, thus presenting a consistent pattern. At the same time, they illustrate how central 'seeing the gorillas' is in the Western experience of Rwanda. Without Fossey's dedication to the primates and her own dramatic tale, it is entirely possible that this endangered species could have slipped into extinction unnoticed. However, her work has made gorilla encounters an essential experience in Rwanda, even under the horrific circumstances of genocide.

Constructing Authentic Experiences

Rwanda is not the first nation to have a tourism industry based on a dark past. Most famously, the concentration camps of Auschwitz-Birkenau have become significant parts of Poland's international tourist industry. Before the mid-1980s, primarily those who had lost family members at the camps or were survivors visited these camps. This changed when Kraków began to benefit from the relaxation of travel restrictions and opening up of Central Europe to tourist markets (Ashworth 2002: 364). In addition, the success of Thomas Keneally's book *Schindler's Ark* (1982), and its film adaptation, Steven Spielberg's *Schindler's List* (1993), brought a dramatic rise in cultural tourism to Poland (Lennon and Foley 2000: 64). Even though the movie was filmed in Kazimierz, not far from the Auschwitz camp, it focused on events that actually happened at a different location (Ashworth 2003: 365). Nevertheless, the sites of the reproduced version have become tourist destinations. For example, the remnants of Spielberg's set became an attraction, partially because they were in better shape and were more conveniently laid out than the actual camps, making them less time consuming to visit than Auschwitz and Birkenau (Lennon and Foley 2000: 64). Kazimierz, one of the oldest Jewish districts in Eastern Europe, finds this

heritage manipulated by a tourist trade in which the Jewish cemeteries are highlighted as film sets, meaningless Hebrew words adorn local gardens, and Jewish-style cafes serve non-kosher products in their attempt to recreate a Jewish experience (Benstock 2005). Thus, recognition from films shapes Kazimierz's identity, prioritizing tourist expectations over authenticity. This has implications for Rwanda, which depends not only on the notoriety of the genocide to distinguish itself in the highly competitive African tourist market but also on Western fetishization of the gorillas and debatable claims of an authentic experience.

For gorilla trekkers, the encounter is highly structured, although framed as an adventure. As in most cases of adventure tourism, tour operators ensure that clients get exactly the experience they have purchased. No mystery lies in whether or not those on a tour will see a gorilla. Each of the gorilla groups visited by tourists has a tracker who stays with the primates 24 hours a day.[9] This tracker is in constant communication with the guide who leads the tourists through the mountains. Therefore, every trek has a very specific destination, and it is more a matter of meeting up with the embedded guide than an actual search for gorillas. Little is *natural* about the adventure, other than the gorillas themselves, who are observed in a very constructed context and, after decades of a thriving tourist industry, are accustomed to spending the allotted hours a day with people (in particular with the trackers who essentially live with them to monitor their whereabouts). However, the experience is framed as a unique and exclusive privilege, partially because the gorillas are endangered and rare. The fact that there is a hefty price to see them up close (the gorilla permit alone costs US$500 and the airfare to Rwanda is substantial for European and American tourists) adds to elitism. The entire encounter, therefore, is a luxury.

When the tours are marketed in print media and on the web, a photograph of a gorilla in the jungle gazing directly into the camera is shown consistently. The animal returning the gaze is an essential part of framing this experience as an exchange with nature à la Fossey, who brought gorillas to the world stage as potential companions. Advertising repeats this trope, displaying a gorilla against the backdrop of the jungle with no visible signs of civilization (figure 32). In reality, viewing the gorillas is a highly orchestrated collective experience with a human audience also participating in the gaze (figure 33). Although ecotourism is presumed to be 'the ultimate immersion and the greatest guarantee of authenticity and realism', this assumption belies its staged nature (Desmond 1999: 145).

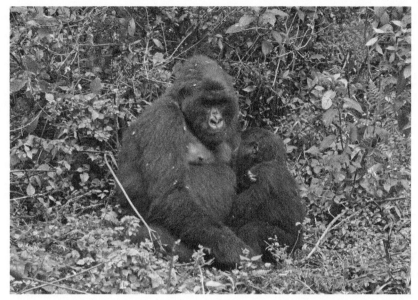

FIGURE 32. Typical presentation of the gorillas in the wild. Photograph by Stephanie McKinney.

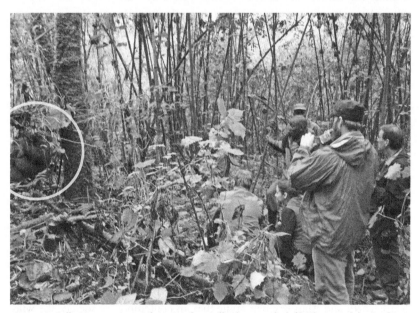

FIGURE 33. Collective experience of viewing the gorillas (seen on the left). Photograph by Stephanie McKinney.

Fundamentally, there is not much difference in viewing a gorilla in the wild and one in a zoo except for the lack of bars and the extra physical exertion required to get to the gorillas in the wild. Nevertheless, the entire industry relies on it being an intimate, if not transformative, experience. As one journalist explains,

> Seeing wild gorilla is a transcendental experience, a discovery of such intensity that each visitor remembers the moment in the most personal terms . . . Meeting the gorilla is a one-on-one experience, and in the dense brush of the Virungas there is no place to run, no way to break free of the entrapping vegetation which the gorilla, if so inclined, can glide through in an instant (in Hayes 1990: 88–9).

This sentiment exemplifies the romanticized gorilla experience and offers no indication that it is a highly structured performance in which only the gorilla's part has any room for improvisation. Thus, this contact with the wild carries a measure of perceived danger since, unlike the tourists, the gorillas are not obligated to maintain the required 15 feet from their human visitors. Owing to their size and strength, the gorillas are potentially dangerous to tourists; however, intimate contact is achievable, as Fossey's scientific study demonstrates, providing the violence and romance that frames the Rwandan tourist experience. While the fetishization of the gorillas dates back to the Belgian colonists' designation of the park for their preservation, Fossey and her highly visible work made this available to anyone with the resources to travel to Rwanda.

The appeal of animal tourism, exacerbated in the case of large, potentially dangerous mammals, depends on being close to nature. As Jane C. Desmond explains, animal tourist venues 'are, in fact, huge industries based on the idea of nature as one of the last bastions of idealized authenticity in the post-modern era and on animals as exemplars of wilderness' (1999: 148). Desmond maintains it is this possibility of reciprocal contact, 'a return of the gaze', that makes these interactions performances rather than exhibits (ibid.: 188–9). Nowhere in animal tourism is the return of the gaze more obvious than in gorilla tourism, where humanity is most projected on the animal subjects. As performances, these encounters are not pure representations of nature but elaborately constructed spectacles designed to fulfil Western fantasies.

This fantasy is increasingly looking towards nature for adventure. Alan Beardsworth and Alan Bryman argue that, in contemporary society, the wild animal embodies 'otherness' for the urban individual since it is 'outside' human

society, yet internalized in society through categorization, recognition and description (2001: 85). This is especially true of primates, who have long been perceived as the gateway between the human and the animal. Fossey's story enhanced primates' importance as the intermediaries between human and non-human life.[10] Additionally, primates represent the primordial origins of man; therefore, their preservation and man's are inexorably linked. This is especially important at a moment in history when 'all members of the Primate Order—monkeys, apes, and people—are threatened', and the doctrine of conservation is as much about human survival as that of other species (Haraway 1989: 3). This survival narrative is heightened by the collocation of gorillas and genocide within Rwanda. Consequently, Rwanda represents the extremity of man's self-destructive potential and the primordial raw material for rebuilding humanity. Furthermore, the gorillas themselves are powerful yet vulnerable due to precarious survival. Their existence is inherently tied to and dependent on human existence, given their endangered status. The proximity of gorillas and genocide in Rwanda potentially annihilates the past, present and future of all primates.

The theme of salvation that characterizes the rhetoric of the mountain gorillas is also directed towards high-end eco-tourists who visit the gorillas, emphasizing the considerable economic benefits that tourism provides. At the close of the gorilla tour, visitors are thanked for their contributions to conservation and encouraged to go home and tell others of the beauty of Rwanda and the wonders of the gorillas. There is little consideration of the cost for local residents, who, as depicted in both Fossey's account and the George's film, encroach upon the park for survival in the most densely populated region of Rwanda (International Monetary Fund 2008: 9). However, the government's desire to maintain and further develop the tourist industry requires attending to the needs of the human population while depriving them of scarce resources to maintain the purity of the environment for the gorillas. This can be achieved through emphasis on development projects, such as a luxury hotel that employs locals. Thus, the overall message is that devoted eco-tourists are saving both the gorillas and the Rwandans. (Given the near extinction of both Rwandans and gorillas in recent history, clearly both need saving.)

The fact that these local issues are not apparent to the average tourist is not surprising. Essentially, tourism is selling fantasy, albeit defined and regulated. Ecotourism is just as guilty of this as any other form of tourism, and perhaps even more so since it purports to offer a kinder, gentler, more culturally sensitive

'tourist gaze' than others.[11] Ironically, the same features that make it environ-mentally friendly, such as catering to small groups, often generate complaints from host communities, who would rather have the employment and income generated by the larger and more 'exploitative' forms of tourism (Bowmann 1996: 84). One fallacy is the presumption that 'ecotourism can save environ-ments, deliver development, and spiritually uplift while using jumbo jet aircraft for transporting ecotourists (ego-terrorists?) to the last "pristine" and "untouched" wildernesses remaining on our heavily burdened planet' (Higgins-Desbiolles 2007: 315). The environmental and financial cost of getting to these places mitigates the negligible benefits to the Third World, making eco-tourism another manifestation of First World privilege. This unequal exchange is made even more onerous by ecotourism's failed promise to deliver 'peace, development, conservation as well as consumer happiness simultaneously' (ibid.: 316). Given the dubious record of any form of tourism reaching these goals, this cynicism is well founded. The marketing forces behind tourism have successfully accentuated these aspects without demanding much analysis of their efficacy, even in terms of cost and benefit to the communities that host them.[12] Thus, the attention to the gorillas fortifies several myths both inside and outside Rwanda. Residents are increasingly made aware of the cultural significance of the gorillas and the need to maintain a mutually beneficial rela-tionship; tourists are assigned the roles of explorer and philanthropist in the scripted gorilla tourist experience.

Scripting Genocide

For many Western tourists, the genocide is largely understood through Rus-esabagina's experience as depicted in *Hotel Rwanda*, making the film a founda-tional story in Rwandan tourism. While the Fossey legend positions her as occupying the space between man and nature, Rusesabagina negotiates between Rwanda and the West. The ability to speak both languages allows him to confer simultaneously with local *génocidaires* and international leaders, a skill that ensures his survival. The film establishes Rusesabagina as a man who under-stands the expectations of both worlds. In the first few minutes, he works seamlessly through a number of challenges to bring lobsters to the luxury hotel, a feat requiring great finesse in a remote, landlocked country. This introduction to Rusesabagina illustrates the difficulty of bringing sophisticated civility to Rwanda and his fluency in several local languages.

Rusesabagina's story, during both the genocide and the film, depend on this fluency. The hotel becomes a refuge for a variety of potential victims of the genocide, including Rusesabagina's Tutsi wife and children. He saves the lives of those besieged in the hotel by bribing the soldiers and exhausting every possible contact within and outside Rwanda to thwart numerous attempts by the *génocidaires* to invade the hotel and remove its residents. To successfully navigate between the West and the chaos that is Rwanda, Rusesabagina needs his title as manager of the Hôtel des Mille Collines and the physical manifestation of the West that the hotel provides. Because it is Belgian-owned, Rusesabagina is not entirely in Rwanda. However, this imperial space is left to Rwandans when all of the white guests (including journalists) flee the country, escorted out of the hotel by UN troops. Recognizing that they cannot maintain order in the face of utter mayhem, the international community (most visible in the form of the United Nations) sits passively and leaves Rusesabagina to fend for himself.[13] Although Rusesabagina demonstrates remarkable diplomacy, he cannot be fluent enough in the language of the West to override his Africanness. This is blatantly pointed out in the film when Rusesabagina breaks down, realizing that the lives of those in the hotel are worthless because they are 'not white'. No amount of *savoir faire* can overcome this, and the salvation of all of those who have entrusted him is his responsibility alone. In the same scene, Rusesabagina becomes a metaphor for Rwanda itself, which was equally abandoned during the genocide in spite of the economic potential it had been previously ascribed.

This metaphor is particularly apt given the international attention Rwanda garnered prior to the genocide as model of development in the Third World. Playing on its reputation as the 'land of a thousand hills', it was also known as the 'land of a thousand NGOs'. This reference to non-government organizations speaks to the potential the West has always seen in Rwanda, dating back to the colonial assertion that the country was a 'colonial gem' and the presumption that the Tutsi, who would later be targeted in the genocide, were the most evolved of the African tribes.[14] Thus, romance has always been part of the Western imagery of Rwanda and its distinctiveness within Africa a key facet of national identity. The fact that so many Westerners were available to witness and flee from the genocide distinguishes Rwanda. In the film, this is depicted as Western journalists and UN troops apologetically withdraw, leaving Rusesabagina, not to mention the rest of Rwanda, alone to deal with the genocide.

In those 100 days of 1994, instructions were broadcast over a national radio station and bodies were heaped in streets, stadiums, schools and churches,

leaving no plausible deniability in this case. The Western lack of response cannot be seen as anything less than an informed decision.[15] Therefore, the film *Hotel Rwanda* has some limitations as a foundational myth for the tourism industry. It is too public and well known to be discounted, but raises difficult questions within and outside Rwanda. The Fossey story capitalized on many pre-existing Western tropes and preconceptions of Africa, making a natural segue between the internationally known story and tourism development. While the genocide, and its film interpretation in *Hotel Rwanda*, contains many of the same themes as Fossey's account, it is far more difficult to translate. The gorillas maintain an unconditional innocence and political neutrality that is difficult to replicate among humans, and Fossey is ultimately a heroic figure whose transgressions can be optimistically interpreted as a manifestation of her passion for a vulnerable species. As a targeted minority, the Tutsi share this vulnerability in the genocide, yet they have no visible Western champion. Instead, as portrayed in the film, an apologetic West departs in a collective radical re-assessment of Rwanda's potential as the nation goes from a model of development to unmanageable chaos and destruction. Even the heroic narrative portrayed in *Hotel Rwanda* cannot mask the fact that, in the end, the story of the genocide is largely one of betrayal.

From a marketing perspective, this makes it difficult to use the genocide in Rwanda as a means of attracting Western tourists. For a variety of political reasons, the role of Western inaction is highlighted in most public renditions of the genocide. These include national genocide commemorations and exhibits at the most visited genocide site, the Kigali Memorial Centre, which contains a museum, mass graves and a documentation centre. It is also the only one to offer any kind of explicit explanation about the genocide. Since the film presents a single story, the larger context of the genocide is largely absent, reflecting the fact that the subject of history has been dropped from the curriculum in post-genocide society (Waldorf 2009: 106). However, in the highly competitive market that is African tourism, there is no bad publicity. The release of this film coincided with the rebuilding of gorilla tourism, which had been devastated during the genocide. However, unlike the leveraging of Fossey's work to build tourism, the Rwanda government is not capitalizing on the acclaim Rusesabagina received for his actions during the genocide. Instead, the complexity of politics in Rwanda means that the story of Rusesabagina is largely suppressed within the country, creating another obstacle to the film being formative in the tourism industry.

One of the reasons for this reluctance is the choice of the hotel owners to emphasize the hotel as a business rather than a genocide site. Repairs were undertaken immediately after the genocide, leaving no physical traces of the siege (Lacey 2005). In 2010, the hotel completed an extensive renovation, erasing any lingering traces in its physical structure. The only tangible connection to the events is the staff that survived the genocide along with the intended targets (ibid.). Although this site has all the makings of a tourist locale, its infamy is secondary to its identity as an upscale hotel and conference centre. Because *Hotel Rwanda* was filmed in South Africa, not Rwanda, tourists will not recognize the locations of memorable scenes, whereas the experience of *Schindler's List*, tourists suggest, can be preferable to the authentic experience. Consequently, little in the hotel itself encourages genocide tourism.

The hotel is also not explicitly highlighted in tourism because of the vehemently negative response to *Hotel Rwanda* within Rwanda, particularly the positioning of Rusesabagina as a hero. The reasons for this are multifaceted,[16] relating to the complex negotiation of ethnic identity in post-genocide Rwanda. Rusesabagina was a Hutu, and Hutu extremists perpetrated the genocide in the name of all Hutu. The fact that the first heroic narrative of the genocide featured a Hutu well connected with the West makes the story a difficult one to tell within Rwanda. With the wounds from the genocide so fresh, and the complexities of victimhood still not fully explored, many Rwandans are not willing to see a Hutu in heroic light (Bisiika 2006). The current government has been especially virulent in discrediting Rusesabagina's story. For example, Kigali's main newspaper described Rusesabagina as an 'impostor humanitarian' and the charitable foundation he established as 'a hoax' (Mugabo 2007). His critics in Rwanda view him as a collaborator and the attention he received through the film as shameless self-promotion. A former head of IBUKA, the umbrella group for survivor organizations in Rwanda, accused Rusesabagina of 'hijacking heroism and trading with the genocide' (quoted in Waldorf 2009: 114). Like many aspects of the genocide, the controversy round Rusesabagina is ongoing, as his June 2011 arrest for funnelling funds to Hutu militants in exile demonstrates.[17] That Rusesabagina and his story have become definitional in the Western understanding of the genocide is viewed as yet another usurping of history that can be attributed to the uncritical relationship between the Hutus and the West, both of which are publicly held accountable for the genocide in Rwanda. Thus, the hotel is not listed on any city tour sponsored by Rwanda's tourism office and the only book available about the genocide at the

hotel site is one discrediting Rusesabagina (ibid.: 102). The presence of the book ironically reinforces the very myth it seeks to negate, providing a concrete connection between the film and the hotel, manifesting the embattled role of memory in Rwanda.

The conflict surrounding Rusesabagina demonstrates the larger conflicts round the genocide and victimhood narratives. Within Rwanda, the genocide must be referred to as 'the genocide against the Tutsi', and failure to use this terminology, which negates any recognition of Hutu victims, can lead to charges of promoting 'genocide ideology' (ibid.: 107). As a result, the options within Rwanda are to stick to a very scripted and limited version of the events of 1994, or risk being accused of actively promoting the mentality that fostered the genocide. Rusesabagina is one of many visible figures associated with Rwanda to face this kind of attack.[18] Therefore, in being the subject of a counter-narrative, both because it features a heroic Hutu and was created outside Rwanda, Rusesabagina has become highly controversial within Rwanda.

In spite of this official rejection of the narrative, the Hôtel des Mille Collines is heavily identified with Rusesabagina and accentuating its connection to the genocide inherently accentuates his story. In this case, the identity of the hotel during the genocide, suppressed within Rwanda, is firmly implanted in the Western imagination, and, despite its identity being officially displaced, the Rwandan population is fully aware of the significance of the hotel to Western tourists and any tour guide or taxi driver will point out the hotel. However, this suppression of identity is unlikely to diminish the hotel's significance in the Western imagination or Rwandan tourism given its notoriety and the fact that it is the most visible touchstone for the Western tourists who come to the country.

Genocide and Tourism

As the *Hotel Rwanda* story demonstrates, Rwanda's relationship with its genocidal past is still hostile, which partially explains the national focus on the gorillas and the scant attention paid to the genocide in the public discourse on tourism. However, the unprecedented increase in visitors necessarily incorporates genocide sites as well. So, while tourists are encouraged to come for the gorillas, once in the country they are encouraged to visit the genocide memorial. This has created a bit of an 'accidental genocide tourism' industry since genocide tourism is not mentioned in the official assessments by the World Bank and

the International Monetary Fund, which highlight tourism based on wildlife. However, visiting a genocide site is virtually a requirement, and even in the remote Virunga Mountains the guides will remind tourists to visit the Kigali Memorial Centre, which is a requisite stop on itineraries of tourists and state officials alike and a means through which visitors can acknowledge the genocide before or after heading off to encounter gorillas. Because there is very little for tourists to do in Kigali, which is still struggling to meet the expectations of its First World visitors, a visit to the Kigali Memorial Centre is actively encouraged by those Rwandans in frequent contact with tourists.

Genocide tourism is downplayed in some public contexts and accentuated in others, demonstrating Rwanda's ambivalence towards promoting this identity. It is conspicuously absent in the official discourse about tourism in Rwanda.[19] Nevertheless, genocide sites comprise about a third of the stops in the official city tour of Kigali (the Hôtel des Mille Collines is not among these) and it is a prominent feature in Rwandan public culture, which has been described as 'obsessed with remembering the genocide' (ibid.: 101). This obsession does not carry over to marketing and promotion in the tourism sector, creating a disjoined practice of accentuating and ignoring the role of the genocide in public culture, as exemplified by the various official negations of the *Hotel Rwanda* story and the willingness of every Rwandan cab driver to point out the infamous locale to tourists.

One of the predominant drives behind genocide tourism is education. Given the contested history that genocide tourism entails and the fact that Rwanda is still very actively wrestling with this recent history, it is a particularly demanding expectation for Rwanda to address. If Rwandans cannot discuss the genocide among themselves, it is difficult to imagine how they will translate this experience to others. Therefore, the genocidal past must be actively negotiated in contemporary Rwanda. The fact that it is so embedded in Rwanda's national identity also ensures that it meets Western tourist expectations, and the current attempt to establish the memorials as World Heritage Sites suggests that this facet of Rwandan identity will become a permanent feature.[20]

While genocide tourism is presumed to encompass memorialization and education, there is also an intangible experience of *knowing* that visitors to sites of mass atrocity often seek (Beech 2009: 202). Journalist Philip Gourevitch analyses both his reader's and his own compulsion to examine genocide sites when arranging his visit to the mass graves of Rwanda:

> Like Leontius, the young Athenian in Plato, I presume that you are
> reading this because you desire a closer look, that you, too, are properly
> disturbed by your curiosity. Perhaps, in examining the extremity with
> me, you hope for some understanding, some insight, some flicker of
> self-knowledge—a moral, a lesson, or a clue about how to behave in
> this world [. . .]. The best reason I have come up with for looking
> closely in[to] Rwanda's stories is that ignoring them makes me even
> more uncomfortable about existence and my place in it. The horror,
> as horror, interests me only insofar as a precise memory of the offense
> is necessary to understand its legacy (1998: 19).

In this passage, Gourevitch evokes Plato's story of Leontius, who, when passing
a pile of corpses, was both compelled to view the site and repelled by his own
morbid curiosity. Ultimately, Leontius gave in, viewed the cadavers and was
amazed by their horrible beauty. Gourevitch returns to the ancient negotiation
of beauty and revulsion, contemporizing by using the overt Conradian reference
to the *horror* to describe his experience in yet another dark chapter in the
Congo region. The passage is more about the viewer's experience than about
the display of skulls at Nyarbuye, the site that provokes Gourevitch's response,
illustrating the prominence of the Western gaze even when viewing other's
atrocities. This narrative of encounter suggests a transformative potential, nec-
essary in the act of viewing, echoing the premise of gorilla tourism. However,
it is the remnants of horror presented in the display of human skulls in many
Rwandan genocide memorials that require Western acknowledgement. The
tourist in Rwanda is positioned between the vacant gaze of the skulls and the
blank stare of the gorilla, both of which purport to offer a better understanding
of (in)humanity.

Without the release of *Gorilla in the Mist* and *Hotel Rwanda*, it is hard to
imagine that the Western tourist would know what to look for in Rwanda. The
publicity that both films generated has distinguished Rwanda and shaped its
tourism industry. While the Fossey story has proven highly lucrative for Rwanda,
and an easy one to integrate, the story of Rusesabagina is far more difficult to
negotiate. The competing narratives demonstrate not only Rwanda's difficulty
in coming to terms with its own past but also that, despite disconcerting limi-
tations on free speech in Rwanda today, the restrictive government cannot
effectively manage popular culture. Both gorilla tourism and genocide sites
allow Western visitors to connect with the primitive, albeit in highly structured
contexts. Framed in terms of educational and ecological benefits, the tourist

experience is also dependent on encountering the Conradian horror, displaying the violent aspects of man's nature from a safe distance. Other narratives, such as the intensity of the genocide in the same region as the gorilla's habitat and the national resources absorbed by privileging these primates, are pointedly omitted. Thus, Rwandan tourism reflects the staged romanticism and contained violence sought by the Western tourist gaze.

Notes

1 Marianna Torgovnick describes the primitive as denoting a generalized image associated with numerous regions, including Africa and the Amazon, in which ritual behaviour (drumming, dancing, initiations etc.) 'expresses respect for the power of nature and the supernatural' (1997: 4).

2 Robert Fletcher argues that adventure tourism depends on a 'public secret' (2010: 10). Despite this kind of tourism being marked as an exhilarating experience, it is actually a highly structured experience where risk has been minimalized to accommodate the masses. Travelling to remote locals for exotic experiences give tourists a sense of accomplishment even though there is virtually no risk involved because the entire experience is constructed (ibid.).

3 Dian Fossey concluded that Digit was not the intended target of the poachers, who were trapping antelope when they encountered Digit's family group. She surmised that he was killed defending his dependents, and that the removal of his head and hands was an afterthought since the profitability of gorilla parts was widely known (1983: 208).

4 Fossey was slaughtered in her cabin in the Virunga National Park, Democratic Republic of Congo.

5 Human Rights Watch estimates the deaths at 507,000 (Des Forges 1999: 17).

6 The hotel appears in this context as a harbour for Belgians in the film *Gorillas in the Mist* in a scene where Dian Fossey (played by Sigourney Weaver) confronts a Belgian official about the selling of baby gorillas to a Belgian zoo. Both in the film and real life, she correctly predicted the infants would die in captivity.

7 The hotel is also central in journalist Philip Gourevitch's account of the Rwandan genocide, *We Wish to Inform You that Tomorrow We Will Be Killed with Our Families* (1998), which features Paul Rusesabagina's story among others. Canadian novelist Gil Courtemanche's *A Sunday at the Pool in Kigali* (2003) also prominently features the hotel, whose pool is referenced in the title.

8 Garth Myers, Thomas Klak and Timothy Koehl have reported that the events in Rwanda were consistently framed in terms of 'tribal warfare' and described

with adjectives such as 'savage' or 'bloodthirsty' far more often than a similar genocide occurring in Bosnia at the same time (1996: 22). The conflict in Bosnia received far more press coverage overall, and was more often described in military terms, in spite of the presence of trained armies in both conflicts. This contributes to the overall 'othering' of Africa that began in colonial times and continues to this day (ibid.).

9 The mountain gorillas live in groups with one alpha male and several female gorillas. In the Virunga Mountains, some groups are monitored for research and not visited by tourists, whereas others are committed to the tourist industry. Thus, the gorillas are quite accustomed to human presence whether or not they are visited by tourists.

10 Donna Haraway's *Primate Visions: Gender, Race, and Nature in the World of Modern Science* (1989) is an in-depth exploration of how primates have been used to reinforce social norms through the intersection of science, race, sexuality and gender.

11 According to John Urry, the tourist gazes in a Foucauldian sense in that it is 'socially organized and systematized' constructed viewing (1990: 1).

12 For example, in Rwanda, tourist revenue is very publicly counted. However, the percentage of the national budget devoted to the support of tourism is much harder to ascertain.

13 For a full account of the complexities and limitations of the UNMIR, see Robert Dallaire (2003).

14 The superiority of the Tutsi and the foundations of that myth have been explored in several sources; for a discussion of this, see Nigel Eltringham (2006).

15 Several works on the genocide make this aspect clear; for relevant discussions, see Linda Melvern (2000) and Michael Barnett (2002).

16 The film was also shot in South Africa, unlike other films on the genocide, such as Raoul Peck's *Sometimes in April* (2005) and Michael Caton-Jones' *Shooting Dogs* (2005), both of which were filmed in Rwanda.

17 Belgian officials are investigating charges that Rusesabagina has been providing funds to the Forces Democratiques de Liberation du Rwanda, a rebel faction composed partially of those who fought for the extremist Hutu government during the civil war which accompanied the genocide (Rice 2010).

18 Alison Des Forges, author of the 1999 Human Rights Watch report that has remained the most comprehensive account of the genocide and is foundational in the field, found herself charged similarly when she supported the relocation of the genocide trials to Tanzania to ensure a fair process (Waldorf 2009: 112).

19 When I discussed tourism development with Emmanuel Werabe, director of Tourism Research and Development at the Rwandan Office for Tourism and National Parks, genocide tourism did not come up in the context of Rwanda's national or international development strategy (interview conducted by the author, Kigali, 4 April 2008).

20 Ildephonse Karengara, director of Memorials, interview conducted by the author, Kigali, Rwanda, 9 April 2008.

Works Cited

APTED, Michael (dir.). 1988. *Gorillas in the Mist: The Story of Dian Fossey*. Universal Pictures, Warner Home Video DVD, colour, 129 minutes.

ASHWORTH, Gregory J. 2002. 'Holocaust Tourism: The Experience of Kraków–Kazimierz'. *International Research in Geographical and Environmental Education* 11(4): 363–7.

———. 2003. 'Heritage, Identity and Places: For Tourists and Host Communities' in Shalini Singh, Dallen J. Timothy and Ross K. Dowling (eds), *Tourism in Destination Communities*. Oxon: CABI Publishing, pp. 79–98.

BARNETT, Michael. 2002. *Eyewitness to a Genocide: The United Nations and Rwanda*. Ithaca, NY, and London: Cornell University Press.

BISIIKA, Asuman. 2006. 'Why Rwanda Is Uneasy about Genocide Movies'. *The Monitor* (*Kampala*), 21 May. Available at: http://allafrica.com/stories/200605220291.html (last accessed on 30 September 2008).

BEARDSWORTH, Alan, and Alan Bryman. 2001. 'The Wild Animal in Late Modernity: The Case of the Disneyization of Zoos'. *Tourist Studies* 1(1): 83–104.

BEECH, John. 2009. 'Genocide Tourism' in Richard Sharpley and Philip R. Stone (eds), *The Darker Side of Travel: The Theory and Practice of Dark Tourism*. Bristol: Channel View Publications, pp. 207–24.

BENSTOCK, Jes (dir.). 2005. *The Holocaust Tourist*. Technobabble/Skyline Films, colour, short.

BOWMANN, Glenn. 1996. 'Passion, Power and Politics in a Palestinian Tourist Market' in Tom Selwyn (ed.), *The Tourist Image*. Chichester and New York: John Wiley, pp. 83–103.

COURTEMANCHE, Gil. 2003. *A Sunday at the Pool in Kigali* (Patricia Claxton trans.). Edinburgh, UK: Canongate.

DALLAIRE, Roméo. 2003. *Shake Hands with the Devil: The Failure of Humanity in Rwanda*. New York: Carroll and Graf.

DES FORGES, Alison. 1999. *Leave None To Tell The Story: Genocide in Rwanda*. New York: Human Rights Watch.

DESMOND, Jane C. 1999. *Staging Tourism: Bodies on Display from Waikiki to Sea World.* Chicago: University of Chicago Press.

ELTRINGHAM, Nigel. 2006. ' "Invaders Who Have Stolen the Country": The Hamitic Hypothesis, Race and the Rwandan Genocide'. *Social Identities* 12(4): 425–46.

FOSSEY, Dian. 1983. *Gorillas in the Mist.* New York: Houghton Mifflin.

FLETCHER, Robert. 2010. 'The Emperor's New Adventure: Public Secrecy and the Paradox of Adventure Tourism'. *Journal of Contemporary Ethnicity* 39(1): 6–33.

GEORGE, Terry (dir.). 2004. *Hotel Rwanda.* United Artists, Eiv DVD, colour, 121 minutes.

GOUREVITCH, Philip. 1998. *We Wish to Inform You that Tomorrow We Will Be Killed with Our Families.* New York: Picador.

HAYES, Harold T. P. 1990. *The Dark Romance of Dian Fossey.* New York: Simon & Schuster.

HARAWAY, Donna. 1989. *Primate Visions: Gender, Race, and Nature in the World of Modern Science.* New York: Routledge.

HIGGINS-DESBIOLLES, Freya. 2007. 'Hostile Meeting Grounds: Encounters between the Wretched of the Earth and the Tourist through Tourism and Terrorism in the 21st Century' in Peter M. Burns and Marina Novelli (eds), *Tourism and Politic: Global Frameworks and Local Realities.* Amsterdam and Boston: Elsevier, pp. 309–32.

INNOMINATE SOCIETY. n.d. 'Karisoke Revisited: A Study of Dian Fossey'. Available at: http://www.innominatesociety.com/Articles/Karisoke%20Revisited.htm (last accessed on 13 January 2011.

INTERNATIONAL MONETARY FUND. 2008. 'Rwanda: Poverty Reduction Strategy Paper'. *IMF Country Report No. 08/90*, March 2008. Washington, DC: International Monetary Fund. Available at: http://www.imf.org/external/pubs/ft/scr/2008/cr0890.pdf (last accessed on 21 October 2013).

KENEALLY, Thomas. 1982. *Schindler's Ark.* London: Hodder & Stroughton.

LACEY, Marc. 2005. 'Dramatic Role in '94 Horror Haunts Hotel'. *The New York Times*, 28 February. Available at: http://query.nytimes.com/gst/fullpage.html?res=9B0CE1-D8153DF93BA15751C0A9639C8B63 (last accessed 21 October 2013).

LANDAU Paul S. 2002. 'Introduction. An Amazing Distance: Pictures and People in Africa' in Paul S. Landau and Deborah D. Kaspun (eds), *Images and Empires: Visuality in Colonial and Postcolonial Africa.* Berkeley: University of California Press, pp. 1–40.

LENNON, John, and Malcolm Foley. 2000. *Dark Tourism: The Attraction of Death and Disaster.* London: Thompson Learning.

MELVERN, Linda. 2000. *A People Betrayed: The Role of the West in Rwanda's Genocide.* London and New York: Zed Books.

MOWAT, Farley. 1987. *Woman in the Mists: The Story of Dian Fossey and the Mountain Gorillas of Africa*. New York: Warner Books.

MUGABO, Charles. 2007. 'Paul Rusesabagina Creates Hoax Charity to Enrich Himself'. *The New Times* (Rwanda), 22 October. Available at: http://www.newtimes.co.rw/-news/index.php?i=1326&a=1788 (last accessed on 30 September 2008).

MYERS, Garth, Thomas Klak and Timothy Koehl. 1996. 'The Inscription of Difference: News Coverage of the Conflicts in Rwanda and Bosnia'. *Political Geography* 15(1): 21–46.

NEILSON, Hannah, and Anna Spenceley. 2010. 'The Success of Gorilla Tourism in Rwanda: Gorillas and More' in Punam Chuhan-Pole and Manka Angwafo (eds), *Yes Africa Can: Success Stories from a Dynamic Continent*. Washington, DC: World Bank, pp. 231–52. [Originally a background paper for the African Success Stories Study, prepared for the World Bank and the Netherlands Development Organization (April). Available at: http://siteresources.worldbank.org/AFRICAEXT/Resources-/258643-1271798012256/Tourism_Rwanda.pdf. Accessed 21 October 2013].

POWER, Samantha. 2002. *The Problem from Hell: America and the Age of Genocide*. New York: HarperCollins.

RICE, Xan. 2010. 'Hotel Rwanda Manager Accused of Funding Terrorism'. *The Guardian*, 28 October. Available at: http://www.theguardian.com/world/2010/oct/28/hotel-rwanda-manager-terror-funding-charges (last accessed on 1 July 2011).

TORGOVNICK, Marianna. 2003. *Primitive Passions: Men, Women, and the Quest for Ecstasy*. New York: Alfred A. Knopf.

URRY, John. 1990. *The Tourist Gaze: Leisure and Travel in Contemporary Society*. London: Sage.

WALDORF, Lars. 2009. 'Revisiting *Hotel Rwanda*: Genocide Ideology, Reconciliation, and Rescuers'. *Journal of Genocide Research* 11(1): 101–25.

WEBBER, Bill, and Amy Vedder. 2001. *In the Kingdom of the Gorillas: Fragile Species in a Dangerous Land*. New York: Simon and Schuster.

WRONG, Michela. 2000. *In the Footsteps of Mr. Kurtz: Living on the Brink of Disaster in Mobutu's Congo*. New York: HarperCollins.

Welcome to Sarajevo!
Touring The Powder Keg[1]

PATRICK NAEF

A powder keg: this stereotypical metaphor often describes the Balkans, a stable and quiet region that burst into violence and became fractured under the spark of one single event. The city of Sarajevo was already compared to a powder keg in 1914, when Gavrilo Princip, a Serb nationalist, assassinated Archduke Franz Ferdinand and his wife. This incident is perceived as the event—the spark—that set off the First World War. This same image is frequently used in reference to what global media and movie productions commonly call the 'Balkan wars'. The film *The Powder Keg*,[2] produced in 1998 by the Serb director Goran Paska-jevic, and *Fire*,[3] produced in 2003 by the Bosnian[4] director Pjer Zalica, are explicit illustrations of this metaphor. Although these films have had some impact beyond the borders of former Yugoslavia, they are not known well enough to influence the imagination of potential foreign tourists. However, the works of world-famous director Emir Kusturica are a major factor in the production of a Balkan imagination, steeped in gipsy music, alcohol and guns. Kusturica's *Underground* (2005), for instance, spans from the Second World War to the conflict of the 1990s, as perceived by a community hiding underground. Kusturica is frequently criticized in his native Bosnia for his seemingly derogatory fantasy with which he often portrays the region. In fact, there seems to be a gap between the ways in which the Balkan reality is seen locally and the 'myth' propounded by the director. As the Slovenian philosopher Slavoj Žižek stated:

> I think that cinema is today a field of ideological struggle, some struggle is going on there and we even can see this clearly with regard to post Yugoslav horrible war; we have some of the films from here which are authentic but unfortunately the biggest successes were not authentic. By this I mean for example Emir Kusturica's *Underground*. I think that film is almost tragic—I would not say misunderstanding falsification—in the sense that: what image do you get of ex-Yugoslavia

from that film? A kind of a crazy part of the world where people have sex, fornicate, drink and fight all the time; he is staging a certain myth, which is what the West likes to see here in [the] Balkans: this mythical other which has been the mythical other for a long period (in *euronews* 2008).

Žižek added that the Balkans seem to form the 'unconscious of Europe', which tends to project on to it 'all its dirty secrets [and] obscenities' (ibid.). The Balkans is thus trapped not only in its own dreams but also in those of Western Europe. This takes us back to our initial queries about the 'other' Balkans. Is this 'mythical' or imagined Balkans present in the field of tourism? How does some of the touristic material participate in the construction of this imagery, in the same way as movies do?

Rachid Amirou takes a psychosocial approach to the 'mythical and anthropological basis of tourist behaviour' (1999: 22; translation mine). He introduces the notion of a touristic imagination and presents tourism as the expression of a triple quest of place, self and others:

> From this viewpoint, the touristic imaginary can be seen from three angles. First, the exotic, rooted in the symbolism of place and space. For each particular place (Paris, Rio, Calcutta) and each type of space (mountain, desert, beach) there are corresponding images, stories and representations that guide and organize tourist behaviour. The two other dimensions refer to tourism as a personal experience. In the relation to self, it equates a quest for meaning. In the relation to others, it translates into the search for forms of sociability that offer an alternative to daily routine (ibid.; translation mine).

Amirou (1994) also notes that the function of stereotypical images shaping the tourist universe has been neglected by researchers and puts forward the idea of tourism as 'transitional object', echoing the theory of child psychiatrist Donald Winnicot (1953) who coined the term. Just as a child's game allows a transition 'between the state of union with the mother to the state where he is in relation with her as something external and separated', the touristic imagination takes place in an 'intermediate area of experience' (Amirou 1994: 151; translation mine), facilitating the transition between here and elsewhere, between the known and the unknown. These stereotypical images, even distorted, have an essential function in the tourist's perception of the unknown. Noel B. Salazar (2009) situates tourism in the conceptual framework that David Harvey (1989) defines as

the 'image production industry' (in Salazar 2009: 49). Salazar adopts, in part, Amirou's theory of tourism as transitional object: 'more than physical travel, [tourism culture] is the preparation of people to see other places as object of tourism, and the preparation of those places to be seen' (ibid.: 50). In a study on the influence of a touristic imagination on the Masai society, Salazar suggests we must ask how tourism and its associated imagination shape and (re)shape cultures and societies. He presents elements which, together with tourism, contribute to the (re)modelling of cultures and stresses the importance of popular culture media: 'The influence of popular culture media forms—the visual and textual content of documentaries and movies; art and museum exhibitions; trade cards, video games, and animation; photographs, slides, video, and postcards; travelogues, blogs, and other websites; guidebooks and tourism brochures; coffee table books and magazines; literature; advertising; and quasi-scientific media like National Geographic—is much bigger' (ibid.: 51).

Whether we are talking of imagination in general or a touristic imagination in particular, many authors agree on the importance of popular culture and associated media in the construction of imagination. It is beyond dispute that elements such as the media, tourist materials and artistic creations contribute to the modelling of these imaginations; but it is also important to observe how these imaginations shape and influence not only a tourist destination but also, as Salazar corroborates, entire societies and cultures.

Maria Torodova (2009) describes the agent and the recipient in the construction of what she construes as the Balkanist 'myth'.[5] She presents Western discourse mainly as an external agent in the production of this Balkanist dynamic, and adds that the outside perception of the Balkans has been internalized in the region itself: 'Although they have been passive objects in the shaping of their image from without [. . .], the Balkan peoples have not been the passive recipients of label and libel' (ibid.: 39). As stated earlier, the tourism sector plays an important part in the internalization of such perceptions. If war heritage, intensively mobilized in cultural areas such as tourism, media or cinema, participates in the construction of tourism imaginaries, conversely, those representations tend to influence the exploitation and interpretation of this heritage. As Victor Alneng suggests, in the Vietnam context, those representations, conceived by the author as tourist phantasms, influence tourism production:

> For tourists, the degree of satisfaction corresponds largely to the degree
> to which a phantasm can be transformed into experience. The disso
> nance between '(t)here' and 'there' can ultimately disillusion tourists

[. . .], and this asymmetrical arrangement of perspectives comprises a potential for social change. This disillusionment, however, is worked against in various ways. The tourism industry seeks to structure tourists' experiences in accordance with phantasms (2002: 465).

Some tourism actors in Sarajevo rely largely on war heritage in the development of their practices, participating in the construction of a place image intrinsically attached to war, thereby reproducing a central component of Balkanist representations. In the Vietnam context, Alneng analyses the intense touristification of war and its integration in popular culture in general, describing a country's identity based solely on the notion of war: 'In this sense, there is a new war in Vietnam—a war of ideological napalm and propaganda booby-traps. This new war is a meta-war. A metamorphosis—the death of Vietnam as a country and resurrection of Vietnam as a War, it is about who will tell who what to remember about that other war' (ibid.: 479). He adds that this process results in the country being 'bombed back into the Stone Age' (ibid.: 485). If Alneng's conceptualization seems extreme, it partly joins the one developed here, putting at stake war heritage promotion in tourism and the construction of Balkanist representations attached to the idea of barbarism and savagery, as described by Torodova (2009).

From War to Tourism

In Sarajevo, the Bascarsija neighbourhood—home of the bazaar and the historical centre of the Bosnian capital—has become the country's main tourist centre since the return of foreign visitors in 2005. Among the goods commonly sold to tourists some items stand out. Besides regular postcards showing the main landmarks of the city, other postcards directly linked to the war of the 1990s are for sale. One represents Bosniak army headquarters during the siege (figure 34) and another juxtaposes four key moments of the twentieth century—the assassination of Archduke Franz Ferdinand, the golden age of the Bosnian capital during the 1984 winter Olympics, the five years of the siege and, present times, ironically described as 'No problem' (figure 35).

Tourist guidebooks sold in souvenir shops are also worthy of analysis. Among regular travel books and guidebooks, one cover catches the eye: *The Sarajevo Survival Guide* (FAMA 1993) (figure 36). Advertised with the tagline 'Greetings from sunny Sarajevo!', the book is structured like a regular travel guide, with chapters such as 'Climate', 'Transportation', 'Eating' and 'Sarajevo

1992 SARAJEVO **2002**

FIGURE **33.** Meeting at Bosniak army headquarters. Photograph courtesy of Zoran Philipovic. Reproduced with permission.

FIGURE **34.** Postcard showing four significant events marking twentieth-century Bosnian history. Postcard from Bosnia, courtesy of Zijad Jusufovic.

FIGURE 35. Cover of *The Sarajevo Survival Guide*. Courtesy of FAMA International.

by Night'. But the chapter 'Sarajevo by Night' does not suggest fashionable night-clubs; instead, it describes techniques used during the siege to produce light, just as the chapter 'Transportation' explains how the people of Sarajevo used to move about the city avoiding snipers; it does not offer a schedule of local public transport as expected. This parody of a tourist guidebook was produced during the siege by FAMA, an organization created at the beginning of the war and made up of journalists, writers and artists. As the foreword states, an object of tourism is used to divert and confront the visitor with an object of memory:

> The Guide Book to Sarajevo intends to be a version of Michelin, taking visitors through the city and instructing them on how to survive without transportation, hotels, taxis, telephones, food, shops, heating,

315

water, information, electricity. It is a chronicle, a guide for survival, a part of the future archive that shows the city of Sarajevo not as a victim, but as a place of experiment where wit can still archive [achieve?] victory over terror, the (sur)real 'The Day After' (ibid.: 1).

This diversion technique can be observed in the tourist maps of the city of Sarajevo and Bosnia-Herzegovina. FAMA has also produced a map of the city that, like an ordinary tourist map, points out all the landmarks, except that the sites indicated are directly linked to the siege: the post office, the Holiday Inn— the safe shelter for journalists during the war—and even the tobacco factory that never stopped functioning throughout the siege, which is described as follows:

> The Marlboro cigarettes produced in the factory under the Philip Morris license were one of the most prized cigarette brands in former Yugoslavia. There is a cult of the cigarette in Sarajevo. Although a large amount of the stored tobacco was destroyed, the factory managed to produce small quantities of cigarettes throughout the siege. In spite of their inferior quality they were eagerly bought sometimes at DM 100.00 (about 70.00 US$) per carton. Cigarettes were the most valued barter commodities. For a pack of cigarettes one could get several tins of humanitarian food. Due to the lack of paper, cigarettes were rolled into various textbooks, books and official documents. You couldn't read on them warning about health hazards but you could learn, for instance, about the process of producing copper. The citizens were often telling the story about how Sarajevo would have surrendered had the cigarettes disappeared (FAMA 1996; translation mine).

In a similar vein, FAMA's geopolitical map of ex-Yugoslavian republics shows the main sites associated with the war (Sarajevo, Vukovar, Mostar, Srebrenica), the various armies and paramilitary groups, refugee camps and population movements. Like the guidebook parody described above, these 'war maps' are on sale next to regular road maps or hiking maps in souvenir shops. Many other war-related artefacts are also displayed in the tourist centre of Sarajevo, such as lighters or pens made out of bullets. According to Volčič, Erjavec and Peak (2013), one may also find victims' shoes and some restaurants even offer the possibility of ordering a 'siege dinner' comprising cans of humanitarian food aid.

Touring the War

In Sarajevo, various tours are offered to visitors who want to see war-related landmarks. The Times of Misfortune Tour is organized by a private tour agency, Sarajevo Insider, and actively promoted by the tourism office. After a brief sightseeing of the city centre in a van, tour groups visit what is called the Tunnel of Hope. During the war, this tunnel was the only connection between the besieged city and the outside world. The guides on these tours are generally students who were often exiled during the war but now have the advantage of speaking foreign languages and interacting with tourists, even though most of them did not live through the city siege.

The Mission Impossible Tour, which is independently organized by Zijad Jusufovic, a former fixer who used to work for the Red Cross and guide UN soldiers during the war, proposes a more complete panorama of sites, including the old bobsleigh track shelled during the war, the ruins of the anti-fascist monument, the burnt-down library and what Jusufovic calls 'the Mujahidin market' next to the Kralj Fahd Džamija (King Fahd Mosque). The guide claims that this mosque is also known to shelter jihad-oriented Madrasas as well as private and mysterious logistical centres. Later, during the tour, a coffee break is offered at the Casa Grande Hostel in the outskirts of Sarajevo. This place is supposedly run by the mob and mafia meetings often take place there. The tourists do not see or hear proof of these allegations. However, in this empty hotel, the tourist imagination is highly mobilized, attributing an aura of crime and mystery to the place. Muslim terrorism, post-war mafia and ruined buildings are among other elements presented in this tour, shaping tourist interests and the identity of the place.

Jusufovic claims to be the first legitimate post-war guide and stresses his impartiality and accuracy as well as the uniqueness of his presentation. He frequently mentions his experience of the war and the extensive post-war research he has carried out over 10 years. He does not hesitate to question the information provided by other tourist guides and emphasizes on his freedom of speech; for instance, he claims that they would not talk about the black market or the idea of constructing a second tunnel during the war. In his opinion, 'Young guides, especially those speaking a foreign language, weren't here during the siege, [so] there is a lot of things they can't know.' The goal here is not to determine who is in possession of the truth among agents in the tourism business, but rather to observe the process of 'touristification' of the war and how this

phenomenon helps create an imagination linked to this war-torn region and its history of conflict.

A Tunnel Source of Mystery

The Tunnel of Hope is today one of Sarajevo's most popular attractions, with hundreds of visitors every day. It is presented in the *Lonely Planet* guidebook as a unique tourist attraction: 'For the ultimate war experience, don't miss a visit to the very thought provoking Tunnel Museum near Ilidža or stroll down "Sniper Alley" with a wartime survivor' (Fallon, Vorhees and Miller 2009). This site is not only an important landmark of the war but also a symbol of Bosniak resistance. Guides describe the archaic technique used to build this tunnel as well as the heroic resistance of the Bosniak army, heavily outnumbered by its opponents. If less glorious aspects of the tunnel's history—black market, war profiteers—are indeed less present in the discourse of some tourist guides recommended by the tourism office than among more independent guides such as Jusufovic, it would be incorrect to assert that those aspects are totally evaded. One of the 'recommended' guides explicitly described wartime black-market practices in the tunnel. Furthermore, a French tourist who took the Times of Misfortune Tour said, 'France waited 40 years before mentioning the existence of a black market during the Second World War.'[6]

It is also interesting to note that in Sarajevo, with its heritage that attracted numerous tourists before the siege, the war's history now constitutes one of the main motivations for tourism. As a guide recommended by the tourism office confirmed, 'The Times of Misfortune Tour is the most demanded of our tours with the Historical Tour.'[7] This observation is backed by some remarks I noted among tourists visiting the war sites; for example, a French woman explained, 'We left for Croatia and we went all the way to Mostar. We finally said to our-selves, "Why not Sarajevo?". We find people in Bosnia more spontaneous, less oriented towards "commercial" aspects. And furthermore it is packed with history and it is very interesting to see a country that is recovering from its war wounds.'[8] And an American tourist wrote in the guestbook of an exhibition specifically dedicated to the siege, 'My time here in the museum and in the city has opened my eyes to a thing I only saw on TV as a young 20-year-old girl.' Another German tourist wrote, 'I was almost a teenager when I saw pictures of this terrifying war on TV, it was impressive enough to make me want to come.'

Thus, the will to understand and to see in person a site that was the lead story in international news media during the 1990s seems to be a key motivation for foreign visitors to the Bosnian capital. Similarly, the movies and news media like CNN or euronews could be considered as agents contributing, if not to the construction of an imagination, at least to the depiction of a place marked by such savagery that people worldwide are visiting to try to understand it. Although this comment certainly ought to be backed by more empirical data, these few elements allow us to identify the war, or at least some elements of the war heritage, as an inescapable part of Sarajevo's international image.

Bosnia between War and Phantasm

The memory of the war is still strong, and this armed conflict has certainly not gone through the process of 'heritagization' like the Vietnam War, for example. Nevertheless, the Tunnel of Hope in Sarajevo constitutes one of the major attractions in the capital and in the whole country. Since the Bosniak army abandoned it at the end of the war, it has become a museum run privately by the Kolar family that owns the house where the entrance is located. They have run it for 15 years without any government support and it has become the most visited site of the Bosnian capital. This success increased interest from the authorities and, in 2012, after a few years of negotiation the canton took over the management of the museum and appointed a five-member executive board.

The very short period that elapsed since the conflict partly explains the lack of academic scholarship on tourism and war in the Balkans in general and Bosnia–Herzegovina in particular. One of the in-depth studies is by cultural theorist Senija Causevic (2008) who explores the post-conflict recovery of tourism in Northern Ireland and Bosnia. Her study focuses on the reconstruction of the country's image and the promotion of Northern Ireland as a tourist destination, demonstrating that it was somehow easier to promote this region as *terra incognita* after a long-term conflict. Developing the idea of discovery and adventure, Causevic presents Sarajevo's Tunnel of Hope as a symbol of the unknown:

> Speaking more generically, the tunnel is perceived as secret and mystical, a symbol of the unknown. What is on the other side of the tunnel? The reason for the Sarajevo Tunnel being the most visited site is that the story of the conflict is explained through the ordinary people of Sarajevo, people in every sense similar to the tourists themselves and whose lives were saved thanks to that tunnel. The result is

319

a cathartic moment. People come to those sites because they themselves want to find the meaning of life (ibid.: 246).

According to Causevic, the experience of the tunnel visit is not limited to its cathartic dimension: 'Backpackers visit Bosnia and Herzegovina to show off to their peers back home [that] they were in a "war-torn" area, and to show off their perceived western superiority over Bosnia, a post-conflict country. Regarding the first, this illustrates superficiality. People want to think that Bosnia and Herzegovina is a war-torn country and being there provides an ego boost' (ibid.: 302). This statement seems to echo Žižek's perception of a dark and simplistic vision that somehow compares Bosnia to the dark hole of Europe (see *euronews* 2008). If the notions of 'mystery and the unknown' are used as tools to attract tourists, the media is also seen as inevitable contributors to international depictions of the place.

Causevic even introduces the notion of a 'CNN factor': 'Generally speaking, media has both positive and negative implications in the process of destination re-imaging. [. . .] The interviewees called those negative media reports, a CNN factor. Whenever there are negative media reports and broadcasting, it has an implication towards the perception of the destination' (2008: 139).

In their founding book, *Dark Tourism: The Attraction of Death and Disaster*, John Lennon and Malcolm Foley (2000) insist on the post-modern dimension of this phenomenon, demonstrating the importance of the media in the transformation of a war site into a tourist attraction. They claim that the development of information and communication technologies (radio, Internet, television) produces an echo to an event such as a war, creating widespread public interest and giving rise to a tourist site. According to Causevic (2008), however, Sarajevo has been only rarely present in the Hollywood cinema industry; it has been mainly media such as CNN or euronews that set Sarajevo on the international front stage.

Although the war in former Yugoslavia did not generate the same amount of international movie productions as the Vietnam War, a few features deserve to be mentioned. Danis Tanovic's *No-Man's Land* (2001) and Ademir Kenovic's *Perfect Circle* (1997) belong to what some have called 'the new post-Yugoslav war movie' genre, which includes more than 300 documentaries and fiction movies (Dakovic 2004). International movies also contributed to this trend with Élie Chouraqui's *Harrison's Flower* (2000) and Michael Winterbottom's *Welcome to Sarajevo* (1997), both of which present the conflict in Vukovar (Croatia) and Sarajevo from the stereotype-laden perspective of Western journalists.

Causevic's study also demonstrates how the Hollywood industry tends to trivialize war by presenting it 'as a battle between good guys and the evil ones, where good guys always win' (2008: 355). The American movie *Harrison's Flower*, about a journalist (played by Andie MacDowell) searching for her husband, a photographer lost in Vukovar, reflects this stereotypical and simplistic view of the war. Serbian soldiers are presented as bloodthirsty barbarians, the local population as completely passive and Western photojournalists as the real heroes. As with Vietnam in Francis Ford Coppola's *Apocalypse Now* (1979) or the Congo in Joseph Conrad's *Heart of Darkness* (1889), Vukovar and its surroundings are depicted as hell on earth, even though Coppola's movie ends on a happy note.

We are thus confronted with one of the main paradoxes of war touristification: the diffusion of knowledge often attached to first-hand information and thus valuable for tourists in contradiction to the simplification process that characterizes the tourism sector and potentially leads to historical distortions. Zala Volčič, Karmen Erjavec and Mallory Peak have demonstrated the limits of 'knowledge diffusion' through tourism:

> The simplification of Sarajevo's violent past and present dilemmas through the depoliticized lens of recovery and personal responsibility provide tourists with a very limited way to learn about Sarajevo's war memories and the impact of violent conflict. It is important to consider what is lost in this simplification, particularly in terms of public education and understanding violence. On the basis of this research, we argue that tourism and branding of the city can both encourage certain kinds of engagement with traumatic experiences, yet at the same time, foreclose on other possible ways of understanding historical and political forces that contribute to violence (2013: 14).

It is thus established that 'what is lost in this simplification' also allows the production of stereotypes, some attached to a Balkanist dimension. In her study, Causevic introduces the notions of 'trivialization' and 'disneyfication' of war through cinema or tourism (2008: 355). By comparing the Sarajevo tunnel and the Cu Chi tunnels,[9] which she presents as two major tourist destinations, and pointing out the process of 'disneyfication', Causevic underlines the fact that these sites have to be understood in their historical dimension: 'Denial is forbidden because it leads to Disneyfication' (ibid.). While this process of disneyfication is questionable from a historical perspective, it also harms the tourist industry itself, especially if we listen to the words of this tourist who

321

compares Mostar and Sarajevo: 'I feel better here in Sarajevo. In Mostar, it was very touristy and this touristy side tended to spoil history.'[10]

Dark Tourism or Hot Tourism?

The touristification of sites related to war is generally problematized through the notion of 'dark tourism' (Stone 2006; Lennon and Foley 2000) or 'thanatourism' (Seaton 1996), as is that of sites linked to natural disasters or terrorism attacks. According to Lennon and Foley, the 'dark tourism' definition applies to sites 'associated with death, disaster, and atrocity, such as battlefields, graves, accident sites, murder sites, places of assassination and death camps' (2000: 4). It is also linked to tourists' desire to satisfy a morbid curiosity. So far, research on this subject has mainly focused on hospitality management and marketing. Most of it is limited to quantitative analyses, leading to results presented through rigid typologies that do not take into account human agency and practices. Philip Stone (1996), for instance, points out the different shades of darkness a site can take on, in a spectrum going from the lightest to the darkest. Following his scale, Auschwitz would be darker than the Holocaust Museum in Washington DC, since the latter is more disconnected from the Nazi genocide. He defines different categories based on such criteria as education, authenticity, leisure, location, chronological distance and even the degree of touristification or development for tourism purposes. I argue that we need a more holistic approach with qualitative and interdisciplinary methods in order to develop an analysis that goes far beyond the tourism industry.

As demonstrated previously, sociopolitical implications associated with the touristification of sites are essential to the understanding of this issue. According to Causevic, 'war tours and general city tours in Sarajevo are very similar. Therefore dark tourism, which deals genuinely with war memorabilia sites, appears to be without meaning. War is a part of every city tour and history is a part of every war tour. Dark tourism as a category does not make any sense' (2008: 355). In another critical approach, Mark Piekarz (2007) deconstructs the concept of battlefield tourism and demonstrates that the implications of this type of tourism vary with the degree of conflict resolution. This type of war tourism or battlefield tourism is situated on a continuum that spreads from hot to cold depending on the nature of the conflict and is based on criteria such as the 'rawness of the visual aesthetic' and the 'degree of tidying up' (ibid.: 156). The first criterion is mainly linked to the removal of war detritus (damaged

vehicles, damaged buildings, bodies) and the second is associated with the process of reconstruction (making sites secure, erecting memorials, establishing proper cemeteries). Piekarz stresses that a site can stay 'hot' long after the official ending of a war:

> For soldiers from the developed world, conflicts can be waged with almost clinical precision, with casualties generally removed from the conflict zone very quickly. For other parts of the world, wars and conflicts can still be fought with a ferocity and rawness familiar to past conflicts, where the sites of conflict can remain hot for years, owing to lack of resources, desire or time to remove the detritus or mess of war (ibid.).

In the Bosnian case, some areas are still infested with landmines and numerous sites are still in ruins. Following Piekarz's analysis, it is incorrect to present Sarajevo as a totally cold war site. Piekarz shows that the concept of battlefield tourism, problematized as an element of dark tourism, does not include the diversity of practices that it covers. Between sensation-seeking tourists, backpackers searching for an 'ego boost' (Causevic 2008: 302) and visitors looking for knowledge, numerous types of tourists coexist in Sarajevo. It is difficult to set clear boundaries between a conflict and a post-conflict period, and between war tourism, with elements of adventure, danger and adrenaline, and post-war tourism, based on the idea of knowledge and closer to cultural, historical or heritage tourism. If it is misleading to define war tourism or post-war tourism as separate practices, we should then even more seriously question the idea of classifying sites such as the Sarajevo tunnel, the Cu Chi tunnels, Auschwitz or the Holocaust Museum according to the typologies proposed by some scholars of dark tourism.

Popular cultural productions such as global news, films and tourism have shaped the imagination of visitors to Sarajevo. And if these images have influenced Bosnia's tourism landscape, we can also question its propensity to shape a society in its entirety. If, as Amirou (1994) argues, each place has corresponding images, the war might then represent Sarajevo in the same way that Auschwitz might symbolize Poland or Ground Zero, New York City. It is important not to fall into rigid formulas that assimilate the entire tourism landscape of a country with a war history. If indeed some major attractions of Bosnia are directly associated with the war, they certainly do not render the full picture. War heritage should not be considered the only attraction for tourists in Sarajevo and Bosnia. If we refer to Amirou's conceptualization, images born out of the war

belong to a transitional area and would paradoxically facilitate tourists' familiarization with a less-known Bosnia (ibid.).

It would be an over-simplification to characterize tourist visits as voyeurism and an attraction for the macabre as suggested by some representatives of dark tourism or other generalist media. A desire for knowledge and self-enrichment is often perceived in the comments of tourists visiting these sites. Equally, it is an over-simplification to suggest that financial gain is the main motivation behind the exploitation of the macabre and victims' suffering by actors participating in the tourisitification of a war. Examples such as FAMA or the discourse of some guides clearly demonstrate a desire to make voices heard on a very sensitive matter and in a national context, which goes far beyond the sole process of past disneyfication postulated in dark tourism. Causevic insists that the Sarajevo tunnel cannot be understood in accordance with the theory of the imaginary world of dark tourism as a 'past disneyfication': 'It is still too early and too disrespectful to do that' (2008: 355). In a country seeking to regain its place on the European tourism circuit, many within or outside the tourism industry are warning against a tendency that might see Bosnia trapped in its dark past. Between the attempt to exploit this recent conflict to boost tourism and the desire to turn the page and revert to traditional tourist sites, different forces compete in a city and a state on the road to stabilization.

Notes

1 This essay is a revised version of my previously published article based on ongoing doctoral research: 'Travelling through a Powder Keg: War and Tourist Imaginary in Sarajevo'. *Tourist imaginaries* 1 (16 March 2012). Available at: http://www.viatourismreview.net/Article5_EN.php (last accessed on 23 October 2013; translations of this previous work are available in German and French). This essay presents research specifically based on empirical data collected in Sarajevo during the summer of 2010.

2 *Bure Baruta* in Serbian, Croatian or Bosnian.

3 *Gori Vatra* in Serbian, Croatian or Bosnian.

4 The term 'Bosnian' refers to the concept of citizenship. It comprises all inhabitants of Bosnia regardless of ethnic origin. 'Bosniak' defines specifically the national and religious identity of one of the communities living in Bosnia–Herzegovina, with strong adherence to Islam.

5 Maria Torodova (2009) introduces the concept of 'Balkanism' which is inspired by Edward Said's (1978) 'Orientalism' that depicts the Western world's production

of false and romanticized images of the East, the 'Other'. Torodova positions herself vis-à-vis this Orientalist concept by deconstructing the discourses and representations on the Balkan region, which she defines as 'Balkanist'. She explains that, as these myths are present in 'journalistic and quasi-journalistic literary forms', they lead to the production of a myth regarding the region (ibid.: 19). According to Torodova, this Balkanist 'myth' was crystallized by specific discourse concerning the First World War and the Balkan wars at the beginning of the twentieth century. As a result of a process of reductionism and stereotyping, Balkan people are defined as the 'Others' of Europe, implying their regression to the tribal, the backward, the primitive and the barbaric.

6 Personal interview with French tourist, Sarajevo, July 2010.

7 Personal interview with guide, Tunnel of Hope, Sarajevo, July 2010. The Historical Tour of Sarajevo leads tourists to the main historical and cultural landmarks of Sarajevo.

8 Personal interview with French tourist, Sarajevo, July 2010.

9 The Cu Chi tunnels are located near Ho Chi Minh City (formerly Saigon). These tunnels were used by the North Vietnamese guerrilla to hide and are now a well-known site in the Vietnamese tourism circuit.

10 Personal interview with tourist, Sarajevo, July 2010.

Works Cited

AMIROU, Rachid. 1994. 'Le tourisme comme objet transitionnel' (Tourism as a Transitional Object). *Espaces et Sociétés* 76: 149–64.

———. 1999. 'Les nouvelles mythologies du tourisme' (New Mythologies of Tourism). *Sciences humaines* 90: 22–25.

ALNENG, Victor. 2002 ' "What the Fuck is a Vietnam?" Touristic Phantasms and the Popcolonization of (the) Vietnam (War)'. *Critique of Anthropopology* 22(4): 461–89.

CAUSEVIC, Senija. 2008. 'Post-Conflict Development in Bosnia and Herzegovina: The Concept of Phoenix Tourism'. Unpublished PhD thesis. Glasgow: University of Strathclyde.

DAKOVIC, Nevena. 2004. 'La guerre sur grand écran: filmographie de l'éclatement yougoslave' (The War on Big Screen: Catalogue of Films on the Breakup of Yugoslavia'), 31 March. Available at: balkans.courriers.info/article4313.html (last accessed on April 2011).

EURONEWS. 2008. 'euronews Talks Films and Balkans with Slavoj Zizek'. euronews, 12 September. Available at: http://www.euronews.com/2008/09/12/ euronews-talks-films-and-balkans-with-slavoj-zizek/ (last accessed on 1 July 2011).

FALLON, Steve, Mara Vorhees and Emma Miller. 2001. *Lonely Planet: Eastern Europe*, 6th edition. Melbourne, Victoria: Lonely Planet Publications.

FAMA. 1993. *The Sarajevo Survival Guide*. Sarajevo: FAMA. Available at: http://www.famacollection.org/eng/fama-collection/fama-original-projects/04/-index.html (last accessed on 23 October 2013).

———. 1996. *Survival Map, 1992–1996*. Sarajevo: FAMA. Available at: http://www.-famacollection.org/eng/fama-collection/fama-original-projects/10/-index.html (last accessed on 23 October 2013).

HARVEY, David. 1989. *The Condition of Postmodernity: An Enquiry into the Origins of Cultural Change*. Oxford: Blackwell.

LENNON, John, and Malcolm Foley. 2000. *Dark Tourism: The Attraction of Death and Disaster*. London and New York: Continuum.

NAEF, Patrick. 2012. 'Travelling through a Powder Keg: War and Tourist Imaginary in Sarajevo'. *Tourist imaginaries* 1 (16 March). Available at: http://www.viatourismreview.net/Article5_EN.php (last accessed on 23 October 2013).

PIEKARZ, Mark. 2007. 'Hot War Tourism: The Live Battlefield and the Ultimate Adventure Holiday?' In Chris Ryan (eds), *Battlefield Tourism: History, Place and Interpretation*. Amsterdam: Elsevier, pp. 153–69.

SAID, Edward. 1978. *Orientalism*. New York: Pantheon Books.

SALAZAR, Noel B. 2009. 'Images or Imagined? Cultural Representations and the "Tourismification" of Peoples and Places'. *Cahiers d'études africaines* 49(193–4): 49–71.

SEATON, A. V. 'Tony'. 1996. 'Guided by the Dark: From Thanatopsis to Thanatourism'. *International Journal of Heritage Studies* 2: 234–44.

STONE, Philip. 2006. 'A Dark Tourism Spectrum: Towards a Typology of Death and Macabre Related Tourists and Sites, Attraction and Exhibitions'. *Tourism: An Interdisciplinary International Journal* 52(2): 145–60.

TORODOVA Maria. 2009. *Imagining the Balkans*. New York: Oxford University Press.

VOLČIČ, Zala, Karmen Erjavec and Mallory Peak. 2013. 'Branding Post-War Sarajevo: Journalism, Memories, and Dark Tourism'. *Journalism Studies*. Published online 30 September. DOI: 10.1080/1461670X.2013.837255.

WINNICOTT, Donald. 1953. 'Transitional Objects and Transitional Phenomena: A Study of the First Not-Me Possession'. *International Journal of Psychoanalysis* 34: 89–97.

Contributors

LAURIE BETH CLARK is a professor in the art department of the University of Wisconsin, Madison, where she teaches studio courses in performance, video and installations and has organized seminars on contemporary visual culture. Documentation of her creative work can be found at www.lbclark.net. She is currently writing a book, *Always Already Again: Trauma Tourism and the Politics of Memory Culture*, based on her research at memorial sites in seventeen countries on five continents. She has published essays on trauma tourism in *Performance Research, Performance Paradigm, TDR, The Memory Market in Latin America, The Object Reader* and *Place and Performance*.

MAURA COUGHLIN is associate professor of visual studies in the department of English and cultural studies at Bryant University in Smithfield, Rhode Island. Trained as an historian of nineteenth-century European art, her current research on mourning and visual culture in Brittany is informed by new materialism, eco-criticism, feminist theory and cultural geography. Her essay on thanatourism is drawn from a larger book project, *Materiality and Ecology in the Visual Culture of Brittany, 1880–1914*.

LINDSEY A. FREEMAN is assistant professor of sociology at the State University of New York, Buffalo. She teaches, writes and thinks about space/place, utopia, memory, nostalgia and the atomic bomb. Freeman is co-editor of *Silence, Screen, & Spectacle: Rethinking Social Memory in the Age of Information* and author of *Longing for the Bomb: Atomic Nostalgia in a Post-Nuclear Landscape* (both forthcoming). She studied history and sociology at the New School for Social Research (formerly the University in Exile) where she received the Albert Salomon Award for distinguished dissertation.

MARY RACHEL GOULD is assistant professor of culture and communication at Saint Louis University and co-director of the Saint Louis University Prison Arts and Education Programme. Her research focuses on the study of transgression in contemporary culture with particular emphasis on the prison system, dark tourism and urbanization. Gould's most recent research examines the ways in which non-incarcerated citizens gain knowledge about the prison system, focusing on visitation to prison museums and tourist attractions.

SUSANNE C. KNITTEL is assistant professor of comparative literature at the University of Utrecht in the Netherlands. Her forthcoming monograph, *The Historical Uncanny*:

327

Rethinking the Memory of the Holocaust in Germany and Italy, examines the cultural memory of the Nazi euthanasia programme in Germany and the legacy of Fascism and the Nazi occupation in northeastern Italy. Her current research, supported by a grant from the Netherlands Organisation for Scientific Research (NWO), focuses on the memory and representation of perpetrators in literature and film and at sites of memory in Germany and Romania.

CARA L. LEVEY is a lecturer in Latin American studies at University College Cork, Ireland. Her work to date has focused on contested commemorations of human rights violations in Argentina and Uruguay. She is particularly interested in the way in which sites of human rights violations are treated by state and societal actors in the long after-math of dictatorship and violence and has published a number of peer-reviewed articles and book chapters on this. Levey is currently preparing a monograph titled 'Fragile Memory, Shifting Impunity: Contestation and Commemoration in Post-Dictatorship Argentina and Uruguay' and is co-editing a volume 'Crisis, Response and Recovery: A Decade on from the Argentinazo, 2001–2011'.

STEPHANIE MCKINNEY completed her PhD in history, with a specialization in genocide and modern war, from the Claremont Graduate University, California. She teaches in the history department of California State Polytechnic University Pomona. Her research interests include the Rwandan genocide, dark tourism and human rights. She also facilitates for the Museum of Tolerance's law enforcement training programmes and volunteers with Amnesty International.

PATRICK NAEF holds a degree in anthropology from the University of Neuchâtel, Switzerland, and is completing his doctoral dissertation at the University of Geneva; he is also a graduate assistant in the Human Ecology Programme at the Environmental Science Institute, Geneva. His research looks at the processes of war memorialization and at the ways in which sites traumatized by a recent armed conflict are turned into heritage landmarks, specifically in Sarajevo and Srebrenica (Bosnia–Herzegovina) and in Vukovar (Croatia).

MARK PENDLETON is a lecturer in the School of East Asian Studies at the University of Sheffield. He has held research fellowships at the Tokyo University of Foreign Studies and the 'Transitions' International Research Centre in Humanities and Social Sciences at New York University. He has published in a range of journals, and is an editor of *History Workshop Journal*. His 2011 *Japanese Studies* article, 'From Subway to Street: Spaces of Memory, Counter-Memory and Recovery in Post-Aum Tokyo' won the 2012 EastAsiaNet Award for Best Academic Article.

S. I. SALAMENSKY is currently associate professor of theatre and performance studies, associated faculty of European and Eurasian studies, and associated faculty of Jewish

studies at the University of California, Los Angeles. She is currently working on a forth-coming book titled *Diaspora Disneys: Spectacular Homes and Homelands in the Global Age*. She is also author of *The Modern Art of Influence and the Spectacle of Oscar Wilde*, and editor of *Talk Talk Talk: The Cultural Life of Everyday Conversation*. Salamensky was recently awarded the American Council of Learned Societies Fellowship.

MARK SCHAMING is director of the New York State Museum in Albany, New York. He spent over 40 days at the World Trade Center recovery operation at Fresh Kills, working with the Federal Bureau of Investigation and the New York Police Department to doc-ument and collect, in the aftermath of the attacks of 11 September 2001. He led the team that collected over 2,000 objects and also extensively photographed the historic operation. He was principal designer of the New York State Museum exhibition, *The World Trade Center: Rescue Recovery and Response*, and the exhibition that toured France and the United States for the 10th anniversary of 11 September 2001, *September 11, 2001: A Global Moment*.

RAINER SCHULZE is professor of modern European history and member and former director of the Human Rights Centre at the University of Essex, United Kingdom. His research interests include the history of the Bergen-Belsen concentration camp, questions of collective memory and identity in twentieth-century Europe, the Second World War and forced migration, and the history of the Sinti and Roma and antiziganism in Europe after 1945. From 2000 to 2007, Schulze was one of the project leaders of the international team of researchers preparing the new permanent exhibition at the Gedenkstätte Bergen-Belsen; in 2005, he became a member of the Gedenkstätte's International Experts' Com-mission. He is the founding editor of the journal *The Holocaust in History and Memory*.

BRIGITTE SION holds a PhD in performance studies from New York University. She is an associate adjunct researcher with the Committee on Global Thought at Columbia Uni-versity, and a co-organizer of the Franco-American seminar 'The Politics of Difficult Pasts: Memory in Global Context'. Her work focuses on the conflicting performances occurring at memorial sites in Germany, Argentina, Cambodia and France—rituals, politics, tourism, education and architecture. She has widely published on this subject, and is completing the forthcoming *Absent Bodies, Uncertain Memorials: Performing Memory in Berlin and Buenos Aires*, her fifth book.

ANIKO SZUCS is an adjunct lecturer at the drama department of New York University (NYU) and John Jay College of Criminal Justice. She is completing her dissertation at NYU's Department of Performance Studies about the recontextualizations of confidential state security documents in contemporary Hungarian performances. She holds MA degrees in English, in communication and in theatre studies and dramaturgy, and was the resident dramaturg of the prestigious theatre company Vígszínház in Budapest between 2000 and 2005. In 2009, Szucs co-curated the exhibition *Revolutionary Voices*:

Performing Arts in Central & Eastern Europe in the 1980s' at the New York Public Library for the Performing Arts, Lincoln Center.

DIANA TAYLOR is university professor and professor of performance studies and Spanish at New York University. She is the author of the award-winning *Theatre of Crisis: Drama and Politics in Latin America* (1991), *Disappearing Acts: Spectacles of Gender and Nationalism in Argentina's 'Dirty War'* (1997) and, most recently, *The Archive and the Repertoire: Performing Cultural Memory in the Americas* (2003). She has edited over a dozen books, has lectured extensively round the world, and is the recipient of many awards and fellowships, including the 2005 Guggenheim Fellowship, the 2012–13 Phi Beta Kappa Visiting Scholar and the 2013–14 ACLS Digital Innovation Fellowship. Taylor is founding director of the Hemispheric Institute of Performance and Politics, New York.

Index

Page numbers in italics refer to figures.

Printed and bound by CPI Group (UK) Ltd, Croydon, CR0 4YY

09/06/2025